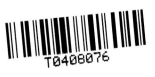

France's Memorial Landscape

Contemporary French and Francophone Cultures, 91

# Contemporary French and Francophone Cultures

*Series Editor*

CHARLES FORSDICK
*University of Liverpool*

*Editorial Board*

TOM CONLEY
*Harvard University*

JACQUELINE DUTTON
*University of Melbourne*

LYNN A. HIGGINS
*Dartmouth College*

MIREILLE ROSELLO
*University of Amsterdam*

DEREK SCHILLING
*Johns Hopkins University*

This series aims to provide a forum for new research on modern and contemporary French and francophone cultures and writing. The books published in *Contemporary French and Francophone Cultures* reflect a wide variety of critical practices and theoretical approaches, in harmony with the intellectual, cultural and social developments which have taken place over the past few decades. All manifestations of contemporary French and francophone culture and expression are considered, including literature, cinema, popular culture, theory. The volumes in the series will participate in the wider debate on key aspects of contemporary culture.

*Recent titles in the series:*

77 Maria Kathryn Tomlinson, *From Menstruation to the Menopause: The Female Fertility Cycle in Contemporary Women's Writing in French*

78 Kaoutar Harchi and Alexis Pernsteiner, *I Have Only One Language, and It Is Not Mine: A Struggle for Recognition*

79 Alison Rice, *Transpositions: Migration, Translation, Music*

80 Antonia Wimbush, *Autofiction: A Female Francophone Aesthetic of Exile*

81 Jacqueline Couti, *Sex, Sea, and Self: Sexuality and Nationalism in French Caribbean Discourses, 1924–1948*

82 Debra Kelly, *Fishes with Funny French Names: The French Restaurant in London from the Nineteenth to the Twenty-First Century*

83 Nikolaj Lübecker, *Twenty-First-Century Symbolism: Verlaine, Baudelaire, Mallarmé*

84 Ari J. Blatt, *The Topographic Imaginary: Attending to Place in Contemporary French Photography*

85 Martin Munro and Eliana Văgălău, *Jean-Claude Charles: A Reader's Guide*

86 Jiewon Baek, *Fictional Labor: Ethics and Cultural Production in the Digital Economy*

87 Oana Panaïté, *Necrofiction and The Politics of Literary Memory*

88 Sonja Stojanovic, *Mind the Ghost: Thinking Memory and the Untimely through Contemporary Fiction in French*

89 Lucy Swanson, *The Zombie in Contemporary French Caribbean Fiction*

90 Christopher T. Bonner, *Cold War Negritude: Form and Alignment in French Caribbean Writing*

SOPHIE FUGGLE

# France's Memorial Landscape

## Views from Camp des Milles

LIVERPOOL UNIVERSITY PRESS

First published 2023 by
Liverpool University Press
4 Cambridge Street
Liverpool
L69 7ZU

Copyright © 2023 Sophie Fuggle

Sophie Fuggle has asserted the right to be identified as the author of this book in accordance with the Copyright, Designs and Patents Act 1988.

All rights reserved. No part of this book may be reproduced, stored in a retrieval system, or transmitted, in any form or by any means, electronic, mechanical, photocopying, recording, or otherwise, without the prior written permission of the publisher.

British Library Cataloguing-in-Publication data
A British Library CIP record is available

ISBN 978-1-83764-478-0

Typeset by Carnegie Book Production, Lancaster
Printed and bound by CPI Group (UK) Ltd, Croydon CR0 4YY

# Contents

*Acknowledgements*   vii

*List of Illustrations*   ix

Preface   xi

Introduction: This Is Not a Camp   1

   1   Window Frame   25
   2   Tricolore   61
   3   Wagon   91
   4   Landscape   129
   5   Sky   163

Conclusion: Recollections of a View   193

*Archival References*   197

*Bibliography*   198

*Index*   217

# Acknowledgements

This project has happened in the interstices between other research, other events, other things. It became bigger than I expected and took far longer than I hoped. If anything, this is evidence of its importance and its refusal to go away or be easily contained and completed. My initial visit to the Camp des Milles memorial took place on an afternoon in August 2015 and I am grateful to my partner John Hutnyk and my father Roger Fuggle for taking time away from the hotel pool to come with me. In the second instance I am thankful to Oliver Davis and Jeremy Ahearne for inviting me to present my initial, very rough thoughts on the memorial as part of a panel on 'Securitization' at the ASMCF annual conference in Aston just over a year later. Paradoxically it was my frustration with the paper I gave that drove me to produce something more worthy of the site and the stories to which it bears witness. In spring and summer 2017, sabbatical leave and generous funding from Nottingham Trent enabled me to spend time at the Centre de documentation juive contemporaine at the Shoah Memorial in Paris and the memorial centre at Drancy as well as visit Les Milles again. The references to French Guiana in Chapter 5 were informed by a research visit to the territory in June 2017 supported by a British Academy small grant (SG162446). I would like to thank the archivists and curators at the various archives and memorial sites for taking the time to discuss my project and direct me towards specific resources. I would also like to thank Chloe Johnson and the editorial team at Liverpool University Press for their excellent support as well as the anonymous reviewers who have offered thoughtful and inspired feedback on early versions of the manuscript.

More general thanks go to colleagues and friends who have offered support and advice on this and other projects in recent years: Charles Forsdick, Maryse Tennant and Samuel Tracol for their shared enthusiasm for penal heritage; Claire Reddleman and Charles Fox for their practical

insights into photography; Kat Massing and Chantal Cointot for their endless patience in letting me bounce ideas off them, as well as Lara Choksey, Agathe Zobenbueller, Ayshka Sené, Gianluca Fantoni, Charlie Gregson and Nicole Thiara. A special mention should also go to Alice Wharton whose undergraduate dissertation on the Vélodrome d'Hiver I supervised in 2014. I am grateful to Alice for introducing me to themes of postwar French memory and forgetting that I had not seriously considered before. Since embarking on this project, I have come to better understand the pull towards this difficult part of French history and its representation and am continually humbled by the way in which my students remind me, through their own burning questions and insightful analysis, that research should always be a vocation not a job.

Finally, there is my daughter Annabel Scout Tate Hutnyk, who was born in Spring 2016. It is fair to say that she has slowed the completion of this book down but also encouraged me to take stock of why I am writing and with what shared future in mind.

# List of Illustrations

Figure 1. View from the 'suicide window' at Camp des Milles. Photograph by the author, August 2015. — xii

Figure 2. Close up of the 'cone of vision'. Photograph by the author. — 2

Figure 3. The tile factory at Les Milles. Photographed by the author from the Chemin des déportés, August 2021. — 12

Figure 4. Window shutter belonging to the 'suicide window' at Camp des Milles. Photograph by the author, August 2017. — 35

Figure 5. European and French flags next to the Wagon du souvenir. Photograph by the author, August 2021. — 88

Figure 6. View of Camp des Milles from behind the Wagon du souvenir. Photograph by the author, August 2021. — 90

Figure 7. The old station at Les Milles. Photograph by the author, April 2018. — 93

Figure 8. View of Montagne Sainte-Victoire from Camp des Milles. Photograph by the author, August 2021. — 137

Figure 9. Gate designed by Raphaël Monetti based on poetry by René Char. Hôtel Bompard. Photograph by the author, April 2018. — 154

Figure 10. Blockhaus No. 1, Camp de la Transportation, Saint-Laurent-du-Maroni. Photograph by the author, June 2017. — 173

# Preface

During August 1942 several women jumped to their deaths from a second-storey window at the tile factory in the small town of Les Milles, located about 6 km from Aix-en-Provence in the southeast of France. Built in 1882, the tile-making factory had ceased operation in 1937 due to the economic recession sweeping through Europe. Between 1939 and 1942 the factory assumed various roles as internment camp, transit camp and ultimately deportation camp. To escape deportation to Auschwitz, women jumped from their dormitory window. Mass deportations were carried out throughout August under the supervision of the Vichy authorities until December 1942. Subsequently requisitioned by the Nazi authorities, the camp was briefly used to store munitions before closing in early 1943. After the war, the factory resumed tile-making until 2006. Following a decades-long campaign, the Camp des Milles memorial museum opened in 2012. A second-floor window is highlighted as part of the exhibition space. Identified as the 'fenêtre des suicides' [suicide window], it looks out onto the now disused railway where a cattle truck used by the SNCF in wartime known as the 'Wagon du souvenir' [Wagon of Remembrance] is on display.

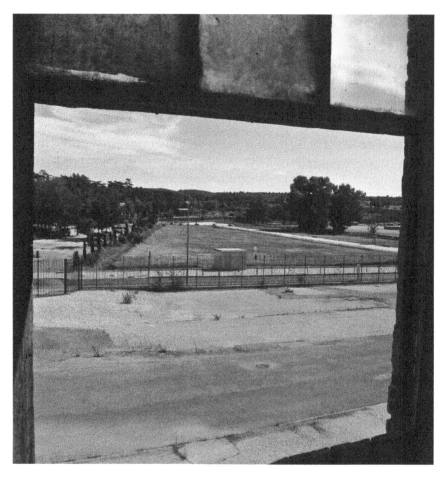

Figure 1. View from the 'suicide window' at Camp des Milles.
Photograph by the author, August 2015.

# Introduction
## This Is Not a Camp

This book is not a book about a camp. It is a book about a view [Figure 1]. The view from a second-floor window of a tile factory. This is a view framed by a camp; framed by *the* camp as concept and history, and framed by *a* camp as an archaeological and architectural site. More importantly, it is a view that is not only conditioned or framed by the camp and its memorial, from a second-floor window, but one inviting different perspectives on the camp. A window on the world outside the camp as seen from within.

Fixed by the limits of the window frame are a series of indices. Collectively they constitute the 'view'. From right to left, bottom to top, these consist of:

- A flagpole flying the French national flag, the Tricolore;
- The Wagon of Remembrance;
- A landscaped area that flanks the cattle truck and flag;
- The sky that fills the rest of the frame.

The flagpole, wagon, landscape and sky as seen through the upstairs window are all captured within the secondary framing of a photograph [Figure 2]. This sequence forms the chapters of this book. Starting with the window frame, each offers a departure point for exploring the internal/external spaces of the camp memorial. In turn, these spaces lead to wider questions about the camp as a site of memory, and of memories of the camps that continue to dominate the landscape of twenty-first-century geopolitics. In the paragraphs that follow, a few brief disclaimers about the camp are worth making before pursuing the different trajectories of each index, resituating the camp *qua* memorial within a wider

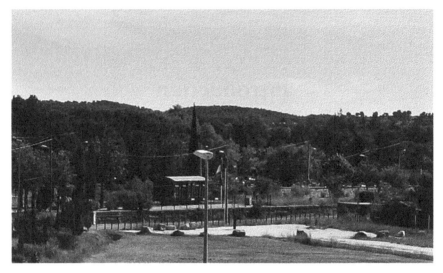

Figure 2. Close up of the 'cone of vision'. Photograph by the author.

network of global Holocaust memorials, collective memory and contemporary discourses of security and human rights.

### i. Camp des Milles Was Not Auschwitz

The names of some cities, towns, villages and *communes* have become synonymous throughout the world with human disaster. Whether marked by widespread atrocities or individual instances of brutality, nothing that happened before or after counts. Nanjing, Auschwitz, Treblinka, Dachau, Dresden, Hiroshima, Mỹ Lai, Bhopal, Bagram, Guantánamo, Fallujah, Abu Ghraib, Darfur. Les Milles is not, or at least was not, one such place. A small town located on the edge of Aix-en-Provence, today little more than a city suburb, it was known, if at all, for its tile factory. A giant, imposing red-brick structure that would be more at home in the industrial cities of England's north and Midlands than amongst the sun-bleached stone facades of Provence. It is only very recently that it has become more widely known that during the Second World War, the factory was used as an internment camp.

During the 1980s and 1990s greater attention began to be paid to France's wartime camps by scholars such as Anne Grynberg (1999) and André Fontaine (1989). This new focus on the largely forgotten or ignored camps took place within the wider shift in Second World

War historiography brought about by Robert Paxton's seminal work on Vichy (*Vichy France: Old Guard and New Order*, 1972). Paxton's extensive use of archival material exposed the extent of collaboration with and complicity in the Nazi regime by France under Pétain. The term 'Vichy syndrome' was subsequently coined by Henry Rousso (1991 [1987]) to define the decades-long adherence to the myth of 'resistance' perpetuated by Charles de Gaulle and its endorsement of collective forgetting of the shame of occupation and the guilt of deportation.

The work to preserve the memory of the deportations from sites in both the occupied and non-occupied zones had already begun before the end of the war with the founding of the Centre de documentation juive contemporaine (CDJC) by Isaac Schneersohn in Grenoble in 1943, operating clandestinely until 1944 when the Centre relocated to Paris after the Liberation (Perego and Poznanski, 2013). Jewish associations and groups of survivors campaigned for memorials at former camp sites but initially, where they existed at all, these took the form of vaguely worded plaques.

The first camp to be properly acknowledged was KL-Natzweiler (Struthof) in Alsace. Arguably this was because it fell within the German borders during the war. Charles de Gaulle inaugurated the memorial site on 23 July 1960.[1] Until recently, the camp continued to be identified first and foremost in mainstream French media as 'le seul camp de concentration nazi sur le territoire francais' [the only Nazi concentration camp on French territory] (AFP, 2015; Dubromel, 2016). While there is nothing inaccurate about this claim, it risks the suggestion that Struthof was the *only* camp 'on French territory' that played a role in the persecution of the Jews and, more specifically, in Hitler's Final Solution.[2]

Grynberg has suggested that the sites of France's former camps did not fit into a national conception of 'lieux de mémoire' [places of remembrance] as propounded by Pierre Nora's epic 6-volume study (1986–1992). Taking issue with the small town of Nexon located

---

1  See https://www.struthof.fr/le-site/le-memorial-et-la-necropole.

2  Since 2014, transnational memory work has been carried out between France and Germany on the network of satellite camps located in and around Natzweiler. This work led to the creation in 2018 of an online portal (http://www.natzweiler.eu) which offers a series of resources including a prisoner database. It also allows for a more nuanced understanding of the term 'concentration camp' which includes mapping the use across the region of 'concentration camps in the service of the war industry' (Natzweiler Memorials Network, n.d.).

about 20 km south of Limoges, Grynberg points out how the former avenue running through the camp there became a residential street renamed 'rue Jean-Moulin' after the war in keeping with the French national narrative of resistance and martyrdom. At the town's cemetery, Grynberg locates a gravestone commemorating the '59 Israélites victimes du nazisme'. She grimly reminds us that most of these victims died before 11 November 1942. In other words, their assembly at Nexon and subsequent deportation occurred at the hands of the Vichy Republic before the occupation of the south (Grynberg, 1999: 10).[3]

The publication of the first academic studies on the camps roughly coincided with a series of inaugurations at newly recognized memorial sites. These included, for example, the renamed Chemin des déportés in 1990 and the installation of the 'Wagon of Remembrance' in 1992 at Les Milles (the focus of Chapter 3).[4] Reflecting on the various commemorative events taking place during 1992, Annette Wieviorka (1993) identified a shift in the memorial stakes. She notes, in particular, the transformation of commemoration into 'spectacle' alongside public calls for the president to acknowledge France's complicity in the deportations. Public-facing memory work during this period culminated in President Jacques Chirac's speech at the Vélodrome d'Hiver in Paris on 16 July 1995. His speech commemorated the 53rd anniversary of the round-up in which over 8,000 Jews (out of 13,000 arrested in Paris) including 4,000

---

3  Only recently have the heritage stakes of such sites in France been collectively evaluated alongside other places of confinement in a 2018 special issue of the journal *Monumental* dedicated to 'Le Patrimoine de l'enfermement' [heritage of detention/imprisonment] edited by François Goven. The Camp des Milles is mentioned briefly (Legendre, 2018: 80) in the chapter focused on wartime camps and prisons. Greater attention is given in the chapter to the memorial work carried out at Camp des Rivesaltes (see also https://www.memorialcamprivesaltes.eu/).

4  A series of different committees and associations dedicated to commemorating the Camp des Milles were formed from the 1980s onwards (MdS MDXVIII-36). These included the Comité de Coordination pour la sauvegarde du Camp des Milles et le souvenir de l'internement, de la déportation et de la résistance en Provence led by Louis Monguilan; the Association Européenne pour la sauvegarde du Camp de Milles; the Association du Wagon-Souvenir des Milles, responsible for the installation of the memorial cattle truck; and, finally, the Fondation du Camp des Milles – Mémoire et Education, a non-profit organization overseeing the operation of the memorial site and officially recognized by government decree as being 'an establishment of public utility' on 25 February 2009 (http://www.campdesmilles.org/fondation-genese.html).

children were held at the Vélodrome for five days before being deported to Auschwitz. Over five decades had passed before a French president publicly and directly acknowledged the French camps and their role in Hitler's Final Solution. At this point, in 1995, de Gaulle, Pompidou, Giscard d'Estaing and Mitterrand had all visited the memorial site at Struthof while in office.

After decades of collective forgetting, a new rhetoric was adopted by academics and journalists alike. It was gradually acknowledged that wartime camps had existed throughout France, of which there are now thought to have been 93.[5] Moreover, the direct link between camps like Drancy and Les Milles and the Nazi extermination camps began to be emphasized. The title of Grynberg's comprehensive study of the camp system in France, *Les camps de la honte* (1999), lays emphasis on the double shame of the camps' existence and the subsequent erasure of their memory from French national consciousness. Like many studies dedicated to the wider history of the Vichy regime, the collection of essays on camps in the southeast including Les Milles edited by Jacques Grandjonc and Theresia Grundtner (1990) evokes an image of the non-occupied zone as a 'zone d'ombres', attesting to the shadowy, concealed existence of the multiple spaces of the camps across the southeast both during and after the war. Fontaine's focused study on Les Milles, just a year earlier, posited the camp as a question, *Un camp de concentration en Aix-en-Provence?* This plays on the public response of disbelief and denial he frequently encountered in the region while conducting preliminary research into the history of the camp back in the 1970s (Fontaine, 1989). Where Drancy, the transit camp located in the northeast of Paris, is now commonly referred to as the 'antechamber of Auschwitz', this designation has also been applied to Les Milles (*L'Humanité*, 2013) – the specific implication of 'chamber' should not be overlooked here. More recently and in a context of 'refreshed' memory, Les Milles has taken on the nickname of the 'Vel d'Hiv du Sud' [Velodrome d'Hiver of the South] (Jaeglé, 2013).

While such nicknames and the associations they invoke are rarely intended to be glib, they do inevitably act as a shorthand with which to understand the Holocaust and the wider atrocities perpetrated by all sides during the Second World War. As the title of a 2008 collection

5  For a useful summary of the main camps including details further archival resources and dedicated studies, see the section 'France/Vichy' in Megargee, White and Hecker (2017: 89–232).

of essays edited by Robert Mencherini, *Provence-Auschwitz*, suggests, Les Milles was the first stop on a one-way journey to the gas chambers. All tracks lead to Auschwitz, which becomes an overdetermined and ultimately empty signifier, a container into which all the unspeakable, unimaginable horrors of the twentieth century are deposited. To refer to the French deportation camps as the 'antechamber' of Auschwitz risks erasing other parts of their history, not least, in the case of Rivesaltes and Gurs, their origins as refugee camps for those fleeing the Spanish Civil War and their subsequent role as assembly points for German nationals and other suspected 'enemies' of France under the Third Republic. If a set of lines can connect Les Milles to Drancy to Auschwitz, we should also remember that each camp is not simply a point on a monochrome map. Comparing the round-ups and deportations which took place at Les Milles to the *grande rafle* at the Vélodrome d'Hiver works as an effective media sound bite, emphasizing both the nature of what happened at Les Milles in the summer of 1942 and the subsequent silence that ensued in the decades after the war. However, it also flattens the complex terrain of the occupied and non-occupied zones, potentially downplaying the active complicity of the Vichy regime along with the different ways in which silence and commemoration have operated and continue to operate at local and national levels in France.

Narratives on Les Milles attest to a tension between acknowledging and seeking to better understand the camp in its historical specificity – in this case, the specificity of Les Milles as neither Auschwitz nor the Vel d'Hiv – and an ethical obligation to abstract a concept of the camp that identifies the limits of its space, the events and pressure points which see biopolitics – the management of life – flip over into thanatopolitics – the administration of death (Agamben, 1998a: 131). Thinking about Les Milles as a real space and set of events whilst conceiving it according to an abstracted philosophical notion of the 'camp' is a difficult but necessary balancing act in the project of its memorialization.

At the Camp des Milles memorial there is a display case featuring a pair of striped pyjamas as worn by those in the Nazi concentration camps. The pyjamas were donated by a survivor of Auschwitz, Denise Toro-Mater. Toro-Mater was not interned at Les Milles but moved to the Marseille area after the war, where she became involved in regional memory work. If Auschwitz has become the metonym for both the Nazi concentration and extermination camps, then the striped pyjamas have become a metonym for life/death in the camps (Baruch Stier, 2015). The pyjamas are presented within a section of the exhibition focused on

the deportations from France. Located on the ground floor of the main exhibition space within the wider story of the Second World War and the conditions in France leading up to the creation of its own system of camps, the pyjamas provide the material proof that we have arrived, following the historical narrative unfolding within the exhibition space, at the obscene core of the Nazi regime. But do the pyjamas provide visitors with a reminder that Les Milles was not Auschwitz? Or does their relocation to within the former French camp constitute a deliberate reframing which emphasizes Les Milles, along with other camps across France and Europe, in terms of the wider structures that supported and enabled the Nazi operation? A further, more difficult, question to pose is whether the pyjamas as sacred relic and general signifier of Auschwitz now both contained and framed within the memorial space at Les Milles, make it impossible to conceive of the camp in any other terms except its relationship to Auschwitz. In other words, can the memorial of the camp at Les Milles only be conceived via reference to other camps, and more precisely, their representations in films, memoirs, novels, poems, artwork, photography, exhibitions and memorials?

In considering how the history and memory of Camp des Milles has been presented, represented and interpreted within the contemporary museum space, this book will draw on existing work around Holocaust and concentrationary memory. Notable here is Marianne Hirsch's work on postmemory (1997; 2012) and its exploration of how secondary and tertiary memory is increasingly mediated through fictional as well as documentary representations and how visual iconography as much as textual narratives embed themselves in collective awareness and understanding of the atrocities of the Second World War. Alongside Hirsch's ongoing work on visual culture, Pollock and Silverman (2011; 2013; 2015a; 2019) have undertaken a large project focused on the concept of concentrationary memory. The concept takes up the legacy of the widespread use of concentration camps during the twentieth century, considering in particular the obfuscation of different types of camp as a result of dominant media imagery associated with the liberation of the Nazi camps by the Allies. The aim of exploring this legacy is directed towards a future imperative of identifying the persistence of cultural imaginaries of the camp and the ethical and political implications of representing the Holocaust. Later chapters will also draw on the work of Michael Rothberg which connects Holocaust and postcolonial memory studies via the notion of 'multidirectional memory'. As will become apparent, the specific ideological agenda at Les Milles

risks what Rothberg has termed 'competitive memory' resulting in a 'zero-sum struggle' (2009: 3). In the case of Les Milles, this struggle is taken up with both how the events at Les Milles should be presented and what should be learned from these events now and in the future.

Taking heed therefore of the difficulty of naming the camp, throughout the book I use 'Les Milles' to refer not just to the camp itself, as tends to be the case with references made to Auschwitz or Dachau, but to the space, the site in its wider context. This includes the tile factory and its grounds, the annexes found in Marseille and elsewhere in the south, the town of Les Milles and, of course, its current manifestation as memorial and exhibition. Where Auschwitz has come to be synonymous with the gas chamber despite also operating as a concentration camp, using the shorthand 'Les Milles' is intended to emphasize the way in which the space exceeds any straightforward appellation of 'camp' rather than reduce it to a metonym. Consequently, one of the aims of this book is to avoid, as far as is possible, unnecessary hyperbole or reductive comparisons when talking about the camp.

## *ii. Les Milles Was Not Built as a Camp but as a Tile Factory*

In *Discipline and Punish* (1975) Michel Foucault asks, 'is it surprising that prisons resemble factories, schools, barracks, hospitals, which all resemble prisons?' (1977 [1975]: 228). If the camp bears no such resemblance in our imagination to any of these nineteenth-century institutions perhaps this is because factories, stadiums, schools, barracks and hospitals, not to mention prisons, all became camps during the Second World War. Our understanding of the camp as it peppered the twentieth-century landscape is that it represents a suspension of regular forms of economic production, circulation and exchange. At first glance, the Camp des Milles seems to embody this notion of suspension.

La Société des Tuileries de la Méditerranée was created on 23 May 1882 (Grésillon, Lambert and Mioche, 2007: 23). Through its activity and related businesses in the region, its owner, Édouard Rastoin, became head of a powerful family dynasty. Several family members were alderman to the Mayor of Marseille, with others taking on the role of president of the Chamber of Commerce thus ensuring political representation of their business interests (Mioche, 2011: 3). Following strikes in May and June 1936, the tile factory ceased operations in 1937 due to economic recession and, specifically, the inability to acquire

replacement machinery (Grésillon et al., 2007: 31–32). It was requisitioned by the French government in 1939. The army surrounded the factory grounds with barbed wire and painted the windows blue for camouflage purposes (Fontaine, 1989: 27). Very few other changes were required to turn it from nineteenth-century disciplinary space into twentieth-century biopolitical space. The piles of unbaked tiles found throughout the factory, evidence of the sudden cease in operations, were reduced to dust with the arrival of the camp inhabitants (Lipman-Wulf, 1993: 17). As dust spread over everything it became an 'affective' symbol of loss and ruin (Sumartojo and Graves, 2018).

The factory reopened in 1946. It enjoyed growth following the Algerian war, when the repatriation of French citizens (*pieds-noirs*) caused increased demand for housing in the south of France (Grésillon et al., 2007: 58). It remained a family business until 1987, when it was passed from global corporation to global corporation until its closure in 2006. The 125-year history of the factory is presented as representative of many of the regional family-run businesses operating in Marseille and Aix-en-Provence from the end of the nineteenth century with emphasis placed on the paternalist management style of those placed in direct responsibility for the site (Mioche, 2011). The period between 1939 and 1942 is bracketed out as a separate history. It is interesting to note, however, that oral testimony from former factory workers includes a brief account from Albert Mille, who worked as an apprentice carpenter at Les Milles prior to the requisitioning of the factory. During that period, he helped the village carpenter make coffins for those who died in the camp (Grésillon et al., 2007: 138).

To read the camp only in terms of suspension or only in terms of its reduction of human life into animal existence is to overlook the widespread importance of the labour camps used throughout the world during the war. It also overlooks how certain modes of economic development provide the very conditions which lead to the subsequent justification of internment as individuals and groups previously welcomed as cheap, available labour are blamed and criminalized for subsequent economic recession or the collapse of certain industries. In the specific case of the Nazi camp system, the initial rationale was not extermination but economic production. Auschwitz was chosen as a site because it was in the vicinity of a sand factory and a town populated by ethnic Germans. The idea behind the choice of location was that the camp would finance both infrastructure and the development of industrial activity (Diken and Laustsen, 2005: 47). This seems to oppose the notion

of total isolation associated with the camps since it is instead predicated on the contribution the camp can make to existing infrastructure, economic activity and their development, even if this is not perceived as long-term. However, an irreconcilable difference emerges between the basic conditions required for effective labour power and those that defined existence in the Nazi concentration camps. This was not the result of a miscalculation or failure to provide adequate standards of living and hygiene but, rather, the conflicting role of the camp space in its production and affirmation of the *Untermensch* (Diken and Laustsen, 2005: 48).

The seemingly close resemblance of some prisons and camps in the twenty-first century might be considered symptomatic of a shift in which the state of exception comes to operate as the political status quo with war feeding, not disrupting, industry. Here, spaces of 'temporary' extralegal internment such as Guantánamo, but also immigration detention centres like Yarlswood in the United Kingdom and those run by the Australian government on Nauru and Manus Island or camps like the (now dismantled) Calais Jungle or Lampedusa, operate in peacetime according to notions of 'emergency' comparable to those that were used to justify the opening of camps across Europe during the Second World War. Mapping a more contemporary understanding of the camp back onto the wartime camp system, how might we read the camps found in France during wartime not as a rupture with economic production but in continuity with a capitalist model of growth and recession that reduces the value placed upon human life to its potential as wanted or unwanted labour?

Les Milles was not itself used as a labour camp. However, beyond the illicit economies that inevitably developed amongst the internee population, there were other ways that the camp operated productively within and beyond the wartime economy. Firstly, internment at Les Milles and elsewhere was bound up with the law passed on 27 September 1940 whereby camp internees were organized into a *groupe de travailleurs étrangers* (GTE) composed of about 250 workers and sent on work assignments across the region. These replaced the *compagnies de travailleurs étrangers* (CTE) established by the Third Republic as part of a decree passed on 12 April 1939 prohibiting foreign nationals from undertaking regular employment and requiring them to provide various forms of manual labour in place of the military service demanded of French nationals. The intention behind the GTEs was to recoup some of the costs of the administration of the camps. Internees

were also given the option to join the Foreign Legion and contribute to the war effort that way.

Second, there is the creative economy produced by the internees while at Les Milles. A key theme running throughout this book is how the camp was represented by those who were interned within its walls and how such representations have subsequently been reframed within the walls of the memorial museum. Many of those interned were artists and intellectuals who had fled Nazi Germany during the 1930s. Their internment as potential members of the Fifth Column constitutes one of the great ironies of the camp. The visual and textual representations they produced provide the museum with a rich set of resources with which to narrate the early period of the camp. In 1997, 15 years before the inauguration of the museum, an exhibition was held at the art gallery Espace 13 in Aix-en-Provence featuring art produced by Hans Bellmer, Max Ernst, Robert Liebknecht, Leo Marschütz, Ferdinand Springer and Wols. In the preface to the exhibition catalogue, regional official Lucien Weygand emphasizes the double role of the exhibition embodying the gallery's remit to present artists based in the region and also the necessity of bringing together these works as a form of collective memory (1997: 5).

The intense productivity that took place amongst the male internee population with over 300 works created (Fondation du Camp des Milles, n.d.: 41) is frequently presented as a form of creative resistance or an active refusal to succumb to the passivity of waiting. Yet, where some of the internees had been banned from working as writers and artists back in Germany, their creative labour was, from the outset, recognized and demanded by the camp management. In his memoir of his time in Les Milles, Peter Lipman-Wulf describes how:

> He [the camp commander] asked now that the intellectuals, artists, musicians and writers form a special group: These individuals would be exempt from the usual chores of cleaning and preparing food so that they could occupy themselves with creative work. I considered myself lucky to be one of them. This group consisted of around 25 or 30 persons: all male and of the emigrant population. There were some Nobel prize winners, famous painters, writers like Lion Feuchtwanger, and later, Walter Hasenclaver, Wilhelm Herzog and Jürgen Schmidt. The coming together of these outstanding personalities was doubtless an exceptional phenomenon, and a very important factor in regards to our imprisonment. (1993: 18–19)

The existence of Les Milles, as both memorial and museum, results from its complex history as both tile factory and camp. Both operations

12  France's Memorial Landscape

Figure 3. The tile factory at Les Milles. Photograph taken from the Chemin des déportés by the author, August 2021.

mark the site's built heritage. Certain annexed buildings were preserved because they contained murals produced by camp internees. During the 1980s they had been slated for demolition. Conversely, where other camps like Saint-Cyprien and Gurs have disappeared almost entirely, the architecture and infrastructure of Les Milles remained intact due to the resumption of factory operations after the war. Consequently, the site makes a double claim to heritage and preservation.

The daunting red-brick structure of the former factory at Les Milles circumvents the possibility of subdued reflection proposed by much memorial architecture [Figure 3]. Its exterior seems to offer a brazen refusal of the calm objectivity of white sandstone, the implacable new brutalism of grey concrete or the impossible dark yet sparkling beauty of black granite. The multiple storeys and uncountable windows, chimneys and annexed buildings attest to a different understanding of violence here. Violence not in terms of rupture but continuity. Violence that defines human subjectivity in terms of its labour value. Violence that ensures the structures which harness human labour power can also hold and punish unwanted labour. Violence that posits all economic threats

as external and which rewrites a history of low-paid labour and poor employment conditions in terms of romantic nostalgia for a family-run, collective enterprise. It is not without a certain irony that the site of Les Milles becomes, in its current form as memorial, exceptional, promoted as 'the only large internment and deportation camp in France still intact and accessible to the public' (Fondation du Camp des Milles, n.d.). The interior of the factory, presented as museum, draws on many established conventions in terms of design, layout and aesthetics associated with a now decades-long tradition of Holocaust memorials. The curation of exhibition material was overseen by the Shoah Memorial (Chouraqui, 2013: 11). Where the signage and other structures organizing the main exhibition areas inside draw on material such as concrete and oxidized steel that emphasize the industrial heritage of the site, such materials are also in keeping stylistically with accepted interpretive strategies found in other Holocaust and atrocity museums with a deliberate focus on simplicity and sobriety (Atelier L'épicerie, 2013: 226). Conversely, the red-brick façade of the factory represents a rupture with purpose-built museum architecture. Interestingly, the architects responsible for the spatial design of the exhibition describe how access to the site was conceived in a such a way that it is only at the end of the visit, when the visitor arrives at the memorial cattle truck (the Wagon du souvenir) that he or she is able to take in a view of the factory building in its entirety (Atelier Novembre, 2013: 214–15).[6] In other words, to understand its heritage as a factory, one first has to learn its history as a camp. Its history as factory and camp are intertwined, as is its memorial status. Les Milles became a camp because it was a factory. It has been preserved as a factory because it is remembered as a camp.

### iii. *Camp des Milles Was Not a Camp. It Was Multiple Camps*

To talk about Les Milles as a camp is not to talk about a single camp but multiple camps. This makes the task of its memorial within the space of the tile factory particularly complex and potentially confusing. Les Milles began its life as a camp under the Third Republic. The first

---

6 The architecture firm Atelier Novembre was awarded the project following a call for tender in 2006. The work was completed in 2012 and came in at €11.9 million. See https://novembre-architecture.com/projet/memorial-du-camp-des-milles-a-aix-en-provence-13/.

internees began to arrive on 7 September 1939 and by November their number had reached 1,800. The camp population was predominantly composed of German and Austrian nationals and others from the German Empire deemed to be 'enemy subjects' to the Third Republic. At this point the all-male camp population included both Nazi sympathizers and those who had fled the Reich, as well as those who had already become naturalized French citizens. The camp population fluctuated as categories of suspicion shifted and men were assigned to workforce groups (GTE) in and around the region. The camp closed for a brief period in April 1940 before the German offensive in May led not only to its reopening but to the internment of women and children in annexes to the camp located in Marseille. The population at Les Milles increased to 3,000.

In late summer 1940, the camp emptied out with over 700 internees handed over to the German authorities in July after they agreed to return to the Reich. The remaining internees were transferred to Camp de Gurs in October. Under the Vichy regime, the site at Les Milles took on the dual function of internment and transit camp, deemed a convenient 'assembly' point for those seeking to emigrate due to its proximity to the port at Marseille.

In July 1942 the Vichy government agreed to hand over all non-French Jews to the German authorities for deportation. This initially meant anyone who had arrived in France after 1936 but was later extended to 1933. Women and children interned in annexes in Marseille and elsewhere were assembled at Les Milles during July and August. Throughout August and early September 1942, a number of deportations took place with a total of 1,928 men, women and children transported by cattle truck to Auschwitz via Drancy (and also via Rivesaltes near Perpignan). Following their occupation of the south, the Nazi authorities requisitioned the site in December 1942 for use as a munitions depot before closing it in early 1943.

While Robert Mencherini suggests it 'served three distinct and successive functions' (2013: 16), the evolution of Camp des Milles is more complex than that. As Olivier Lalieu points out, 'this is not a linear story; it was subject to two different political regimes and depended on two entirely different ways of thinking' (2013: 198). What is important to note here is how these different ways of thinking – democracy and totalitarianism, the democratically elected Third Republic and the self-appointed Vichy government – both call upon the camp. Moreover, while individual camps were often poorly set up and managed, these

formed part of a larger camp system established by the Third Republic and conceived to grow to absorb ever-greater numbers of displaced and exiled populations as the war unfolded (Grynberg, 1999).

Thus, not only did Les Milles assume multiple roles under different French and subsequently Nazi regimes but it existed within a wider network of camps across the southeast of France. Some of these were large purpose-built sites, although hastily erected and conceived as temporary, such as Rivesaltes and Gurs, but others consisted of hotels such as the Hôtel Terminus des Ports and the Hôtel Bompard in Marseille, hospitals, prisons and other requisitioned buildings or sites. The constellation of sites lacking a centralized administration or strategic organization has been referred to as the 'Galaxie des Milles', with smaller 'satellite' camps orbiting around Les Milles. Even when Les Milles closed temporarily or emptied out, with large groups of internees transferred to smaller camps, work groups and centres, it continued to act as a centripetal force around which the other sites clustered.

Les Milles's multiple roles correspond to the notion of (in)difference put forward by Diken and Laustsen to explain the underlying logic of the camp. Here (in)difference not only refers to the abandonment of those placed within its confines – the public 'indifference' to the plight of those interned at Les Milles and subsequently deported but also to the operation of the camp as predicated on its ability to 'differ' from itself, in other words, shift the scope and limits of its operation as well as redefine the terms and conditions of internment without sanction. Les Milles's existence and operation was predicated not only upon its own internal differences as it shifted in its operation but also on a wider network of camps via differences produced between camps. As Diken and Laustsen suggest: 'every camp relates to other camps that, as difference-machines, further differentiate it. Thus each camp being already an (in)difference, must be understood in a variable relation with other (in)differences' (2005: 150). Such differences might be conceived of in terms of the separation of families within the camp system as women and children were interned in annexes to Les Milles. Or the ad hoc dispensation of permissions and liberties including those required to apply for visas to the Americas. And, finally, the minute differences, the month of a child's birth, the ability to produce evidence of having been baptized, that resulted in names added to and struck off the deportation lists. Differences that elsewhere would be imperceptible, irrelevant, arbitrary come to represent the difference between life and death at Les Milles.

### iv. This Is Not a Book about a Camp

The idea of an empty camp continuing to act as a gravitational force, feeding off smaller camps within its force field suggests the notion of Les Milles as a black hole. This was no doubt implied by the initial references to the 'Galaxie des Milles'. As tempting as pursuing such a metaphor might be, I want to keep my word and avoid reproducing further hyperbole around the camp. Not least because the metaphor does not hold anyway. There were plenty who escaped from Les Milles and the stories of these flights form part of the dominant narrative around the camp. A black hole suggests the permanent, absolute loss of matter and emphasizes the silence and erasure that both scholarship and the memorial have worked tirelessly to counter.

One of the fundamental stakes of this project is to explore some of the aporias or blind spots produced within the memorial space of Les Milles via the view from the second-floor window. The brief and often vague and conflicting references to the anonymous suicides at Les Milles, some of which involved jumping from the second floor, do not offer up a counter-narrative to other accounts of community, belonging, artistic creativity or courageous escape and rescue plans. The suicides might best be posited as a response not to the internal workings of the camp itself but, rather, to the external world of the wider camp network running through France, Germany and the rest of Europe. Distinguishing between Les Milles as internment camp and Les Milles as deportation camp provides license to privilege the experiences of internment within its interior space, especially when more is known about such experiences, setting these apart from those of deportation which took place outside and beyond the camp's own confines.

In identifying this tension between different 'versions' of the camp and the individual subjectivities which inhabit and traverse these, the intention is not to produce a complete, and definitely not a coherent, 'story' of the camp. This book does not take up the impossible task of telling such a story. Others have already attempted this to different ends and varying effects. Instead, the project I am proposing pursues the idea of the camp as 'difference-machine' suggested by Diken and Laustsen: 'the camp must not be thought of as an identity but also [sic] as a virtual difference that differs from itself, a potentiality not necessarily actualized into distinct and determined forms' (2005: 150).

The memorial museum's attempt to 'fix' the camp as an identity might be defined, at least initially, in terms of two parallel processes.

The first concerns the presentation of a clearly defined story or set of stories relating to the camp's own history and the contextualization of this history within the wider history of the Second World War and the extermination of European Jews by the Nazi regime. The second process involves extrapolating a series of messages from the lived experience of the camp and the subsequent deportations to affirm the specific identity of the memorial museum. If the story of the camp creates an opportunity to deconstruct French myths of citizenship, hospitality and resistance, the memorial museum's overriding function is to rehabilitate and further affirm these myths. Thinking of the camp as difference-machine gives us the chance to challenge the dominant narratives found in the museum as well as analyse the different interpretive strategies used to present these. If this is not a book about a camp, it is a book about the representation of a camp.

## v. This Is Not a Book about a Memorial of a Camp

If the memorial museum at Les Milles attempts to 'fix' the identity of the camp, this book does not seek to 'fix' the identity of the memorial and its message. In exploring the tensions, contradictions and aporias in the exhibition narratives, the intention is to interrogate the potential of a museum to exceed its own claims. As Amy Sodaro has pointed out in *Exhibiting Atrocity*, 'memorial museums are deeply political institutions and their utopian goals are often challenged by their political genealogies' (2018: 4). The task of presenting complex and difficult history and heritage and the limitations imposed upon the museum's narrative frame by a range of local, state and transnational stakeholders also offer an opportunity to the visitor. This is the opportunity to better understand our own positionalities when visiting such spaces. It is the opportunity to think more about how we look and what we see as well as how we document, remember and renarrate our visits afterwards.

Where museum professionals employed at Les Milles were consulted regarding some of the more enigmatic or ambiguous claims made about the site both within museum interpretation and elsewhere, the museum's president and founder, Alain Chouraqui, was not interviewed as part of the research undertaken for this book. The Chouraqui family were involved in the memorial campaign from the outset. Alain's father, Sidney, was a Jewish lawyer who took part in the Resistance in North Africa during the Second World War. On the one hand, therefore,

narrative and interpretation at Camp des Milles strongly reflects the work of personal, intergenerational activism by the Chouraqui family and other associated campaigners. The personal stakes are further affirmed in archival material now housed in the Centre de documentation at the Shoah Memorial in Paris (MdS MDXVIII-36). Letters and memoranda dating from the late 1980s to early 1990s (prior to the inauguration of the Wagon of Remembrance in 1992) emphasize the complex stakes of forming an advisory board composed of different associations along with decisions as to who to include and exclude from decision-making around the future memorial project. On the other hand, it is via Alain Chouraqui's role as public academic (formerly director of research at the Centre national de la recherche scientifique (CNRS) and currently UNESCO chair of Education to Citizenship, Human Sciences and Convergence of Memories) that the museum affirms its commitment to French state ideology around universal rights and public responsibility in the face of extremism. Consequently, this book will draw on public statements made by Chouraqui about the role and agenda of the museum including those reported in the press and found in academic publications and documentary footage produced in conjunction with the museum.

The book you are reading offers one set of encounters with Les Milles based on visits made between 2015 and 2021. These visits are juxtaposed with others to memorial museums across France including in Compiègne and Caen. Recognizing these museums as heavily mediated spaces, always already framed by popular imagery and established aesthetics of Holocaust remembrance, the book draws extensively on other cultural representations. Sometimes these are used to contextualize the interpretive strategies and iconography found at Les Milles within a wider set of imaginaries. Elsewhere, they act as counterpoints to the narratives presented. On occasion they are evoked as objects of existing analysis, offering up inspiration with which to define and understand possibilities of looking at Les Milles.

The first such inspiration can be found in Allan Stoekl's reading of Claude Lanzmann's *Shoah* (1985), a film that will be discussed in more detail in Chapter 3. Stoekl picks up on the work of earlier scholars who have identified Lanzmann's film as replete with 'indexical signs' (Brinkley and Youra, 1996). Such signs do not represent but rather 'reference' the Shoah. They are objects, topographies, texts, gestures which collapse past and present whilst simultaneously holding these apart: 'Such a deciphering takes place over time, through time; and

time as well, while not entailing any simple union of past and present, nevertheless involves a contiguity, a fragmented joining which is also unbridgeable separation' (Stoekl, 1998: 79).

Stoekl draws on Gilles Deleuze's *Proust and Signs* (1972) to offer a way out of the critical deadlock produced by much scholarship on *Shoah* around witnessing and the interpretation of signs. The interpretation or 'deciphering' of signs does not assume a stable signifier or a stable subject carrying out the interpretation. In other words, no witness, viewer, visitor or narrator can claim an authentic understanding of the sign since none exists. Yet this does not endorse an endless play of signifiers or cheap, sensationalist storytelling. The confrontation of past and present occurring within the space of the sign produces a shock and as such offers up a kind of truth to the narrator (in this case Lanzmann):

> The unification of viewpoint of the narrator is always a multiplicity of viewpoints, a series of perspectives without unity, a collection which always threatens a scattering. And out of that comes the question of the truth, the question of our position in relation to crime, our witnessing, along with, and against, the witnessing of the viewpoint that was 'there'. (Stoekl, 1998: 81)

If the second-storey window at Les Milles appears to offer a fixed viewpoint from which to view a series of indexical signs, such fixity is only fleeting. The signs which are referenced as chapters in this book are not preordained and their meaning is not intrinsic. I am not looking to locate any hidden truths or use these in a purely metaphorical or allegorical fashion. Instead, it is as material, memory, symbol, metaphor and connection that these indices are explored. If there is a will to interpret this should not be taken as a will to explain away, to produce a totalizing reading of the camp and its memorial. Rather, what seems to be taking place in the writing of this book is an attempt to document, to narrate the aftereffects of a shock brought about by the incomplete witnessing of a crime scene.

## Outline of Chapters

### *Window Frame*
This first main chapter offers a critical overview of the museum's interpretive strategies centred around the second-storey window. The

aim here is to emphasize the potential of looking as an act that exceeds the museum visit itself. Chapter one identifies the open window as a valve, offering air and light and momentary respite from the dark, artificially lit factory interior and its multimedia representations. But the window is also a memorial within a memorial, left open to commemorate the lives of the women who jumped from their dormitory on the second floor. To stand at the window is to stand at a threshold. The view from the window allows for an alternative reading of the visitor as witness to the one proposed in the museum's 'reflexive' wing. The witnessing proposed forms part of an ethical spectatorship which comprises Jacques Rancière's notion of the 'emancipated spectator' and Ariella Azoulay's concept of 'repaired citizenship', bringing these together before the photograph of the window frame. Establishing possibilities for ethical spectatorship lays the groundwork for the subsequent chapters and their focus on objects beyond the museum.

*Tricolore*
The location of the French national flag next to the commemorative cattle truck at Les Milles situates the memorial of the deportations within the context of collective memory as a state-endorsed initiative. Building on the critical account of exhibition narratives and visual displays in the previous chapter, the intention here is to focus on specific tensions and aporias between the museum's claims as a site dedicated to social inclusion and equality *and* its attempts to limit and police what such inclusion looks like in a French and European context. Chapter Two uses the multiple, complex symbolism of the Tricolore as marker of French national identity and a set of constitutional ideals dating back to the French Revolution to explore how such ideals remain ever-present within the memorial space. Of key importance are the links emphasized in the memorial between French national identity and a discourse of resistance and hospitality. How can the museum's call to resist xenophobia and undertake 'righteous' acts of hospitality be reconciled with France's punitive policies against those who offer support to the *sans papiers*?

*Wagon*
Taking a step back from the discussion around contemporary forms of social exclusion mediated by discourses of national identity, Chapter Three refocuses on the events taking place at Les Milles in summer 1942 and the difficulty in adequately representing these. Recognizing

the global iconography of the cattle truck as well as the centrality of the railway to mass human transit from the late nineteenth century onwards, the chapter situates the memorial cattle truck alongside other media representations of the train journey. Throughout the chapter, the view of the wagon as a reconstruction will be privileged over against the wagon as memorial. At stake is the tension between the assumption of the position of the women who awaited and watched the arrival of the train from the window and the impossibility of ever really imagining what they saw. With reference to camp records, archival images, journals and other documentation relating to the deportations in August 1942, the chapter considers the silences around the women who never boarded the train, who chose instead to take their own lives. Returning to Azoulay's concept of 'repaired citizenship', the chapter asks to what extent it is possible to enact such a reparation towards those unnamed women via the photograph taken of the view from the suicide window.

*Landscape*
The aim of this chapter is to explore 'landscape' as object and verb within a wider memorial context as a means of better understanding the role of Camp des Milles. As verb, landscaping is an official activity undertaken in and around built heritage, but it is also something that we, as individuals, can take part in via our own itineraries and visits to named and unnamed sites of atrocity. Where a landscaped area such as the small space at Les Milles might operate as a form of containment, marking out the limits of memorial activity, Chapter Four argues for a broader understanding of landscape drawing on W.J.T. Mitchell's reading of landscape and power. Emphasis is placed on our own accountability for what we view. The geographical context of Aix-en-Provence and the backdrop of the Montagne Sainte-Victoire are explored with reference to Cézanne as inspiration to many of the artists interned at Les Milles. The views presented by Cézanne required exclusive and privileged access to landscapes. Such exclusion offers insight into the way in which memorial museums also often function as exclusive and privileged spaces despite claims to the contrary. The chapter considers the memorial landscape in France and Europe more generally via different creative engagements before focusing on the wider internment 'galaxy' around Les Milles, linking the memorial site to hotels in Marseille – Hôtel Bompard, Hôtel Levant and Hôtel Terminus des Ports – that once housed women and children later transferred to Les Milles for deportation. It concludes

with reflections on what it means to return to a site of suffering as both primary and secondary witness.

*Sky*

Chapter Five, the book's final main chapter, focuses on the piercing blue sky captured in the photograph of the window frame. The sky allows for global connections between the museum, camps, deportations situated within wider histories and geographies. The approach is indebted to Michael Rothberg's 'multidirectional memory' and takes up the task of exploring seemingly 'unusual conjunctions' (Rothberg, 2009: 3). If these connections appear wide-ranging, they are not arbitrary and can frequently be mapped back onto the museum's own use of iconography such as the 'mushroom cloud' and its claim to a more universalist agenda as 'Musée de l'Histoire et des Sciences de l'Homme' [museum of history and human sciences]. Initially, however, the blue sky is identified as specific to the Provençal landscape and evokes the punishing, unforgiving summer sky of French literary tradition. The single cloud captured in the photograph taken from the museum window invites consideration of the possibilities of thinking the museum as cloud. It also interrogates the role of museums in representing different temporalities of violence in contrast to the visual spectacle of war and disaster embodied in the image of the mushroom cloud. The concept of 'galaxy' explored in the previous chapter is then developed following two distinct but interrelated trajectories. The first expands the parameters of the so-called 'galaxy' of camps to incorporate France's use of 'concentration' camps across its empire both during and after the Second World War. The second takes up the figure of the 'satellite' once used to describe the smaller camps and internment centres located around the south of France. The satellite takes on a new form within postwar French politics as rocket launch sites are set up first in Algeria and subsequently in the Pacific and French Guiana. Having established these complex links between camps and satellites across France's former colonies, the question of hospitality is taken up more forcibly in the context of contemporary France. Drawing on Peter Sloterdijk's work on atmospheres, especially foam and bubbles, the chapter then looks at how the solid, brick structure of Les Milles will give way to the temporary, organic structure of the camp as refugee or migrant 'welcome' centre. Returning to the question of the museum in the context of contemporary and future societal and atmospheric pressures, the chapter then suggests ways museums including the memorial at Les Milles might position themselves in the

context of present and future climate disaster. Where the sky appears to offer little shelter from impending catastrophe, its changeability can nevertheless provide us with a source of hope.

*Conclusion: Recollections of a View*
A short concluding chapter returns focus to the space of the museum. It provides a brief summary of the challenges and tensions found in the museum's exhibition narrative and offers some final reflections on the approaches taken across the chapters before returning to the suicide window as impetus for the book.

CHAPTER ONE

# Window Frame

### Light

> Looking into the main building from the yard through one of the great doors, one saw nothing but a huge black hole.
>
> (Feuchtwanger, 1941: 25)

The 'suicide window' at the Camp des Milles memorial is located on the second floor. It is easy to spot from outside but only if you know where to look. It is the first window belonging to the right-hand wing, situated to the far left (if you are facing the building). It is the only window that is partly open. It is nothing more really than a small black rectangle but one that punctures the closed, silent monotony of the building and seems to offer the possibility of shadowy life inside the bricks. All the windows measure approximately 1 metre in height although some are double that across. All have wooden shutters with a small triple-paned section at the top left uncovered, allowing a small strip of light inside. This small strip is further reduced by the grime covering the windows.

Although we will look specifically at the site's official entrance in Chapter Two, it is the window that offers both a way in and a way out of this study of Les Milles. In this chapter, the window will be situated in relation to the rest of the museum in terms of physical location as well as the different displays and interpretive practices occurring across the museum's multiple exhibition spaces. Of particular importance is the interplay of natural and artificial light within the museum as it combines built heritage and screen technology. Beyond the interpretive framing taking place across the exhibition space, the window frame can also be situated within broader conceptions of the 'frame' and, indeed, its deconstruction as found in the works of various artists

interned at Les Milles, such as Max Ernst. Identifying the frame as both liminal space and collapsing its spatial hierarchies sets up subsequent discussion on photography and what it means to take photos at a site of atrocity like Les Milles. Through the specific act of photographing the window frame at Les Milles, the chapter will consider both the photograph as complex souvenir and the photographer as tourist turned secondary witness.

Historical accounts of Les Milles such as those offered by André Fontaine (1989: 26–27) and Denis Peschanski (2002: 115) emphasize that, during its operation as a camp, the windows did not offer ventilation or useful light by which to read, write letters or play cards. The shutters were kept closed and the panes at the top of the windows had been painted blue by the army on requisitioning the building for camouflage during air raids. According to Fontaine, the darkness at Les Milles was, along with the dust, yet another 'fléau' [affliction] (1989: 27) that the internees had to deal with. In these accounts, Fontaine and Peschanski draw heavily on the comprehensive details of the interior space of the factory provided by internee Lion Feuchtwanger in his autobiography *The Devil in France*. Feuchtwanger's descriptions of life in the camp also constitute a significant primary source frequently cited on panels around the memorial museum. In particular, he identifies the role of the factory's windows in the play of light and darkness in the exterior and interior spaces of the camp and how both natural light from outside and artificial light inside, comprised of a few 'very feeble electric bulbs', served to emphasize the darkness inside the factory: 'The inside of the building seemed twice as dark as it actually was because the yards outside lay, for most of the day, under a dazzling sunlight' (Feuchtwanger, 1941: 26).

Concentrated in shards, when it does filter into the factory space the light becomes violent, blinding, a confrontation with the darkness of the interior space. This contrast, which Feuchtwanger acknowledged during his internment, has subsequently been captured by photographer Yves Jeanmougin in a series of images taken between 2008 and 2010 prior to the conversion of the tile factory into a memorial space. Entitled 'In these brick walls…' taken from the poem by Benjamin Fondane (Fondane was interned at Drancy before being deported to Auschwitz-Birkenau), Jeanmougin's series occupies the central plates of the memorial's accompanying coffee-table volume, *Memory of the Camp des Milles* (2013) and features over 50 double-page spreads of photos of the site.

Presented without the customary white border, cropped to the edge of the page or bled into black margins, the black-and-white images which force this contrast between light and darkness push it to its limit evoking the idea of a place in which everyday objects, spaces, relations become abstracted, saturated, turned into extreme, monstrous versions of themselves. A monstrosity that is also a futility. Uselessness. Pointlessness. There is paralysis in these photographs, maybe partly due to their subject matter – out-of-commission machines; damaged, eroded architecture. The images represent the ruins of industry more than the operation of the camp. Yet it is the light and darkness presented in Jeanmougin's series that offers up the visual spectre of the camp as described by Feuchtwanger.

A window in a museum is a notable thing. But it is important not to conflate glass and window. A window is not simply a receptacle of light or source of ventilation. There is no shortage of glass in the art galleries and museums that define the late twentieth century. Older museums like the British Museum and the Louvre have been supplemented with glass roofs aimed at shedding the image of the museum as dark, dusty and elitist enclave. From the 1960s new architectural projects for museums intended to house valuable art and artefacts have been caught up in what Joe Day has referred to as the 'battle of the skylights' (2013: 71–76). Light ceases to be artificial or blocked out, as it is in casinos or cinemas, but instead carefully regulated to allow maximum visibility of the objects displayed whilst protecting these from the damage caused by excessive and prolonged sunlight.

Natural daylight is not called upon to illuminate the displays at Les Milles but itself constitutes a display in the form of pockets, pools or shards in which the dust, which remains integral to the space, continues to dance and spiral. Much of the interior exhibition at Les Milles relies on artificial light and, I might suggest, is conceived according to a similar experience of immersion as that of a cinema or casino. This is part of a common architectural and curatorial strategy found in the plethora of Holocaust and, more generally, atrocity museums that have sprung up in recent decades (Williams, 2007).

Regardless of whether a memorial museum is purpose-built or located in repurposed buildings such as Les Milles, visitors are often required to follow a prescribed path, described by Day as an 'Ikea-style forced march' (2013: 180), within the museum space which guides them through a chronology of events before being required, at various points, to reflect on the histories presented.[1]

1  On 'ikeafication' at Yad Vashem, see Oren and Shani (2012).

Day goes further here, comparing such a technique with the disorienting spatial configurations of contemporary prison architecture designed to prevent inmates from fully grasping their location within the prison layout. When intended for educational rather than punitive ends, such configurations take on the guise of what Day terms an 'infotestine', defined as follows: 'These circuits of spatial processing harden what used to be a flexible curatorial strategy for organizing a route through a show into a fixed architecture of sequencing in which institutions ingest their visitors and those visitors in turn digest its holdings and mission' (2013: 180). To situate the open suicide window within the wider exhibition space at Les Milles, it is useful to consider in some detail the role of artificial forms of light found throughout the museum. As Cécile Denis (2015) has suggested, 'La fonction du mémorial est étroitement liée à l'organisation de l'espace' [The function of the memorial is closely linked to the organization of the space]. Denis's observation echoes the vision presented by the architects themselves:

> The need for the visitor's itinerary to progress gradually through the building, respecting the sequence of the three sections, historical, memorial and for reflection, was at the heart of our thinking, and is in fact the heart of the project, the pivot around which the functional parts are organised. As well as this, we had to make this gradual progress meaningful according to the areas available: we had to take a clear option when dividing up the space without betraying the overall spirit of the site in any way. (Atelier Novembre, 2013: 215)

The main exhibition at Les Milles has been divided into three *volets* meaning sections or zones. Significantly, the term *volet* can also be translated as 'blind' or 'shutter'. These are comprised of a historical zone, a memorial zone and a reflective zone. Each *volet* can only be visited in sequence. The interior space has thus been carefully conceived to immerse visitors in a trajectory guiding them through a comprehensive political history of France's camp system onto a less structured exploration of the factory's architecture before being asked to consider the wider, ongoing implications of racism and xenophobia. A short introductory video at the start of the exhibition outlines the content and role of these zones, insisting perhaps a little too forcibly on the requirement to engage in each section and the reason for doing so. 'Voir pour comprendre, comprendre pour agir' [See to understand, understand to act] is the non-negotiable imperative with which the video concludes. Additional screening rooms, where films insert the camp's history into

a wider discourse of resistance, punctuate the visitor's independent exploration of the exhibition and can be bypassed, but this first one is compulsory. There is no entry to the museum without passing through the screening room at the scheduled start times.

In the later screening rooms, you move from the artificial spot and strip lighting of the exhibits and are plunged into darkness and the concentrated, rectangular glare of the movie screen. On reaching the final reflective zone, visitors are treated to an 'immersive film'. The screen becomes triple, an intensification of media which distinguishes itself from the other, more conventional use of screens throughout the exhibition. Sometimes the three screens show different things. Different histories, different genocides. The Armenian Genocide of 1915 and the Rwandan Genocide of 1994 are called upon specifically as supplements to the Holocaust, further examples of humanity's capacity for violent self-destruction. Sometimes the screens all show the same set of images, creating a *mise-en-abîme* from which there appears to be no way out.

Anonymous actors appear full-length like holograms superimposed against dark backgrounds and step forward to interpolate the audience via citations from celebrated authors. These scenes provide a marked contrast to the use of washed-out archive footage or the boxed-in miniature talking heads of survivors shown elsewhere in the exhibition. Propaganda from the Nazi regime is then produced in triplicate as a sensory onslaught intended to produce discomfort, a simulation of the power of discourse on the uncritical masses.

The notion of 'immersive' is problematic not least in its uncritical assumption of the power of the screen and the intensification of its power via its proliferation. Immersion here might be contrasted with the equally suspect notion of 'interactive' as used within museum spaces to evoke visitor-led engagement with the information on display (Heath and Vom Lenh, 2010). Immersion implies the type of sensory overload that the German population was invited to experience at the Nuremberg rallies. It is telling, and not without a certain irony, that in its account of the war machine as first and foremost a sight machine, Paul Virilio's classic study *War and Cinema* (1989) includes a plate featuring a sketch for a proposed triple-screen cinema designed by Spanish architect Fernandez Shaw in 1930 (figure 14 of Virilio's central plates). Virilio notes that the outward-facing screens were intended for a drive-in audience sat in aeroplanes as well as cars. More importantly, he makes the point that the plan for the cinema predated Albert Speer's *Lichtdom* [Cathedral of Light] used at the Nuremberg rallies between 1934 and

1938 and documented in the 1937 propaganda film *Festliches Nürnberg* directed by Hans Weidemann.

Although Virilio does not develop the comparison further, it is clear he wanted his readers to understand the triple screen as part of the same specular ideology, offering a comparable wall of light to the 152 anti-aircraft searchlights used in the *Lichtdom*. Such a comparison can be read both in terms of the structural intensity and expansiveness of the light rendering anything outside its parameters into total darkness *and* of the ways in which both structures were co-opted by a myth of enhanced military infrastructure. Hitler overrode Göring's reluctance to allow the use of a limited reserve for searchlights since it implied to the outside world precisely the opposite – an abundance of them (Kitchen, 2015: 35).

The concept of the 'immersive film', again without irony, also evokes the simulated experiences of warfare found in the war museums built after 1945 described by Virilio:

> [T]his cinematic artifice of the war machine spread once more into new forms of spectacle. War museums opened all over liberated France at the sites of various landings and battles, many of them in old forts or bunkers. The first rooms usually exhibited relics of the last military-industrial conflict (outdated equipment, old uniform and medals, yellowing photographs), while others had collections of military documents or screenings of period newsreels. It was not long, however, before the invariably large number of visitors were shown into huge windowless rooms resembling a planetarium or a flight (or driving) simulator. In these *war simulators*, the public was supposed to feel like spectators-survivors of the recent battlefield. Standing in near-total darkness, they would see a distant, accurately curving coastline gradually light up behind the vast pane of a panoramic windscreen, which then displayed a rush of events indistinctly represented by dim flashes, rough silhouettes of aircraft and motor vehicles, and the glimmer of fires. It was as if newsreels had been too 'realistic' to recapture the pressure of the abstract surprise movements of modern war; and so, the old diorama method, with its enhancement of the visual field, was brought into service to give people the illusion of being hurled into a virtually unlimited image. (1989: 48–49)

Virilio emphasizes not only the continuum between battlefield and cinema screen but also locates the emergence of the war memorials, the 'cenotaphs, indestructible mausoleums and other monuments to the glory of [Europe's] dead millions' which appeared across the continent after the First World War, on the same temporal plane as the cinema-palaces

being built in the United States. Virilio likens these to modern-day cathedrals, 'deconsecrated sanctuaries' where the play of light evokes a similar spectacle to that previously introduced by the stained-glass window in houses of worship (1989: 31–32). Yet it is with the emergence of the atrocity museum that mourns the victims rather than celebrates the heroes of war that we see the ultimate synthesis of the cinematic and the sacred monument.

There are intense scholarly debates as to whether sites like Auschwitz should be considered 'sacred' according to a Judaic understanding of the term. After all, these are spaces where man's relationship with God is pushed to its absolute limit (see Agamben, 1998b: 20). Spaces seemingly abandoned by God. Such debates have traditionally been situated within the wider theological problem of the Shoah as sacred event (see Hansen-Glucklich, 2014). However, more recently discussions have expanded to consider ways in which memorial museums not located *in situ* but rather *in populo* (Cohen, 2011) such as Yad Vashem in Israel and the United States Holocaust Memorial Museum (USHMM) in Washington, DC draw upon their architecture, recovered artefacts and nationalist discourses to evoke the sacred (see also Baruch Stier, 2015). Things are further complicated at sites likes Les Milles, which eludes both definitions of *in situ* and *in populo* due to its location in France, where an emphasis on secular, republican interpretation oversees the ethico-moral imperatives impressed upon those who visit (see Chapter Two). Along these lines, we might propose, albeit tentatively, the notion of the sacred as not merely a site which demands respect and reflection towards those who once suffered there but, rather, in terms of a possibility, the opening up of a space in which the present is placed into the service of both past and future.

Nevertheless, such a possibility remains at risk of sabotage by the unavoidable presence of the eternal present produced by the screen. While the immersive film seeks to make a case for sustained analysis of historical events over against the instantaneity of the news image, such analysis is predicated on a series of visual and narrative juxtapositions which see images and data about different genocides presented simultaneously across the three screens. This simultaneity risks producing what Virilio has termed a 'factitious topology' which renders 'all the surfaces of the globe [...] directly present to one another' (1989: 46).

Here in the case of the 'immersive' triple screen, this appearance of proximity or 'imposture of immediacy' is at once deeply alienating and the likely outcome is to leave viewers feeling powerless in the face of

such widespread atrocity. Yet it fails to convey the long-term ethical responsibility, the concrete political action and care required to confront and arrest the mechanisms, the systemic inequalities and exclusions which continue to legitimate both violent and passive destruction of certain individuals, groups and populations. Virilio suggests elsewhere: 'it is history which is becoming "accidental" – through the sudden pile-up of facts, through events which were once successive, but are now simultaneous, cannoning into one another, in spite of the distances and time intervals that used to be required for their interpretation' (2006). Thus while there is a tacit acknowledgement of the power of the media to persuade, disorient, overwhelm and misinform embedded in the immersive film, there also seems to be an assumption that media and, more specifically, the widescreen cinema, is a neutral form that can be decoupled from the military political ideology with which its origins and technological development are closely bound. We should be wary of the assumption here and elsewhere that the proliferation of screens and circulation of information are inherently democratic. For Virilio, a museum dedicated to the twentieth century, and here we might suggest Les Milles is one such museum, must necessarily acknowledge the role of various forms of media in defining this history via its presentation and representation of human catastrophe:

> All museology requires a museography, and the question of the presentation of the harm done by progress has not received any kind of answer; it therefore falls to us, as a primordial element of the project, to provide one. At this point we have to acknowledge that it is not so much in history books or in the press that this particular historical laboratory has been prefigured, as in radio, cinema newsreel and, above all, television. (2006)

As an external counterpoint to the application of 'immersive' media within the museum and in the context of the camp internees own theatrical performances, it is worth also mentioning Kamal Rawas's recent play, *Les Milles – empreintes* (2021), which is described as 'théâtre immersif'. It is an example I will return to later in this chapter and also in Chapter Three. Growing up in Les Milles during the 1960s, Rawas was familiar with the tile factory but only heard the story of the camp and deportations much later. The play makes use of the fragmented stories and experiences linked to Les Milles, dividing audience members into two groups – those interned in the camp and the villagers. Each group watches different sets of scenes and thus has access to only one version of events. These two narratives are tied together by

a narrator from the present named Khalil Saouar, whose biographical details appear to be loosely based on Rawas himself. The story of Les Milles emerges via an encounter with an Israeli border guard, Menahem Ange Neije, great grandchild of former internees Léon and Sarah Neije, who are also characters in the play. Initially, Menahem is suspicious of Khalil, his Muslim heritage and interest in doing business in Palestine, but ultimately a friendship emerges based on their shared but distinct connection to Les Milles. The commentary thus offered on the Israel-Palestine conflict is subtle and based on the idea of another possible world. The understanding of 'immersive' adopted by Rawas challenges the idea of both sensory and information overload at work in the museum. Instead, the audience are made aware that the story they are watching unfold is incomplete. This places the onus on them in terms of how they understand the play and its telling of what happened at Les Milles. The play is an invitation both to find out more and to recognize the ease with which collective forgetting can occur.

If the 'immersive' film and the short videos that precede it offer the most intense spectacles of artificial light within Les Milles, elsewhere in the exhibition, a more nuanced negotiation between light (artificial and natural) and darkness is at work. Besides the suicide window, there are few other spaces where natural light is allowed into the memorial space. In the main building these include the entrance hall, refectory and the pressing room. Located in the middle of the historical zone, the pressing room has been preserved as factory space separated from the memorial displays by a wall of glass.[2] The space forms an atrium and houses a collection of defunct machinery and empty shelves, with light allowed in via original skylights. A panel informs visitors that it also offered the best light during the operation of the camp and internees would use it to stage plays such as *Milles et une nuit* (pun intended).

Following this interlude of natural light, the exhibition continues with the story of deportation featuring displays focused on Auschwitz located around the bases of the factory's two large chimneys. Alongside the intentionally evocative architecture of the chimneys, a carefully curated play of light and darkness is at work here as the visitor moves from the bright space of the pressing room and pun-filled accounts of the creative activities of the internees to the figurative darkness of

---

2   On the use of the site's industrial architecture and machinery to create 'atmosphere' and an affective visitor experience see Sumartojo and Graves (2018).

Auschwitz, sparingly lit with the use of spotlights. A projected image of a snow-covered railway track leading to the entrance to Auschwitz acts as one of the main sources of light. An oft-used image, when placed in this specific context the snow almost gives it the appearance of a photographic negative, as if light and darkness have been inverted. Throughout Les Milles light and darkness coexist in a similarly ambiguous relationship.

## Frame

So far, we have looked at the specificity of the window as a source of natural light. This has been considered primarily in its juxtaposition with other sources of light including the use of immersive film in the reflective section of the exhibition. Moving from this wider consideration of the museum's interpretation and design strategies, I now want to focus on the window itself and, more precisely, its frame. The window frame is both architectural feature and integral to the story of the Camp des Milles [Figure 4]. The concept of the 'frame' also allows us to think about the metaphoric and metonymic function of the window frame connecting it up to the site's other stories and frames of reference.

As a liminal space which is at once inside and outside, the window frame offers potential for rethinking the limits of inside and outside. It has long functioned as source of inspiration for the artistic imagination and, moreover, as metaphor for the act of painting itself with Leon Battista Alberti's *De pictura* commonly cited as one of the earliest examples (Patterson, 2011; Allmer, 2006). Windows and paintings alike are conventionally rectangles, which are not, Patterson reminds us, naturally occurring shapes:

> The orthogonal is, however, implied both by the perpendicularity of the earth's surface to the path of gravity and by human verticality. The rectangle can thus be said to be the shape of removal from the earth, of technes, of construction and dwelling apart; it is the shape of utility, and thus of the faculty that we have come to call reason. (2011: 8)

It is the assumed appeal to reason and order of both canvas and window frame that is subjected to so much derision in René Magritte's paintings. As container of the outside, the window is of course always already a paradox. Writing of Magritte's use of the frame across his *œuvre*, Patricia Allmer suggests that: 'The frame is centripetal

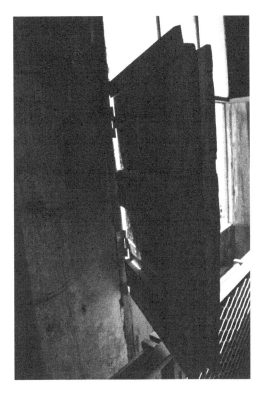

Figure 4. Window shutter belonging to the 'suicide window' at Camp des Milles. Photograph by the author, August 2017.

and centrifugal, pulling together, enclosing, detaching and creating a self-contained space which folds back upon its surroundings, negating it and creating a world made up of frames' (2006: 130). We might think first of *La condition humaine I* and *II* (1933), where the 'flimsy, tenuous' (James, 2015: 269) presence of the easel in both paintings works to undermine the border delineating the painting and its subject, a view framed by a window. A flattening takes place and what we are offered is a painting of a painting of a window and the view it contains. Yet at the same time as this flattening occurs, we are also offered a glimpse of what lies behind, or in the case of the later *La lunette d'approche* (1963), outside the representation. A glimpse but one that refuses to commit itself (or Magritte). The slightly open window suggests nothing but blackness beyond the windowpanes painted to depict blue sky and white fluffy clouds. But the darkness we are shown is inconclusive, we cannot assume it continues beyond the thin slice revealed to us.

In contrast to Magritte's flattening of painting and referent in his window images, Max Ernst's earlier painting *Two Children Are Threatened by a Nightingale* (1924) sees the image exceed the limits of its frame. The frame itself is composed of multiple borders none of which confirms the interior limits of the painting. The painting and its emphasis on the porosity of the frame seem to pre-empt Ernst's time at Les Milles during 1939 and 1940. During his internment he produced numerous works including *Créations, les créatures de l'imaginaire* (1939), a collage on brown paper made with fellow internee Hans Bellmer (Fondation du Camp des Milles, 2013: 36).[3] The image is composed of a brick wall resembling those of the tile factory. On it is a painting in an ornate frame. The painting resembles a photograph and the frame is similar to those used to frame mirrors. In the painting within the image, two near-identical women kneel over two prostrate men, most likely dead. The man in the foreground has his arm stretched out so that his hand reaches beyond the limits of the frame where it appears translucent, blending with the frame as it grasps the skeletal limb of a sexless, faceless ghoul making its way into an apparent opening in the bricks. The opening appears not to lead beyond the walls but deeper inside them.

Much of the work produced by Bellmer, including his portraits of Ernst, takes the bricks of the factory building as its subject. The bricks in Bellmer's rendering become fluid or porous, rather than assigned to fixed, immovable structures. But such porosity bears no intimation of liberation. It is monstrous and often, as in the sketch *Les Milles en feu* (1941), seems to swallow and vomit up everything it encounters. Bellmer's work does not so much 'represent' Les Milles but rather reimagines the darkly surreal space of the camp. In many ways, the 'monstruous *entre-deux*' that James (2015: 261) associates more widely with Surrealist art and which can be found in Bellmer's brick imagery already existed in the material reality of Les Milles. As Max Ernst once claimed, the camp was located on the axis between the world of Père Ubu and that of Kafka (cited in Fontaine, 1989: 299).[4]

In returning to the suicide window at Les Milles, we must keep hold of these images of monstrosity evoked by Bellmer and reconfigured decades

---

3   The exhibition 'Bellmer, Ernst, Springer, Wols au Camp des Milles' was held at the Camp des Milles memorial between 20 September and 15 December 2013.

4   Père Ubu was the central figure in a series of satirical plays by Alfred Jarry including *Ubu Roi* (2015 [1896]).

later in Jeanmougin's frameless photographs of the factory as ruins. It is this insistence on the monstrous that recalls the radical possibilities of the window frame. To photograph the window, its view and its frame, is at once to produce and enter its *mise-en-abime*, the endless reflection of the abyss that Magritte barely lets us glimpse behind the easel.

## Viewfinder

Precisely who takes photographs at a site of atrocity? What makes the act of taking a photograph an appropriate response at a memorial? What, by contrast, is deemed an inappropriate use of the camera? Artistic photography projects have long played an important role in both affirming and challenging established aesthetics at sites associated with atrocity and disaster. French photographer Ambroise Tézenas coined the term 'tourisme de la désolation' to describe contemporary fascination with such sites. His 2014 photo book of the same name captures both the spectacularism of such sites and the visitors they attract. In *Memory Effects* (2002), Dora Apel identifies James Friedman's *12 Nazi Concentration Camps* as a notable example of 'secondary witnessing' as artistic practice. Travelling to various sites across Europe between 1981 and 1983, Friedman deliberately challenged standard photographic approaches to documenting these sites. Notably he used colour film and 8 x 10 format (2002: 119). As Apel points out, although the Nazis used colour film in some of their propaganda photography, 'we have learned to recognise the Holocaust only in black and white'. Friedman's project is not only interesting as an example of colour photography. What is significant is the way in which he refuses to produce an aesthetics of absence that defines much memorial camp photography including that used by the memorial museum at Les Milles. Conversely, his work makes the presence of visitors and the museum infrastructure a central focus:

> Friedman's photographs make no attempt to travel back in time; instead they unsettle viewers' expectations, presenting such startling elements as concession stands, maintenance workers and tourists who wander through the grounds of the camps or pose for the camera in front of monuments to the dead. By shortening the focal length of the lens, a dark circle surrounds many of the images, producing vignettes that are constant reminders of the camera's presence and disrupting the conceit of omniscience in documentary photography. (Apel, 2002: 110)

In contrast to the different types of artistic project identified by Apel, there is a consensus that taking selfies at Auschwitz and other memorials constitutes unacceptable behaviour on the part of tourists. In 2019, the Auschwitz memorial museum tweeted a request to visitors not to post photographs of themselves posing on the railway tracks leading to the camp (Hucal, 2019). Previously, in January 2017, Israeli-born author Shahal Shapira launched a web project entitled 'Yolocaust' (a play on the phrase 'you only live once' in which he photoshopped selfies taken at the Berlin Holocaust Memorial onto images taken from concentration camps. Scrolling over the original images revealed the photoshopped images with the intention of drawing attention to the irreverence of some visitors to the site. Shapira later removed images from his website following apologies from some of the people he had photoshopped. The site yolocaust.de subsequently featured responses (comprising the positive, critical, abusive and spam) to the project (Faiola, 2017).

Yet between the irreverent or 'fun' selfie and the professional photography *qua* artwork we might situate a whole range of images taken by different types of visitors to these sites. In recognizing the impetus to photograph, alluded to by Georges Didi-Huberman in *Bark* (2017), how might we offer a more nuanced understanding of tourist photography which refuses the easy demonization of certain categories of visitor *qua* consumer of the macabre? How might we also call to account those who claim a more respectful (yet often equally uncritical) engagement with sites of dark heritage? Finally, how might we, the researcher *as* tourist, interrogate more forcibly our own use of photography and how we legitimize the aesthetics of framing we reproduce in the images we capture?

Photography (without flash) is permitted at Les Milles. This contrasts with other museums and memorial spaces such as Drancy, where during a visit in March 2017 I was only allowed to take pictures of the view from the top-floor window of the museum and not the material exhibited inside. But beyond an interest in the museology of the space, memorial displays (as distinct from their architecture which is often impressively photogenic) don't tend to lend themselves to amateur photography. The reflective glare of spotlights can make it near impossible to capture image and text boards. Photographs of glass-fronted displays often reproduce a ghostly shadow of the photographer. Of course, you can use filters but again this would imply professional, even artistic, motivations for visiting the space rather than personal curiosity.

Yet as with other types of museums and galleries there is a compulsion to photograph, to document one's visit and provide proof of having encountered the objects inside. On returning home, such photos seem odd, poorly executed and incapable of doing justice to the museum experience they were supposed to capture and it is hard to remember why they were taken in the first place. As a memory support they fail massively, not least since they often end up deleted from the memory card before the journey home. It is only perhaps with the passage of time, decades rather than years, that the ghostly shadows and ill-framed shots acquire their own value. Only then does it become possible to identify what Roland Barthes (1980) would term the 'punctum' – the thing that doesn't fit yet unlocks the entire sense of the image. To commit to the punctum over and above the immediate desire for the aesthetically 'neat' – the shot which removes audience and display frame altogether – requires a long-term investment in documenting (and indeed reframing) an act of framing located within the memorial or museum which may itself be only temporary.

The view from the second-floor window at Les Milles invites contemplation but also photography whilst precluding the possibility of a selfie. Yet the window itself is easy to miss. Although today the path through the museum means access to the reflective zone is via the second floor, this was not the case when I first visited in 2015. The second floor is a quiet, isolated, almost bracketed-out space where the clear narrative of the rest of the exhibition appears temporarily suspended. Like the pressing room, which momentarily disrupts the ground floor historical zone, the second-floor area is framed by the materiality of the factory but also features video testimonies from survivors of the camp, an account of the memorial's decades-long struggle into existence and the accompanying research publications and press support contributing to this. Consequently, it is a space that seems dedicated less to a coherent narrative than to tying up the loose and disparate ends of the building's history. This seems to be aimed at drawing a distinct line under the very 'sitedness' of the memorial that is also what makes the space so important. Only then, it seems, can visitors move on to the more global, abstract concepts presented in the reflective zone.

## The Bystander Effect

Yet it is not so easy to move beyond this sitedness, to step back from the view offered by the window and into the artificial light of the reflective zone. The window seems to ask too many questions, as do the objects it frames. Visiting the reflective zone only seems to make these questions more persistent. In the final part of the exhibition, the window becomes abstracted and oversimplified as a space where those with the power to act or intervene fail to do so. Before considering in more detail the potential of tourist or visitor *as* a specific type of witness via the photograph as both act and object, it is important to look at how the museum conceptualizes notions of looking, witnessing and acting. Notable here is the significance attributed in the reflective zone to the theory of the 'bystander effect'.

Now largely discredited, the 'bystander effect', was a theory developed by US sociologists John Darley and Bibb Latane (1968) based on the case of Kitty Genovese, murdered in New York City in 1964. Genovese was stabbed on her way home from work as a bar manager. It was a warm night and so many people living on the street had their windows open and could hear the ordeal which lasted a total of 30 minutes. Initial reporting of the murder by the *New York Times* and the NYPD suggested that while 38 people witnessed the murder from their apartment windows, no one called 911, thinking that someone else must have already done so or simply not wanting to get involved. The exhibition draws on the study as part of its call for individual action in the face of group apathy.[5]

We should be wary of the simplicity of the conclusions drawn here. In recent decades the *New York Times* has admitted various flaws in its initial reporting (Sexton, 1995; Rasenberger, 2004; Dunlap, 2016).[6] Of the 38 witnesses originally interviewed, only a couple had a clear view of what was going on. Those who had dismissed it as a domestic argument

---

5   Another set of panels and video footage which forms part of this section of the reflective zone is dedicated to the highly controversial Stanford Prison Experiment, conducted in 1971, whose conclusions have recently been heavily contested (Blum, 2018). Like the bystander effect theory, the Stanford Prison Experiment is oft-cited as incontrovertible evidence of collective behaviour in certain situations.

6   In 2016, a new documentary, *The Witness* directed by James Solomon, followed Kitty's brother, William Genovese, as he attempted to gain clarity on what happened.

or had not wanted to get involved were condemned in the original article and the entire street became a cautionary tale, a metonym for middle-class self-interest. There is little analysis here on why middle-class, predominantly white citizens might be reluctant to call the police yet this was surely a factor at stake. When the police finally were called it was at the behest of a man who climbed a roof to request an elderly neighbour make the call. There are multiple, complex reasons why, both back in 1964 and today, people of all demographics do not trust law enforcement. To cite just one possibility here, if some of the witnesses genuinely believed it was a domestic incident then they may have also assumed, in keeping with the time, that the police would either make it worse or do nothing.[7]

Thus, in the reflective zone at Les Milles, the window is reframed as a position of power and security. Any ambiguity surrounding the decision to act or not alongside the ever-present threat of police violence in democratic as well as totalitarian states is bracketed out here. This is echoed in another panel which emphasizes the positive role of law-making in responding to racism and other hate crimes. As will be explored in the next chapter, questions about how one negotiates the call to hospitality and to resist collective xenophobia in the context of France's draconian laws on immigration are deliberately absent from the museum's interpretation. The reframing of the window within the parameters of law and state obliges us to move beyond the suicide window and the complexity of what it also frames. Part of the project of this book is to insist on the view from the suicide window over and above these abstract insights, the *windows onto the world*, presented in the reflective zone.

### Souvenir

In returning to the second-floor window, I am not proposing that it offers up any kind of incontestable truth in contrast to the discredited claims of the studies cited in the reflective zone. The view from the window does not make any claim to objective truth. It is a view that is carefully staged. It is in some ways a simulacrum, an imperfect representation of another

---

7  What might lend more nuance and relevance to the theory and the example that underpins it is a discussion of the role and responsibility of today's 'digital bystander' in a position to record and live stream events as they happen.

view but one that almost coincides with it. The window affirms the camp once more as an (in)difference machine. The staging of the view calls to mind that of Walter Benjamin's grave, a story worth recalling here due to its overlap with those belonging to Les Milles. Benjamin is often referenced in relation to the internment of German Jewish intellectuals and artists, many of whom, including Max Ernst and Lion Feuchtwanger, ultimately achieved safe passage to the United States. In the catalogue (CDJC, 1996: 30–31) to an early exhibition on the camps, 'L'Internement des Juifs sous Vichy' held at the Shoah Memorial in Paris, Benjamin is misidentified as having been interned at Les Milles, a mistake echoed in the 'Les Milles' entry in USHMM's *Encyclopedia of Camps and Ghettos* (Megargee, White and Hecker, 2017: 168).[8] The details of Benjamin's suicide, both concrete and anecdotal, are often invoked to fill the silence in other narratives that also end in suicide. Silences such as those surrounding the identities and lives of the women who jumped at Les Milles. Even in the most detailed accounts of the deportations of August 1942, there is no mention of their names, no details of their identities.

There is, of course, a deep irony here given Benjamin's call to remember the nameless victims of history in his Paralipomena to 'On the Concept of History' written shortly before his death. As Benjamin himself emphasizes, 'It is more difficult to honor the memory of the anonymous than it is to honor the memory of the famous, the celebrated, not excluding poets and thinkers' (2003: 406). The history of Les Milles and its privileging of its male artist and intellectual internees alongside the tangential story of Benjamin, which brushes the edges of the camp galaxy of Provence, embodies this difficulty. The stories of the anonymous women at Les Milles seem to have less to offer us in terms of sabotaged brilliance. Their tragedies are personal tragedies, not public ones. Lost manuscripts and unwritten works count for more than merely lost lives and ruptured families it seems. But alongside the concrete, nameable circumstances leading up to Benjamin's death, his trek through the Pyrenean foothills, the receipts from his stay at the Fonda de Francia and his arrest by the Civil Guard on 25 September 1940, there is the ephemeral. First there is the anecdotal evidence provided by Benjamin's travelling companion Henny Gurland, who claimed that he took a morphine overdose. Then there is the alternate

---

8   Benjamin was arrested in Paris in September 1939 and interned initially at Nevers and then nearby Vernuche.

ending in which Benjamin died at the hands of Stalinists.[9] There is the mysterious disappearance of the suitcase allegedly containing his latest manuscript, the unfinished masterpiece. And finally, there is the problem of locating his grave at the cemetery in Portbou. All becomes dust then whispers then dream.

It is in pursuit of this dream rather than the death cult around Benjamin that the anthropologist Michael Taussig (2006) visited the cemetery and the grave dismissed as 'apocryphal' by Scholem and others. As Taussig discovered, the grave paid for by Gurland ended up under the name Benjamin Walter. Benjamin was thus buried not as a Jew but as a Roman Catholic. His death, like the grave in which he is buried, is fake. Or rather, his death is not fake but its representation is. What this discovery seems to attest to is the impossibility of memorial since any attempt at remembrance requires the finality of death. Yet death is always such that it seeps into the life it cuts short. All memorials are fakes to some extent and as Michael Eaude has suggested, perhaps it is fitting that Benjamin has come to represent those whose histories cannot even be faked:

> Historians should tell the story of those who have no name or an unofficial story, which is usually the history of how history has been falsified. Despite Benjamin's growing fame, which has turned Portbou into a site of pilgrimage, the poignant destiny of his salt-bleached bones in the ossuary makes him an apt representative of nameless victims. (2007: 26–27)

The suicide window presents us with a similar paradox. Not simply because there is no guarantee that it was from *that very* window that the women jumped. The window is also misleading in its claim to remembrance. What kind of memorial is a memorial to those whose lives can only be commemorated via reference to the death they chose as preferable to what life had to offer?

But if the story of the Camp des Milles seems to lead us away from the camp itself, offering us Benjamin as a token in place of those who remain nameless, it is Benjamin himself who leads us back here. To retell the story of Benjamin is less to overwrite the story of Les Milles with a more interesting mythology and more to emphasize the ability of the camp as

---

9  This is the ending proposed by journalist Stephen Schwartz in 2001 and generally met with a certain degree of incredulity by scholars invested in Benjamin's biography. See, for example, Leslie (2007: 218).

network or galaxy to subsume everything in its reach as encapsulated by Bellmer's artworks. An empty frame, a simulated view – how, then, can we begin to look for these women? How might we locate them not only in the privileging of male genius but also in the missing or incomplete archives, the unsubstantiated rumours and anecdotes, the forgotten sites where they were interned for weeks and months before being transferred to Les Milles? The photograph of the suicide window is the first step in this search which will be taken up more directly in Chapter 3, where the memory of the specific events of 1942 will be analysed in greater detail, and in Chapter 4, where the wider camp landscape including the sites in Marseille which held women will be explored. It is also an attempt to start a new archive as it documents another moment in the history of Les Milles. After all, if the window and the view are stand-ins or simulacra (like Benjamin's grave), the photograph is real.

The photograph is real not in its faithfulness to any so-called 'reality'. It is, after all, a photograph of a reconstruction. Its significance lies in its existence as a photograph. Writing in 1999 at the dawn of digital photography as a commercial format, Elizabeth Edwards suggested that our attachment to the materiality of the printed photograph would outlive its existence as mode of production. Yet a photograph's materiality persists even in digital form. It is a form at least as vulnerable as its printed predecessor. The anxiety at losing a digital image is arguably greater than that experienced around a printed photograph. Where the printed image was at risk of damage from excessive handling, greasy fingers, sunlight, damp or fire, the digital image suffers from comparable threats as it is transferred from camera to laptop to USB key to email to PowerPoint. The more copies seem to exist, the more it risks accidental erasure, corruption or loss of quality. As Edwards points out, the photograph's value lies not in what it shows but in the desire to show what it shows. The photographs taken by visitors to memorial sites are not to be valued for any aesthetic achievement, itself open to suspicion. Instead, it is the desire to show what is there. A photograph in this case becomes an important souvenir and it is the fact of having personally taken such an image, owning the file and being able to call it up and share it that makes it so.

The notion of photograph as souvenir is important and requires some unpacking especially in the context of a site commemorating atrocity. A souvenir is often posited as a theft. It is something stolen from the dead by the victors. As Benjamin wrote in 'Central Park', 'The relic comes from the cadaver, the souvenir comes from the defunct experience

[*Erfahrung*], which euphemistically calls itself experience [*Erlebnis*]' (2003: 183). A relic or a spoil of war? A proof you were there and that you won. The tourist collecting souvenirs is involved in a similar form of plunder. The objects accumulated become affirmations of an experience of somewhere else, an experience which never really happened. The objects always refer one back to home. The mass production of trinkets sold at sites of interest shifts the terms of the encounter from one of straightforward theft to a complicit yet cynical exchange between tourist and local. As Esther Leslie states in her reading of Benjamin's writing on the souvenir, 'The souvenir is the packaging up of experience – which means the experience contained is inaccessible' (2010: 132). Nowhere, we might argue, is this more the case than at the memorial museum.

Whether a memorial tells the story of history's victors or its victims determines to some extent the nature and role of the souvenir. At the Musée de la Paix in Caen, it is the victors who are represented first and foremost. The museum tells the story of the Allies, the heroes who liberated France and restored democracy to the Western world. The first thing one is met with on entering are the piles of mugs on sale in the gift shop, mugs bearing the US, British and Canadian flags with a smaller reference to the museum printed underneath. Here the souvenir and the figure of the tourist reach their apotheosis. The museum is dedicated to those who travelled to France in the name of their own national identity. The museum sells this identity back to their grandchildren as souvenirs, replica US military aviators, lighters, t-shirts and bomber jackets along with 'Keep Calm' biscuit tins evoking fantasies of wartime solidarity that apparently once belonged to a Britain now divided over Brexit.

At Les Milles the history being presented belongs to the victims not the victors. The selling of relics is more complicated. Unlike Caen, there are no overpriced restaurants selling burgers, fries and cans of Kronenbourg. The 'souvenir' objects offered up for consumption or collection here are presented as objects of knowledge, understanding and respectful commemoration aimed at extending the experience which began at the memorial. In the absence of snow globes and stuffed toys, museums like Les Milles have extensive bookshops selling expensive hardback history and art books along with postcards, bookmarks and, occasionally, pens and pencils. The shop at Les Milles also has t-shirts and badges containing contemporary slogans calling for resistance to extremism. Like the overly curated space that precludes the possibility of casual wandering, the *flânerie* that Benjamin celebrated as necessary to a personal experience of remembering, the 'souvenir' books enable one

to forget the embodied and affective experience of visiting Les Milles, which is substituted with the established narratives and iconography of print publications. Like the trinket that reminds us we *must have been* somewhere, the gift-shop history book tells us, without us ever having to open it, that we *must have learned* something. I feel this is a theft of sorts, too, again disguised as a form of complicit exchange.

If the souvenir trinket makes the experience of a place inaccessible, it can, when presented to those back home, give rise to a whole series of new experiences and memories. This might be in the form of fetish object, love token, tasteless joke and so on. The unopened history book less so. Consequently, the photograph taken at the memorial site acquires greater importance as a souvenir and, I would argue, as a material object produced by the tourist (like writing on the back of a postcard), it remains tied to the physical experience of the visit, the physical, mechanical act of taking the photograph. The image produced does not simply become a stand-in for direct experience but is part of that experience. Moreover, while we might purchase souvenirs out of a desire to 'lock-in' or 'package' an experience we fear to be otherwise ephemeral and superficial, the photograph is taken not to fill an absence of meaning but out of a desire to retain something of the present meaning. This comes with the recognition that the meaning we want to capture will no doubt change in the future. The wager we make is that the photo *will continue to mean something* with the passage of time. This is not to say that an experience of a museum cannot be impoverished due to overzealous photography that limits direct engagement with the exhibits. I have certainly been guilty of this. However, it is the potential offered by the museum via points of reference such as the suicide window to produce one's own 'souvenir' image that both rehabilitates the role of photography within such spaces and allows the tourist to engage in a form of 'witnessing'.

## Witness

To argue that tourists can act as 'witnesses', especially at Holocaust memorial sites, is a contentious claim. It first requires some acquiescence as to what form such 'witnessing' takes before the wider ethical responsibilities associated with the concept of the 'witness' can be explored in greater detail. To some extent the impossibility of bearing witness to the most atrocious events of the Holocaust is made manifest by

the memorial at Les Milles. As suggested above, there is a refusal to 'reconstruct' life at the camp. There are no mannequins of internees or guards, the stripy uniform from Auschwitz is not 'modelled'. Living quarters are not replicated in any way. All insights into life in the camp offered by the first-person testimony provided by internees are presented as artistic or literary representations, such as the descriptions offered by Lion Feuchtwanger or the artworks of Max Ernst and Hans Bellmer. Such representations are then used as signposts that structure the narrative of the memorial.

The closest the interior space of the factory comes to being 'reconstructed' as camp is via the use of a cartoon by Hans Engel (interned at Les Milles between 1939 and 1940) which depicts rows of men sleeping with the inscription 'Chérie, laisse-moi, je suis tellement fatigué' [Darling, let me be, I'm so very tired]. A disclaimer reads as follows: 'This wall projection is intended as a presentation of the internees' life in the kilns based on a drawing by one of them at the camp.' The specific kiln in which we are now standing does not seem to have housed dormitories. What is being emphasized here is that this is first and foremost an artistic representation rather than an accurate reconstruction of the sleeping quarters *as they were*.

The memorial thus demonstrates an awareness on the part of its curators as well as those visiting that what is experienced in the exhibition is in no way to be conflated with the experience of suffering by those interned in the camp. Such an awareness attests to an increased sensitivity in the curation of Holocaust exhibitions. The comparatively recent inauguration of former camp sites in France as memorial exhibitions, Compiègne in 2008, Les Milles in 2012 and Rivesaltes in 2015, means that those involved in the restoration and curation projects have been able to draw on decades of best practice and accompanying theory and critique while sites elsewhere in Europe have evolved their displays in a more organic, ad hoc manner. However, such sensitivity is the fortuitous outcome of decades of silence, forgetting and ignorance around the sites in France where elsewhere the imperative to both commemorate and educate local and international visitors about the events of the Holocaust was deemed more urgent.

In *The Drowned and the Saved*, Primo Levi provides one of the best cases against the figure of the witness. Levi recognizes the impossibility of being a good or reliable witness if one has truly suffered the atrocities of the concentration camp or the gas chamber. Here, witnessing precludes survival. Those who survived largely did so due to obtaining certain

'privileges' within the camp system and thus did not experience its worst abuses and degradations. Such a strategic negotiation of the camp system also tended to mean a strategic 'remembering' of one's experience and specifically one's complicity in the camp's systemic violence. Levi classes himself amongst those survivors who were neither complicit in the camp regime nor, for various reasons, reduced to the lowest forms of existence, embodied in the figure of the *Muselmann*. For Levi, those who like himself survived largely through luck, without subservience to the system, without demonstrating a willingness to inflict violence on others to assure one's own survival, make the best historians of the camp. Yet their testimony remains imperfect. They are unreliable witnesses. More so with the passing of time:

> [T]he passage of time has as its consequences other historically negative results. The greater part of witnesses, for the defence and the prosecution, have by now disappeared, and those who remain and who (overcoming their remorse or, respectively, their wounds) still agree to testify, have ever more blurred or stylised memories; often, unbeknown to them, influenced by information they gained later from readings or the stories of others. In some cases, naturally, the lack of memory is simulated, but the many years that have gone by make it credible, also upon examination the 'I don't know' or 'I did not know' said today by many Germans no longer shocks us, but they did shock or should have shocked us when events were recent. (Levi, 1989: 8)

Ironically it is Levi's claim to be unable to accurately witness that not only makes him such a compelling witness but also makes his argument against the 'witness' so difficult to refute. It is his struggle to make sense of this role, the ethical responsibility not simply to provide an account of his own experience in the camp but to stand in for those who are no longer present to bear witness that Giorgio Agamben takes up in *Remnants of Auschwitz* (1998). Drawing on the etymology of the notion of testimony, Agamben teases out the gap between the third-party witness [*testis*], the uninvolved bystander called upon to provide objective, neutral evidence to an event and the person who experiences an event or act first-hand [*superstes*] (1998b: 17). As we have seen in the earlier discussion of the 'bystander effect', there is no such thing as an objective let alone innocent bystander. Furthermore, the third-party witness cannot really witness since he or she has not directly experienced the events taking place or acts committed upon the first-person witness. Yet the first-person witness cannot be charged with the presenting of facts as to what has happened either. His or her story cannot be trusted as accurate; nor,

as is the case with Auschwitz, can it be heard since to witness Auschwitz precludes the possibility of surviving Auschwitz.

If Levi's writing posits the problem of witness testimony as experienced by the reluctant, incomplete witness *qua* survivor, Agamben's commentary (and he insists on this term 'commentary') on the paradoxes of Holocaust testimony asks a different set of questions directed towards the future rather than the past. How to navigate between the historical reality, the carefully documented and archived details of the Nazi exterminations and the aporias produced by an ongoing insistence that what happened remains unimaginable, unfathomable, beyond the grasp of human comprehension? And in carving out a path between these two seemingly untenable positions, what are we to do with all of this? Agamben identifies his task here as follows: 'For my own part, I will consider myself content with my work if, in attempting to locate the place and theme of testimony, I have erected some signposts allowing future cartographers of the new ethical territory to orient themselves' (1998b: 13).

Such a task is echoed by Griselda Pollock and Max Silverman (2011; 2013; 2015a; 2019) in their setting out of the notion of the 'concentrationary'. Their recent work on the concentrationary is a collective project taken up with sustained analysis of the cultural production and representation of the concentration camp as key organizing referent for the activities cumulatively termed the Holocaust or Shoah. In considering the emerging landscape of Holocaust memorial across France in contradistinction to those dedicated to the Resistance or Liberation, we should also recognize such orientation, really a reorientation, as literal as well as figurative. This is something we will return to in Chapter 4, when we consider the 'landscape' captured in the photograph. To think of memory spatially here, we might also evoke the grey zone alluded to by Agamben, a space in which the roles of victim and oppressor fail to remain distinct. But here the grey zone has shifted along with the notion of responsibility. In the era of 'postmemory' (Hirsch, 2012), bearing witness is no longer a matter of *what one sees* since all is representation, retelling and reframing but, rather, *how one sees*.

Levi completed *The Drowned and the Saved* in 1986 shortly before dying by suicide. Written decades after his experience at Auschwitz, it grapples with the shadows that mark time and the shifting response of a new generation of Germans coming to terms with the atrocities perpetuated by their parents and grandparents. It is this new generation who look to Levi for both clarity and absolution, neither of which he

can offer. Yet this does not constitute a failure on his part or an offence on theirs. Rather, it insists on the irreducible gap between experience and the subsequent articulation of that experience. It is the ability to acknowledge this aporia between the events that happened and their representation within the memorial space that, Daniel Reynolds convincingly claims, can reposition the tourist to such spaces as another form of 'witness'. Following Agamben's line of argument, Reynolds suggests that:

> [T]he separation between the tourist and the victim by both the silence of the dead and the distance of time do not negate the tourist's potential to bear witness; instead, they mark its possibility, even its necessity. The tourist's experience of inhabiting the place of suffering, even if mediated through facsimiles and exhibitions, represents an attempt to overcome the experiential and temporal distance from the victims and to take on the duty of bearing witness to what they endured. (2016: 343)[10]

This is a secondary witnessing in that visitors are only witness to a representation of suffering, one in which the victims are notably absent and silent. Yet it is also a primary witnessing to the silences produced within the memorial space. The ethical subjectivity of the visitor lies in how he or she opts to negotiate such silences. Here, it is the museum space that must be called to account. This no longer refers only to the representation of past victims and victors but, as is the case at Les Milles, is now also directed towards the future. This marks the shift identified by Pollock and Silverman from Holocaust to concentrationary memory. To remember the Holocaust is to draw a line under its events and in doing so demand that they are never forgotten. To insist on a concentrationary memory is, without homogenizing the experience of the Shoah so that its specific racial and cultural implications are erased, to assume perpetual vigilance against the re-emergence of a 'concentrationary universe' under another name.[11]

---

10   Reynolds also provides some interesting insights into the complex etiquette of photography at Holocaust memorials and exhibitions based on ethnographic observation. Some of these pertain specifically to the negotiation of crowded spaces where tourists vie to obtain the best shots free of other visitors whilst maintaining the appropriate level of respect and decorum required by the site. Such issues arise less at a site like Les Milles that does not attract the crowds of international visitors found at Auschwitz.
11   The term 'univers concentrationnaire' was originally coined by David Rousset (1965). Pollock and Silverman offer a sustained analysis of Rousset's work as well

Pollock and Silverman's multifaceted project also moves the discussion of what it means to 'represent' the Shoah beyond the critical gridlock of earlier decades. On the one hand, this involves having done with the dogmatic refusal of representation via declarations that Auschwitz is and must remain unimaginable, unspeakable and therefore unrepresentable. These are the type of sweeping claims that Didi-Huberman takes to task so forcefully in *Images in Spite of All* (2008) where he considers the complex, shifting role of the only four existing photos showing the mass extermination taking place in the camps. On the other hand, this also involves acknowledging the role played by representations and reconstructions of the Holocaust at all cultural levels and in all formats in shaping a contemporary public imaginary and thus understanding.

It is in this shifting context that we must locate the changing and complicated figure of the witness, a witness not necessarily to unmediated acts of atrocity but, rather, to the presentation and framing of such acts within the memorial space. An attempt to articulate this shift in how we understand the figure of the witness and his or her responsibility, our responsibility, is integral to this book's project. The first point to make is that acknowledging and assuming this responsibility might at first appear to lack urgency as we walk the ruins of history *at our leisure*. This is not the responsibility to bear witness assumed by those who, appreciating the urgency of the task, took immeasurable risks to photograph images of the death camps. For example, the *Sonderkommando* who, in smuggling a camera into the camp, knew the respite from death and the material privileges that recompensed their work in and around the gas chambers were but temporary, who knew that they would not survive to bear witness in person (Didi-Huberman, 2008). It also bears little resemblance to the crushing burden of responsibility to remember and record that compelled Levi to spend the decades following his internment writing.

What are we to understand by the term 'leisure' in the context of Les Milles? Tourism, entertainment, consumerism are all ways that the act of visiting a memorial museum or site of atrocity have been defined. All sit uneasily with the proclaimed curatorial objectives of such spaces. With the obvious exception of regional school trips, all such visits are rendered possible within a framework of leisure time,

as a detailed exposition of their own definition of the 'concentrationary' in their introduction to *Concentrationary Cinema* (2011: 18–28).

global tourism and the imperative to consume which structures the moments in which wage labour is, or appears to be, suspended. But Les Milles as internment camp was also a site in which both regular wage labour and citizenship were suspended. What lines must we draw between our own 'leisure' time and the enforced 'leisure' of the internees? What is dangerous about the museum's celebration of the 'creative resistance' of the internees as they produced art, writing, organized plays, concerts and conferences is that such a celebration fails to examine how such activities must be seen as either the product of enforced leisure time *or* as unpaid and thus slave labour. In acknowledging such temporal structures past and present, how might we move beyond the boundaries of paid and unpaid labour and leisure towards a more sustained form of ethical engagement? To what extent can we think about witnessing as a form of care? This involves an acknowledgement of the time and labour involved in assuming the burden of care but one which falls to the collective, not individuals, and cannot be inserted into systems of commodity exchange.

The photograph I took through the suicide window is a starting point for my own witnessing to the concentrationary memory of Les Milles. As a souvenir object, it has led me to open history books in search of words, marks, traces which might fill the silences left hanging in the dusty air of the factory. In this sense it has not packaged up my experience as other objects might have done. In its insistence on its materiality where other photos taken on the same day have since been lost, deleted or corrupted during file transfer, it provides me with a physical, albeit digital, link to the space at Les Milles. Yet its very subject matter, starting with its frame, make it impossible to leave it be. So, although I might have visited the space *at my leisure*, there is nevertheless something urgent about the task opened up to me. I am overwhelmed with the feeling that the view from the suicide window belongs to a moment, the meaning of which will only become fully apparent after it is too late. What does it mean, in other words, to witness something *before* rather than *after the fact*? Is this what Benjamin means when he speaks of the present as 'shot through with splinters of messianic time' (2003: 397)?[12]

---

12  The complex temporalities of Les Milles and especially August 1942 will be explored with further reference to Benjamin's notion of 'messianic time' in Chapter 3.

## To Photograph the Frame

To photograph the view from the suicide window and include the window frame within the photograph is harder than it looks. Stepping back from the window to include the frame, the detail of its shutters and grime-covered upper panes, risks reducing the view to a square of saturated white light as my small Nikon 1 J5 struggles to capture the contrast between the sombre interior of the second floor and the bright sunlight of an August afternoon. The wagon and the flag are miniscule and quickly pixelate when I attempt to enlarge the photograph. Looking back, I find it hard to imagine that I only took one photo and didn't try to zoom in closer on the wagon. But there is only one photo taken at the window from my first visit in 2015.

Writing on the photography of torture that emerged and circulated post-9/11, Judith Butler asks how we might photograph the frame itself (2010: 71). She suggests that such an act of photographing shouldn't be dismissed as mere 'hyper-reflexivity' but constitutes a means by which we are able to better scrutinize the restrictions placed on our understanding or interpretation of reality (72). Where Butler is referring to the specific regulation of images of war by social and state apparatus, her analysis of the frame is no less relevant for thinking about the window frame at Camp des Milles.

Butler describes the attempt to 'photograph the frame' as a 'disobedient act of seeing' (2010: 72) since it calls into question the objectives and techniques involved which make certain images both possible and desirable. However, in their attempt to provide more transparency about their practices and objectives, museums are increasingly drawing attention to their own uses of different framing techniques. Like other Holocaust museums such as Yad Vashem in Israel, the Camp des Milles memorial includes the story of its inception, details of its sponsors and supporters and the thinking behind some of its curatorial decisions. The open window to which we are directed might be read as part of this claim of transparency.

Nevertheless, we still need to ask what is at stake when our attention is directed explicitly towards an act of framing as much as to what is being framed? In photographing the frame, we are in danger of simply affirming claims of transparency rather than giving these closer attention and analysis. In highlighting various indices as visible through the open window, I intend to suggest over subsequent chapters how the failure or refusal of such indices to be contained by the physical and ideological

space of the memorial site produces a form of destabilization. While at odds with the central ideology or organizing logic of the memorial or museum, such destabilization remains necessary to the museum's role in the production or transformation of its visitor as an ethical subject or spectator. Once again, this is where the radical potential of the window and its frame lies.

Beyond the empirical function of the photograph within the context of carrying out research on dark heritage, might it also be possible to develop a theory of 'photographing the frame' precisely within such a context of vicarious memory or looking? Can such an act of photographing the frame be situated within a wider understanding of an ethics of spectatorship at work within and beyond the space of the memorial museum? To attempt to articulate what this notion of ethical spectatorship might involve, I find it useful to draw upon both Jacques Rancière's concept of the 'emancipated spectator' (2009) and Ariella Azoulay's 'repaired citizenship', which she locates within her wider understanding of a 'civil contract of photography' (2008).

Focusing in the first instance on theatre, Rancière describes the paradox of the spectator, required to watch a play or performance yet posited as passive in contrast to the action on stage. Moreover, since this action is associated with knowledge, the actors are driven by and to knowledge here, the inaction or immobility of the spectator is conversely associated with ignorance. Here, Rancière paraphrases Plato's claim that the theatre is where the ignorant come to watch the suffering of others. Immediately it is possible to see how this assumed reading of spectatorship as both grounded in ignorance and delighting in suffering located in theatre inserts itself into the space and agenda of the Holocaust or atrocity museum. The idea of the ignorant masses in need of enlightenment not only defines the museum's approach to the presentation of material, in the case of Les Milles the story of the camp and its role in the wider history of the Second World War and the Shoah, *but* it is also against 'ignorance' presented as the root of xenophobia and extremism that the museum articulates its mission.

The dogmatic structure of the 'infotestine' layout, to return to Day's indictment or the sensory onslaught of the tripartite 'immersive film' mentioned earlier, does little to contest the hierarchies of knowledge transmission or the crudely assumed trajectories from information to action. As Rancière neatly puts it, 'Being a spectator is not some passive condition that we should transform into activity. It is our normal condition' (2009: 17). Consequently, many of the attempts to 'enlighten'

at Les Milles evoke instead the precise image of 'stultification' that Rancière depicts in both *The Emancipated Spectator* (2009) and his earlier text on education, *The Ignorant Schoolmaster* (1991). As he writes in the former:

> This is the logic of the stultifying pedagogue, the logic of straight, uniform transmission: there is something – a form of knowledge, a capacity, an energy in a body or mind – on one side, and it must pass to the other side. What the pupil must *learn* is what the schoolmaster must *teach* her. What the spectator *must see* is what the director *makes her see*. (2009: 14)

Against this logic, he reimagines the spectator as active interpreter or translator of the performance or, indeed, exhibition they are viewing. The so-called 'ignorant schoolmaster', Joseph Jacotot, who forms the basis of Rancière's study, did not explain or translate material for his Flemish students eager to learn French. Jacotot did not speak Flemish. Rather, he simply located the tool or object, the French-Flemish edition of Fénelon's *Télémaque*, that would enable the students to undertake this activity themselves (Rancière: 1991: 2).

That the contemporary museum space might be reconceived along the same lines as Jacotot's project has been suggested by Jung (2010) and more recently developed by Sitzia (2018). However, where this seems achievable and even straightforward within a modern art museum or even in exhibition spaces which present contemporary creative, artistic engagements with the Holocaust,[13] this is perhaps less viable in a memorial space dedicated to the presentation of a detailed historical narrative. The interpretation offered by the memorial space of Les Milles is non-negotiable. The parameters of understanding are also clearly defined and limited to a series of key figures. We might insist further that the inevitable hierarchies, exclusions and alienation that this interpretation risks reproducing, particularly for adolescent school groups visiting the site, occurs precisely via the 'stultifying logic' that sees knowledge as something to be imparted by a 'master' to an 'ignorant' student.

This is not to preclude the possibility of a different, emancipated form of spectatorship from taking place within the museum at Les Milles.

---

13  See, for example, Ariella Azoulay's discussion of the 'Live and Die as Eva Braun' exhibition by artist Roee Rosen, first shown at the Israel Museum, 1995–1997 (2001: 50–74).

Indeed, such spectatorship does not have to involve the type of 'immersion' proposed by Rawas in his play. For Rancière, attempts by modern theatre to collapse the physical space between audience and stage remain fixated on the idea that a spectator is by default 'passive', something he contests. Thus, while an emancipated spectator would be required to undertake a different form of looking to the one prescribed by the museum's frames, this does not necessarily mean a direct contestation or refusal of these frames. The memorial can and does facilitate this spectatorship by, for example, directing our gaze to the window – the cone of vision. Consequently, and this is something we must come back to, what is perhaps at stake here is the role of the museum as necessarily self-contradictory. The museum as pedagogical rather than purely memorial space provides us with a series of supports that strive towards their own obsolescence or redundancy. This is, to some extent, the antithesis of a museum conceived of as a sealed-off collection of relics and artefacts. This is something that becomes apparent in a multimedia space which opens up storytelling to as many forms as possible. This involves a huge risk, of course, since it invites a contemporary form of 'museum fatigue', particularly when there is an overriding insistence on the total knowledge of the space.[14] Yet the wager in positing a form of interpretation that leaves nothing out is that every visitor will leave with an image, a story or an object which has somehow resonated, and which enables them to act as witness.

If we identify the ability to 'witness' with a certain mode of emancipated spectatorship, then this takes on a further ethical responsibility in the space of Les Milles. It is, as stated earlier, a form of witnessing which is secondary and as such calls to account not the acts committed in and beyond the camp but the framing of these as both memorial and pedagogical museum. In what ways can and should the memorial site aim to speak for those who cannot or can no longer speak for themselves? But how might such a restored or reconstructed testimony be about seeing as much as it is about speaking? This is again

14   The concept of museum fatigue was originally developed in relation to the physical discomfort experienced by visitors obliged to stand for excessive periods of time and strain to view awkwardly positioned display cabinets located at ground level (Ives Gilman, 1916). For reviews of classic and more recent scholarship see Davey (2005) and Bitgood (2009). Today, since museums have developed a strong awareness of accessibility, it is a critique perhaps better directed towards the intensity and extensiveness of collections and the more complex histories they seek to present.

to pursue the line of argument presented by Didi-Huberman when he makes the case for the four images taken at Auschwitz as both objects and acts that play a key role in our understanding of the extermination camps. It is also to pick up on his critique of a reading of the photograph as fixed and static both in terms of what it captures but also in its status as historical artefact *qua* fetish object (Didi-Huberman, 2008: 72ff.).

It is as an act, set of acts, processes and relations that Ariella Azoulay sets out to articulate the potential of photography in 'repairing' or 'restoring' what she defines as 'impaired' citizenship. Azoulay is an Israeli-born photographer and art historian whose photography and scholarship has focused on the role photography can play in both documenting human rights abuses enacted on Palestinians living under the Israeli occupation *and* in affirming subjectivities and forms of citizenship which resist paralyzing narratives of victimhood. She has also called into question the ways in which the Israeli community has sought to limit and control the memory and representation of the Shoah. This occurs, according to Azoulay (2001: 66–70), both in terms of its singularity, which precludes comparison with other genocides and atrocities, and in relation to what can and cannot be said and by whom. Consequently, her work on photography and citizenship seems especially pertinent to the photographing of the window frame at Les Milles.

Azoulay's work relies upon the acknowledgement of how photography can operate as an act employed and incorporated into state power whilst also providing the means by which ordinary citizens can contest official discourses of power. She focuses on the way in which photography in the framing, production and circulation of an image involves a series of different actors beginning, in the first instance, with photographer, subject and spectator. Each of these actors possesses an agency and as such can be implicated in a new politics of photography. The intention here is to move away from the notion of photographer as artist or author capturing or framing the figure of the 'victim', offering them up for passive consumption by a spectator who views the photograph from a position of relative privilege and security. Instead, Azoulay asks how the photograph might evoke a collective citizenship shared by each actor, by precisely 'deterritorializing' citizenship to produce a citizenship that transcends or extends beyond the limits of citizenship imposed and denied by individual nation states. She defines this as the 'civil contract of photography'. The notion of the contract, Azoulay claims, enables her to think about how photography can function beyond the production and circulation of images which produce subjects as 'victims' and in

doing so incite 'guilt' and 'compassion', but continues to maintain the existing political structures which produce such suffering (2008: 88). Her particular focus is on the ways in which photography might be used to restore or repair citizenship denied to Palestinians living under the Israeli occupation. She contends: 'As long as photographs exist […] we can see in them and through them the way in which such a contract also enables the injured parties to present their grievances, in person or through others, now or in the future' (Azoulay, 2008: 86).

I wonder how the photograph of the window frame at Les Milles might also enact a form of civil contract which restores the citizenship of the women, both those who jumped and those who were deported. Of course, this is not via their physical presence in the photographic image but precisely in the absence of an image. What can the absence of the image of these women tell us? How might the photograph of the suicide window constitute an attempt to produce this image of absence as an attempt to present 'their grievances' *in the future*? Thus, this occurs not by looking at photographs of victims or survivors but instead by producing a photo that repositions them behind the camera as an attempt to reconstruct their gaze somehow. The image of the view from the window is an attempt to reconstruct the gaze of those who jumped. This is clearly anachronistic given the very different way in which cameras and screens have come to mediate our view of the world. But to do so would be one way to affirm the democratic dimension of photography asserted by Azoulay.

Inherent in such an affirmation is an uncoupling of the notion of photography as predicated on a series of technological 'inventions' belonging to a few individuals, focusing instead on the different sets of relationships that photography invites (Azoulay, 2008: 92). It is via this admittedly anachronistic attempt to reconstruct the gaze that the indices, the different objects, frames, backgrounds which compose our snapshots demand interrogation. Not only in terms of what these would have meant. After all, we can only speculate or try to imagine. We should also question what these things should mean to us now in the opening decades of a new century which like the twentieth may continue to be defined in terms of its systemic use of camps and other forms of confinement. The photograph of the suicide window is an attempt to capture the lost or missing image of what Azoulay refers to as 'existence on the verge of catastrophe' (2008: 47).

In marking the moment before the catastrophe, the photograph of the window and its view also marks a moment when a decision was made.

The decision to jump or, in the case of other women, the decision not to jump. To think of this in terms of a decision is the starting point in the process of restoring the citizenship that was denied or rescinded by the French authorities in the summer of 1942. In seeking to reposition the women at the window as actors and not merely as invisible victims, the next chapter will consider how the memorial museum at Les Milles is underpinned by the notion of universal rights of man, affirmed in Azoulay's notion of citizenship, at the same time as this concept of citizenship is held hostage by an exclusionary, homogenizing interpretation of universality at the heart of the French nation state.

### Threshold

At the end of this chapter, we arrive at a threshold between the positing of the photograph of the window frame and the close reading of the indices that mark the view it encloses which will take place across subsequent chapters. The window is of course itself a threshold that marks the inside and outside of the museum space but also the limit between life and death. As such it is a threshold we cannot cross. It belongs to a series of thresholds that define the experience of internment and deportation across Europe under the Nazi regime. We will return to this concept of the threshold in Chapter 3, when we consider the role of the 'Wagon du souvenir' and return our focus to the story of the women who jumped.

The window at Les Milles is disconcertingly reminiscent of the travelling shot taken from inside the guard's tower in Alain Resnais's *Nuit et brouillard* (1955). The camera takes us to the window through which we see a piercing blue sky before taking us outside. Via the camera, the viewer assumes the gaze of the guard. To assume this view, to be invited to survey the overgrown remnants of the camp below, we are also invited to recognize our survival, our complicity, our role as victors of history. Even in 1955, Auschwitz and other sites had already become tourist destinations, and scriptwriter Jean Cayrol's dry references to the picturesque postcard images of the extermination chamber implicates the film's viewers as much as it does those who made the journey to see the site first-hand. The movement of the camera through the window in the guard's tower is mapped onto the movement between archival and present-day images of the camps. The window as a trope reappears in the footage of the *kapo*'s room and the image of

the officer's house with its central feature window flanked by two small pillars. The position of power and therefore responsibility we are invited to assume is confronted with the fixed, prolonged gaze in the eyes of the dead and the uncomprehending stares of the survivors.

The view from the suicide window extends this call to account to incorporate a more forcible acknowledgement of the French camp network than Resnais was able to achieve due to censorship issues. The position of power that a second-storey window seems to offer in terms of surveillance and security is subverted by the window's own history. Even if this window and its view are reconstructions. Where Resnais's film provided a sharp commentary on Algeria which circumvented the limits of French censorship (see, for example, Debarati, 2011), the window at Les Milles perhaps offers its own critique of the space within the museum. The missing images and testimonies of the women who jumped draw our attention to the missing images and testimonies of those detained and incarcerated in France and across Europe today. To photograph the window frame is also to challenge the notion of the photograph displayed inside the museum, turning this inside out and placing the museum, but museum as frame or threshold *not* as object, inside the photograph.

This chapter has largely focused on the strategies for interpretation and framing found in atrocity and Holocaust museums worldwide as these have been developed within the specific multilayered exhibition space at Les Milles. In doing so, the possibilities for visitor understanding and engagement through photography as a conduit rather than impediment to secondary witnessing have been explored. In the next chapter, the discussion will shift to the more specific national context of France, considering the memorial stakes at Les Milles alongside those found at other sites across the country. What role does the Tricolore play in framing narratives around occupation, deportation, resistance and hospitality presented at these sites?

CHAPTER TWO

# Tricolore

From the marked distance between the window and the wagon next to which it hangs, the Tricolore is but a fleck. Its pole is dwarfed by a lamppost in the foreground. Yet there is no mistaking it. Even when a lack of wind leaves it hanging limp, its three colours remain visible – red, white and blue. There is much to grasp in its symbolism – both that of the Tricolore and its positioning next to the wagon. It would be easy enough to limit this symbolism to an acknowledgement of the acts – deportation and others – perpetuated by the Nazi and Vichy regimes and the incorporation of this acknowledgement into official state discourse led by Chirac in the 1990s. All that can be grasped in the flourish of an official signature. But there is more at stake here. It seems to me that the Tricolore might lead us to more complex discussions of the way collective memory is mediated through official discourse and the other symbols and myths this incorporates.

In this chapter, the presence of the Tricolore across France's memorial landscape will be explored in order to better understand the specific role of the nation, its symbols and myths at Les Milles. Other memorial museums including the Musée de la Paix in Caen and the Mémorial de l'internement et de la déportation at Compiègne will be discussed not simply in terms of their use of the Tricolore and other flags but in their representation of national and nationalist identity both during the Second World War and today. Other material supports such as the ribbon and the blanket will be added to the flag in order to consider how discourses of hospitality are presented in the museum together with the longer-term implications of these discourses. The paradox of the museum's call to hospitality in a context of increased securitization and targeted suspicion and hostility towards certain groups and individuals will be unpacked via close reading of museum text and statements made by the museum's founder Alain Chouraqui alongside

key commemorative speeches given by Jacques Chirac and François Hollande during their presidencies.

## Flagpole

We expect to see flags at war memorials. They remind us who won, who was set free and, most important, who gets to tell the story of what happened. Yet, with the increased focus on the atrocities, not glories, of war emerging via the inauguration of sites such as Les Milles, it becomes increasingly difficult to believe anyone actually won the Second World War. The number 50,000,000 representing the dead etched in large white letters into the wall inside the Musée de la Paix in Caen suggests as much. The rows of flags outside the museum resemble a United Nations in miniature. This collective commitment to peace is reinforced by the famous bronze sculpture by Swedish artist Carl Fredrik Reuterswärd of a Colt Python .357 magnum revolver tied in a knot. The sculpture is called *Non-Violence*. But such a commitment to peace is really nothing more than a thinly veiled commitment to securitization. The sculpture is far smaller in real life than it looks online. As I sat outside the Musée de la Paix on a crisp sunny day in April 2017, it occurred to me that there was probably more metal in the actual firepower carried by the eight armed guards on patrol. Carved into the sandstone façade of the museum building in capital letters is the following inscription by Normandy poet Paul Dorey:

LA DOULEUR M'A BRISÉE, LA FRATERNITÉ M'A RELEVÉE
DE MA BLESSURE JAILLIT UN FLEUVE DE LIBERTÉ.

[Pain broke me, brotherhood lifted me up
From my wound sprang a river of freedom]

The bloodshed of a single soldier is posited as expiation of the 50,000,000 faceless, nameless dead. A testament to the glory of war. In identifying the international identity of the museum at Caen, Sophie Wahnich describes how the local context is removed. This is despite the museum being located at the site of a former Nazi bunker. War is presented as a global phenomenon: 'The circuit on war that the museum offers is implacable, and one could almost say teleological, in the way it is entirely focused on the victory of the great alliance, D Day, and the Normandy landings' (Wahnich, 2008: 216).

I mention this as a preface to an analysis of the Tricolore at Les Milles because of both the continuity and discontinuity between the memorial at Caen and the memorial at Les Milles. The affirmation of Western democracy and its war machine, refracted into the respective narratives, iconography and memorial gardens of the US, Canadian and British allies that define Caen demands the telling of a different, more difficult story at Les Milles and other sites. Culminating in the Normandy landings, the story at Caen is one of salvation and freedom. At Les Milles, the story which ends with suicide and deportation is one of failure and betrayal. Yet the largely unspoken, unarticulated stakes of the increasing number of camp memorials in France – Drancy, Compiègne, Rivesaltes – is the same affirmation of Western democracy and the military and security forces underpinning its ideology of freedom. The complex task at work at Les Milles, for example, is how to find a way to narrate the camp that rehabilitates French national identity within its narrative while insisting on a positive reading of French exceptionalism. In other words, how can a memorial museum displace the guilt of complicity and the shame of surrender without simply reproducing a debt of gratitude to France's allied liberators? The ambiguous role of the Tricolore in such a task of remembering is of paramount importance here.

In early 2017, I came across two recent publications dealing with the theme of the flag: journalist Tim Marshall's *Worth Dying For* (2016) and Bernard Richard's *Petite histoire du drapeau français* (2016). Both constitute populist forays into vexillology, and both are rather too keen to champion the romanticism of the flag's symbolic power. This is despite acknowledging that such power must be situated within a wider context of social and political unrest and hence violence. Marshall points out that 'Much of the symbolism in flag design is based on the concept of conflict and opposition – as seen in the common theme of red for the blood of the people' (2016: 6). He goes on to suggest that national flags function as 'ideological anchors' that enable citizens of a country to ground and make sense of their experience during a time of upheaval (8). Focusing on the Tricolore, Richard argues along similar lines that the French flag has lost its symbolic power precisely because France has enjoyed an extended period of relative peace since the Second World War (2016: LOC 722). He cites Pierre Nora's 2007 interview in *Le Monde* in which Nora claims that French national identity is heavily bound up in the idea of war. The presence of the Tricolore at national monuments and other state institutions including (since 2012) schools is not generally considered to evoke or demand a patriotic response.

Instead, this presence seems to be taken for granted alongside the 'fiscal branding' introduced in 2000 under Chirac, which saw the introduction of a single state logo that incorporated the outline of Marianne into the white of the Tricolore (Benoit and Scale, 2008: 152–55).

Of particular relevance, however, is an ongoing association of the Tricolore as ceremonial centrepiece with the political spectacles via which Philippe Pétain performed his leadership. The position of the Tricolore next to the Wagon of Remembrance cannot but evoke this image. The overstated role of the Tricolore within the Vichy regime has come to be considered an act of bad faith through which an illegitimate government sought legitimation through endless performance of ceremonies and production, circulation and display of insignia, printed propaganda and statues of the Maréchal.

At the Camp de Royalieu memorial in Compiègne, a two-minute film of Pétain's visit to Aix-en-Provence on 23 July 1941 is shown as part of the museum's extensive use of archival video footage. The streets are lined with flag-waving crowds including families with small children. The film works alongside other similar shorts and is presented as part of a critical display on Pétain's propaganda machine.[1] This footage is notably absent from the exhibition at Les Milles in its direct reference to the local context of the camp (although Pétain does not seem to have visited Les Milles).[2] The curation of film footage at Les Milles is very different and arguably more carefully controlled (as discussed in the previous chapter). Moreover, the footage of the visit provides incontestable evidence of widespread local support for the Vichy regime, something the exhibition at Les Milles chooses to downplay in favour of a narrative focused on resistance and hospitality. Its own display dedicated to Vichy propaganda is limited to generic posters leaving the specific local effectiveness of their message unqualified.

On assuming power in 1945, Charles de Gaulle is claimed to have refused to appear on the balcony of the Palais d'Élysée, a public gesture that usually marks the inauguration of a new government. Such a move in continuity with political tradition would have implied the Vichy government was a legitimate regime (Sherman, 2011: 237). Although

---

[1] On the use of cinematography to showcase Pétain's travels around Vichy France, see also the documentary *Les voyages du Maréchal*, directed by Christian Delage (1990).

[2] In addition to his visit to Aix on 23 July, Pétain visited Marseille on 3 and 4 December 1941 (ADBR 76 W 177).

Free France had responded to Vichy's use of the Franciscan axe in the white centre stripe of the flag with a double cross, the Croix de Lorraine, de Gaulle and his new government were nevertheless acutely aware of the extent to which Pétain had damaged the visual iconography of the French flag and its role in political ceremony. In refusing the ceremonial in this instance, de Gaulle effectively produced a double rupture with Vichy and its attachment to ceremony thus enabling the subsequent return to political tradition, and its symbols and ceremonies, momentarily interrupted by war.

The presence of the Tricolore next to the Wagon of Remembrance is disconcerting not simply in its evocation of the flag ceremonies held at similar sites during the Vichy regime. Archive photographs displayed inside the museum at Les Milles indicate that there was a flagpole flying the Tricolore located next to the camp throughout its operation, reminding us of the unspoken link between the internment camps set up by the Third Republic and the French prisons and detention centres bearing the Tricolore outside their gates today. Nevertheless, its present-day incarnation at Les Milles next to the cattle truck is intended in part to purge Pétain's version of the flag. The memorial project at Les Milles and other sites associated with the persecution of the Jews in France has been integrated into the French Republican tradition of commemoration even as the notion of 'memory' remains problematic. As Sherman explains:

> Commemoration seeks to reinforce the solidarity of a community by fixing a common version of events that have in some way disrupted it. The challenge and dilemma of republican commemoration lies in the fact that the Republic's claim on the community, the French nation, has long been contested, and the events it tried to stabilize included those that repeatedly created and destroyed it. If commemoration thus has difficulty representing the Republic as its object, a republican *type* of public commemoration gradually developed, emphasizing public participation, pedagogy, and the values of secularism, progress, and the ideals of the Republic's motto. (2011: 324)

Indeed, the permanent flag found at memorial sites including Les Milles is often supplemented with vintage flags bearing the Croix de Lorraine during commemorative events. I came across a couple of these banners in the chapel at Compiègne. The rich embroidery on the heavy material offered a stark contrast to the simplicity of the unmarked flag lightly fluttering in the wind at Les Milles. Yet the presence of such flags emphasizes rather than avoids a suggestion of historical continuity between the present day and the time of the camp. However, it is an

emphasis that focuses on the possibility of resistance symbolized by the Croix de Lorraine in contrast to the Franciscan axe appropriated by Vichy.[3] This focus on resistance is key to many of the memorial projects, monuments and exhibitions, existing in France and, in the case of those dedicated to the victims of French complicity with the Nazi regime, it functions as an antidote to the silence and paralysis of guilt and shame. Consequently, it is possible to notice a privileging of the narrative of resistance over and against the suffering and death of those interned and subsequently deported from camps across both the unoccupied and occupied zones of France. A common trope in commemoration speeches and plaques is the swift movement from a call to reflect on the atrocities inflicted (often the direct implications of France's deportation of the Jews is glossed over or rendered as euphemism) to a celebration of those who risked their lives to help Jews hide and escape.

In March 1992, three years before Jacques Chirac's election to the presidency and his watershed speech at the Vél d'Hiv, an exhibition organized by the Mémorial de la Shoah/CDJC was held at the Mairie de Paris entitled 'Le Temps des rafles' dealing with the round-ups of Jews across France. Chirac provided a preface which anticipated his later speech in its acknowledgement of French complicity in the round-ups and deportations. Certain parts of the text were reproduced word for word at the Vél d'Hiv ceremony in 1995, such as its reference to Pharaoh:

> La 'Thora' fait à chacun devoir de se souvenir. Une phrase revient toujours: 'N'oublie jamais que tu as été un étranger et un esclave en terre de Pharaon'. Cinquante ans après, fidèle à sa loi, la Communauté juive se souvient et témoigne. (Chirac, 1992: 3–4)
>
> [According to the Torah, each and every one of us bears the duty to remember. A phrase continues to reoccur: 'Never forget that you were a stranger and a slave in Pharoah's land'. Fifty years on, faithful to its law, the Jewish community remembers and bears witness]

In this earlier text it is also possible to track the movement from the memory of those deported to a celebration of those who fought for the Resistance. The vague reference to the thousands of anonymous fighters enacts an elision from the specific acknowledgement of Jewish

---

3  Where the Franciscan axe or Francesca evokes the medieval French weapon, the double-bladed axe used in Vichy insignia was made to resemble the Roman fasces, which at that point had come to be associated with fascist political movements in Europe, especially in Italy.

combatants to a more generalized community of resistance, giving this latter group the final word:

> Paris, qui n'a pas oublié, accueille aujourd'hui 'Le Temps des Rafles'. Cette grande exposition, conçue et réalisée par le Centre de Documentation Juive Contemporaine, retrace les journées terribles: la peur, la douleur de perdre des êtres chers et, à la fin, l'agonie derrière les miradors et les barbelés. L'héroïsme aussi, encore mal connu, des combattants juifs dans la Résistance.
>
> Le courage, enfin, de ces milliers d'hommes et de femmes, anonymes, qui aidèrent, au péril de leur vie, les Juifs de France à échapper à leurs bourreaux. (Chirac, 1992: 4)

> [Paris, which has not forgotten, today welcomes 'The Time of the Round-Ups'. This large exhibition, conceptualized and curated by the Centre for Contemporary Jewish Documentation, retraces terrible days: the fear, the pain of losing loved ones and, at the end, the agony behind watchtowers and barbed wire. The heroism too, still little-known, of Jewish resistance fighters. The ultimate courage of these thousands of anonymous men and women who risked their lives to help French Jews escape being sentenced to death]

Missing from this text specifically focused on the memory work of the CDJC is the hyperbole of the 1995 speech intended for a national audience, through which the shame over past events is emphasized via the reactivation of French nationalist myths of universal human rights, tolerance and asylum:

> Certes, il y a les erreurs commises, il y a les fautes, il y a une faute collective. Mais il y a aussi la France, une certaine idée de la France, droite, généreuse, fidèle à ses traditions, à son génie. Cette France n'a jamais été à Vichy. Elle n'est plus, et depuis longtemps, à Paris. Elle est dans les sables libyens et partout où se battent des Français libres. Elle est à Londres, incarnée par le Général de Gaulle. Elle est présente, une et indivisible, dans le cœur de ces Français, ces 'Justes parmi les nations' qui, au plus noir de la tourmente, en sauvant au péril de leur vie, comme l'écrit Serge Klarsfeld, les trois-quarts de la communauté juive résidant en France, ont donné vie à ce qu'elle a de meilleur. Les valeurs humanistes, les valeurs de liberté, de justice, de tolérance qui fondent l'identité française et nous obligent pour l'avenir. (Chirac, 1995 reproduced in Guerrier, 2014)

> [Certainly, mistakes were made, and wrongs were committed, a collective wrongdoing. But there is also France, a certain idea of France as right, generous, faithful to her traditions, to her ingenuity. This France was

never Vichy. For a long while, she cannot be located in Paris either. She is in the sands of Libya and everywhere that free French are fighting. She is in London, embodied in the figure of General de Gaulle. She is present, whole and indivisible, in the hearts of those French, the 'righteous among nations' who, in the darkest of hours, risked their lives to save, as Serge Klarsfeld has written, three-quarters of the Jewish community residing in France, and in doing so brought out the best in France. The humanist values, the values of freedom, justice and tolerance that form the basis of French identity and call us to account for the future]

If you approach the Camp des Milles memorial on foot rather than by car, perhaps getting off the bus at the stop marked 'Gare des Milles', besides the brown heritage road signs there is a small plaque. The plaque is located at the site's perimeter just after you cross the railway tracks and reads as follows:

> Dans ce bâtiment ont été internées entre 1939 et 1942 plus de 10 000 personnes, dans des conditions de plus en plus dures. Réfugiées en France, la plupart fuyaient le totalitarisme, le fanatisme et les persécutions en Europe.
> 
> L'histoire du Camp des Milles témoigne de l'engrenage des intolérances successives, xénophobe, idéologue et antisémite, qui conduisit à la déportation de plus de 2 500 hommes, femmes et enfants depuis Les Milles vers le camp d'Auschwitz, via Drancy ou Rivesaltes.
> 
> Ils faisaient partie des 11 000 juifs de la zone libre qui, avant même l'occupation de cette zone, ont été livrés aux nazis par le gouvernement de Vichy, puis exterminés dans le cadre de la 'solution finale'.
> 
> Face au racisme, à la lâcheté et à l'indifférence, des résistants, aux Milles comme ailleurs, sauvèrent l'honneur de la France et de l'Humanité.
> 
> Les victimes espéraient que l'on se souvienne; afin d'éclairer notre vigilance, aujourd'hui et demain.

[Between 1939 and 1942 more than 10,000 people were interned in this building, where they were subject to increasingly difficult conditions. Having sought refuge in France, many were fleeing the totalitarianism, fanaticism and persecution occurring across Europe.

The story of Camp des Milles bears witness to the escalation of ongoing intolerance, antisemitic and political xenophobia which led to the deportation of more than 2,500 men, women and children from the Camp des Milles to Auschwitz via Drancy or Rivesaltes.

They made up part of the 11,000 Jews from the 'free zone' who, even before the occupation of this zone, had been delivered up to the Nazis by the Vichy government before being exterminated as part of the 'Final Solution'.

In the face of racism, cowardice and indifference, there were those at Les Milles, as elsewhere, who resisted and in doing so saved the honour of France and that of humanity.

The victims hoped they would be remembered to inform our vigilance both today and tomorrow]

This statement is followed by a quotation from Paul Éluard: 'Si l'écho de leur voix faiblit, nous périrons' [If the echo of their voices fades, we will perish]. Again, the call at the end of the plaque to actively remember and prevent similar atrocities from happening again, reinforced by Éluard's quote, is posited within a context of national honour and not national shame. This occurs despite the direct acknowledgement that the government acted of its own initiative in sending Jews to their deaths at Auschwitz. The plaque thus sets up an uncomfortable disjunction between its careful exposition of the mass suffering and deportations experienced at Les Milles and its vague references to the resistance that provide an expedient redemption not only of France but humanity in general. This is not a case of poor wording, nor does it arise out of the awkward task of drawing public attention to a site of atrocity. The privileging of 'resistance' is fundamental to the ideology of the memorial site at Les Milles. It is precisely as a vague, unsubstantiated concept directed as much at present-day visitors that 'resistance' is intended to be understood. Since the late 1990s, the general concept of resistance found at memorial sites in France has been supplemented with a more focused presentation of 'righteous acts' and the commemoration of the 'Righteous amongst Nations' awarded by Yad Vashem since 1963 (Gensburger, 2012). At Les Milles, the two narratives coexist. A 'wall of righteous acts' features at the end of the permanent exhibition and, as will be discussed in Chapter 4, a series of panels on the 'righteous' have more recently been added to the Chemin des déportés. The commemoration of 'righteous acts' officially endorsed by Yad Vashem and the Israeli government directs understanding of 'resistance' as the specific act of helping Jews escape the Nazi and Vichy regimes and works alongside a vaguer idea of 'resistance' which, as this chapter will argue, is co-opted to a discourse of national security.

Continuing towards the memorial entrance from the plaque, the first flag you might come across is not necessarily the one located next to the Wagon of Remembrance as viewed from the suicide window. There is another Tricolore (just as there is also another wagon located behind the factory) positioned next to the factory gates at the end of a short grey concrete wall bearing the sign SITE-MÉMORIAL DU CAMP DES

MILLES. In case the nineteenth-century red-brick structure confused us, the grey, new brutalism of the wall and its lettering make it clear that we are visiting a memorial to the Holocaust. Here it might be easy to dismiss the flag as of little consequence beyond delineating our arrival at a national monument. It certainly does not form part of a *mise-en-scène* set up for us to discover. Yet when I revisited Les Milles in 2017, a recently added sign on the window to the security hut (where individuals enter one at a time and have their belongings scanned by an X-ray machine) demands that we also pay attention to this second flag and its positioning outside the entrance gate. The sign reads: 'Dans ce lieu, les mesures de sécurité témoignent que l'antisémitisme et les racismes frappent encore. Votre visite est un acte de résistance face aux extrémismes identitaires qui nous menacent tous' [At this site, security measures bear witness to ongoing racism and antisemitism. Your visit is an act of resistance against the extremism that threatens us all].

The securitization of sites such as the Shoah memorial in Paris existed long before the widespread bag checks imposed throughout France and especially the capital since the attacks in Paris and Nice in 2015 and 2016, respectively.[4] While refusing to live in fear of future attacks posed by extremists might indeed be the only possible way to respond, it is unclear that visiting a museum constitutes an act of resistance any more than any other public activity. More concerning here is the deliberate conflation of such an act with the genuine acts of resistance celebrated inside the museum. An act of resistance can in this context come to mean anything, everything and thus nothing. This conflation also allows further deliberate confusion about exactly what one is resisting. This in turn enables one to forget that at one point this meant resistance against the French state under the Vichy government. The embodied experience of passing through security including the, albeit momentary, anxiety of being placed under suspicion and having one's possessions scrutinized comes to be co-opted into the larger museum encounter. Resistance becomes an act akin to cooperating in the name of national security.

---

4  On 13 November 2015 a series of coordinated terrorist attacks took place across Paris using explosives and assault rifles. A state of emergency was declared by François Hollande. A hundred and thirty civilians and seven of the attackers were killed. On 14 July 2016, a truck drove into crowds celebrating Bastille Day on the Promenade des Anglais in Nice; 87 people including the perpetrator died.

## Myths

On 8 October 2015, a few weeks before the Paris attacks, then French president François Hollande made a visit to Les Milles. This was the first time a French head of state had visited the site and the occasion was considered a key moment in French national memory akin to Jacques Chirac's Vél d'Hiv speech in 1995 (Bretton, 2015). In his speech Hollande referred to Camp des Milles as the 'Vél d'Hiv du Sud'. Hollande had already been compared to Chirac due to his prolific 'memory work' during the first six months of his presidency.[5] In addition to a ceremony in July 2012 marking the 70-year anniversary of the round-up at the Vélodrome d'Hiver, Hollande was the first French president to publicly acknowledge the massacre of Algerians demonstrating for independence by French police on 17 October 1961, having attended the 50-year commemoration ceremony as Socialist Party presidential candidate the previous autumn.[6]

The ceremony at Les Milles also marked the naming of the memorial as the new UNESCO Chair for Education for Citizenship, Human Sciences and Shared Memories. In anticipation of Hollande's visit, the memorial's director, Alain Chouraqui, gave an interview with *Le Nouvel Observateur* (now *L'Obs*). He was asked, notably, about the connections that might be made between the operation of the camp and the plight of refugees in Europe today. His response went as follows:

> Il nous paraît à la fois délicat de faire des amalgames et impossible de ne pas pointer des éléments de rapprochements assez forts. Ce dont nous sommes fiers dans le passé, ce sont toujours des 'actes justes' de quelques-uns, pour écouter, aider, soutenir ceux qui en avaient besoin, des actes dictés par leur conscience morale quelles que soient les bonnes raisons de ne rien faire. Dans l'Histoire, nous ne nous souvenons jamais de ceux qui ont fermé leur porte, se sont repliés, calfeutrés. Espérons que l'expérience

---

5   Reporting in *L'Obs* paid particular attention to Hollande as heir to Chirac's legacy. Where Sarkozy refused to follow in Chirac's wake due to the clear risk of direct comparison, the reimposition of silence produced an opportunity for Hollande, for whom the comparison no doubt worked favourably. See Salor (2012) and Salor and Bertrand (2012).

6   While the total death toll is still not known and estimated as up to 300 deaths (with a more conservative consensus being 50–150), in 1998 the French authorities finally officially acknowledged 40 deaths, having originally claimed that only three people died as a result of self-defence by police.

de ce passé permettra à nos actions présentes de ne pas faire rougir demain nos enfants. (quoted in Dély, 2015)

[It seems both problematic to conflate them and yet impossible not to acknowledge some fairly strong points of convergence. What we are proud of about the past is that there have always been 'righteous acts' by some who have listened, helped and supported those in need, acts determined by moral conscience regardless of compelling reasons to do nothing. History never remembers those who shut their doors, withdrawing into the comfort of their own homes. Let us hope that the experience of this past will prevent our present actions from causing our children shame tomorrow]

Although Chouraqui has provided more complex arguments elsewhere (see, for example, Chouraqui, 2016), within the context of Hollande's visit he cleverly evades a political response. In other words, the moment when the world (or at the very least the French national press) was paying attention, Chouraqui refuses to pass judgement on the systems and structures in place throughout Europe. It is because of these systems that we continue to see (when indeed we do see) refugees dying *en route* to Europe, languishing in camps and detention centres or returned to countries where their safety cannot be assured. Instead, he adopts the same narrative found throughout the memorial – that of the individual who objects, refuses or resists, whose individual acts of charity and kindness are remembered over and against mass oppression, complicity and ignorance.

What emerges in Chouraqui's response is the tension between an obscene nostalgia for the conditions of possibility that enabled resistance against the Nazi and Vichy regimes and an acknowledgement of the ongoing policing of 'hospitality' by the French state. This is a policing which is twofold. On the one hand, it involves policing the idea of hospitality as integral to French national identity, something transmitted most forcibly in Chirac's Vél d'Hiv speech. On the other hand, it constitutes policing *tout court* in the form of sanctions against those who are found to have 'helped' illegal immigrants, the *sans-papiers*.

There is also a marked shift in Chouraqui's presentation of the memorial site which coincides with the changing stakes of the memorial project at Les Milles. Chouraqui had been involved in the project alongside his father Sidney Chouraqui since the early 1980s. At a speech inaugurating the Wagon du souvenir and the Chemin des déportés on 9 November 1992, a moment when the French population was just starting to recognize the need to 'remember', Chouraqui neatly dismisses the double-edged

myth of resistance and complicity: 'notre mémoire nationale ne tombe heureusement plus dans le mythe de la France toute entière résistante, ni dans celui, aussi infondé, de français qui seraient collectivement complices de tous les crimes de la collaboration' (MdS MDXVIII-36) [Our national memory fortunately no longer wallows in the myth of a France united in its resistance, nor of the equally unfounded myth of a French population collectively complicit in all the crimes of collaboration].

The enormous project of remembering not just the deportations but also the wider history of Les Milles within the camp system inaugurated by the Third Republic in 1939 was, at that point, dependent on moving beyond such myths and the silences they produced. Yet, interestingly, the passage of another 20 years has allowed for the crystallization rather than the disappearance of the myth of resistance that continues to frame the memorial discourse. Alongside the specific references to the 'Righteous among the Nations', this increasingly occurs now as an abstract ideal rather than concrete history.

Throughout the tour of Camp des Milles, the visitor is presented as individual agent with the power and responsibility to resist and speak up against collective acts of racism, oppression and ultimately genocide. The call to individual agency is supplemented by a panel emphasizing international and national laws against racism and hate crimes. Bearing the header 'La force du droit contre le droit du plus fort' [the force of the law/what is right against the law/rights of the strongest], the panel creates a deliberate elision between 'right' (conceived as human rights, being ethically right) and 'law' via the French term 'droit' suggesting, somewhat erroneously that the two forms of 'droit' support one another. The irony of such claims will be explored further in Chapter 5, where France's response to Surinamese refugees fleeing the Interior war during the late 1980s will be discussed.

As was discussed at length in the previous chapter, the memorial is an intensely visual space that includes the display of multiple artworks produced within the camp. In themselves these representations might be held up as examples of 'creative' resistance to both the space itself and the wider context of the Holocaust. Yet, as I argued in the Introduction, this overlooks both the multiple and complex functions of the camp (since most artwork was produced during its operation as an internment camp under the Third Republic). It also ignores the different ways in which creative work undertaken in the camp by established artists and intellectuals challenge the notion of the camp as exceptional site where existing forms of economy are suspended.

Lion Feuchtwanger's autobiography recounts how he was faithfully followed and served by a young Austrian, Karl N., who appointed himself as Feuchtwanger's 'valet' (1941: 27). At a later point he acquires a second servant, benefitting from the food they both cleverly source for him while he struggles to find enough work for them to do in his service (63–64). Such anecdotes demonstrate the duplication of the class system within Les Milles. Despite Feuchtwanger's claims that these men practically begged to be in his service, he cannot extricate himself from the implication that his own intellectual and creative output largely resulted in self-preservation rather than collective resistance or meaningful self-sacrifice for the benefit of others. Thus, while the representation of the camp by such artists offers us a posthumous critical and imaginative commentary, we might question whether it can also be defined as a form of direct resistance. The subsequent repositioning of these artworks and narratives within the memorial space risks a form of recuperation that romanticizes the camp as a site of creative production.

Despite this affirmation of creativity amongst internees, within the space of the memorial exhibition, the dominant image of resistance comes from elsewhere – the iconic image of a solitary man, arms firmly folded, refusing to join his comrades in giving the Nazi salute. This image of a German, generally thought to be August Landmesser, taken during a 1936 rally in Hamburg, appears at various points throughout the exhibition and is featured on its postcards, guidebooks and website alongside a call to resist. In the final, 'Reflective' zone of the memorial tour, it is enlarged to take up an entire wall. Removed from its original context and reframed with text in French, 'Chacun peut resister, chacun à sa manière' [Each one of us can resist, each in our own way], the image becomes emptied of its original signifying force. Landmesser's own story, his membership of the Nazi party and subsequent desire to marry a Jewish woman followed by his later separation from her and their children, is filtered out.[7] The image is transplanted to the French context of the Camp des Milles and used to transmit an abstract educational message of resistance.

The decontextualization and depoliticization of the image of Landmesser calls to mind the image of the young African soldier on the

---

7   The man in the photo has also been identified as Gustav Wegert who, like Landmesser, was also employed at the Blohm+Voss shipyard. Wegert was a Christian who refused to salute on religious grounds.

cover of *Paris Match* discussed by Roland Barthes in his 1957 essay 'Le mythe aujourd'hui':

> And here is now another example: I am at the barber's, and a copy of *Paris-Match* is offered to me. On the cover, a young Negro in a French uniform is saluting, with his eyes uplifted, probably fixed on a fold of the tricolour. All this is the meaning of the picture. But, whether naively or not, I see very well what it signifies to me: that France is a great Empire, that all her sons, without any colour discrimination, faithfully serve under her flag, and that there is no better answer to the detractors of an alleged colonialism than the zeal shown by this Negro in serving his so-called oppressors. I am therefore again faced with a greater semiological system: there is a signifier, itself already formed with a previous system (a black soldier is giving the French salute); there is a signified (it is here a purposeful mixture of Frenchness and militariness); finally, there is a presence of the signified through the signifier. (1972: 115)

In the case of Camp des Milles and its use of Landmesser's image, the underlying myth is one that links an abstracted national identity with the idea of individual responsibility and resistance. Like the young black soldier, the image of Landmesser is one in which meaning (the complex and precise circumstances of an individual life) is suppressed or impoverished by the form (the reduction of an individual – Landmesser or the soldier – to a generic representation). As Barthes bleakly puts it: 'this history that drains out of the form will be wholly absorbed by the concept' (1972: 117). The foregrounding of this decontextualized and visually simplistic image over and above the more complex, often-ambiguous avant-garde representations of the camp itself by artist-detainees, subdues the message that resistance can operate from within such spaces as well as from without.

Alongside this process of abstraction, Chouraqui's additional, deliberate 'depoliticization' of Les Milles is precisely what enables the memorial to serve French state ideology rather than suspending or meaningfully challenging this. By limiting the idea that one can 'resist' one's own oppression, the onus is placed on the host; the one in a position to offer hospitality is the one required to act. But the requirement to act might also be read as an entitlement to act, a privilege that is only extended to some. This in turns denies action to others – or, more precisely, *requires them not to act*. If we read the call to resist in this way, as a form of hospitality, then we can further problematize the notion of resistance presented by the memorial.

## Blanket

In her reading of Jacques Derrida's complex and disparate work on hospitality, Judith Still reminds us that hospitality is a structure 'with no fixed content' (2010: 11). What this means, following Derrida, is that while hospitality is at once based on an unconditional, absolute Law, and at the same time subject to a series of secondary laws, a structure we recognize and understand precisely because of its paradoxes – there is no specific act, object, gesture or utterance that represents hospitality (Derrida, 2000 [1967]: 25ff.). Unconditional hospitality must surely mean being completely open to the other, the guest, offering up what he or she desires, needs, requests, whilst asking nothing in return. It both entails pre-empting such needs and desires but also requires that we make no assumptions about these either. Yet hospitality as subject to various laws including those of convention means that there are inevitably certain acts and objects which function as commonplace markers of hospitality. A cigarette or a cup of coffee. A bowl of soup, some bread. A place by the fire. Markers of hospitality as a response to immediate, basic physical needs. Or if hospitality is about more than that, about exceeding the expectations of one's guest, then the lavish meal, fine wine, white fluffy towels, Egyptian cotton sheets. Hospitality posited here as a form of material luxury. In thinking about these material markers, I arrive at a singular object, the blanket.

As a staple of humanitarian aid, can a blanket also constitute a marker of hospitality? There is the immediate warmth and protection that it offers but it can also represent an invitation to stay, to sleep until morning without being woken by the cold. It can also function as a place to hide from the authorities or provide a cloak with which to disguise oneself. In his memoir, Lipman-Wulf describes how internees clothed themselves in blankets, assuming the age-old figure of the refugee:

> [O]thers had transformed their woolen blankets into covering capes with hoods. No one seemed to belong to a particular historical period; everyone timeless. With the artificial light and reflections of the red-hot burning ovens, one would first believe oneself to be in an asylum of homeless people. A second glance seemed to reveal a strange group of pirates and robbers, or a get together of survivors of a ship-wreck. Those humans did not belong to any specific epoch, but to something greater which transcends the limits of time and space and which is defined rather through the human and inhuman experiences which formulate our beings. Eternal mankind, looking for consolation and salvation from persecution. (1993: 70–71)

In the entrance hall at Les Milles, there is a row of dark brown army blankets neatly folded to form banners like those one might have found hanging in a medieval hall. There are six blankets, each marked in red lettering with a different word: *Liberté, Égalité, Fraternité, Justice, Dignité, Laïcité*. The rallying cry of the French Revolution is supplemented here with three additional terms – Justice, Dignity and Secularism. As the accompanying tract 'Petit manuel de survie démocratique' explains, these terms are all embedded in the French Constitution (Fondation du Camp des Milles, 2016: 47). However, in the museum entrance, the red, white and blue of the Tricolore have been replaced with the neutral brown of the woolen blanket. If the use of the blankets here is intended to limit the symbolism associated with French identity in favour of a universal hospitality extended to all, the six terms unequivocally set out the conditions of that hospitality as positioned within a lexicon of French Republicanism.

It is the last of these terms, *laïcité*, a term with a cultural and political weight that far exceeds its direct English translation as 'secularism', that appears most contentious, not least within a memorial dedicated to victims of religious persecution. Before considering the antisemitism underpinning France's economic and immigration policies from the 1930s onwards, it is first useful to outline the revolutionary origins of the French myth of hospitality that are intertwined with those of the French flag, considering how myth and symbol alike unravelled during the late 1930s and early 1940s before being rehabilitated as 'resistance'. This should make it clearer why the myth of resistance *qua* hospitality can be seemingly appropriated by state discourses even when this appears self-contradictory.

## Ribbon

The first manifestations of the Tricolore appeared in the days immediately following the storming of the Bastille on 14 July 1789 in the form of rosettes. These were inspired by the rosettes of the earlier US revolution and declaration of independence. The colours were flown as separate flags and weren't combined until later. It was around 1810–1812 that a consensus was reached on the direction and order of the stripes, vertical in contradistinction to the Dutch national flag, with blue located next to the flagpole (Richard, 2016: LOC 1136). However, where the specific composition and hues of the flag remained open to interpretation and

confusion, and threatened by replacement in 1830 and again in 1870 first by a white then a red flag, there is a moment early in the Tricolore's history that ties it closely to the question of hospitality to foreign subjects in France. In her painstaking research into the complex and frequently contradictory discourses around hospitality in the immediate aftermath of the revolution and specifically during the Terror, Sophie Wahnich came across a decree from August 1793 requiring all foreign subjects to wear a ribbon bearing the colours of the tricolore marked 'Hospitalité' and carry a certificate attesting to their loyalty to their host country about their person at all times (1997: 23). Wahnich finds no further discussion of the ribbon except a brief summary in *Le Moniteur universel*. In a revised decree of September 1793 it has been dropped as a requirement.

The ribbon, even as a purely imagined symbol, poses important questions about how hospitality as a fundamental tenet of the universal rights of man can so rapidly be transformed into a demand for foreign subjects to 'prove' their loyalty to France, a demand itself underpinned by an assumption of suspicion. Wahnich suggests that the ribbon, once it had been used to articulate the desire for the total representation of foreign subjects, had no need to be enacted. Constant suspicion and uncertainty around the presence and role of all foreign subjects was deemed preferable, perhaps, to total transparency (1997: 25). Suspicion inserts itself into the heart of the revolutionary notion of hospitality. Moreover, beyond the direct actions intended as the consequences of such decrees, a clear message is sent in which the demands of war and security are privileged over the revolutionary logic underpinning the call to war. Without wishing to conflate or flatten two different historical contexts, I cite this early and, arguably, founding example to emphasize the longer history of the Tricolore as material, visual marker of Republican universalism *and* conditional hospitality.

During the 1920s, renewed tension arises between a discourse of hospitality insisted upon during the early years of the interwar period when immigrants were 'invited' to contribute to France's workforce in exchange, ultimately, for naturalization, and an atmosphere of increasing hostility and suspicion which led to a withdrawal of the invitation and a renegotiation of the naturalization process. Anne Grynberg's comprehensive study of France's system of camps situates the emergence of the camp network within the earlier context of increased controls imposed upon immigrant workers which began around 1926 when foreign workers were henceforth required to obtain identity cards allowing them

to work (1999: 23).⁸ Grynberg suggests that throughout the 1920s the French authorities oscillated between two contradictory positions with regard to immigration: 'd'une part une politique généreux et un accueil chaleureux envers les nouveaux arrivants, d'autre part, une administration exigeante et tracassière' (1999: 39) [on the one hand, a generous policy which offered a warm welcome to new arrivals and, on the other, an administration that was demanding and annoying].

At this point the anti-immigrant and, more specifically, antisemitic rhetoric of the right-wing press was linked to the growing economic crisis rather than any imminent threat of war. Conversely, it was the absence of the 'total war' that later came to define the Nazi regime that offered justification to those wanting to refuse entry to Jews and other anti-fascist Germans fleeing the Third Reich. In April 1933, Jean Dobler, secretary to the French ambassador in Cologne, claimed that Jews seeking visas to France were not to be considered refugees and should be subject to strict bank account checks. By 1938 the influx of refugees fleeing other parts of Europe resulted in stricter sanctions for those entering France without the correct documentation. This consisted of a fine of between 100 and 1,000 francs and, in some cases, a prison sentence of between one month and a year. In the case of camp internees, this had increased to up to three years by 1942 (Grynberg, 1999: 33). Those caught helping illegal immigrants were threatened with similar sentences. Hotels housing foreign nationals were expected to declare their presence to the local police, thus instituting a culture of surveillance.

There was widespread public protest against the measures now thought to have impacted on over 20,000 Jews (Weinberg, 1974: 218, cited in Grynberg, 1999: 34). An open letter addressed to Albert Sarraut, Minister of the Interior, was published in *L'Humanité* criticizing the impossible bureaucracy of the measures and condemning the expulsion of foreign citizens as against French ideals. Despite this, the government decided upon an ever-stricter course of action in face of the growing number of refugees. On 12 November 1938 a decree was passed which insisted on a tightening of regulations around naturalization such as via marriage as well as the expulsion of 'undesirables':

> Enfin, s'il fallait strictement réglementer les conditions d'acquisition de la nationalité française, il n'était pas moins indispensable d'assurer

---

8  Grynberg cites the ironic slogan 'Liberté, Égalité ... Carte d'Identité' that circulated amongst Jewish refugees during this period (1999: 39).

l'élimination rigoureuse des indésirables. Sans doute le ministre de l'intérieur a-t-il le droit d'expulser les étrangers résidant en France, ou, s'ils sont dans l'impossibilité de trouver un pays qui les accepte, peut-il leur assigner une résidence dans une localité déterminée, mais il est de ces étrangers qui, en raison de leurs antécédents judiciaires ou de leur activité dangereuse pour la sécurité nationale, ne peuvent, sans péril pour l'ordre public, jouir de cette liberté encore trop grande que leur conserve l'assignation à résidence. Aussi est-il apparu indispensable de diriger cette catégorie d'étrangers vers des centres spéciaux où elle fera l'objet d'une surveillance permanente que justifient leurs infractions répétées aux règles de l'hospitalité. (extract from 'Décret-loi du 12 novembre 1938 relatif à la situation et à la police des étrangers')

[Consequently, if it is necessary to strictly regulate the conditions under which French nationality can be obtained, it is no less indispensable to ensure the rigorous elimination of undesirables. In all probability the Minister of the Interior possesses every right to expel those foreigners residing in France or, in cases where it proves impossible to find a country to accept them, to assign them a residence in a determined locality, but it is those foreigners who, as a result of previous legalities or activities that posed a threat to national security, cannot without risk to public order enjoy the huge freedom afforded to them by being assigned residence. It moreover appears indispensable to direct this category of foreigner to special centres where they will be subject to permanent surveillance justified by their repeated contravention of the rule of hospitality]

The language used here, which already employs the terms 'elimination' and 'expulsion', is chilling. While the term 'internment' is not used, it is here that the need to regulate and monitor foreign nationals is established via their relocation to 'special centres'. The necessity of such action is framed within a discourse of national 'hospitality'. These 'centres spéciaux de rassemblement' [special assembly centres] became officially known as 'centres d'accueil' [welcome centres] or 'centres d'hébergement' [accommodation centres], while the press simply called them what they were, 'camps de concentration'. Grynberg points out that during this period in which the camp system was put in place in France, the government found itself caught between a revolutionary tradition that championed hospitality to those fleeing oppressive regimes and the genuine material and ideological pressures of a Europe on the brink of war (1999: 39). Consequently, the camp system emerged in the interstice of this tension that precluded the possibility of developing a sustainable, long-term 'politics of immigration'.

I cannot help but think Grynberg is being too generous here in her otherwise merciless study of the camps in France. There is an inherent danger in dismissing the ad hoc camp infrastructure set up by the Third Republic as simply poor planning or ridiculing, as Lion Feuchtwanger (1941: 40) does, the *je m'en foutisme* of French bureaucracy which saw Jews and other anti-fascists interned in France between 1939 and 1941 as suspected members of the Fifth Column. There is nothing *laissez-faire* about the increasingly punitive treatment of foreign nationals seeking asylum nor regarding the measures introduced against those who offered them assistance. There is also nothing *laissez-faire* about the increased surveillance and restriction of movement of internees including, by 1942, those hospitalized with TB. Over the past 70 years we have seen these types of measures repeatedly introduced and publicly enforced by successive French governments. The impossible bureaucracy is intended to place individuals, outsiders, into endless feedback loops ensuring their status remains permanently temporary. The permanent guest becomes an unwelcome guest, a guest who has outstayed his or her welcome, and it is via this move that outsiders become constructed as interior enemies requiring constant surveillance and restriction of their movements.

## Folds

The image of the folded flag is usually associated with the official burial of dead military personnel, particularly those who died in action. During the ceremony the flag is neatly and expediently converted into a souvenir that packages up an experience, enacting this so very precisely. There is general acquiescence that the experience is to be rendered inaccessible by this act of folding. The flag becomes a container, a second urn that allows people *not to know what happened*. But folds in the flag produce ambiguities, attesting to dark pockets of history and their concealment. Folds suggest turbulence rather than the flat, smooth legibility of a flag on display. There is a wall in the historical zone at Les Milles that features a selection of images and other propaganda used by the Vichy regime. These include a poster depicting a member of the Resistance holding a revolver and using the Tricolore as a cloak. Standing in the shadows behind the flag is a Russian communist soldier. The slogan reads, 'Ils assassinent! Enveloppés dans les plis de notre drapeau' [They assassinate! Hidden in the folds of our flag]. According to Richard (2016: LOC 676), this was one of the most widely circulated

images of the Vichy regime with thousands of copies of the poster and two million tracts produced. The image suggests that the folds of the flag produce a perverted concept of national identity, evoked by the Resistance to justify their crimes. However, the flag is also represented as providing both cover and shelter. It is through the hospitality of the French population that the Resistance fighter has the freedom and protection to operate. Although the poster belongs to the very specific iconography of Pétain's government, it bears witness to the underlying tension between an imagined tradition of hospitality and the fear that those welcomed inside will abuse this hospitality. In place of the dark, shadowy folds in which internal enemies might conceal themselves, we should substitute the vision of a bright, flattened flag which leaves no place to hide, no ambiguity. Hospitality should be restricted to a ribbon, not extended to a blanket.

During his visit to Les Milles in 2015, Hollande made the following statement: 'La République ne connaît ni race, ni couleur de peau, ni communauté, elle ne reconnaît que des citoyens libres et égaux. Ce principe n'est pas négociable et ne le sera jamais' [The French Republic does not recognize race, skin colour or community, it only recognizes free and equal citizens. The principal is non-negotiable and always will be] (*Le Monde*, 2015). The statement was intended as a riposte to opposition politician Nadine Morano's comment the previous month that 'France is a Judeo-Christian country, of white race'.[9] Yet Hollande bolsters rather than contests Morano's claim here. Despite having just spoken on the need to challenge antisemitism as a specific form of racism, Hollande proceeds to deny the specific challenges faced by certain racial and cultural communities. Instead, he evokes a French society composed of homogeneous, independent individuals unimpeded by social inequality or exclusion. Such citizenship can only ever be imagined as a form of 'whiteness' and even then is only granted to certain members of France's 'white' population.[10] Likewise, the individual interpolated within the space of the Camp des Milles memorial belongs to the same imagined category of white citizen, able to recognize his or her privileged status

---

9 For a detailed account of the debacle following Morano's claim made on France 2 on 26 September 2015, see Lambert (2015).

10 On 'whiteness' see the chapter on 'White Culture' in MacCannell (1992: 121–46). More recent critiques of racism and white privilege include Eddo-Lodge (2018) and, in a specifically French context, Collectif Piment (2020).

as 'free and equal' citizen and the potential for responsibility and 'resistance' enabled by this status.

In the reflective zone, a panel entitled 'La Science contre le racisme' [Science against racism] uses the genetic convergences between people of different ethnic backgrounds to claim that 'for science, races do not exist'. The assumption made here is that science, limited to a particular form of biological research consisting of genetic sequencing, provides incontrovertible evidence against racial difference. Yet such a statement fails to consider the historical role of science in perpetuating racial hierarchies and stereotypes. It also fails to acknowledge the lived experience of racial discrimination and inequality experienced by many of France's non-white citizens. In the documentary *Récits du Camp des Milles* (2015), witness testimony is interspersed with scenes of guided tours around the museum. In one such tour, a group of children aged about seven or eight and from a variety of ethnic backgrounds are asked the following question: 'How many races are there?' Most of the children looked stumped but a couple enthusiastically put up their hands. 'Six?' asks one. 'Two?' asks another. Others have guessed the correct answer and the educator looks pleased, 'That's right', he tells them. 'There is no race, only the human species'. Some of the children look confused. Already at the age of seven, their own everyday experience of race tells them something quite different.[11]

## The Face in the Sand

The museum at Les Milles bears the subtitle 'Musée d'Histoire et des sciences de l'Homme' [Museum of History and Sciences of Man]. As a site claiming to both present and foster research on the history of genocide in the twentieth century with particular emphasis on sociology and other social sciences, the museum is arguably directed towards the future as much as towards the past. This seems to embody the new agenda articulated by Silverman and Pollock in their work on the concentrationary outlined in the previous chapter. However, there is also much in this appellation that evokes the museum as nineteenth-century institution whilst referring back to the Enlightenment ideals

---

11  This position is also assumed in the account of the museum's 'anti-racist' best practices offered by Bernard Mossé (2020), head of scientific and educational content at Camp des Milles.

from which the notion of a 'Science de l'Homme' emerged. There is also an interesting tension between the singular reference to 'History' and the pluralization of 'sciences' (see Chappey, 2006). France's involvement in the Shoah had long been obscured in its official history and the museum's role is fundamental in ensuring this History or *Grande Histoire* now involves a full acknowledgement of the camp network and systematic deportations. Yet there is a risk of dogmatism that creeps in when history is emphasized as a singularity. This is the history of the victors that Benjamin warned against. Chouraqui's claim, cited above, as to who and what is 'remembered' by history also seems to endorse this singular narrative rather than offer a more nuanced idea of history as comprised of multiple perspectives and narratives, the complexity of which are key to understanding deep-rooted racism and exclusion at different moments and places in time.

In its 'volet réflexif' the museum makes extensive use of social sciences or 'sciences humaines' to explain the phenomenon of racism. Such explanations are arguably based on a 'universal' notion of 'man' or 'humankind' rather than via the affirmation of difference. Science, where it refers to social sciences, might be presented as plural as a kind of concession but 'Man' continues to function as Enlightenment philosophical concept. This is apparent in the reference to 'La Science' to refer to biology, as producing incontestable, singular truths about race as discussed above.

In thinking about the museum's use of a universal figure of Man and the idea of a single, human race, I am struck not so much by the immovability of these conceptions or their duration but rather their fragility and hopelessness. I am reminded of Michel Foucault's reference to man as a face drawn in the sand at the end of *The Order of Things* (1966). Why attempt to redraw the exact same face that was washed away by the atrocities of the mid-twentieth century? To cling to the same myths of the universal figure of 'Man' is also to construct the same figure of the 'other' or the 'stranger' who is denied their humanity by not conforming to the universal.

A more radical gesture towards hospitality would perhaps have been, following Françoise Vergès (2010), to name the memorial site at Les Milles a 'maison' rather than a museum. This is a suggestion that might appear contentious, even in bad taste, in relation to a space which 'housed' thousands of internees and that, in 1942, became an antechamber to Auschwitz. Of course, Vergès suggests the move from museum to house within the highly specific context of a proposed (yet

never realized) project that would bring together the multiple cultures, histories and identities comprising contemporary Réunion. But to define something as a house does indeed place the onus on hospitality. Everyone who enters is a guest and must be welcomed as such. To enter is not, therefore, as the sign at security outside Les Milles declares, an act of resistance but something else. A seeking of shelter, on the one hand. And, on the other, an act of welcome.

But, of course, hospitality cannot function as an imperative here. Hospitality cannot be policed. Nor can the parameters of resistance be appropriately defined. As Derrida suggests, hospitality requires an opening towards the stranger *qua* stranger that does not ask his or her name. Hospitality does not require any sort of verification or validation, certainly not of the type demanded of foreign workers in France from 1926 onwards:

> [A]bsolute hospitality requires that I open up my home and that I give not only to the foreigner (provided with a family name, with the social status of being a foreigner, etc.), but to the absolute, unknown, anonymous other, and that I give *place* to them, that I let them come, that I let them arrive, and take place in the place I offer them, without asking of them either reciprocity (entering into a pact) or even their names. (Derrida, 2000 [1967]: 25)

Of course, the paradox, as Derrida points out, is that in not asking for a name, the stranger remains a stranger. He or she cannot become familiar or family. But there are perhaps ways of asking for a name that do not also simultaneously demand the translatability of the name into fixed identities and categories of belonging. To make hospitality an imperative, as is the case within Les Milles, is to impose limits on who can receive that hospitality. This means demanding and translating the name of the stranger into the French language. It means demanding a competence in a language the stranger does not speak or does not speak well as a precondition to hospitality. Derrida often talks of the violence of translation.[12] This violence is perhaps most apparent in France's language of hospitality (Derrida, 2000 [1976]: 15). To reproduce this language within the space of the memorial risks enacting a divisive politics.

---

12   Most notable here is his critique of Claude Lévi-Strauss in *De la grammatologie* (1967).

## Return of the Flag

Following the terrorist attacks in Paris and Nice in 2015 the Tricolore returned as a visible marker not simply of French nationality but also of wider solidarity against the threats posed by terrorism. However, this symbolism was largely predicated on fear and unity via the construction of an 'interior enemy'. This is the suggestion made by Richard in his reading of the events. Yet in identifying the social unity embodied in the unabashed display of *tricolores* from private properties, particularly round the Place de la République in Paris, Richard fails to recognize the problematic construction of national identity around fear of the 'other'. He goes on to suggest that reluctance to display the Tricolore in the same way as Americans display the Star-Spangled Banner is a consequence of two factors. The first, as mentioned earlier, is the flaunting of the flag by Pétain during the Vichy regime (2016: LOC 739). The second is the association of the national flag with a quasi-religious sanctity which makes its display tantamount to a public display of religious symbolism (2016: LOC 753). The irony here should not be lost in the idea of a secular republic replacing religious iconography with that of the state. Richard goes on to link this reluctance to brandish the Tricolore with dominant critical attitudes towards other forms of religious display, namely the wearing of veils and headscarves by Muslim women in France. Might the veil constitute, Richard speculates, something akin to a 'flag'? (2016: LOC 772). Richard poses this question without identifying or attending to the deep collective anxieties such a possibility would necessarily attest to. Such a suggestion is also deeply divisive given the contentious issue of dual citizenship within France's own history of immigration policy not least the insistence that individuals gave up their Arab status and identity to obtain French nationality.

Richard brings to the fore the historical complexities underpinning the Tricolore and exposes the deception of its apparent simplicity – blue-white-red. However, what he refuses to entertain is the equally complex construction of the Muslim 'other' within French society. The legacy of antisemitism in the Second World War must necessarily include the history of how France produced a new 'interior enemy' (Rigouste, 2011). Not a new enemy *per se* but one which – pre-empting both the need for the importation of colonial subjects into the workforce *and* the displacement of further colonial subjects following decolonization in the latter half of the twentieth century – largely (though not completely) replaced the figure of the Jew on French soil as figure of contempt with

that of the Muslim as figure of terror. Within the space of the museum, a series of strategic moves occurs which enable terms such as 'totalitarian' and 'fascism' to be replaced by the much vaguer notion of 'extremism' and its closer links to religious rather than political beliefs. The call to resist racism is turned into its obscene double, a call to react against extremism. Hospitality is once more turned into suspicion.

### 30:33:37

These are the dimensions of the Tricolore's stripes. During a brief period under Napoleon I they were exactly equal but in 1853 the Navy reverted back to the 30:33:37 ratio because this ensured all colours could be seen equally when the flag was flown. Yet, if we think about the Tricolore at Les Milles, what appears is a privileging of the white central band of the flag. It was the white band where the struggle for France took place symbolically with the de Gaulle's Croix de Lorraine pitted against the Franciscan axe of Pétain's Vichy. It is the white space that implies peace over and against the red of communism and republican bloodshed. However, as the Musée de la Paix at Caen demonstrates, such peace is always predicated on security over and above freedom. Suspicion remains the organizing principle of hospitality. To cite Derrida once more: 'Hospitality, hostility, *hostpitality*' (2000 [1967]: 45).

It is the white that refers to sovereignty (once representing the king's battle colours), the sovereignty of the French state in this history as it continues to evoke the myth of resistance, a self-defeating resistance against its own laws and statutes. It is the white band that allows notions of republicanism and exceptionalism and the exclusionary practices they impose to persist. It is the white that continues to define what it means to be a French citizen.

\*

When I returned to Les Milles in summer 2017 and followed the Chemin des déportés to the Wagon du souvenir, I noticed a second flagpole now located a couple of feet from the Tricolore [Figure 5]. This second flagpole bears the blue EU flag featuring a circle of stars representing the original member states. Had it always been there? The presence of this second flag diminishes the symbolic power of the lone Tricolore. Blue now emerges as the dominant colour. Unlike the previous visit, there was a lot of wind this time and the flags repeatedly got tangled up,

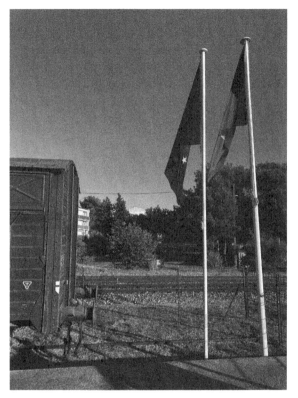

Figure 5. European and French flags next to the Wagon du souvenir.
Photograph by the author, August 2021.

overlapping one another. While this chapter has focused on the specific French nationalist discourse built around resistance and hospitality, the EU flag provides a reminder of how the memorial exists within a wider European landscape and narrative.

To what extent does the prevalence of blue, present in both flags, allow us to move beyond questions of 'whiteness'? Blue is the colour most often associated with French national identity. It is worn by France's national teams in various sports, who are cheered on as 'Les Bleus'. As Michel Pastoreau has argued, the colour blue has come to represent a neutralizing, consensual force in Western culture (2000: 159). Not only is it the colour privileged by the United Nations and European Union as a symbol of unity and peace but it is used by pharmaceutical companies to denote sedatives. What is at stake in the presence of the calming, neutralizing symbolism of the EU flag at Les Milles? How can we resist

the anaesthetizing effect of its blue, added to that of the Tricolore? A presence which offers to obscure the more politically factious red and white bands of the French flag? If you walk down the Chemin des déportés towards the Wagon du souvenir and look up at the two flags you will notice a small white canvas hem containing the eyelets through which the cord of the flagpole is threaded. Even as our line of vision is flooded with blue, the white can still be found, marking the flag's rigid, structuring mechanism alongside its blue flapping.

In taking up the Tricolore as our first visual marker viewed through the open window (following discussion of the window frame itself), the complex significance of the flag as physical, material object and long-term symbol of French national identity emerges. There is no simple way to reconcile myths of hospitality and resistance which both frame the museum's narrative and extend beyond its walls and the histories contained within these with the extensive use of the flag within Vichy itself. However, it is the juxtaposition of the flag next to the Wagon du souvenir that provides a reminder that the memory of deportation in France is framed by a contemporary national agenda. As we shift our gaze to focus more sharply on the wagon, we might reflect further upon what the presence of the Tricolore at Les Milles meant to those who were gathered there in the summer of 1942. And it is to them that we now redirect our attention.

Figure 6. View of Camp des Milles from behind the Wagon du souvenir. Photograph by the author, August 2021.

CHAPTER THREE

# Wagon

The Wagon du souvenir [Wagon of Remembrance] was inaugurated at Les Milles in 1992 [Figure 6]. This followed an earlier ceremony that took place in December 1990, in which the path that had been taken by deportees from the tile factory to the railway tracks 100 m away was renamed the Chemin des déportés. A report published in *Le Provençal* describes the awkward moment where the solemnity of the ceremony was inadvertently subverted by a passing freight train:

> L'intervention émue de M. Bulowko, vice-président du Congrès Juif Mondial, fut troublée par l'arrivée d'un train de marchandise stoppant à la hauteur de la cérémonie. Cette coïncidence, bien que de mauvais goût, a eu une portée symbolique. (Martin, 1990)

> [The moving speech given by Monsieur Bulowko, Vice President of the Jewish World Congress, was interrupted by the arrival of a freight train stopping on the tracks next to where the ceremony was taking place. This coincidence, while in somewhat poor taste, had a symbolic impact]

Another article reporting the same event, presented the arrival of the train as more serendipitous:

> Le convoi de marchandise s'est arrêté en rase campagne, le long de ce qui fut un quai de gare et où les souvenirs douloureux des mois d'août et septembre 1942, sont rongés aujourd'hui par les herbes folles. Hier après-midi, le convoi s'est arrêté là où d'autres partaient pour ne plus revenir. Son conducteur a respecté la mémoire de ceux qui, il y a un peu plus de 48 ans, étaient poussés de force dans d'autres convois de marchandises, s'entassent dans d'autres wagons où la vie décroissait à chaque tour de roue. (author unknown, n.d., extract preserved in press dossier, MdS MDXVIII-36)

> [The freight convoy stopped in open countryside, alongside the former station platform where the painful memories of the months of August

and September 1942 have been eroded by prolific weeds. Yesterday afternoon, the convoy stopped at the point from which others left never to return. The driver paid his respects to those who, a little over 48 years ago, were forced into other freight trains, crushed in other wagons where life diminished with each turn of the wheels]

The hyperbole of the latter report notwithstanding, the freight train appeared to offer an embarrassing, unintended reminder of the arrival of the convoys into the small station of Les Milles. A reminder that it was the Vichy bureaucracy, its politicians and police force employing the infrastructure of France's railways, that allowed the mass deportations of Jews to the extermination camps across Nazi-occupied Europe. This was all the more sensitive at a moment where France was only just coming to terms with its complicity in the atrocities. To give a sense of context, the ceremony took place five years before Chirac's presidential 'Vel d'Hiv' speech. At this moment, the old station at Les Milles and its railway tracks were largely hidden from view by overgrown vegetation, obscuring the direct link between the factory site and the railway, between internment and deportation [Figure 7].

It is possible to see, therefore, the enormous shift in memorial stakes occurring first with the inauguration of the wagon at the end of the Chemin des déportés and, subsequently, the opening of the museum, 20 years later, in 2012. Memorial director Alain Chouraqui (1996) has evoked the idea of 'forceps' in relation to the long and difficult 'birth' leading to acknowledgement and the commemoration of the site. Until the repurposing of the factory as museum offered the possibility of a public view from the upstairs window, the presence of the wagon, while impressive, could easily have been ignored or overlooked by those passing by. The ceremonial marches along the Chemin des déportés recreate the short yet interminable walk taken from Les Milles to the awaiting trucks. The view of the waiting truck, now permanently waiting, from the suicide window offers a different, alternative experience of secondary witnessing. As suggested in Chapter 1, to photograph the frame together with the view from the 'suicide window' is an act which opens up the possibility of an ethical spectatorship via the idea proposed by Azoulay of a 'civil contract of photography'. The view from the second-storey window takes us to a threshold we cannot cross, a moment before the catastrophe. This chapter takes up this particular moment in the history and memory of Les Milles. As such it is focused on the wagon as the most important object or marker viewed from the second-storey window. In the first sections of the chapter, the wider role of the cattle

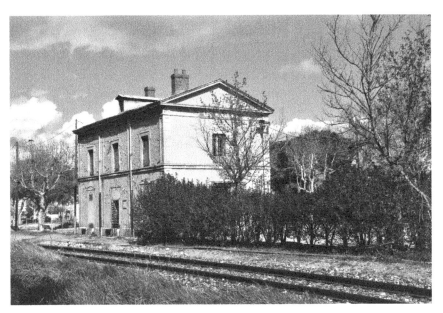

Figure 7. The old station at Les Milles. Photograph by the author, April 2018.

truck as historical artefact turned Holocaust 'icon' will be explored with particular attention given to trucks on display in France today. The representation of other trains in relation to Les Milles and its wartime history including the story of the 'phantom train' will be explored as a precursor to the moment of the deportations in 1942. In the second part of the chapter, discussion will turn to the difficulty of imagining, understanding and representing the experience of those who boarded the trains in the summer of 1942 and, moreover, those who refused to, choosing defenestration instead. Archival material and creative interpretations will be drawn upon but with the intention of showing that there is no archival document, no complete account, no cultural representation that can offer a definitive version of what happened.

Without the wagon, there is no 'cone of vision'. There is no reconstruction without the wagon carefully placed next to the railway line. The wagon comprises reconstruction, artefact and memorial. Indeed, it is the specific configuration of these different functions as at once part of the museum space and external to it that defines the uniqueness of its display at Les Milles. Prior to the inauguration of the memorial museum at Les Milles, the wagon was used as a small, temporary exhibition space (Bertaigne, 1992). Today, however, the wagon cannot be entered.

It is also worth noting briefly that there is another wagon on the site which you pass when walking between the main factory and building to the annexes where murals painted by internees were discovered and restored while the factory was still in operation. Since December 2019, it provides a backdrop to a permanent outdoor exhibition 'Du Camp des Milles à Auschwitz, l'engrenage vers l'abîme' [From the Camp des Milles to Auschwitz, spiralling towards the abyss], which tells the stories of individuals deported from Les Milles to Auschwitz.[1]

The second wagon provides a strange doubling and in doing so seems to affirm the significance of the memorial wagon, highlighting the difference between a reconstructed scene and a museum artefact. It also contributes to the disorienting sensation of the museum experience since when one steps out into the daylight it takes a while to realize this is not the same wagon one saw from the upstairs window. Its presence should also remind us that such wagons did not exist as singularities. There were once thousands of such wagons in use all over Europe. They were not a rare item that was particularly difficult to salvage and their use to transport freight or livestock continued after the end of the Second World War.

Writing on the cattle truck as 'Holocaust icon', Oren Baruch Stier (2015) suggested that there are at least 35 cattle trucks located in Holocaust museums and memorials around the world.[2] He also posits that the symbolic value of these artefacts is greater in locations outside of Europe. The presentation of each truck attests to different historical narratives and curatorial choices themselves shaped by the wider community invested in the memorial space at specific locations. As the case of Les Milles demonstrates, the appearance of memorial wagons in France at sites associated with deportation often predates the inauguration of a memorial museum on or near the site of a former deportation camp. At Drancy, the cattle truck was added to the memorial site in

---

1  See http://www.campdesmilles.org/site-memorial-detail-visite.html. The exhibition is the outcome of a collaboration between the Conseil départemental des Bouches-du-Rhône, the Auschwitz-Birkenau State Museum (https://www.auschwitz.org/) and the Kazerne Dossin Memorial Museum in Belgium (https://kazernedossin.eu/).

2  The total of 35 includes three memorial wagons located in France. However, in addition to two wagons at Les Milles, and those at Drancy and Compiègne, there is also a wagon at the small station of Langeais in the Indre-et-Loire *département* near Tours and there may well be others. The wagon at Compiègne was only inaugurated in 2013.

1988, framed by a sculpture by Shlomo Selinger which was inaugurated in 1976. The Mémorial de la Shoah Documentation Centre opened across the road in 2012, inaugurated by François Hollande.

Drancy was frequently the last point within France on the route across Europe to Auschwitz. Where for many in France it was better known as a transit camp, it has come to be synonymous with deportation. Between 1942 and 1944, approximately 64,000 Jews were deported to Auschwitz-Birkenau from Drancy with an additional 3,000–4,000 sent to Sobibór extermination camp.[3] The memorial wagon and sculpture are located in front of the Cité de la Muette housing estate, low-level accommodation blocks organized into a U-shape which had been built during the 1930s. The estate was transformed into a prisoner of war camp and subsequently used to intern those awaiting deportation. Despite the high memorial stakes, after the end of the Second World War, the buildings became public housing once more and continue to be used to house Paris's poorer residents today.[4] The trains actually departed from the Gare de Bobigny over a kilometre away and thus the role of the wagon is primarily memorial rather than reconstruction. The documentation centre which houses a reading room and exhibition space embodies a contemporary, minimalist architecture and features wall-to-ceiling windows which overlook the memorial. But despite the structural similarities of such a view to the one offered by the suicide window at Les Milles, the documentation centre at Drancy attests to different postwar and, indeed, contemporary politics of space.

A further example, which also belongs to the camp network in Occupied France, is the Camp de Royalieu[5] in the town of Compiègne located an hour's train ride from Paris. The camp had been a military barracks before it became an internment and deportation camp for Jews and members of the Resistance. The memorial museum is located on the site of the camp but unlike Les Milles, which was able to make use of the vast interior of the tile factory, the small barracks and chapel that remain at Compiègne are now fronted by a purpose-built memorial entrance, its grey concrete and stencilled lettering conforming to the familiar new brutalism of the late twentieth-century Holocaust museum. There is also a memorial wagon at Compiègne. Unlike Drancy, where the wagon

---

3 See https://encyclopedia.ushmm.org/content/en/article/drancy.
4 The housing estate was the subject of a 2015 documentary film, *La cité muette* directed by Sabrina van Tassel.
5 See https://www.memorial-compiegne.fr/.

has been placed immediately outside the former camp, the wagon at Compiègne is located in a small fenced-off area at the train station itself located about 1.5 km from the camp.[6] Deportees would have had to walk through the town centre to the station. In contrast to the memorial wagon at Les Milles, the wagon at Compiègne is immediately visible to the town's residents and notably the commuter population travelling into Paris each day. But it is perhaps just as easy to miss or overlook. I did not spot it on my arrival into the station and only noticed it on my way back to Paris after visiting the museum. I wonder what it means for those taking the train from Compiègne each day, walking back along the platform on their way home.

What these three different memorial wagons (at Les Milles, Drancy and Compiègne) all demonstrate is the complexity of the camp network, the varying proximity of camps to the railways and the differing levels of public visibility of the deportees as they made their way on foot from the camp to the cattle trucks. Secondly, decisions surrounding the acquisition and installation of each memorial wagon produces different juxtapositions between the space of the camp and that of the railway station. Les Milles as a former French site of deportation is unique in that the proximity of the railway line to the camp makes it possible for a memorial wagon to double as a reconstruction within the immediate locale of the factory turned camp turned museum.

It is the uniqueness of the wagon at Les Milles that I want to emphasize in this chapter. Its presence on the site needs to be contextualized in relation to other stories about other trains that form part of the wider narrative of resistance. The view of the wagon as seen by museum visitors from the upstairs window also offers the possibility of telling a different, more personal story within the wider history of deportation. Such an approach is indebted to the work of Simone Gigliotti (2009) and her call to resituate the specific experience of the train journey at the centre rather than the margins of Holocaust memory. Her collation of survivor testimonies emphasizes the specificity of lived, affective experience in contrast to other historiographies focused on documenting the sheer enormity of the deportations and exterminations. It also attests to the difficulty and often impossibility of witnessing. The accounts I am looking for in relation to Les Milles also affirm this impossibility. I am obliged to rely on anecdotes, archives and lists to produce meaning about those who disappeared without a trace. Such aporias can, however, hold

6   To enter the memorial space, you need to request the keys.

the key to understanding the stakes of our own secondary witnessing and the possibilities this holds for forms of looking, remembering and caring which challenge the demands posited by official representations and the political agendas these endorse.

### Other Trains

Baruch Stier (2015: 36) has suggested that the symbolic power of the Holocaust-era wagon is twofold in its ability to represent the scale of the deportation whilst offering up a specific example of its operation. The wagon at Les Milles constitutes a memorial framed both within and outside the memorial site. How might we compare and contrast this with the striped Auschwitz pyjamas which are framed inside within an actual frame but also within the museum as frame? The Auschwitz pyjamas are another example of Baruch Stier's 'Holocaust icons' – like the wagon, their function is metonymic in that they stand in for those who wore them, representing everyday life in the concentration camps. But they also suggest much more. The pyjamas symbolize the stripping of the Jews and the plundering of their clothes and other belongings on their arrival at the camps. The pyjamas are central to the image of the camp populations, distinguishing older detainees from those newly arrived. This is the image, evoked by Gigliotti, of the zombie-like creatures in stripy, pyjama-like uniform that the deportees saw when they first got off the train at the concentration camps and had difficulty recognizing as fellow human beings let alone fellow Jews. But if the pyjamas come from outside Les Milles despite being an integral part of its story, the wagon functions symbolically in a different way. It represents a trajectory, a connection, one that is real, physical, mechanical and geographical between Les Milles and Auschwitz via Drancy.

In claiming that the wagon has become the 'supreme Holocaust icon', Baruch Stier also locates a heightened aura existing around it within the specific context of museums located outside of Europe. His examples include museums in the United States, notably the United States Holocaust Memorial Museum (USHMM) in Washington, DC and the Dallas Holocaust and Human Rights Museum (DHHRM), as well as Yad Vashem in Israel. Based on his own experience working with Holocaust museums in the United States, he identifies a keen interest (he carefully refrains from using the word 'obsession') amongst visitors in the authenticity of the cattle trucks which often play a central

role in the museums' interpretation. Where some might find abject the reuse of these trucks for freight after the war, given their role as mobile sites of suffering, torture and death, this invariably happened across Europe. The wagons themselves, of which there would have been thousands in use across Europe, are both homogeneous in appearance and vary in terms of the minutiae of their design and markings. Some would not have been decommissioned until decades later. Consequently, the donation of trucks from different European railways to museums involved the caveat that their specific histories were unknown or difficult to trace despite assurances that they were, in fact, used for deportations. Baruch Stier recounts the complicated history of the cattle truck donated to the USHMM from Poland. The Polish authorities confirmed the truck had been used in the deportations yet were unable to supply records from the period that would support this. Prior to shipping, the truck was painted, suggesting a conflicting desire to cover up its previous role (2015: 47–48). Baruch Stier (2015: 52) describes the problems this posed for the museum both in terms of restoration and in how they presented the truck as 'representative' of the era and the type of trucks used for deportation without making any greater claim to authenticity. Shifting the perspective to the museum visitor, for whom the deportations constitute a distant and difficult-to-grasp history, the value of the museum experience becomes tied to questions of authenticity as if, somehow, the story of the deportations cannot be adequately told without recourse to a truck that had itself witnessed the transportation of hundreds of Jews across Europe. The truck thus becomes a stand-in for the human witness via its materiality and the marks or traces it bears. As suggested above, the Wagon du souvenir at Les Milles functions as artefact, memorial and reconstruction. This means that the emphasis on its 'authenticity' lies less in the specific material history of the wagon itself, which may or may not have been used in the deportations across France, and more in its positioning next to the railway line. The wagon has recently been repainted in a dark brown (it was previously a fawn colour and was no doubt painted to protect the wood from the weather) with white lettering 'Hommes 40 / Chevaux 8' stencilled onto the entrance hatch, based on photographs of wagons from the period.

The powerful image of the cattle truck, which is instantly recognizable as part of what Pollock and Silverman term 'concentrationary imaginary', nevertheless needs to be situated within a more complex set of images and narratives that place the railways at the centre of mass human transit from the late nineteenth century onwards. When Paul Virilio

(2007: 10) claimed that the invention of the train was also the invention of the train wreck, he was referring specifically to the vicissitudes of high-speed technology development rather than the appropriation of the railways as a system of effective and efficient mass transit by a politics of forced migration and definitive exclusion. If crowded train stations often feature in wartime representations as shorthand for the separations of families resulting from the demands of war, conscription, evacuation and so on, the train also features heavily in narratives of resistance, romantic encounter and political diplomacy.

The first cattle trucks to arrive in the United States from Europe were not associated with the deportations but rather took the form of a 'Merci Train', composed of 49 carriages, these were filled with gifts and sent from France to express gratitude for the 'friendship' train of 1947 which travelled across the US collecting foodstuffs to send to France and Italy. The trucks were painted in different colours and bore a tricolour sash with the inscription 'MERCI TRAIN DE LA RECONNAISSANCE FRANÇAISE'. Each truck was decorated with the coats of arms of different French *départements*. The trucks were also known as the 'forty-and-eights' because of their markings. Thus, where today these markings are synonymous with the dark irony of the deportations which saw up to 100 men, women and children crammed into each truck, in the immediate aftermath of the Second World War, the reference was employed as an affectionate nickname for mass transit employed as part of the Allied war effort. As the memorial plaque accompanying the display of a truck in Pennsylvania reads:

> This 40&8 boxcar is one of forty-nine cars that comprised the merci or gratitude train, a gift to the American people from the citizens of France. Pennsylvania received it at a ceremony in Harrisburg on February 6, 1949. All forty-eight States received a boxcar filled with gifts, ranging from humble offerings to priceless art and antiques. The District of Columbia and the territory of Hawaii shared the forty-ninth car. Gifts of sacrifice from individuals conveyed each donor's depth of gratitude for liberating France in two World Wars and for sending the friendship train, a $40 million food relief effort carried out by American volunteers in 1947, which saved many French citizens from starvation. The 40&8 boxcars, so named because of their capacity to hold either 40 men or 8 horses, transported soldiers and horses to and from the French battlefields during WWI. Many WWII soldiers rode the boxcars as well. The Merci Train boxcars now stand as a tribute to the sacrifices and bravery of American veterans who served in France in two World Wars and as

a symbol of gratitude between the people of the United States and the citizens of France.[7]

The memorial cattle truck located at Compiègne was inaugurated in 2013 at the same time as the memorial museum at Camp Royalieu. However, the town and its surroundings bear witness to the story and memorial of another, different wartime train, the 'wagon de l'armistice'.[8] The carriage was the site of the armistice agreement signed in 1918. The decision to move the carriage to the forest near Compiègne was made to ensure the safety of all parties given the huge losses sustained by communities in the region. During the interwar years, the carriage was moved to Paris, where it was visited by thousands and considered a symbol of peace. It was returned to the town of Compiègne in 1927 to form part of a purpose-built memorial. However, in 1940, Adolf Hitler chose the carriage as the location for the signing of the armistice. He first had the carriage moved from its memorial location to the site of the original tracks as part of what has been described as a 'surreal theatrical restaging' (Adamson, 2018) before taking the carriage to Germany for display at Berlin's cathedral as a symbol of the reversal of the 1918 Armistice which saw Germany capitulate to France. Today a replica of the carriage is on display in Compiègne, where it is located at the centre of the Musée de l'Armistice.[9] It was visited by German Chancellor Angela Merkel and Emmanuel Macron in 2018 on the 100-year anniversary of the First World War armistice (Adamson, 2018).

As a key part of local history and a story which anticipates the further appropriation of the French railways by the Nazi regime, the two-part tale of the train carriage also forms a major display at the Musée de l'Internement et de la Déportation at the former Camp Royalieu site. The museum contains few physical artefacts, and its displays are largely composed of archival film footage. There has been a clear intention to focus on the presentation of multimedia images although, as with Les Milles, such presentation is not accompanied by any sustained reflection

---

7  See https://www.themetrains.com/merci-train-boxcar-pennsylvania.htm. For a more detailed account of the train as well as the subsequent exhibition of the gifts at museums across the United States, see Nondrof (2015).

8  For a longer account of the carriage and its complex role as tourist attraction both during the interwar years and between 1940 and 1944, see Gordon (2018: 59ff.).

9  The replica dates from shortly after the Liberation, during which the original carriage was destroyed (Gordon, 2018: 62–63).

on its own display choices.[10] However, while other displays at Royalieu are clearly intended to overwhelm, the display focused on the train carriage makes effective use of audiovisual elements to neatly highlight the strange doubling orchestrated by Hitler. Images telling the stories of the two armistices are projected onto opposite walls, thus emphasizing the dark repetition of history and the return of war in Europe after only two short decades. Visitors have a choice between trying to watch both simultaneously, shifting their attention between the two walls, or one at a time. What becomes apparent in either approach is the way in which different historical events bleed into one another via performance and re-enactment.

Into this context of trains which are the same but different, we might situate the multiple, competing stories about the trains at Les Milles. The physical presence of the Wagon du souvenir opposite the tile factory might be offset against the story of a different, somewhat mythical train. This is the train that provides the focal point to the 1995 film *Les Milles: le train de la liberté* directed by Sébastien Grall. The film predates more widely distributed and globally acclaimed films focused on the Vel d'Hiv round-ups, *Le rafle* [*The Round-Up*] (2010) and *Sarah's Key* (2011), and avoids any treatment of the deportations. Consequently, it might be situated within a longer history of representation within France aimed at diverting attention from the role of the SNCF in the deportations, focusing instead on stories of resistance and rescue taking place on France's railways. Ludivine Broch (2017) has pointed out how the embedding of stories of resistance within cinematic representations of France's railway network began early on in the 1945 film *La bataille du rail*, which portrayed railway workers (*cheminots*) as playing a central role in the resistance effort.[11] Later

---

10  Video displays include footage from Pétain's various flag-waving ceremonies and visits, including one made to Aix-en-Provence in 1941. This is notably absent from the exhibition at Les Milles. Another display juxtaposes documentary footage taken by the Allies when they liberated camps across Europe. Much of this footage is disturbing given the piles of corpses and emaciated, frequently naked internees. Playing simultaneously, on loops of differing length, the intended effect appears to be to overwhelm viewers perhaps replicating the sudden explosion of images that emerged from the camps at the end of the war. In this format, the display precludes any discussion of the skewed view presented by these images or what form of ethical spectatorship might be possible.

11  For a more detailed account of the complex experience of railway workers under Vichy, see also Broch (2016).

films, such as Marcel Ophül's *Le chagrin et la pitié* (1969), challenged some of the earlier myths. The so-called 'SNCF Affair' saw first- and second-generation Holocaust survivors call for reparations from the SNCF for its role in the deportations.[12] As a consequence of such calls, the involvement of the SNCF in the memory work of Serge Klarsfeld and others,[13] including the organization's sponsorship and hosting of exhibitions on deportations, has arguably resulted in a certain framing of the deportations within museum and memorial exhibition spaces. Les Milles has become the permanent home for Klarsfeld's exhibition on the deportation of Jewish children, '1942–1944: 11 400 enfants juifs déportés de France à Auschwitz' [1942–1944: 11,400 Jewish children deported from France to Auschwitz]. As part of the 60th anniversary of the deportations, between 2002 and 2005 the exhibition was displayed in over 20 train stations across France (see Klarsfeld, 2008).

*Les Milles: le train de la liberté* tells the story of an early period of the camp (spring 1940), when it operated as an internment camp for various foreign nationals deemed a potential threat to France. The narrative highlights the camp's various absurdities, notably the internment of German intellectuals and artists as potential enemies of France despite the glaring evidence that they had fled the Nazi regime. Loosely based on Lion Feuchtwanger's autobiography, *The Devil in France*, the film presents many of the dark ironies of the camp. These include an episode in which an architect claiming to have designed Berlin airport is charged with building the latrines and another involving a group of Nazi dwarves belonging to a travelling circus troupe who pass temporarily through the camp. It is against this backdrop of general chaos and Kafkaesque absurdity that the film conducts a character study

---

12  The first person to claim reparations was Kurt Werner Schaechter, whose Austrian parents had been deported from France to Auschwitz in 1942. Many of the claims were made by US-based survivors and the call for reparations became bound up in a complex political and economic affair which saw politicians in the state of California refuse to consider the SNCF for railway contracts unless formal apologies and reparations were made. See Broch (2017). Debates around the validity of the claims have been widely discussed in global media. Notable here is the French journalist Raphaël Delpard's documentary *Les convois de la honte* (2010), based on the book of the same name.

13  The SNCF appointed historian Christian Bachelier to conduct detailed archival research into its history during the Occupation, resulting in a 5-volume report published in 1996 by the Institut de l'Histoire du temps présent (IHTP) and the CNRS.

of the central protagonist, the camp's newly appointed director, Charles Perrochon, played by Jean-Pierre Marielle.

Perrochon, a fictionalized version of the camp's commander Charles Goruchon, is depicted as a wounded military man who finds himself in the administrative role of managing the camp. He is the only character given any real depth in the film with the camp guards and the German internees presented as cardboard cutouts. Perrochon is caught between following orders and demonstrating the type of integrity befitting a military hero. Such a psychological character study might have also been applied to the later story of the deportations. Camp guard Auguste Boyer helped numerous families to escape during the summer of 1942. There is also evidence in the diary of Pastor Henri Manen (2013) suggesting the camp's later director, Robert Maulavé, was sympathetic to Manen's work and did what he could to prevent individual deportations. Along with other camp administrators he was charged and detained on 27 September 1942 before being dismissed in February 1943. However, the possibility of funding a film based on the later history of the camp remained difficult in France even as late as the mid-1990s.

In addition to Perrochon's supportive yet concerned wife, the female cast is supplemented by that of a fictional American reporter (played by Kristen Scott Thomas), brought into the story to highlight the ongoing work of philanthropist Varian Fry, who succeeded in securing emigration papers to the United States for a number of Les Milles's celebrity internees. Where the presence of Scott Thomas bolsters female representation in the film, her role in highlighting American intervention and support also attests to the crude pandering towards an American audience that marks the French (alongside the British) film industry in the 1990s. What this makes for is an interesting example of both the memorial stakes of the mid-1990s, which saw the inauguration of the Wagon du souvenir along with Chirac's Vélodrome d'Hiver speech, while a wider cultural imaginary remained constrained by the demands of a global film industry dominated by US ideologies of national pride and heroism. It is in this context that the chosen episode from the longer history of the Camp des Milles makes perfect sense. Perrochon's integrity can be translated into effective action as he allows hundreds of internees to escape by train. The possibility of such action would diminish once the Nazis occupied northern France in the summer of 1940 and when Pétain later approved the deportations from the Vichy camps in July 1942.

The film concludes with the internees arriving just outside Bayonne after various low-level threats. The internees join the crowds fleeing

the region on foot, heading towards the Spanish border. The news of a train carrying Germans has caused widespread panic that the Nazis have arrived. The final image is of the sun setting over the water and the silhouette of the ship intended to carry the internees to safety. This is a deliberately ambiguous ending which is supplemented with narration emphasizing Fry's efforts whilst also indicating that the complexity of emigration meant escape was not imminent for many internees. It is a vague and largely unsatisfying end to a film which does little to develop its characters beyond the figure of the director, relying on anecdote and cliché in its representation of the celebrity internees such as Max Ernst and Hans Bellmer. Yet the decision to focus on this period from within the longer, more complicated story of the camp at Les Milles is significant within the wider context of French memory. Where various other trajectories – in the double sense of escape routes and plot lines – might have been pursued, such as the passage from Marseille to the United States via the Caribbean (see Jennings, 2018), the decision to tell a largely inaccurate story of an escape by train suggests the desire to represent an alternative narrative of the trains leaving Les Milles to that of the deportations. If the train does not become a fully fledged symbol of resistance, at the very least its role during the Second World War is neutralized.

In the memorial space of Les Milles, the story is told quite differently under the header 'Le Train Fantôme' [Ghost Train]. On 22 June 1940, 2,010 internees boarded a train which was to head west towards Bayonne, whence many hoped to reach the coast and ultimately North Africa. On arrival at Bayonne, rumours that the Nazis were on their way caused some of the internees to destroy their personal documents. The train headed back but around 100 men opted to escape during a night stop. The rest were taken to another camp at Saint-Nicolas near Nîmes and many subsequently found themselves back at Les Milles. The story is situated within a series of panels demonstrating the complex camp network across the south of France as well as the difficulties encountered by those seeking to leave Europe due to their status as 'undesirable'.

Situated within a wider iconography of railways and train journeys as the dominant mode of mass transit during the twentieth century, the image of the cattle trucks is also heavily mediated both in archival photography and documentary footage of the period and in subsequent cinematic representation. Much archival footage, most notably that produced by the Nazis, suggests the complicity of the deportees as they make their way down platforms seemingly without complaint. Gigliotti

has contested such imagery and its use both as Nazi propaganda about resettlement and subsequently in debates around why the Jews did not resist their fate:

> Although postwar documentary and narrative cinema gave voice and vision to victims' testimonies, it also conflated experiences, scenes, and archival photography to present a generic cinematic journey. These acts of appropriation have been exhibited in museums, where the photography of deportation has emanated from wartime film footage of transit and resettlement, images that have produced a collective deportee identity, and a decontextualized and visually mobile victim of universal suffering without much reference to the ethnic or religious biography of the represented person. (2009: 12)

Such 'generic images' can be found at the memorial museum at Les Milles. Perhaps the best-known image of the cattle trucks is the photo of a young girl, Settela Steibach, peering out of the door of one. This image, as Gigliotti points out, offers a 'universal' image of vulnerability which goes beyond the specific circumstances of her personal history and racial identity. The image features briefly as part of the immersive video in the reflective section of the museum at Les Milles, where it is shown (as is commonly the case) without commentary or context. As suggested previously, the museum depends on a well-established aesthetics and design 'best-practice' associated with Holocaust museums globally. Moreover, it is worth also noting the appropriation of this aesthetic in the museum's own iconography. Another image central to the site's self-presentation is a photograph taken of the tile factory from behind the Wagon du souvenir. The photograph is rendered in sepia and the wagon is cropped so that it is unclear whether it belongs to a longer train. It also acquires the feel of archival footage from which it borrows its aesthetic authority. Taken from this angle, the photograph foregrounds the wagon and thus the story of the deportations. However, it is an image devoid of people and as such endorses a framing of experience that does not rely on individual presences. The photograph represents a tendency, highlighted by Dora Apel in *Memory Effects* (2002), to present sites associated with historical events as timeless, empty spaces with visitors carefully cropped out.

The use of black-and-white or sepia photography is one obvious example of a mode of presentation which conforms to public understanding and expectations about how the Holocaust should look. This careful framing of memorial sites belongs to a more general

reframing of historical narratives within the context of the museum space. The longevity of the memorial is emphasized over and above the events themselves. However, this historical abstraction seems to be at odds with a more contemporary understanding of the memorial museum as a space which fosters creative responses to past atrocities, one which is open to more interactive audience engagement and a transformative, self-reflective museography. The image taken from behind the wagon freezes both it and the factory in time. This is interesting as it retrospectively distils the story of Les Milles into a single moment – the moment before the train moved away from the platform. This is the moment that arguably defines Les Milles. What is also interesting from the point of view of secondary witnessing is the position of the photographer in taking the photo. He or she would have to have been stood on the railway tracks themselves, or at least would have needed to cross them to take the photo. The photograph presents a reverse image of that viewed from the suicide window, but it also inverts the position of the witness or spectator. The photographer is either standing in the empty space where the train once stood or assumes the position of an onlooker, standing on the other side of the tracks.

## Difference and Repetition

Some of the most chilling scenes in Claude Lanzmann's *Shoah* are the performances of difference and repetition he exacts from his interviewees. Where Alain Resnais's *Night and Fog* juxtaposed archival images with present-day footage of the abandoned camps, Lanzmann actively refused the use of archives as part of a claim that the Shoah cannot be represented with recourse to such material. Instead, the 9½-hour film makes exclusive use of interviews conducted by Lanzmann with different 'witnesses' as well as cinematography of the landscapes, architecture and infrastructure that once served the Final Solution.

The idea that this is not a form of representation and does not involve various aesthetics of framing and interpreting has long been dismissed with Lanzmann's own somewhat dogmatic statements about the film, taken less as authoritative insights and more as emblematic of the film's complexity and the impossible attempt of an artist to retain control over his material (LaCapra, 1997: 233). Such control seems all the more impossible given the type of material Lanzmann was dealing with: filmed over a ten-year period in multiple locations across Europe, the United

States and Israel and involving six different languages.[14] Yet what remains undisputed amongst scholars and critics is the power of Lanzmann's refutation of straightforward chronologies, opting instead for fragmentary scenes with different survivors, perpetrators and bystanders. The film eschews commentary, there are no voice-overs offering contextualization or conclusions. There is no closure or catharsis achieved for any of the interviewees and often, in the case of the Polish bystanders, there seems to be only bemusement as to what Lanzmann hopes to learn from talking to them, since they themselves knew almost nothing about what was happening. It is this bemusement which is most telling as interviewees unwittingly reveal their own myths and fantasies about the Jews and why they were exterminated. There are no epiphanies, no concrete admissions of guilt and no healing. The film is thus about the impossibility of catharsis as much as about the impossibility of witnessing. Individual stories are, of course, recounted throughout but they contain no message and do not belong to a narrative arc.

The film raises interesting questions about the relationship between the ideas of representation and reconstruction. Lanzmann seems to take representation to mean an attempt to show history *as it was* and denies not only the possibility but the ethical validity of attempting to do so with the Shoah. Reconstruction, which might also be described as the same process, is in *Shoah* taken to mean the recreation or re-enactment of the embodied experiences of the witnesses either via a repositioning within former landscapes of death or via a line of questioning that produces significant juxtapositions with what is happening around them. What is most interesting for my own reading of the Wagon du souvenir as a form of reconstruction at Les Milles are the scenes involving the formal signalman Henrik Gawkowski driving a locomotive hired by Lanzmann for the occasion. The single wagon might be compared, whilst reiterating the non-reproducibility of either as a model or format for remembering or witnessing, to the single locomotive that Lanzmann hired and requested Gawkowski drive while imagining it was coupled to 40 or 50 trucks.

Embedded within the often traumatic, sometimes disconcertingly mundane scenes with both survivors and perpetrators, is Lanzmann's

---

14  Various scholars have analysed the use of language(s) and the effects of translation as well as subtitles in *Shoah*. See, for example, Habib (2015), Stoicea (2006) and McGlothlin (2010). I am grateful to Lara Choksey for alerting me to this area of study.

discussion with the historian Raul Hilberg. LaCapra has emphasized Hilberg's unique position in the film as 'historian' and, moreover, 'the only nonparticipant or secondary witness' (1997: 262), contesting Shoshana Felman's claim that Hilberg is at once historian and witness (Felman, 1991: 112). As Lanzmann himself emphasized, Hilberg's historiography plays a significant role in the film's approach to the Holocaust. However, the carefully reconstructed data that Hilberg spent an entire academic career working on would perhaps be meaningless if it were not juxtaposed with the individual acts of repetition demanded of Lanzmann's other subjects. In other words, although it is the clinical planning and organization of the operation of the Final Solution, coordinating railways across Europe, which is horrifying, especially the negotiation of fares which were passed on to the deportees themselves, does the presentation of this cold, hard systematic operation shock audiences as much as it should? What is required is the human face of the operation. Not images of politicians. Hitler and Himmler are not mentioned in the film (LaCapra, 1997: 263). Instead, the banality of bureaucracy is explored via a study of regular people carrying out the basic tasks required to make it all a success. Repetitive tasks which do not require thought and which in themselves do not affirm one's complicity with the death machine. Most notable here are the scenes in the staged barbershop with Abraham Bomba, who had been forced to cut the hair of Jewish women before they were gassed.

It is also interesting to note how Lanzmann, in his self-professed obsession with railways and locomotives, keeps the focus of *Shoah* as far from France as is possible (LaCapra, 1997: 259; also Furman, 1995). Margaret Olin describes this as a 'blank space' on Lanzmann's map, more noticeable given that French is the main language of the film: 'French, as the language of translation, is neither the language of extermination nor the language of refuge. It is as though, in French, the Holocaust could be experienced only vicariously, through translation' (Olin, 1997: 7). The absence of France's role in the deportations is not simply the result of not filming on French soil but also the absence of any French Jews from Lanzmann's collection of witnesses. Whether this was due to potential censorship imposed by the French Ministry of Culture, which funded the film, or Lanzmann's claim that the French would never have permitted extermination camps on their own soil, as Olin points out: 'Whatever the cause, the effect of the erasure of France from *Shoah* is that one can look at the film in its country of origin without having to master the past' (1997: 6).

Yet in developing its own iconography of trains and railways, *Shoah* contributes to public perceptions (regardless of how many people actually watched the film in its near ten-hour entirety) of the role of the railways in the Final Solution at a moment when the first cattle trucks were being inaugurated as memorials in France (Drancy) and elsewhere in Europe. In his focus on what might be termed the endpoints, the extermination camps and forests near Treblinka where Jews were gassed in vans, Lanzmann also explores the point at which a path or trajectory becomes an endpoint. In a seminar given at Yale in 1990, he recalled his interest in the crossing of the limit, the moment at which death becomes a given:

> I remember when I was shooting the film, I was absolutely obsessed in Auschwitz. It is very obvious in Auschwitz. There is a big sorting station, with many rails coming from everywhere, and suddenly you have this unique one, this unique one which leads to the big gate of Birkenau, the bird of death. It was very difficult to film this. I remember I was walking without the camera, asking myself: 'At which moment did it start to be too late?' Of course, when the gates of the camp are passed it is already too late. It is too late when the gates of the crematorium are …, but here it was already too late. When they were on the train it was already too late. When they boarded the train in Drancy or in Salonika it was already too late. When was it not too late? How will this story be helped? I know that I was obsessed with these questions. I was asking myself: 'How to transmit these questions? How to transmit these feelings to the spectators, to the viewers of the film?' Between the main railroads and the gate of Auschwitz it is two kilometers. It's very difficult because you cannot make a 'traveling' shot of two kilometers. If you make a panoramic shot it's also very difficult; it's too long. If you take a zoom it's very complicated too. It was very difficult to do this. But these were all the …, I don't want to say moral questions, but all the questions of content were immediately questions of technique and questions of form.
> (Lanzmann, Larson and Rodowick, 1991: 89–90)

This is a moment, albeit post-film, where Lanzmann *does* mention France in his allusion to Drancy. The question as to when it becomes too late and the answer that it was always already too late. If we follow this line of questioning back to Les Milles, we arrive at the point, the moment when the locomotive pulling five trucks arrives outside the small station in August 1942. This is the moment when it became too late for the Jews interned across the south of France. And what this means in the case of Les Milles is that the wagon should not be read as a marker which holds

Les Milles and Auschwitz apart. Instead, it brings the death of the Final Solution into the space of Les Milles.

## Timetables

Time itself becomes unbearable. At once accelerated and static, a time that is running out but simultaneously brought to a standstill. The space of Les Milles is transformed into what might be described as a 'timescape'. The waiting trains embody the paradoxical duality of time during this period of the camp's operation. The Wagon du souvenir embodies this duality.

Elsewhere, in other museums, the temporal symbolism of the memorial cattle truck embodies different conceptions of time. At Yad Vashem, a cattle truck donated by Poland has been transformed into what Baruch Stier refers to as a 'monumental icon' (2015: 61). The truck forms part of Israeli architect Moshe Safdie's 1995 monument *Memorial to the Deportees*. Its location at the edge of a valley suggests a rupture, a cutting short. This might be read as the cutting short of life but, in this new context, it can also represent the abrupt end to the violence and death of the Nazi regime embodied in its mass deportations. As Baruch Stier emphasizes, the truck as 'monumental icon' plays a central role at Yad Vashem in its emphasis on a new time, that of the postwar creation of the Jewish state of Israel. Safdie's memorial belongs to a wider memory project taken up with a reimagining, an opening up of possibilities directed towards the future. If, as we will consider in later chapters, the view from the window invites the visitor to explore the world outside the museum and is, in this sense, also very much directed towards future potentialities beyond the limits of the curated space, it first forces us to focus upon a very specific moment in the camp's history, that of the deportations.

Unlike camps such as Drancy, which operated as a deportation camp from June 1942 until July 1944 and saw an astounding number of convoys depart (64 trains carrying a total of 67,400 Jews) for Poland having also seen an astounding number arrive from camps around France, Les Milles operated as a deportation camp for a relatively short period during the late summer of 1942. By the end of September, the camp had all but emptied out before being closed and turned into a Nazi artillery store.

The use of the vast network of railways across Europe in the systematic deportation and extermination of the Jews marks a turning point in

the Nazi's programme. Where memorial wagons in Compiègne and Drancy are situated within a narrative of Occupation, the deportations which took place from Les Milles are part of Vichy's difficult history of collaboration. In addition to the demand made by the Nazis to deliver up all foreign Jews over the age of 16 (with clear indication that this would eventually extend to include French Jews), Prime Minister Pierre Laval also offered to send children over the age of two along with their parents (Hilberg, 1994: 679). The decision to deport foreign Jews from both the occupied and unoccupied zones was made on 4 July 1942 during a meeting with Vichy chief of police René Bousquet and SS officer Theodor Dannecker at Gestapo headquarters in Paris. This was followed by an inspection of the camps including Les Milles by Dannecker. All visas permitting foreign Jews to emigrate were subsequently cancelled via an order given by Bousquet on 17 July (Grynberg, 1999: 559). Instructions for the Bouches-du-Rhône prefecture were initially given verbally on 23 July and subsequently confirmed by telephone. A telegram from Bousquet's deputy, Henri Cado, dated 29 July fixed 6 August as the departure date for the first convoy from Les Milles (Peschanski, 2002). This ultimately took place on the morning of Tuesday 11 August at 8 a.m. (see Manen, 2013: 21; Fontaine, 1989: 147). The telegram advised telling internees they were simply being transferred to another camp in France rather than revealing the real destination (ANF F7/15088, cited in Peschanski, 2002: 350).

The central claim of Gigliotti's argument is that the experience of deportation cannot be reconciled with the bureaucratic management of the railways across Europe by the Nazis and their collaborators. Instead, she argues that we need to try and 'imagine' the experience of the cattle trucks.[15] Moreover, Gigliotti makes a compelling case for a rethinking of the cattle trucks as not simply prefacing death but constituting in themselves a form of dehumanizing torture and death.

15   Arnaud Rykner's 2010 novel *Le wagon* attempts this very act of imagining, offering up a short fictionalized account of one of the final train journeys in 1944. The protagonist is a young man arrested for resistance activities. He is about to turn 23 and his reflections pivot around the irrelevance of this birthday within the space of the truck. The narrative is an attempt to evoke the embodied experience of the journey. As such it draws on details from oral testimony, threading these together in a way that a survivor would struggle to achieve. It is an exercise in how and why we might try and imagine, and why we need to imagine even when we fail. It ultimately fails in its depiction of the interminable and the abject – we are let off too easily – but any attempt to represent will fall short.

Although it is possible to get closer to the wagon at Les Milles and even to touch it, this is not really what is at stake. The possibility of entering its space is precisely the point in other non-sited spaces such as Holocaust museums in the United States where visitors experience a conflict between wanting and not wanting to enter, the discomfort of wanting to experience something akin to what was experienced by the deportees whilst recognizing the impossibility and poor taste in even attempting to do so. What is at stake at Les Milles is the non-place between the wagon, its interior and the upstairs window. This is a short yet also interminable, impossible distance. Gigliotti talks in some detail about train platforms as well as the specific aura of train stations. But she is talking either about train stations in metropolitan hubs or the fake stations, with their fake station houses and hanging baskets, which were often built at the camps in order to fool deportees as the trains were frequently held outside the camps for long periods, thus circumventing a stampede and attempts at flight once the wagons were opened up.

The tiny station at Les Milles is neither [Figure 7, above]. It was not a fake countryside station but a real one. A freight train was no doubt a regular sight for those living and working in the town and its environs. It is this familiarity, the systematic, routine arrival of the trains which forms part of what Hannah Arendt has termed the 'banality of evil'.[16] And it is only by understanding the chasm between this routine arrival and what it meant for those held inside Les Milles that it is possible to make sense of the suicides from the upper window. Not simply as panic but as an acknowledgement that death begins here. At Les Milles, the wagons are not antechambers of Auschwitz but exist in a continuum with it. Their arrival indicated, to paraphrase Lanzmann once more, that it was *already too late*.

Standing at the window we are not voyeuristically looking at the deportees but instead assuming their position. This is a difficult claim to make, especially as we are not seeing what they saw but rather a minimalist reconstruction. Does the single wagon imbue us even vicariously with the sense of awe that a train made up of 5, 20 or 40 trucks would have done? It cannot possibly. Yet the single truck has nevertheless taken on the role of metonym. It is a metonym both for the Holocaust and for the whole train of which it once formed a part. The

---

16 Arendt (1964) uses the term in her consideration of Adolph Eichmann, his trial and the question of what it means to be an administrative 'cog' in a large bureaucratic machine such as the Nazis' Final Solution.

sheer scale of the trains that travelled from Drancy to Auschwitz goes some way towards emphasizing the magnitude and scale of the Nazi operation as it coordinated railway systems across Europe as part of its death machine. But, on the other hand, if we think about the individual experiences as collated by Gigliotti, these are less taken up with questions of scale. Experience comes down to the space one occupied within a single truck, the bodies in immediate proximity, the sensory onslaught – sound, odours, touch intensified by visual deprivation.

But what about those who never made it onto the trains?

## August 1942

Amongst the stories and rumours about Les Milles there is one I keep returning to. It is the one through which the window acquires its significance and the one around which this whole book has been conceived. It is impossible to verify its precise details. Taking a photograph of the window and all it frames gestures towards the creation of a different type of archive, one taken up with repairing or restoring the 'impaired citizenship' of the women who jumped as well as those who were deported. Is there any way to start to plug the gaps and silences around these women, whose stories have been recounted by those who were not there, and whose names and faces have been erased? The rest of the chapter is taken up with piecing together the traces but also the absences that define these women and their lives. Such an activity forms a contribution to what Lia Brozgal (2020) has referred to, in a different context, as the 'anarchive'.[17] The 'anarchive' is what emerges in the absence of clear archival evidence of something that occurred, often in the form of artwork, literature, film and even graffiti. As a memorial space, the second-floor window is itself a part of the 'anarchive' as it invites visitors to try and imagine the same view during the summer of 1942 without making any claim to authenticity or closure.

The story in question consists of a brief reference to a suicide in André Fontaine's account of the Camp des Milles. Much of his narrative is based on accounts from locals in the town of Les Milles to whom he talked in

---

17  Brozgal's own study of the 'anarchive' is based on the massacre of Algerians by police in Paris on 17 October 1961 and the ways in which the 'absent' archives from the period have been supplemented by different forms of creative response.

the 1970s. Fontaine provides a chronology of events from the summer of 1942. This echoes yet also contradicts the diary of Pasteur Manen, who worked at the camp and intervened to save as many of the internees as he could by offering proofs of their status as Christians. Official records from this time are patchy. The records from the camp (now housed in the Bouches-du-Rhône departmental archives in Marseille) which indicate the number of internees, employees and deaths are missing from July 1942 onwards.[18] Up until that point there had been very few deaths in the camp, fewer than one per month. The absence of death despite the food shortages and lack of proper sanitation is most likely a result of the transferral of very sick internees to hospital.

The story involves a woman who allegedly jumped from the window with two babies or small children in her arms. According to the story, neither the woman nor her children survived the fall. Fontaine recounts this in his book and claims he is citing Swiss pastor Paul Vogt. Yet Vogt's text does not appear in Fontaine's bibliography. It has also not been possible to track down its possible source amongst Vogt's publicatons and reports. Did this really happen? Is this part of the same folklore of Les Milles which also sometimes phantasmagorically numbers Walter Benjamin amongst its internees? There is no direct mention of the mother in Pasteur Manen's diary.

While it is possible that Manen was not present at the camp when it happened, it is unlikely he would have not been aware of such an act or unaffected by it. It is possible that he could not bring himself to document it, yet his diary attests to a responsibility to report on what was happening at Les Milles as it happened. He finishes his account of 10 August, the date when the first train arrived at Les Milles (although it only finally departed at 8 a.m. the following day), with the following statement: 'Nous ne pouvons clore le bref compte-rendu de cette journée sans mentionner qu'un homme et une femme se sont ouvert les veines et ont été transportés à l'hôpital dans un état désespéré' (2013: 21) [We cannot conclude the brief report of this day without mentioning that a man and woman slit their wrists and were taken to hospital in a desperate state].[19]

---

18  On writing to the Bouches-du-Rhône administration in 1962 to request the files pertaining to her internment at Les Milles, Anna Schafir received a letter from the department dated 2 March 1962 stating that the files had been destroyed at the request of the Nazis (MdS MXII_11726).

19  According to Fontaine's account, this was the writer Moritz Bardach and his

There is no judgement in Manen's writing of those he documents who made deliberate attempts on their own lives. In the days that follow the departure of the first convoy, references to suicides nevertheless take the form of statistics, which comes from his recognition of the need to record objectively (whether this is simply for his own peace of mind at a moment filled with urgency and chaos or out of an awareness of the wider necessity of bearing witness): 'Mardi 11 août [...] Deux tentatives de suicide [...] Mercredi 12 août. Dix tentatives de suicide marqueront cette journée hallucinante' [Tuesday 11 August (...) Two suicide attempts (...) Wednesday 12 August. Ten suicide attempts will mark this horrific day] (Manen, 2013: 22). Nothing is indicated in these entries as to whether these attempts were successful or how the internees tried to kill themselves. These numbers also diverge quite significantly from those suggested by André Fontaine based on other accounts from the afternoon of 10 August:

> Les évanouissements se succèdent dans la cour. Nombreuses sont également les tentatives de suicide, seize dont deux ont une issue fatale, d'après Hans Fraenkel, cinquante dont six morts selon l'UGIF. Le chiffre six est sans doute exagéré. (1989: 144)
>
> [People fainted one after another in the courtyard. There were also numerous suicide attempts: sixteen of which two were fatal according to Hans Fraenkel, fifty of which six died according to the UGIF [Union Générale des Israélites de France]. The figure of six is probably exaggerated]

These discrepancies attest to the chaos at the camp around the time of the first deportations as well as the general secrecy surrounding what was happening. A report issued from Vichy on 24 July 1942 concerning the transfer of women housed at the Hôtel Terminus des Ports and Hôtel Bompard to Les Milles indicates that there should be no visitors to the camp until after the departure of the convoys. It also suggests precautions be taken to avoid escapes and suicides.[20] A local police report issued on

---

wife Lucie. It was possible to find a camp record for Bardach and Lucie (née Rosenberg), who had previously been at Rieucros and then Hôtel Bompard. There is no mention of the attempted suicide or what happened to the couple subsequently in the Bouches-du-Rhône archives. Lucie Bardach may have escaped to Switzerland in October 1942 (see Fivaz-Silbermann, 2020).

20  Rapport de la direction police du Territoire et des étrangers, 'Renforcement du Camp des Milles', Vichy, 24 July 1942. Reproduced in *Récits du Camp des Milles* (2015).

suicides in the camp, dated 16 August 1942, mentions the death of a doctor and his wife at the hospital in Aix-en-Provence following consumption of narcotics. The report also notes ten other suicide attempts: seven men and three women, six by narcotics, four by lacerations to the wrist. This information is followed by the brief reflection that the 'foreigners' were aware of what awaited them: 'exécution massive' [mass execution], a brief yet direct acknowledgement that the authorities were fully aware of the ultimate purpose of the deportations.[21] There is no mention of defenestration whatsoever in the report.

In the memorial space of Les Milles, stories of suicides are presented at various points throughout the exhibition. Witness testimony is presented from survivors who had been children or adolescents at the time of the deportations. An account by Manfred Katz features in the introductory video that all visitors must watch at the start of the exhibition.[22] Katz describes how, following the arrival of the train opposite the factory and the initial boarding of people into the trucks, women jumped from the second floor of the building. A different, more detailed version of this event is offered in video testimony from another survivor in Part 3 of the ground-floor exhibition detailing Les Milles's role as deportation camp. He describes how they could hear the cries of women and their children without seeing what had happened but learned there had been suicide attempts. The next day, windows had been cemented up.

The documentary film *Récits du camp des Milles: l'engrenage fatale* (2015), partly filmed within the memorial space, includes a moment where a tour guide shows the suicide window to a group of teenage girls. The window remains open, she points out, in memory of those who jumped. According to the film's voice-over, there were around 20 suicide attempts via the upstairs windows including a mother and her child.

Based on these multiple accounts of suicides which cannot be confirmed or denied, the window and the 'cone of vision' onto which it looks out, crystallize a moment in Les Milles's history. The moment

---

21 Rapport de l'Adjudant, Commandant la Brigade, 'Sur des suicides et tentatives de suicide, au Camp des Milles', Aix-en-Provence, 16 August 1942, Service Historique de la Défense [reproduced in *Récits du Camp des Milles* (2015) and as a panel within the memorial museum].

22 Manfred Katz's account of the camp is also available as part of a short film *Histoire et témoignages* (2009) hosted on the Camp des Milles website: http://www.campdesmilles.org/videos.html.

when time implodes. August 1942. On 3 and 4 August, women were transferred from various sites in Marseille including the Hôtel Bompard, the Hôtel du Levant and the Hôtel Terminus des ports. Some of the women interned in these requisitioned hotels had come from other camps across the south including Gurs.

The records of these women consist of the files that were kept at the various hotels which made their way into the Bouches-du-Rhône departmental archives (ADBR 7 W 108-112). Digitized versions of the files are also available for consultation in the Documentation Centre at the Shoah Memorial in Paris. This is where I first encounter them and begin my search for these unnamed women who jumped. Details of transfer to Les Milles is added in dark red ink at the top of the brown cardboard records. Sometimes it is covered over using a lighter red ink. A later annotation in light blue dating from the 1950s indicates the fate of many of the women sent to Les Milles – the subsequent transfer (often via Drancy) to the gas chambers in Auschwitz. Trawling through document after document looking for something that is missing, it is easy to become systematic, caught up in a process of elimination, the irony of which should not be lost.

In *Concentrationary Memories* (2014), Griselda Pollock focuses on the lesser-known artist Charlotte Salomon, who spent time at Gurs before being deported and murdered at Auschwitz. Pollock talks about the moment of finding her in the archives and the conflicting feeling of excitement and sorrow in finding what one is looking for amongst the lists of the dead, amongst the lists of those who died in the camps. She also talks about the irony whereby the artist is first acknowledged as such in these archives. She has been put down as 'designer' and, as Pollock points out, this not only distinguishes her from most of the women who are listed as *ohne*, referring to the fact that they are 'without' profession (2014: 164) but it also implies a sense of agency in being able to refer to herself as such. Designer rather than artist, since this would have made her more employable within the camp:

> Not having a culturally recognized 'name' and hence being nameless was a considerable factor in the ultimate destruction of Charlotte Salomon. Had she been 'someone', had she had a 'name', her encounters in Gurs might have become her lifeline, because Gurs played an important role in the story of the rescue of European artists and intellectuals caught up by internments in France firstly in 1939, for the men and in 1940, for the women. Names are, however, linked with the sign of both dehumanization and salvation within this system: lists. (Pollock, 2014: 163–64)

Pollock's interest in Salomon lies in the potential of her art and life to enact what she terms a 'concentrationary memory'. The notion of a concentrationary memory is structured around the void of her existence and death in the camps of France and Auschwitz. The artwork she produced before 1942 is read by Pollock as an aesthetic resistance to life in the 'hell-hole' of Gurs. It is not a representation of Gurs or even an acknowledgement of the camp. In place of the camp, it takes up other, often violent, subject matter: 'She could paint bloodied suicides, abusive sexual assault, attempted rape, escape, solitude, and even pose the question of killing herself. But she would not bear witness to what she had seen in Gurs' (2014: 189). It is this refusal to bear witness to the camp that Pollock finds so compelling and so necessary a supplement to existing representations and narratives of the camp. It is a refusal that 'might be the indexical sign of a traumatic expulsion or a conscious decision to create an aesthetic counter-memory that delineates the concentrationary by means of creating images of life (art and music) and even of other kinds of death'.

Yet, unlike Pollock, I am not looking for a name or even a profession. There is no such trace, no body of work that can offer up some kind of memory. There is only the void, the absence, the *ohne*. This makes my search all the more macabre. I am simply looking for a cause of death. Defenestration. Or, more specifically, the defenestration of a woman with two small children. The archives I am searching through have been digitized. I do not even get to touch the files, the documents, to feel their fragility, to trace the lines of the fountain and ballpoint pens that have completed, updated and ultimately signed off on these women. Instead, I just click through a seemingly endless list of jpegs. I don't get to feel the weight of the dossiers. There is no sense of gravitas in a jpeg. I begin by wanting to make a note of everything. Details that will not bring me closer to the name I am looking for or the circumstances of a life rendered anecdote, a cautionary tale told with a sigh. I cannot possibly note everything, so I become more efficient. The clicking gets faster. I don't have much time left in Paris. But it is disconcerting how easy it is to dismiss hundreds, thousands of lives as irrelevant. Of course, they are not irrelevant. Each life, each story must be told at some point, to someone.

After 12 August, Manen ceases to write a diary, he is so taken up with the events at Les Milles and therefore unable to coherently write down all that he is witnessing. He resumes his account in September, after the final convoy leaves Les Milles, during a short break taken to

recover. It is possible to note a different style in this second part of his account compared to the first which attests to a more frantic attempt to note down everything of apparent significance as it comes to him. Together the two parts form an important testimony not only to the events themselves but to the difficult task of witnessing and documenting one's testimony.[23] In this later account, which includes details of the arrival of those subsequently rounded up from the Bouches-du-Rhône region after the first convoys had already left Les Milles, Manen does refer to one young woman's suicide by defenestration recounted to him by her parents:

> Les récits que nous avons entendus de la bouche des victimes elle-mêmes formeraient à eux seuls une anthologie de douleurs. Que de foyers brisés, que de bonheurs paisibles détruits, que de dignités piétinées, – et ceci en quelques minutes par la tornade effrayante! Ces parents qui ont vu leur jeune fille se précipiter par la fenêtre et s'écraser au sol pour échapper au sort qu'elle prévoyait! (2013: 29)

> [The accounts that we heard from the mouths of the victims themselves alone would form an anthology of pain. Nothing but broken homes, simple pleasures destroyed, dignity trampled – and all in the space of a few minutes by this terrifying tornado. These parents who watched their young daughter jump to her death from a window to escape the fate that awaited her!]

Fontaine also cites a further example of defenestration during the police raids in Marseille. This was recounted to him by Austrian survivor Elizabeth Steinitz. Steinitz had been about to emigrate to Mexico but was arrested towards the end of August. In a letter to Fontaine dated 6 June 1984, she recounts how a young Polish refugee attempted to escape the round-ups by jumping from a second-storey window. She survived both the jump and the war and, according to Steinitz, settled in London (Fontaine, 1989: 210).

I do not succeed in finding a name or names of those who jumped at Les Milles. This does not mean those names do not exist to be found. But what I do find, much later, is a photo. It is one of a series taken at the Hôtel Bompard by Resistance photographer Julia Pirotte shortly

---

23 Manen's son, Bertrand, has suggested in *Récits du camp des Milles* that the reason his father kept a diary was because what was happening was so unbelievable that without a written record one could easily think one had imagined it or cease to believe it had really happened.

before the transfer of women and children to Les Milles in July 1942.[24] The photo is of two very small children, babies really, both about a year old. At first glance they look like twins. The caption reads 'Bébés jouant [babies playing], camp de Bompart, Marseille (Bouches-du-Rhône), France, 1942' (MdS CIII_272). One of the babies is sitting on a large pillow placed on a wooden chair. The other is standing on tiptoe and kissing (or biting) the first baby's leg. In the background, it is just possible to see the sandal-clad foot of a woman. The photo leaves me cold. It is such a joyful image, and the babies are chubby and healthy. What happened to them in the days and weeks that followed?

## Suspended Lives

The story of the suicide window also captured the imagination of Rawas, as seen in his immersive play, *Les Milles – empreintes*, which was introduced briefly in Chapter 1. The rumour recounted by Fontaine is turned into a key moment in Rawas's script but one where the action takes place off-stage. In this fictionalized version of the events of summer 1942, one of the women transferred to Les Milles, Sophie (wife of internee Heinz Müller), covers herself in petrol and sets fire to herself as she jumps from the window. The guard who witnesses the act recounts how she jumped with her two children: 'on a vu leurs vêtements et leurs doudous, elle a allumé puis elle a sauté' (Rawas, 2021: 141) [I saw their clothing and their comforters; she struck a match then jumped]. As it turns out, the children's clothing is a ruse. Sophie has faked their deaths to ensure they can escape to safety. The fire ensures certain death for her but makes it harder to identify what or who remains. Rawas's interpretation of events renders Sophie's act a definitive act of heroism and self-sacrifice. The ambiguity of the act of jumping from the second floor is removed. Yet we never see Sophie on stage. She is only referred to by others. Even in this fictional version, she does not get to tell her own story.

What does it mean to jump from an upstairs window? We will never know what it meant for the women who jumped but clearly it should not be reduced to a tragic fatalism nor romanticized as an ultimate act of

---

24 The series, which is part of the collection donated by Julia Pirotte, has been digitized and is now searchable on the Shoah Memorial database (https://ressources.memorialdelashoah.org/).

resistance or survival. Both positions are in play simultaneously. It must also be understood in relation to the different temporalities playing out in Les Milles in August 1942. The interminable wait, the suspension of time in the internment camp coupled with the rush each day to acquire transit papers, departure visas and boat tickets.

We do not get to hear from the women themselves. Scholarly reflection on suicide as a phenomenon of the Holocaust focuses on the male intellectuals who killed themselves both during the war and decades afterwards (Nusan Porter, 1994). Instead, we might turn to Joan Ringelheim's research on the different experiences of women during the Holocaust, which includes testimonies from those who survived Auschwitz and other camps. These include references to the threats posed to mothers whose babies cried and to the different ways in which suicide was contemplated. In exploring an appropriate feminist framework in which to read and understand the testimonies of women without over-reifying these and/or reducing these to some form of biological determinism, Ringelheim ends up with a list of questions. Questions that don't produce answers, just more questions. Among them is how we understand survival and resistance within the camps as well as the conflation of the two, survival *as* resistance, resistance *as* survival:

> What is resistance? Is anything an oppressed woman does an act of resistance? Is survival resistance? What if a person kills herself? Does suicide then become resistance? If suicide is sometimes an act of resistance, is it always so? Is dying resistance? Is courage resistance? Is singing on the way to the gas chamber resistance? Is maintaining the Jewish religion resistance? Is stealing resistance? Is hiding resistance? Escape? Is helping resistance? Is sabotage? Is killing the enemy resistance? See how the term becomes neutralized – worse, destroyed. Such slippage in language suggests that all Jews became heroes or martyrs and all women heroines. Can that possibly make sense of what happened? Do descriptions of the lack of active or armed resistance against the enemy (either by the Jews or women or others) have to lead us not only to defend what they did but also to glorify it, to make of it what it was not? And so we reach what has become a common feminist position: Survival is resistance. (335–36)

I find this line of questioning helpful and have reproduced a fairly lengthy quotation since it shows the evolution of Ringelheim's thought process. Seeing this process laid bare reassures me that slippages in the language we use to make sense of these accounts are both inevitable and yet perhaps tell us more about our own preoccupations, what we are looking for, than about the experiences of the women in the camps. In being

careful to avoid reductive readings which identify women's experiences of the camps as intrinsically different, the spatiotemporal experience of Les Milles is nevertheless gendered due to the earlier separation of men and women. The arrival of women at Les Milles marks a different moment, that of the deportations, from the longer operation of the camp as an exclusively male site of internment. At the same time, the transferral to Les Milles from sites in Marseille marks not only a shift inland and, in a sense, away from the highly visible infrastructure of escape via emigration but also from smaller hotel residences such as the Bompard to the intimidating architecture of the tile factory. It is not unreasonable to speculate on how arrival at Les Milles would have marked an intensification of the camp experience for those previously based elsewhere in the region.

Fontaine, Manen and others attempt to document this intensification of competing temporalities in their accounts of the deportations. The sudden transfer of women to Les Milles and the (albeit temporary and generally fatal) reunification of families at the camp brings a momentary end to the suspended lives lived in separation. But this is succeeded by the arrival of the trains. A train, symbol of movement, of crossing land, of physical displacement but also of waiting, of suspension, of (even for regular journeys) remaining in the same, confined position for hours, days on end.

To what extent might we think about the women who jumped, about whom we know so very little, *traces of traces* (to adopt a phrase often used by Lanzmann), as enacting a further suspension? A suspension of the already suspended time of the camp and the suspended time of the train journey. To jump from the upper window involved the crossing of a threshold, a limit, an act which halts, if only temporarily, the crossing of all the limits, all the thresholds that mark out the networks of camps and railways across Europe. Is this suspension of suspensions where we might find what Walter Benjamin referred to as 'splinters of messianic time'?

Benjamin, who took his own life at the Spanish border in September 1940, wrote his essay 'On the Concept of History' sometime in the late 1930s or in 1940. As a philosophical response to the rise and spread of fascism across Europe, the text includes a call to the historian to rescue the oppressed from the vicissitudes of History. 'Only that historian will have the gift of fanning the spark of hope in the past who is firmly convinced that *even the dead* will not be safe from the enemy if he wins. And this enemy has not ceased to be victorious' (2005 [1940]). It is also

a warning against the failure to understand the 'state of exception' or 'emergency' as that which defines the rule of law itself. The Camp des Milles, marked as it is by the productivity of its internees, embodies this emergency state, the extralegal space surrounded by barbed wire which sees the law coming into its fullest operation.

Writing in another context, that of slave suicides, Kathryn Yusoff describes an archive sketch dated 1817 of a woman mid-jump located in the collection at the National Museum of African American History and Culture. The (anonymous) woman who, according to the accompanying text, jumped out of the window after her husband was sold into slavery, remains suspended in mid-air.[25] Her physical suspension is coupled with that of temporal suspension – the moment where something different might be possible. As Yusoff suggests: 'In the geophysics of this image of the suspended woman, gravity is both the problem and the solution, rendering her invulnerable, held in the possible, awaiting a different tense of being'. (2018: 93).

Indeed death is rarely certain when one jumps from a second-storey window. Rawas's retelling requires supplementing defenestration with self-immolation to overcome this uncertainty. To jump might also be conceived of as an attempt at survival and an assertion of agency at the point of complete hopelessness. This seems to be the assessment pronounced by the anonymous internee from Gurs whose account of her failed suicide is cited by Grynberg:

> Je suis actuellement à l'hôpital, parce que j'ai fait une chose ou, plutôt, j'ai voulu faire une chose qu'on ne doit pas faire, j'ai été sauvé avant. J'en avais assez et je ne voulais plus continuer à participer à cette folie mondiale. Je me demande si je reverrai Alice, car le monde est si fou. Où chacun de nous finira-t-il son existence? [...] Je n'avais pas envie de continuer. Appelle cela de la lâcheté si ti veux, mais pour cette lâcheté il faut du courage et on ne doit pas intervenir dans ces cas-là. Que deviendrons-nous? (27 November 1940, ANF AJ/41/505 cited in Grynberg, 1999: 158)

> [I'm currently in hospital having done something, or rather, I wanted to do something that one must not do but was saved before it was too late. I had had enough and I didn't want to take part in this crazy world anymore. I wondered whether I would see Alice again since the world is so crazy. Where will each of us end their existence? I didn't have the will

---

25  Jennifer Boum Make (2022) discusses the possibilities for a literature of 'care' in relation to the story of the anonymous African women who jumped from the slave ship *Le soleil* in 1774 as creatively reimagined in *Humus* by Fabienne Kanor (2006).

to continue. Call that cowardice if you want, but this kind of feebleness requires courage and one shouldn't intervene in that case. What will become of us?]

This short extract deserves further attention. The writer shifts frenetically between temporalities and modalities: the definitiveness of her act is undermined by its failure yet she refuses to downplay the strength of her previous convictions. It is unclear whether she is relieved to have been 'saved'. Her hopes of seeing 'Alice again' are juxtaposed against the despair she continues to feel about the future – 'what will become of us?' It is the impossibility of making the right decision attested to here and the contradictions of her statements that invite our empathy.

The problem with Rawas's rewriting of the defenestration at Les Milles is that it attempts to remove any ambiguity surrounding the act and consequently any discomfort caused in those encountering a story in which a mother jumps with her children. The story is reimagined instead as a redemption of the anonymous woman who may or may not have taken her children to their deaths. In her examination of narratives of female suffering and female violence, including filicide, Kathryn Robson draws on contemporary French women's writing to explore how such stories can create space for ambiguity and discomfort as a necessary part of empathy. As she argues, 'empathy is not a definable response to a closed narrative, but a renegotiated relationship through which alternative narrative versions might be opened up' (2019: 92).

In the context of Les Milles, we might associate this idea of 'alternative narrative versions' with Azoulay's notion of 'repaired citizenship'. To 'repair' the quite literally destroyed citizenship of those who jumped or boarded the trains is to refuse to fix their identities in terms of loss and death. In focusing on the moment of suspension evoked by Yusoff, we might think of the window as the starting point for an infinite number of possible futures. The question 'what will become of us?' written by the anonymous internee in Gurs is no longer imbued with despair but henceforth possibility. Furthermore, while standing at the second-storey window invites the possibility that we can 'bridge the gap' between us and the women who once also stood there, such a possibility cannot be cathartic or result in any sustained form of identification. As Robson suggests, 'The point is not to deliberately refrain from attempting to bridge the gap, but to avoid the temptation to assume that the gap can be bridged without registering the discomfort – or awkwardness

– that it generates' (2019: 93). The fragments of stories and the silences surrounding the women at Les Milles call upon us to find out more, to look for the details that would fill the gaps. Yet, ultimately, such answers would not bring us any closer to understanding what happened. It is the recognition of the impossibility of understanding that defines the act of secondary witnessing as a form of ethical spectatorship at Les Milles.

In identifying the wider iconography of the cattle truck within Holocaust and Second World War memory, the primary focus of this chapter has nevertheless been those who did not board the train. The aim has been to place the story of the woman or women who jumped, which is barely a trace of a story since there are no real details, at the centre of Les Milles. It acts as counterpoint to the two other narratives highlighted previously. The first being the notion of artistic endeavour amongst male internees which, given the relative wealth of material available, allows this to frame Les Milles and affirm the productivity of its operation. The second is the myth of resistance directed towards those outside the space of the camp. Manen's diary is key to countering this. The impossibility of saving everyone against systemic oppression, exclusion and extermination eventually reduces his role to a witness or onlooker to the mass deportations. There is, moreover, a need to reposition agency within the camp.

Yet this must be done with a view to assigning agency to all placed within its space. An agency which should not be elevated to blanket resistance, heroism or martyrdom, as Ringelheim warns, but rather in terms of simple hope. Those who boarded the train did so not with fatalistic resignation or even naivety about what awaited them at the other end. It is not naive to believe in a basic notion of humanity that values all human life. It is not naive to place one's faith in a republic founded on the notion of the universal rights of man. As survivor of Camp des Milles Herbert Traube puts it: 'Comment se fait-il que des gens, […]

des gens que nous devions considérés comme nos protecteurs étaient, en fin de compte, nos bourreaux, comment se fait-il?' [How is it possible that the people, […] the people we should have considered our protectors were, at the end of the day, our executioners, how is it possible?] (*Récits du camp des Milles*, 2015).

It is not naive to believe that the government that has thus far provided you with basic necessities will not abandon you to your death let alone facilitate it. It is not naive to believe that complying with the authorities will ultimately assure your protection and safety even after

loss of citizenship, employment, status and property. As Charlotte Delbo so precisely puts it – 'they expect the worst – they do not expect the unthinkable' (1968: 6). To board the train was also to put an end to the suspended time of the camp, even if this simply meant swapping one camp for another where conditions were largely unknown. It is also important not to underestimate the desire for movement after months of stasis.

Thus, it is not through the experience of the inside of the wagon or its reframing as artwork that we are offered the opportunity to 'witness'. This occurs instead via a different form of embodied viewing experience which keeps us outside of the wagon quite deliberately, but which nevertheless highlights the abject horror of its interior precisely by keeping us at a distance – the very distance from which those detained at Les Milles would have first seen the trains arrive. Indeed, at all sites of atrocity there are points which allow for some kind of embodied identification with the gaze of the victim. Sometimes this takes the form of an initiation, a passing through a door or gate. Baruch Stier provides a detailed account of how a cattle truck was originally used as part of a ritual passing through at the Holocaust and Human Rights Museum in Dallas, Texas.[26] However, while passing through the gates marked 'Arbeit Macht Frei' at Auschwitz must surely constitute the most sinister of such tourist experiences, this notion of passing a threshold is not a feature unique to Holocaust memorials but can also be found at sites dealing with other forms of atrocity.[27] A notable example is the 'Door of No Return' which forms part of the Maison des Esclaves [House of Slaves] on Gorée Island in Senegal. Visitors are invited to look at the Atlantic Ocean through the door that slaves were said to have passed through on their way to the galleys. However, since the 1990s scholars have generally discredited the historical accuracy of this claim and the door (along with the island more widely) has come to represent a symbolic performance of memory.[28]

26  For a brief account of how the 'boxcar' is used today, see https://www.dhhrm.org/exhibitions/holocaust-shoah-wing/.
27  See, for example, the chapter 'Crossing Imaginary Borders' in Alvarez (2018: 106–29).
28  Historians have argued that while around 33,000 slaves may have transited through Gorée, earlier claims that millions passed through the island and, indeed, the Maison des Esclaves, have been largely discredited. The island has been visited by various politicians including Nelson Mandela and Barack Obama. Critics of the Gorée myths point to the way in which this shifts attention from other sites across

The view of the train from the window at the Camp des Milles does not invite this type of ritualistic 'passing through' but instead a halt, a stopping short. Before pursuing the paths and trails that lead us out of Les Milles in Chapter 4 and, moreover, the wider, global mobilities within which the history and memory of Les Milles will be situated in Chapter 5, it is worth pausing to reflect briefly on this enforced stopping. We cannot go where those who stood here before looking out went, we cannot follow them. Does this produce paralysis or perhaps allow for a stillness? A stillness against forced movement. Against the forced movement of the deportees. But also against the curated movement around the museum, the movement of time, the progression of history, the narrative arc which ends not with the deportations but the 'science' of understanding and the affirmation of the righteous.

Senegal that were central to the transatlantic slave trade. For a discussion of the various debates and memorial stakes around Gorée Island, see Forsdick (2015).

CHAPTER FOUR

# Landscape

The Wagon du souvenir at Les Milles is without doubt the most striking object or marker framed within the view from the second-storey window. Even if we have encountered similar wagons at other museums and memorials, its location next to the railway tracks gives it a *sitedness* that brings home the experience of deportation for Jews living in the south of France in 1942. Leading up to the wagon is the Chemin des déportés. On the left-hand side of the *chemin* there is a small landscaped area described in the memorial guide as an 'area of reflection'. This consists predominantly of a large patch of grass, kept short but far from resembling a carefully manicured lawn. A few small boulders have been placed at the far end near the wagon. These provide informal seats for anyone who chooses to pause and rest. A row of pines and smaller shrubs block a direct view to the railway tracks and the old station building further along. The patch of vegetation is little more than a curated wasteland. It breaks up yet also exists in continuity with the dusty yellow landscape on either side, which also includes the museum car park. It is an unassuming space intended, I imagine, to mark off the Wagon of Remembrance and the *chemin* leading up to it without distracting from these. But it is precisely as an unassuming and easily overlooked piece of land that this area is of interest. I feel this interest lies in the fact, suggested by W.J.T. Mitchell in his eighth thesis on landscape, that landscapes are boring (2002: 5).

Although we are not supposed to define landscapes in this way, to recognize they are boring whether due to cliché or banality is necessary to understanding how geography works to both acknowledge and forget multiple, complex and, indeed, violent histories. In his provocation, Mitchell is of course referring in the first instance to views and vistas considered indisputably breathtaking, awe-inspiring, sublime. It is the indisputability that makes them boring. Views which we have already

seen in advance of visiting a place, indeed often the reason we choose to visit one place as opposed to another, views which are endlessly reproduced on postcards, photographs and paintings. Such landscapes, traditionally conceived, offer up a view of a world which affirms the power of nature, seemingly unmarked or unmodified by human activity. Or they demonstrate human mastery of nature in the form of the cityscape, the skyline dominated by skyscrapers or suspension bridges spanning large expanses of water. It is only more recently that the ravages of human activity, war and industrial capitalism have come to be acknowledged, appreciated even, as alternative spectacles in the form of deathscapes. These landscapes, at least in the Global North, while leaving indelible marks upon both land and community, are often temporary (Mayo, 2009), with the sites subsequently reimagined and rebuilt according to the demands of the real estate market. The repurposing of the space is planned and framed in terms of renewal and regeneration whilst collective memory is curated in ways that will contain, control and limit the contours of the deathscape.

Whether they attest to the wonders of nature, the majesty of human endeavour or the potential of both nature and humans to damage, destroy, ravage, desecrate and efface, such landscapes are boring. Boring in their fatalism, boring as a foregone conclusion, boring in the way they hold us at a distance, boring in the privileging of sight above sound, smell and touch. Boring in the hold these flattened images have on what is both a landscape and a deathscape. What I see when I look out of the second-storey window is unquestionably a deathscape yet one that is dwarfed by the dramatic and timeless landscape of Provence.

This chapter is an attempt to navigate between the different 'scapes' that lie beyond the memorial museum. The wider camp landscape and its commemoration will be explored using the outdoor reflective area at Les Milles as a starting point. Given the relatively late inauguration of Les Milles as a memorial site in 2012, earlier examples including the gardens at Musée de la Paix in Caen and the Mémorial aux martyrs de la déportation located behind Notre-Dame in Paris will be briefly examined as a form of contextualization. Alongside these, the specific landscape of Provence will be drawn upon as backdrop to the camp and, notably, as aesthetic inspiration to many of the artists interned there. Beyond the Montagne Sainte-Victoire, the wider networks, journeys and horizons that formed life for those attempting to leave France in 1942 will take us to other lesser-known spaces such as the Hôtel Bompard

in Marseille. Many of the paths were taken on foot or using public transport. The places and spaces explored are not arbitrary since they are all, in some sense, connected to Les Milles, but certainly do not follow any replicable itinerary or result in an exhaustive mapping or even counter-mapping of France's use of camps during the Second World War and their subsequent forgetting or commemoration (and sometimes both). At stake is an attempt to signal the uneven and fragmented memorial landscape, suggesting that while official forms of memory might offer a starting point to our own secondary witnessing, it is often necessary to deviate from the beaten track, carving out our own paths, routes and trajectories. Moreover, this form of secondary witnessing is further shaped via other accounts (both textual and visual, documentary and fictional) of landscapes and the journeys taken to find them. Finally, the chapter also considers what it means to return to sites of mourning and memory both intentionally and unintentionally. Such an exploration of landscapes is also intended to lay some of the groundwork for Chapter Five as it moves beyond discussion of war memorials in mainland France to consider a more global network of camps within the wider context of the French colonial occupations both before and after the Second World War.

## What Is a Landscape?

As the result of considered design decisions, the small reflective area at Les Milles provides certain insights into the role of landscape in the memorial both at Les Milles and the wider context of both Vichy and the Holocaust. While the wagon was installed before the tile factory was turned into a memorial, the landscaped area forms part of the more recent wider memorial project and is important in understanding the contemporary memorial agenda in France. As will be explained later in the chapter, the area itself has undergone certain small modifications since my first visit in August 2015. Such changes emphasize the memorial site as a space in flux and, in a sense, confirm an agenda directed towards the future rather than one that is concerned with a crystallization of the past. Yet these changes, in both their narrative and materiality, contribute to a sense of permanence and longevity. We might understand this in terms of an 'accelerated' form of memory work taking place across France over the last decade. For those involved in it, there is an urgency to this work, a *making up for lost time*.

At once a clearly delineated space and part of a wider terrain, the space also provides a starting point for thinking about the notion of a memorial landscape beyond carefully curated interior spaces such as the museum with its prescriptive layout and information overload. Indeed, it is via the view of the landscaped area that the heavily securitized, self-contained interior space of the tile factory turned museum is reconnected with the outside world. As suggested in earlier chapters, the window offers a way out of the museum. A way out which should not be considered as being at odds with the interior curated space but, rather, as fundamental to the function and relevance of the twenty-first-century museum. Thus conceived, the window ceases to represent an escape but acts as an opening onto the world. This takes the form of an invitation to assume responsibility for one's own understanding, an ethics of secondary witnessing directed towards the threats presented within our own current political moment in Europe and beyond. The landscape immediately in front of us, below us, grounds this invitation, suggesting a series of paths starting with the Chemin des déportés.

At the start of *Landscape and Power* (2002), Mitchell sets out the case for thinking of landscape not as a noun but a verb (1). In other words, he issues a call to think of landscape as a practice, an act, a process rather than an object, a scene, something we believe we can capture or possess, if only temporarily. But in thinking of landscape as 'to landscape', we must inevitably also explore why we are so easily seduced by the idea of the landscape as object as much as by the landscapes we hold in our gaze if only momentarily.

Where an outdoor landscape is offered up often alongside a museum or exhibition space, this exterior area often provides an intentional contrast to a carefully detailed explanatory narrative found inside. The intention is to offer a space of meditation or reflection via a 'natural' or 'abstract' aesthetic which might take the form of a memorial garden, sculpture park or walkway. A particularly notable example of extensive landscaping can be found at the Musée de la Paix in Caen. As discussed in Chapter Two, the museum's overarching ideological narrative includes the affirmation of Allied intervention and a celebration of the different national identities of the Allied forces. This is something which extends to the large outdoor area behind the museum. Following the inauguration of the memorial park, which included the planting of the site's first tree by Israeli President Chaïm Herzog in 1988, three distinct landscaped areas have been created.

The first, created in 1994, is the American souvenir garden located to the left-hand side of the museum. The garden's main feature is a fountain which resembles a small waterfall. Walking beneath the water provides access to plaques acknowledging different regiments for their service in Normandy (MacDonald, 1994). The garden offers an image of rugged nature but one that is carefully controlled by human intervention. In stark contrast to the American garden, the Canadian memorial area opts for extreme minimalism and was designed by architecture students. Its centrepiece comprises a large granite slab inscribed with a quotation from Virgil, *Nulla dies umquam memori vos eximet aevo* [no day will ever erase you from the memory of time].[1] Via its simplicity, this space which is at the centre of the outdoor terrain, embodies an aesthetics of unrepresentability found at many war memorial sites and, as the museum's website, suggests 'invites reflection'. Finally, the British memorial garden provides a further departure from the two previous interpretations of the landscape. Inaugurated somewhat later, in 2004, it presents visitors with the deliberate artifice of a traditional English garden. One enters the garden via a pergola in the shape of a Celtic cross which marks off the space as distinct from the rest of the outdoor area. The garden is organized using geometrically shaped hedgerows and neatly spaced cypress trees along with busts representing different individuals who died in the landings. Exploring this part of the memorial space feels like entering the royal gardens in Alice in Wonderland. Considered in juxtaposition, the different memorial stakes emerge as less about commemoration of collective events and more about affirmation of the national identities of the Allies, defined here by contrasting rather than communal approaches to landscaping.

A very different example of memorial landscaping can be found a short walk from the Shoah Memorial building in the Marais, across the bridge to Île Saint-Louis then over to Île de la Cité behind Notre-Dame. It is here that we find one of the earliest acknowledgements of France's role in the deportations, the Mémorial aux martyrs de la déportation. The garden and the crypt were inaugurated by de Gaulle in 1962, evidence for some that French complicity during the Second World War had been acknowledged (see Nord, 2020: 219). De Gaulle himself maintained that responsibility for the deportations lay entirely with the Nazis and Pétain's unconstitutional Vichy government (Paxton, 1972: 236). The crypt is not located at a site specifically associated with the

1 https://normandy.memorial-caen.com/museum/souvenir-gardens.

deportations. Rather, it was designed by Georges-Henri Pingunsson and built on the site of a former morgue. In a certain sense the network of camps and process of round-ups was so ubiquitous, spreading across both the occupied and unoccupied zones, that no site can ever be representative of all the sites. No single site can do justice to the wider landscape rendered deathscape. The Camp des Milles perhaps comes closest in its attempt to map the network of camps, drawing on the very real materiality of its architecture to provide a reminder of what can easily disappear without a trace.

I arrive at the Mémorial aux martyrs just after they stop letting people in. It is early evening on the first day of summer in 2017. It is 24°C and there is a sense of celebration in the air, amongst the throngs walking through Île Saint-Louis. Buskers play, badly, on the bridge. I think about the garden here having already visited the memorial gardens in Caen. This could be just another square in Paris with its green benches and squares of grass. There is a small avenue with four trees, planted at equal distances and neatly pruned. This is carefully curated, geometrically consistent nature but not intended to attract attention, shock or surprise. Nature or, rather, horticulture must conform in Paris. The white stone gravel synonymous with French town squares crunches satisfyingly as people walk past. The pigeons here seem healthier, less abject than round the front of the cathedral. Despite the brass plaque and entrance to the memorial gardens, once you sit down the crypt disappears from view, making it is easy to forget its existence. There is a small sign amongst the bushes and a map of memorial sites in and around Paris is attached to the fence surrounding the grass. The meaning of this signage cannot be discerned without close, deliberate attention. It is as if the memorial is there in plain view for those who care but easily forgotten or overlooked by those who don't or who would rather not be reminded.

Both centrally located and hidden, the memorial offers an abstracted acknowledgement of the deportations, a symbolic gesture intended to obscure questions of responsibility. We should note the time lag between its design and inauguration and that of the 'jardin souvenir des enfants' [memorial children's garden] at the former entrance to the Vélodrome d'Hiver on rue Nélaton in July 2017, which marked the 75th anniversary of the round-up.[2]

---

[2] Prior to the creation of the memorial garden, the site was commemorated by a plaque and sculpture featuring statues of deportees huddled together. Details of

Such outdoor memorial spaces do not claim to be 'natural' but rather to curate elements of nature, to harness the therapeutic, reflective qualities associated with nature. Nevertheless, following Mitchell, we might consider how this 'landscaping' combines both modernist and postmodern understandings of landscape which simultaneously naturalizes the outdoor space of the memorial whilst providing visitors with a symbolic understanding of the space as cultural production. Yet even when a space of constructed or curated 'remembrance' acknowledges or incorporates the story of its inception and evolution into its presentation, such a story nevertheless also works to obfuscate the more complex cultural practices and political agendas at work across the space.

However, there is a danger in reducing the memorial landscape to someone else's project rather than thinking through our own engagement and encounter with the space as an ethical imperative that extends beyond a visit or a view. Is it possible that the memorial landscape can move us beyond passive consumption of a carefully curated history? How might the view offer us the potential for resistance proposed by the museum's narrative? This seems particularly urgent when the constraints of the exhibition inside the museum seem to contain and shut this potential down. Can such outdoor spaces engender a form of reflection that is not simply hopeless melancholy towards the past but rather meaningful, useful anger or anxiety directed towards the future? This book, considered as a project, offers some sort of affirmation of this semi-rhetorical question but, as has been evident all along, it is an affirmation which requires a relentless critique of the memorial and a deliberate refusal to smooth over its contradictions and exclusions. It has also produced a restlessness which has sent me in search of other memorial sites across France, some of which have made it into the book, some I am still yet to visit. There are always other places, other landscapes, other tragedies.

## Montagne Sainte-Victoire

In his account of Les Milles, André Fontaine describes the landscape around Camp des Milles as follows:

---

the garden design project can be found here: https://mutabilis-paysage.com/projet/jardin-des-enfants-du-vel-dhiv/.

Les environs du village, vallonnés, verdoyants, faits de vergers, cultures maraîchères, vignes, sont absolument charmants. On aperçoit à l'est l'aqueduc de Roquefavour qui approvisionne à lui seul presque entièrement la ville de Marseille, et à l'ouest la montagne Sainte-Victoire. Très souvent, les internés montent au grenier ou même sur le toit pour admirer le site que Paul Cézanne a immortalisé par une cinquantaine de toiles. Les nombreux artistes et autres internés s'extasient devant cette montagne toujours aussi belle dans sa diversité des teints et les flamboyants couchers de soleil. (1989: 13–14)

The areas surrounding the village, with their verdant rolling hills formed of orchards, market gardens and vineyards, are absolutely charming. To the east one can see the Roquefavour Aqueduct which supplies almost the entire city of Marseille and to the west the Sainte-Victoire Mountain. Often the internees would climb up to the loft or even the roof to admire the site immortalized by Paul Cézanne on fifty-odd canvases. Numerous artists and other internees were enraptured by this mountain whose beauty is defined by its shifting colours and flamboyant sunsets.

Looking out from the second-storey window, our vision is directed towards the memorial wagon and the Chemin des déportés. We are not high enough to take in the wider environs of Les Milles and the surrounding countryside. Instead, we find ourselves trapped between the respective positions of 'walker' and 'voyeur' identified by Michel de Certeau (1984 [1980]). However, revisiting the museum in summer 2021, I notice it is now possible to access another window, on the left-hand side of the suicide window [Figure 8]. This window, like all the others on the floor, had been blocked previously. Even now it remains closed, its panes covered in a grimy film. Yet through the dirty glass it is just possible to make out a hazy image of the Montagne Sainte-Victoire, the 'view from everywhere' (Smith, 2013). The view recalls the scene in *Les Milles: le train de la liberté* where Commander Perrochon looks desperately at the mountain from his office in the camp, as if it might offer him some indication of the whereabouts of the train and its passengers.

Fontaine's description of Les Milles is based on his visits during the 1970s, stories from the local population and accounts together with sketches and artworks produced by internees. At work in his writing is a synthesis of agriculture ('vergers, cultures maraîchères, vignes') and infrastructure ('l'aqueduc de Roquefavour'), a landscape marked by forms of human activity rendered ahistorical via their juxtaposition with the Montagne Sainte-Victoire. But most interesting here is the reference made to Paul Cézanne as the all-too-human artist responsible

Landscape 137

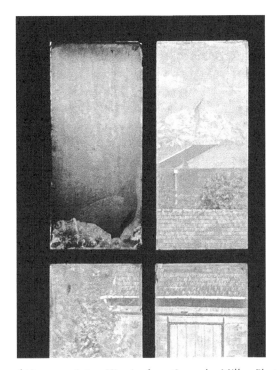

Figure 8. View of Montagne Sainte Victoire from Camp des Milles. Photograph by the author, August 2021.

for 'immortalizing' the mountain. The view from the roof has already been represented, imagined and framed. Although his work was not properly exhibited in Aix until the 1950s (Richardson, 1956), Cézanne would have constituted, and indeed still does, the aesthetic lens through which the landscape surrounding Les Milles and beyond was filtered. Having painted the mountain dozens of times, Cézanne is the region's local celebrity and features heavily in the cultural landscape of Aix.[3] According to Lipman-Wulf, Cézanne was the reason many of the artists interned at Les Milles had originally settled in the region (1993: 19). Nevertheless, in evoking the Aixois landscape as a source of inspiration for those interned at the Camp des Milles, there is a danger that even the surrealist nightmares of Max Ernst and Hans Bellmer become complicit in a collective evocation of a fantasy of an eternal France embodied

---

3  Although Picasso's estate is located in the small village of Vauvenargues to the north of Aix and the artist is buried on site, his presence in the region is far less pronounced.

in the nostalgic hyperbole of de Gaulle's memoirs. It is these ideas of essentialism and continuity, but also of exclusion, that I want to explore in more detail via the image of the mountain.

Although much of his work was produced in locations slightly north of Aix, his brother-in-law's property in Bellevue, south of Aix and only about 5 km from Les Milles, was also a viewpoint Cézanne used to paint his landscapes and in particular views of the Montagne Sainte-Victoire. To focus briefly on the mountain, its representation and symbolism, brings into relief some of the wider stakes of the memorial landscape. It allows for comparison with other sites such as Yad Vashem, Bergen-Belsen and the aforementioned souvenir gardens at the Musée de la Paix in Caen where more extensive landscaping has taken place in the service of specific ideologies of national identity:

> One should bear in mind that the Sainte-Victoire massif is visible from great distances (from up to 100 km) when viewed from western Provence, standing out as the single dominant mountain in the region. Such a topographical feature may have both attracted and repelled different groups of people over the centuries. (Walsh and Mocci, 2003: 65)

A limestone massif stretching approximately 10 km, Sainte-Victoire exists in isolation. It is not part of a larger mountain range but, as archaeologists Kevin Walsh and Florence Mocci have pointed out, exists as 'a detached upland situated within a lowland' (2003: 46). The mountain is about 1,000 m high while the surrounding topography, though undulating, is on average 750 m lower. It is this isolation which defines its dramatic appearance, particularly in contrast to the 'bourgeois, controlled landscape of Aix' (68). The mountain seems to operate as a 'barrier to the flow of people' (46). In contrast to the more fertile, verdant terrain of the surrounding lowlands, described by Fontaine in his account of Les Milles, the mountain itself is dry and dusty and forest fires in the early 2000s destroyed a large area of pines. Richardson (1956) has suggested that the cracked, dusty materiality of Cézanne's unvarnished canvases capture this aridity.

Although Walsh and Mocci together with a larger international team of archaeologists identify various forms of settlement on and around the mountain dating from the sixth century BCE, their suggestion that the mountain operates as a barrier is interesting, as is their undeveloped, tantalizing comment that the mountain may have been conceived by local populations, particularly in Roman times, as a site of refuge and resistance (2003: 107). Without overreading here, it is possible to conceive

of the effect the mountain might have had upon the imaginations of those interned at Les Milles. Fontaine describes this in terms of the aesthetic ecstasy of an artist given a chance opportunity to offer their take on a famous landmark and, in doing so, join the canon of artists who had done so previously. But the possibility of escape and protection, of resistance and refuge, offered up by the mountain must be coupled with a rugged, barren vulnerability, the risk and exposure it exhibits to human and natural elements. Moreover, just as access to the roof of the tile factory was indicative of certain privileges within the camp that were later withdrawn, the mountain, as always already framed by Cézanne's vision, attests to deep-rooted myths of access and exclusion that emerged in nineteenth-century landscape aesthetics across Europe. It is a variation of such myths that achieve fulfilment in twentieth-century Nazi discourses of *Blut und Boden* [Blood and Soil].[4]

Such discourses and their appropriation of nature provide us with strict warnings about the way in which memorial landscapes risk repeating a similar gesture in their endorsement of an understanding of the natural environment as innocent, neutral, set apart from the all-too-human architecture of camps and prisons. Here, the memorial space at Bergen-Belsen serves as a cautionary tale. Rob van der Laarse (2015) identifies the paradox whereby both Nazi-funded design technology and agricultural policy produced specific aesthetics whose popularity endured on a national and global scale after the end of the war whereas Nazi 'art' including Hitler's infamous watercolours became taboo objects, hidden away from the world. The greatest irony was the repurposing of sites formerly designed according to National Socialist ideologies of Teutonic death cults to serve as memorial spaces. Van der Laarse (2015: 362) describes how the same architects and environmental planners who had overseen the camp design at Belsen-Bergen under Himmler were employed to design the memorial space. He also suggests the camps had originally been designed with the very return to nature deployed in the memorial envisaged once their aim had been achieved. Embedded into the aesthetics of the camps was a natural aesthetic captured in the infamous photo album taken by Karl Höcker and often

---

4  For a relatively early study of the Nazi adoption of Darré's 'blood and soil' discourse, see Lovin (1967). Further reflection on the specific role of forest preservation within Nazi ideology can be found in Schama (1996, 82, 118–19) and Lekan (1999).

referred to simply as 'The Album'.⁵ The very few surviving sets of images of the camps taken during their operation are uncomfortable viewing, not because they depict torture and extermination but precisely because they don't. They feature deathscapes that do not look like deathscapes but holiday resorts. These serve as a disturbing riposte to the dominant images of the camps produced by the Allies towards the end of the war. But these other images are not the result of deliberate obfuscation or concealment. The camera has not been set up to lie but simply directed towards areas or scenes inside the camp the photographer desired to commit to memory.

Focusing on the presentation of key elements of the memory landscape, van der Laarse (2015: 366) points out how, for example, boulders once used to represent Teutonic death cults are now re-presented to the public as evoking sites of sacred Jewish ritual highlighting the obscenity of such a move. He extends his analysis beyond camp memorials like Bergen-Belsen to include other memorials including the stones at Hyde Park in London, which also received criticism for their bland abstraction (see also Cooke, 2000). The overriding conclusion here is that we should be wary of the essentialism presented by such landscapes which affirm continuity between fascism and democracy:

> Put otherwise, these 'anti-fascist, fascist landscapes' confront us with the uncomfortable possibility that Nazism still 'speaks'. Reframing the blood and soil metaphor in a new notion of the perpetrator's absence, these mystical, organic, decaying images composed of oaks and boulders mask the horrible sublime behind the fatal attraction of the innocent picturesque. For behind our nostalgic gaze upon historical landscapes lurk the traumascapes of modern society. (Van der Laarse, 2015: 369)

Within the wider memorial landscape of Europe, we return to the complicated issue of the memorial space *qua* art gallery that applies to much of the presentation at the Camp des Milles. This is supplemented by a further recuperation of the space outside the tile factory, the landscape imbued with the myth of natural timeless innocence coupled with a parallel myth of artistic creativity. This abstract notion of creativity captures and frames the landscape unshackled from the vicissitudes of capitalism, nationalism and genocide. It is this abstraction which also facilitates the airbrushing out of Cézanne's antisemitism

---

5   https://www.ushmm.org/collections/the-museums-collections/collections-highlights/auschwitz-ssalbum/album.

defined by his position on the Dreyfus Affair, something which should make us wary of using him as an artistic lens through which to filter the landscape around Les Milles.[6]

Recent scholarship on Cézanne and specifically the paintings he produced around Aix-en-Provence frequently expounds the analysis offered up by Maurice Merleau-Ponty in his essay 'Cézanne's Doubt' (1964). Paul Smith (2013) has carried out a useful study which links Merleau-Ponty's essay more clearly to his wider *œuvre* on perception and flesh via Cézanne's painting. Smith's analysis focuses on the purely physiological and mechanical processes of perception as manifest in the multiple viewpoints presented within a single representation of the Montagne Sainte-Victoire, suggesting that this multiplicity can and was produced solely via retinal motion rather than requiring a larger physical shift in viewpoint. Questions are raised about Cézanne's eyesight which seek to affirm the specificity of his embodied experience whilst nevertheless 'naturalizing' this as biological. The resulting emphasis is thus on artistic genius or creativity as a biologically rather than socially conditioned gift. An important counterpoint to this is Albert Boime's earlier discussion of Cézanne's artwork. Boime (1998) points out that Cézanne's unique perspective not only issues from privileged access to certain sites but also presents a view which naturalizes private property as protector of nature against the threats of modernism and its encroaching urbanism. According to Boime, this is the paradox of modernism in art. Cézanne enjoys privileged access to sites and viewpoints because of family wealth and connections which include the estate owned by his brother-in-law in Bellevue. Consequently, not only does Cézanne's work issue from sites denied to others but this exclusion or inaccessibility constitutes a key feature of his paintings.

As a spectator standing inside the museum and looking out, our view is directed towards the memorial wagon as exceptional scene. On my first return visit to Les Milles in the summer of 2017, a netting had been placed across the lower half of the suicide window, carving up the space into smaller plots of land and sky. This prevented a more peripheral view as it became more difficult to lean out of the window. Yet, despite

---

6   Much ink has been spilled in telling the story of how different artists responded to the Dreyfus Affair. See for example Nord (1998) and Kleeblatt (1987). Cézanne's reaction is considered muted in comparison to others, such as Degas. Nevertheless, the breakdown of Cézanne's friendship with Emile Zola is attributed to the artist's belief that Dreyfus was a traitor.

this 'restricted' view, it is impossible not to look beyond the 'cone of vision' to the wider Provençal countryside. The notion of the 'view from everywhere' which Smith uses to describe Cézanne's aesthetic rendering of the Montagne Sainte-Victoire might also apply to the deathscapes, now largely forgotten and invisible, that can be mapped across the south of France. The camps were everywhere across Occupied France and Vichy. The tracks which carried the cattle trucks of deportees continued to link up the two parts of France. Like arteries running through a body, they turned the entire landscape into a deathscape via the co-option of France's railway infrastructure to the Nazi Final Solution.

At stake in our engagement with Cézanne's artwork and the notion of the 'view from everywhere' is also a recognition of the position of privilege which allows one to assume this viewpoint. This raises the tricky question as to how one's own ability to represent involves different practices of exclusion, shutting off access to others via certain claims to ownership. A view is not private property yet access to a 'view' is often dependent on privileged access to private or ticketed space. Mitchell's take on 'ownership' here offers a useful supplement to our earlier discussions around ethical spectatorship and the figure of tourist as possible witness. He suggests that the idea that no one 'owns' a view does not simply gloss over the privilege which allows for views to be enjoyed by some individuals and groups more than others. It also denies our individual and collective responsibility for such views. Mitchell proposes the notion of 'owning' in its more contemporary iteration, as an owning up to our responsibilities.

Owning up to my responsibilities involves an acknowledgement of my privileged access to the view from the memorial museum, limited to paying visitors with the mobility and opportunity to travel to Aix-en-Provence. As an academic, the ability to travel gives me a cultural currency transformed into intellectual authority. We should only write about what we know, what we have experienced first-hand. Writing about places and spaces we haven't seen or only experienced second-hand via art, literature and film is frowned upon. Yet we do little to challenge the (often Western) privilege that renders possible extensive overseas fieldwork trips. As a result of all this, I often feel that there is a distortion, a blurring and indeed a swollen, bloated feel to the parameters I have chosen to emphasize in my writing about Les Milles. My access to the space is privileged, as is the freedom to write about it in this way. But my intention is, as Smith suggests of Cézanne, to surprise the spectator, to articulate one's own surprise precisely by attempting to

show how what appears stable and fixed, not least the Montagne Sainte-Victoire, becomes distorted, blurred as one shifts one's gaze or stares too long. I have been staring a long time.

### Paths

As a backdrop to landscape, the Montagne Saint-Victoire is at once co-opted into the world of the camp and its memorial and largely uninvested in it. It serves as a timeless marker from which the camp's existence and operation has been fenced off. If the mountain might be conceived as aloof witness to the historical vicissitudes of humankind, elsewhere other mountains have been called upon to play a different role within the memorial landscape. In the previous chapter, reference was made to the positioning of a memorial cattle truck at Yad Vashem in Israel. Oren Baruch Stier (2015) describes how the truck is positioned at the edge of a cliff, made to appear as if it has been torn out of history and re-placed in a new dramatic context.

As a memorial which displaces Holocaust memory from specific sites of atrocity, Yad Vashem provides an important counterpoint to memorial sites located across Europe as well as Holocaust museums in the United States. The Valley of the Communities is a landscaped area within the memorial intended to represent the lost Jewish diaspora across Europe. As part of her study of 'modelscapes', Yael Paeda (2017) offers some interesting insights into the space which, she points out, often welcomes school-age children who are prevented from entering the main museum exhibitions due to age restrictions. She also points out that for other visitors, the space is often too much after the extensive and intensive experience of the museum. Herein lies the irony of the memorial landscape which, while designed to provide a space of calm reflection via sculptures and gardens, often doesn't fit the temporal constraints of visitors or consider the museum fatigue produced by exhaustive and intense exhibition material.

The narrative underpinning the Valley is one of Zionist nation state building which identifies Israel as the true home of Jews in contrast to Europe, where the diaspora was seen as a brutal failure. This is something of a misnomer as many of the communities represented in the Valley were not completely destroyed. Furthermore, the land was taken from Palestinians and the stone for the site includes archaeological relics from ancient Palestinian settlements (Feldman, 2007: 1161; Paeda,

2017: 190). The Valley also links the museum to another memorial landscape, that of Mount Herzl, Israel's national cemetery named after Theodor Herzl, founder of modern Zionism. Jackie Feldman (2007) has charted the shift from two independent sites bearing different narratives to increasing proximity via organized walks. She suggests these appropriate the walks carried out by Israeli youth visiting Poland (see also Feldman, 2008) but are aimed at those unable to afford trips to Europe. Feldman's study situates the route between Yad Vashem and Mount Herzl within a wider landscape of fear and securitization. Writing during the so-called 'War on Terror' which defined the Bush Jr administration, she evokes as a point of comparison the memorial landscape in Washington, DC. For Feldman these landscapes justify and are justified by discourses of securitization which link past loss of life (whether as victims or military heroes) to current political anxieties. The presentation of similar anxieties can also be witnessed at Les Milles and other memorial sites in Europe. In France, as I have already argued in Chapter Two, the specific discourse of securitization presented must navigate specific republican myths of equality, resistance and hospitality within a context of heightened Islamophobia and anti-immigration policies that frame the political and geographical landscape of France and Europe alike. It is also possible to note the presence of an explicitly Zionist discourse at work both within the exhibition space at Les Milles and within the wider memory work dedicated to the deportations in France.

In July 2017, the inauguration of the Vel d'Hiv memorial garden caused controversy when President Emmanuel Macron invited Israeli Prime Minister Benjamin Netanyahu to attend the ceremony. Critics of the event included the Union of French Jews for Peace, who described the invitation as 'shocking' (RFI, 2017). The French Communist Party also protested that Netanyahu was not 'bringing a message of peace'. The event took place in the wake of comments made the previous April by far-right politician Marine Le Pen that France was not responsible for the Vel d'Hiv round-up (Agence France-Presse, 2017) and thus offered Macron an opportunity to respond. Consequently, his speech reaffirmed the responsibility of the French government and its administration for the round-ups. He then went on to state that 'anti-Zionism' was a 'reinvented form of antisemitism' (Élysée.fr, 2017) – a statement not previously made by a French president and, moreover, one which marked out a very different position to that taken by Hollande on the Israel-Palestine conflict. Netanyahu was also invited to give a speech, in

which he claimed that 'Militant Islam wants to destroy our civilisation' (BBC, 2017). What thus emerged from the event, during which Macron referred to Netanyahu as 'mon cher Bibi', was a specific instrumentalization of French national memory work aimed less at commemorating those deported and more at fostering political diplomacy with Israel via open support of its occupation of Palestine. The geopolitical stakes of France's Holocaust commemorations are worth noting here as they offer greater context to the narratives around the Israeli state at Les Milles.

As part of the 'reflective zone' at Les Milles, a panel entitled 'Histoire d'un antisémitisme millénaire' [History of a thousand years of antisemitism] features the subheading 'Les figures changeantes d'une haine qui dure' [Changing figures of an enduring hatred]. One might be mistaken in thinking that in the aftermath of the Second World War the shifting figure of hatred in France was, as Mathieu Rigouste has extensively and convincingly argued in *L'Ennemi intérieur* (2011), that of the Muslim. On reading the panel, however, it turns out that what is being described, and denounced, are contemporary criticisms directed towards the Israeli state. The panel claims that such criticisms are not only anti-Zionist but exist in continuity with earlier forms of antisemitism. Thus, rather than presenting visitors with discussion of the shifting parameters of racism within France and Europe, the panel, situated incongruously within a 'reflective zone', seems aimed at shutting down any possible debate about the legitimacy of the Israeli state and its persecution of the Palestinian population. Given the well-known politics of fear which defines everyday life for Palestinians and Israelis alike within the Occupied Territories, the panel appears even further at odds with the dominant narrative of the exhibition in its warnings against collective fear of the other as a tool of xenophobia and totalitarianism.

If it is possible to map a direct path between the museum space of Les Milles and that of Yad Vashem, there are other more complex paths leading from and to the memorial that we might follow. I do not identify such paths with the official, ceremonial walks such as the marches in Israel and Poland or the annual procession along the Chemin des déportés at Les Milles. Instead, what is emerging across France and indeed Europe is an uneven, fragmented memorial landscape in which different narratives exist in uncomfortable juxtaposition for those who notice. Beyond the originary exclusions which define the difficult histories of the sites and the trajectories that link them, Europe's memorial landscape is subject to additional, ongoing acts of exclusion. These can take the form of forgetting, whether via erasure or the use of abstract markers to denote a

memory site, as discussed above. Exclusion can also occur via the limits imposed on the accessibility of a site. While these might be economic or infrastructural, the cost of tickets or availability of public transport, they might also be less immediately visible. Who is welcome at a space like Les Milles? Who will be treated with heightened suspicion by its security guards? Who is addressed by the exhibition? Who is included in its calls to resist and who is deliberately left out?

Indeed, various erasures also occur across the European memorial landscape in relation, notably, to the longer histories of antisemitism and the persecution of different Jewish populations prior to the Nazi regime. Such erasures evoke the concept of 'landscapes of exclusion' adopted by William E. O'Brien (2016).[7] Carrying out painstaking, difficult research into France's Second World War camps during the 1980s where forgetting and denial were prevalent, Grynberg (1999: 10) noted the lack of precision (where Jewish deaths were commemorated) at sites as well as, more generally, a lack of acknowledgement altogether. Former camps along with other sites of detention and confinement did not fit comfortably into established notions of *patrimoine* [heritage], and were not easily recognized as 'lieux de mémoire' as defined by Pierre Nora in his seemingly exhaustive 6-volume study.[8] Grynberg contrasted this absence on the landscape with the detailed commemoration of other histories or

---

7   O'Brien's study is focused on racial segregation in state parks in the southern US. In addition to debunking long-standing myths around the 'natural' spaces of state (and to a lesser degree, national) parks as sites of innocent leisure, exploration and freedom intended to provide accessible respite from urban living, O'Brien highlights the lack of memory around such segregation today. The erasure of the history of such segregation both in the parks themselves and in the mainstream narratives told about America's parks, allows the persistence of older myths around public access to nature, limiting awareness of hard-fought struggles for inclusion.

8   A recent collection of essays (Achille, Forsdick and Moudileno, 2020) aimed at redressing the various omissions from Nora's lexicon of 'sites and symbols' relating to France's colonial history includes Susan Ireland's account of Rivesaltes (also known as Camp Joffre), which operated as refugee camp, deportation camp and detention centre at various points during the twentieth century. Prior to the site's redevelopment as a memorial museum, novelist Alain Monnier (2008) produced a literary account of a walk around the ruins of the site. Another notable absence from the 'lieux de mémoire' project commented on by Forsdick (2020) is the extensive carceral landscapes of the *bagne* – France's overseas penal colonies in French Guiana and New Caledonia. The 'camp' network existing in French Guiana both before and well beyond the Second World War will be explored in more detail in the final chapter.

the reuse of sites for other tourist activities (such as the *stations estivales* [summer resorts] in Argelès, Barcarès and Saint-Cyprien). Quantitative proof of this disjunct in memorialization can be found in the photo project carried out by Étienne Madranges in *Prisons: patrimoine de France* (2013). Madranges's career as a magistrate has given him exceptional access to prisons (historic and contemporary) across mainland France and French overseas territories, resulting in a collection of over 2,300 photographs of dungeons, prisons and internment camps. A section dedicated to commemorative plaques features photographs of 90 memorials dedicated to those imprisoned, deported and/or killed during the Second World War. Amongst these, there are only five which refer explicitly to the deportations of Jews or commemorate victims of antisemitism (386–89).

Navigating the wider memorial landscapes both within and beyond France, different artists and writers have creatively drawn upon absences and disappearing material traces in ways which challenge the fixed, nationalist narratives of museum exhibitions and eschew the spectacle and performance of official commemoration and dark tourism alike. I would now like to cite a few examples here which serve as a wider context and inspiration for my own explorations around Les Milles, Aix-en-Provence and Marseille. These creative engagements not only emphasize travel and movement as an inherent part of memory work but also recognize how any attempt to uncover or understand the past is subject to perpetual recontextualization by the present-day landscape and shifting sociopolitical context.

In his 2011 autobiographical graphic novel, Parisian Jérémie Dres recounts a trip with his brother Martin in search of his maternal grandmother's Polish-Jewish heritage. The title *Nous n'irons pas voir Auschwitz* emphasizes the reluctance of the brothers to pursue a conventional memorial route or to allow their search to be co-opted to the sensationalist dark tourism that has come to be associated with Auschwitz.[9] Instead, they focus on sites linked to the lives (not deaths) of their Polish ancestors. In Warsaw they find that much of the historic built heritage of the former Jewish quarter has been restored but in such a way that Jewish presence is erased from the area.[10] Elsewhere,

---

9  This refusal sets their journey apart from other earlier travelogues such as Martin Gilbert's account of travelling with a group of postgraduate students to visit sites across Eastern Europe, *Holocaust Journey* (1997).

10  A similar erasure is observed by Juan Mayorga and an attempt to relocate lost sites forms the basis of his 2014 play, *The Cartographer. Warsaw, 1:400,000*.

interest in the memory work carried out by Warsaw's small Jewish community comes largely from third-generation Americans in search of their Jewish ancestry. Travelling to the small town of Żelechów, the brothers encounter hostility as they visit the overgrown Jewish cemetery and enquire about their great-grandparents at the registry office.

*Nous n'irons pas voir Auschwitz* provides us with a form of visual ethnography which is both distinct from and incorporates earlier tropes of comic autobiography.[11] As such it provides just one example of 'postmemory' storytelling identified by Marianne Hirsch (2012) as the way in which the Holocaust is creatively and visually explored by second and third generations increasingly removed from first-person testimony.[12] The book is a work of mourning and the fulfilment of a posthumous promise to Dres's grandmother to connect with forgotten Jewish roots. But it also documents the reconnection of the two brothers during the journey and the working through of unresolved tensions, something emphasized by the inclusion of a postface written by Martin. It is this reconnection that constitutes the most moving part of the narrative and highlights the potential of postmemory work as a form of creative practice directed towards repair in both the present and future.

In *Memory Effects* (2002), Dora Apel explores the work of different artists who have produced work around camp landscapes. These include the canvases of Matthew Girson, notably his 1994 series of paintings based on details reproduced from photographs taken at the sites of different Nazi extermination camps and the subsequent *Not a Forest* series (1995) in which the outline of a plume of smoke photographed at Treblinka in 1943 is reproduced as an abstracted, isolated image resembling that of a tree. Apel is especially taken with a later series which Girson has referred to as 'counterlandscapes', comprising 24 'graphite wash' drawings in which the centre of the image has been erased by a white square. The square offers a riposte to over-produced images of

---

11 I am grateful to Chantal Cointot for her insightful comments on this. In the context of the Holocaust and its memory, Art Spiegelman's *Maus* (2003) is considered one of the best-known autobiographical graphic novels. On the wider tradition of Holocaust representation in comics and graphic novels, see Stańczyk (2020).

12 For a detailed analysis of the comic and its exploration of third-generation experience, together with narratives of exile associated with the Holocaust, see Gorrora (2018).

landscapes but also attests to aporias in memory and knowledge about a place. As Apel suggests:

> The counterlandscapes evoke the rhetoric of countermonuments, which disappear and become invisible, returning the burden of memory to the contemporary viewer and disallowing the object to become a convenient repository for memory in which historical forgetfulness is not prevented but, perhaps, secured. (2002: 153)

Apel also evokes the work of Susan Silas, who has focused on re-enactments of the death march walks taken by deportees but with emphasis on the way such walks are now mediated by contemporary markers such as road signs and street furniture. Rather than ignoring these markers, they are actively called upon to encourage greater self-reflexivity and awareness of the experience of moving through a landscape subject to change, not fixed in time. Of note are the convex mirrors designed to allow drivers to see around narrow bends:

> The mirrored, distorted self-representation not only reflects the performance of the walk, but reproduces the conceptual nature of the project, that is, the relationship between the secondary witness and the site of memory at a remove. It also unsettles our expectations of the landscape itself, juxtaposing one scene in the mirror with the very different landscape in which the mirror itself is positioned. (Apel, 2002: 143–44)

Both Silas's and Girson's works are interesting because they posit the idea of having to 'work' on memory. This involves recognizing what has been rendered invisible and lost without a trace. But it also invites visitors to engage with the space around the camp in terms of complex and competing sets of signs and objects. This differs from the exhibitions inside the museum space where the memory work is done for the visitor via the use of carefully labelled, abstracted objects and heavily prescribed routes.

It is this type of personal memory work that can be found in Guillaume Ribot's 2008 photography project, *Camps en France*. Having already undertaken photography work at sites of atrocity including Auschwitz, Ribot was nevertheless surprised to learn about the camp network in France. Preliminary research led him to the name Gerhard Kuhn. Astounded by the number of times Kuhn was transferred between different camps, Ribot decided to make Kuhn 'un fil rouge' [a guiding thread] for his project. Further work across numerous archives led to the discovery that Kuhn had stayed in no less than 13 different camps

including Gurs, Rivesaltes, Saint-Privat, Fort Barraux, Vénissieux and Drancy in France. Ribot set about visiting the sites of the former camps and photographing what remained of them, if anything. He initially assumed that Kuhn had finished his journey in Auschwitz yet discovered that he had survived, and had been transferred to other camps after the Liberation, eventually making the journey to the United States in 1946. Kuhn died in 2002 in Erie, Pennsylvania and Ribot returned to the cemetery at the former camp in Gurs, where he placed a stone on the grave of Kuhn's grandfather in his memory. The story which does not end with Auschwitz also emphasizes the erasure of sites particularly in France. In the preface to the book, Denis Peschanski notes: 'depuis une trentaine d'années, les recherches se multiplient sur les camps français. Mais il est presque trop tard pour qui veut inscrire cette histoire et cette mémoire dans l'espace' (2008: 10) [in the last 30 years, research on the French camps has proliferated. But it is almost too late to inscribe this history and this memory within these spaces].

A short walk from the Les Milles factory grounds on the rue du Souvenir français which runs parallel to the Chemin des déportés, is the cemetery. I was told by one of the archivists at the museum that this might be where the women who died by suicide in the camp were buried. I'm not sure what I'm looking for but most of the graves here are more recent. In the corner of the Jewish section a large granite tombstone belonging to Sidney and Juliette Chouraqui stands out noticeably in contrast to the older stone graves. The grave is a recent addition (Juliette died in 2014 and Sidney in 2018) placed against the backdrop of the factory building. Lives framed not so much by the camp itself, perhaps, but certainly by the family's decades-long struggle for its memorial.

I also explore the Saint-Pierre cemetery in Aix where Paul Cézanne is buried. It is flanked by the Avenue des déportés de la Résistance Aixois. It was created in 1824 on the site of two former cemeteries – one Protestant and the other Jewish. Again, I find no indication, not even a memorial to those who were deported from Les Milles or who died during their internment, but I do find war memorials for those who fought in the two world wars as well as for France in colonial wars of independence, Algeria, Indochina.[13] According to Derobert-Ratel in her detailed sociological study of the Jewish part of the cemetery, the reference 'et à la mémoire de tous les autres restés inconnus' [and

---

13  On the memorial dedicated to those repatriated from Algeria who fought on the French side in the War of Independence see Smith (2013).

to the memory of all the others who remain unknown] at the base of the cenotaph dedicated to the 20 Jewish martyrs who died as part of the Resistance alludes to at least 60 other Jewish residents of Aix who were also deported to Auschwitz (2015: 15). Most were deported in 1943 and 1944 after the closure of the Camp des Milles. Derobert-Ratel also identifies 25 internees (23 men and 2 women) from the camp who later died either at the hospital in Aix, rue Pasteur, or the Montperrin psychiatric hospital, and were buried in the cemetery. Most were placed in communal graves and have since been moved due to overcrowding (2015: 18).

Back at Les Milles, I wander further about the immediate area around the tile factory, crossing over the railway track to a small square next to the old station building. Today the square seems to be used primarily as a car park and a small *pétanque* pitch. In the centre there is a statue of a man collapsed against a pile of sandbags, a memorial to the town's residents fallen in battle on behalf of France. Where once the only memorials that could be found in a place like Les Milles were those celebrating patriotic sacrifice, today these statues and plaques exist alongside memorials to the deported. How do these two sets of memorials coexist? It is common to come across small, local memorials to those who were deported from their hometown, especially children. Yet there is a disconnect between these and the largely forgotten camp landscape. What is being remembered are members of a community who were taken away, not the local sites through which they transited on their way to Drancy and Auschwitz. Memorials focused on loss without necessarily acknowledging complicity in that loss. Exploring the town of Les Milles as well as the larger 'galaxy' in and around the region, the memorial landscape is uneven and fragmented with complicated absences.

## Peripheries

Beyond the town of Les Milles and Aix-en-Provence, there is a wider landscape across the south of France which bears witness to the history of camps and deportations. This includes hotels and other residences initially requisitioned by the French government. These form part of the 'galaxy' gravitating around Les Milles but also extending beyond the tile factory. However, the memorial at Les Milles acts as metonym for all these sites, absorbing their complexity and fragmentation within

its red-brick walls. As set out in the Introduction, there is a memorial museum at Les Milles precisely because the site was not a camp but a factory before and after the Second World War. The museum provides extensive exposition including maps explaining and defining the camp network across both Occupied France and Vichy. Is this documentation and exposition adequate? Does it compensate or redress the erasure that has occurred elsewhere? Or does it achieve the opposite? Does it allow for the memory at these other smaller sites to be forgotten more easily? Similarly, is it possible to see a displacement occurring across France whereby carefully chosen sites absorb the difficult history of the deportations? It is easier perhaps for us to conceive of war in terms of specific events and isolated battlefields rather than a landscape peppered with civilian camps serviced and maintained by civilians alongside the military and police forces. Likewise, as suggested above, it is perhaps easier to remember those who were taken 'elsewhere' than acknowledge that 'elsewhere' as already existing within one's own hometown or region.

In April 2018 I spent a night in the Hôtel Bompard. The hotel was a holiday residence before being requisitioned during the Second World War. As mentioned in the previous chapter, it held many of the women and children who were subsequently transferred to Les Milles in August 1942 and deported to Auschwitz. Any children spared deportation were subsequently sent back to the Bompard. Comprising, at the time, 25 guest rooms, the hotel held up to as many 250 internees (Ryan, 1996: 94). In 1962, it was also used as a 'centre d'accueil' for *pieds noirs* arriving from Algeria during the War of Independence (Jordi, 2003).

Located on the rue des Flots bleus, the hotel is nestled in the foothills of the seventh *arrondissement* in Marseille. Other hotels that operated as *centres de rassemblement* [assembly centres] for women and children such as the Hôtel Atlantique, the Hôtel Levant and the Hôtel Terminus des Ports were in downtown Marseille close to the station.[14] The Hôtel Terminus des Ports is now short-term accommodation which appears to be targeted at migrant workers. The Hôtel Levant has been demolished and replaced with a shiny, sterile apartment block. Any reference to the

---

14  There were multiple sites used as camps across the city and wider Bouches-du-Rhône region. These included camps at Sainte-Marthe, Lambesc and Carpiagne, the Saint-Pierre and Brébant prisons, the Château des Fleurs and a school in La Major (Ryan, 1996: 93).

Bompard's temporary function as an internment and transit camp is absent in the residence's current manifestation as luxury boutique hotel.[15]

To enter the hotel today you go through a small, recently built reception building that then leads onto the garden around which all the hotel rooms are organized in buildings constructed at different points. The reception smells strongly of strawberry-scented potpourri, resembling an American boutique hotel or homeware store. While waiting to check in, I scan the reception area for any historical information about the hotel. Usually, hotels like to boast about their histories – whether these origins tell the story of a humble coach house or the summer residence of a wealthy aristocrat. But here everything has been completely depersonalized. The walls of the reception are painted in a shabby chic blue eggshell – Farrow and Ball style.[16] Behind the counter, shelves displayed an array of historical trinkets – books, test tubes, an old maths slate and ruler. Perhaps these have a tangible link to the site but more likely they were purchased from flea markets by the interior designer commissioned by the hotel chain.

The only trace of any of its history is a couple of paintings located in the restaurant. According to one of the curators I spoke to at Les Milles, the hotel owners have thus far refused to put up a memorial plaque. This raises the complicated question as to why people might feel uncomfortable staying here if they knew more about the site's history. After all, the Bompard was not built as a prison or camp. Yet elsewhere, former prisons have been repurposed as forms of tourist accommodation from youth hostels to high-end luxury hotels, such as the Liberty Hotel in Boston and the Four Seasons Hotel in Istanbul.[17] Unlike purpose-built prisons, the Hôtel Bompard was not a site of atrocity. Despite the shameless profiteering of its owners during the running of the camp (Ryan, 1996: 95), food shortages and overcrowding were not intended to be punitive. During this period, the Bompard also became a holding pen regularly used by the police to detain unmarried foreign women under the spurious charge of prostitution (94). A series of slippages occur whereby a transit camp becomes a deportation camp, and the

---

15  At the time of visiting in April 2018, the hotel had been developed as part of the small Marseille-based chain New Hôtel. However, it was later taken over by the Accor group and rebranded as Mercure Marseille Centre Bompard La Corniche.

16  This has since been repainted a burnt orange as part of the Accor rebranding.

17  On the repurposing of prison sites as hotels see Schept (2014); see Fleetwood and Turner (2017) on visiting prisons in Latin America.

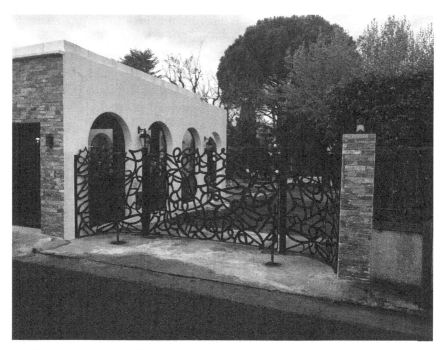

Figure 9. Gate designed by Raphaël Monetti based on poetry by René Char. Hôtel Bompard. Photograph by the author, April 2018.

criminalization of identity allows the mapping of further 'criminal' charges onto such identities.

At the Bompard, a single, notable reference to the Second World War comes in the form of the wrought-iron entrance gate composed of distorted words from a René Clair poem [Figure 9]. The deliberate obscuring of the words as a design feature seems to be a further statement on the part of the hotel owners and management that only an abstract representation of history is possible here. Yet an account of the hotel's twenty-first-century redevelopment on the Marseille tourism website Love Spots emphasizes the layers of architectural history that define the Bompard's present-day incarnation as boutique hotel:

> Là-haut sur le rocher se cache dans un écrin de verdure un hôtel de charme aux allures de campagne florentine où le temps semble suspendu. Plus dur sera la redescente!
>
> Au sein du petit groupe hôtelier marseillais New Hôtel, cet établissement revêt une valeur sentimentale. Celui qui s'appelait alors la Résidence Bompard fût le premier hôtel du groupe en 1968, là où descendait de

*Landscape* 155

nombreux artistes venus peindre les collines de Bompard que soutenait déjà en mécène George Anton, le propriétaire des lieux. Mais on ne fait pas de l'hôtellerie avec de bon sentiments. Après avoir connu de multiples extensions, il a fallu redonner standing et confort à cet établissement qui n'en conserve pas moins des univers très singulier: une fois franchi l'élégant portail de Raphaël Moretti constitué d'une dentelle de lettres réalisée à partir des vers de René Clair, vous découvrez autour d'un magnifique jardin aux essences méditerranéennes les différentes unités d'habitation possible pour votre villégiature marseillaise. Dans la bastide historique, vous retrouvez l'esprit originel et classique des lieux alors que dans la première extension où les chambres possèdent toute leur petit balcon la rénovation s'est joué sur un registre sobre et contemporain. En rez-de-jardin de coquets bungalows à la déco très Miami 70s vous invitent au farniente tandis qu'un petit et un grand mas sous les arbres présentent un décor provençal de carte postale. (2019)[18]

[At the top of the hill, hidden amongst the greenery, there lies a charming hotel reminiscent of the Florentine countryside where time seems to stand still. Descending will be harder!

Part of the small Marseille-based hotel chain New Hôtel, this establishment is adorned with sentimental value. Once known as the Bompard Residence, it was the first hotel acquired by the group in 1968 at a time when numerous artists came to paint the Bompard hills under the patronage of its owner, George Anton. But one does not become a successful hotelier with good intentions. After a series of extensions, it was necessary to return the hotel to a level of standing and comfort whilst maintaining its distinct 'universes'. On crossing the elegant entrance designed by Raphaël Moretti using interlaced letters taken from verses by René Clair, you will find the different accommodation units on offer for your Marseille vacation situated around a magnificent Mediterranean-style garden. In the historic farmhouse, you will encounter the original, classic spirit of the place whereas the first extension, where each bedroom has its own small balcony has been renovated in neutral, contemporary tones. At garden level, stylish bungalows with a 1970s Miami décor invite relaxation while a small and a large cottage located under the trees offer a postcard image of Provence]

What this extended quotation suggests is that the site has a memory but one that has been tastefully and conveniently air brushed. There is something jarring about the marketing copy of this text when read

---

18   The original description on the website has been edited since the hotel was acquired by Accor.

in the knowledge of the Bompard's role as a 'centre de rassemblement'. Consider the seemingly neutral choices of language and imagery evoked: the crossing of the threshold via a wrought-iron gate, the suspension of time, the 'univers très singulier' and the difficulty of making the descent back down the hill. The awkward conflation of holiday and internment camp in the flowery language of a hospitality writer does not simply draw our attention to both the dangers and necessities of forgetting. It also reminds us how the internment camp, when remembered, is also often presented in terms of a holiday camp, a slippage that often risks occurring in accounts of life in Les Milles during the early phase of its operation. A hotel with a nice garden is not a prison or even a camp. It's a place of leisure. This is suggested in Pirotte's photos taken at the Bompard in summer 1942 as they depict scenes of conviviality and even joy amongst the women and children present. Yet imposed leisure is not leisure. It is simply waiting.

As it became harder and harder to secure passage on one of the ships leaving from the port of Marseille, such waiting became associated with abandonment and the foregone conclusion of being deported east. In her novel *Transit* (1951), which skewers the absurd bureaucracy required to emigrate from the city during 1941 and 1942 and the combination of anxiety and ennui experienced by those trying to leave, Anna Seghers identifies the Bompard as a site not only of waiting but one that signalled the closing down of possibilities. As pointed out by Marie, who is hopelessly trying to track down the ghost of her husband, it is not the camp itself or its conditions that are the cause of despair but, rather, the abandonment that the Bompard represents: 'I'm not afraid. Because if I have to stay behind by myself, I won't care whether I'll be free or imprisoned in the camp at Bompard or in some other camp. On the earth or beneath it' (2013 [1951]: 126).

There is a danger of conflating the prison and the camp or, indeed, the 'almost-camp'.[19] But there is an equal danger in holding them apart as completely separate phenomena. Earlier categories of war and peace no longer hold in the twenty-first century. Can we still distinguish between a criminal act and the rendering illegal of individuals because of their birthplace and parentage? Our governments do not seem to

---

19   The concept of the 'almost-camp' is taken up by Dreyfus and Gensburger (2003) in their study of annexes across Paris used to intern Jews before they were either released or transferred to Drancy.

think so.[20] The criminalization of hospitality in France further calls these categories into question. Most alarming perhaps, and the reason we need to remember the complex histories of spaces like the Bompard, is the rapidity with which such spaces can be turned into camps or 'almost-camps' before being dismantled or repurposed, leaving little or no trace of this brief suspended time. I shall return to the disappearing of the camp in the final chapter.

After checking in to the hotel, I decide to take a walk. I follow the route down to the main road and walk along the coast a short way towards the city centre. I get as far as the Porte de l'Orient then turn back. I head up to the hotel via a different staircase running alongside the Parc Valmer. If you enter the park from the top the first view of the sea which appears between the trees neatly encompasses the Château d'If. I wonder if it was the same back in 1942. The freedom and calm offered by the sea seems to be interrupted by the small island of If which forms part of the Îles du Frioul about 1.5 km outside of the port of Marseille.

Originally conceived as a fort from which to defend the port, the poorly designed Château d'If was repurposed as a prison during the nineteenth century, housing thousands of prisoners including *communards*. Gaston Crémieux, leader of the Marseille Commune, was shot on the island in 1871. Today his story and those of other political prisoners are overshadowed by the mythology of If's most famous inmates – the unfortunate rhino brought to Europe as a gift for Pope Leo X in 1516 and Alexandre Dumas's Count of Monte Cristo.[21] I wonder what this view meant for the internees leaving the Bompard each day to head into Marseille in order to apply for emigration visas and to try and secure passage on one of the ships leaving for the Americas and North Africa.[22] The sea seems to taunt with the possibility of freedom but the island, often compared to Alcatraz, acts as a reminder of a long history of

20  Revising this chapter in late 2021, this statement has become more apt in the context of British Home Secretary Priti Patel's statement that British citizenship is a 'privilege, not a right' and the subsequent borders bill passed by the government in December 2021.

21  The rhino perished shortly after a brief stop on the Îles du Frioul in a shipwreck off the coast of Italy. However, it was immortalized in Albrecht Dürer's wood carvings despite Dürer never having seen it in the flesh.

22  Eric Jennings (2018) has taken up the story of those who did manage to escape to Martinique where, despite being interned in the Balata internment camp, many were involved in creative endeavours including the journal *Tropiques* edited by Suzanne and Aimé Césaire.

imprisonment for those holding different religious and political beliefs. The impossible, dramatic escape of Edmond Dantès is, after all, just a story.

Back at the Hôtel Bompard the wind rises, creating tiny whirlwinds which pick up dead leaves and other debris from around the garden. This creates a feeling of restlessness, a haunting. I could understand why one might choose to haunt this place. It is a nice place for the living to be, a place which makes it easy to forget. Yet no one except me seems concerned with ghosts here.

## Retracing One's Steps

Beyond the commemorative walks which become regular fixtures in the memorial calendar, there are different types of return to the landscapes that Otto Dov Kulka has referred to as the 'Metropolis of death'. While he is talking specifically about Auschwitz, where he spent time in the family camp as a boy, such returns often occur in dreams or at other sites. He describes the uncanny familiarity when visiting the unkempt site of Temple Mount in Israel, the rusting barbed wire reminding him not of the camp during its operation but of its subsequent ruination (Kulka, 2014: 72–74). He also describes the alienation he felt when reading the accounts or memoirs of others who survived Auschwitz. To deal with this sense of alienation, he turns to an unlikely source of comfort, the work of Franz Kafka and, notably, the scene from *The Trial* where Josef K. arrives at the gate (81). For Kulka, this scene provides an acknowledgement that while the gates into Auschwitz provided by others in their writing or films deny him access, the landscapes he creates which 'intermix' childhood memory, his return visits and the surreal events of dreams, offer him his own way back in. And, as he concludes, just as the gate Kafka intended for Josef K. alone was actually open to everyone, so might his landscapes be open to others beyond himself in the form of memories first recorded onto tape and then transcribed, printed and published.

The return of survivors to the sites where they witnessed and experienced atrocity are often presented as both impossible and necessary returns. There are complex forms of claims taken up in such returns or their refusal as they pertain to both survivors and their descendants. But what claims do such sites make on everyone else? For those of us for whom the encounter or awareness of a site

is always mediated through its incarnation as a memorial first and foremost, what does it mean to return? I did not intend to return to Les Milles or expect it to lead me elsewhere. In *M Train* (2015), Patti Smith talks about unintentionally making three visits to Sylvia Plath's grave in Heptonstall, West Yorkshire. Smith describes how the first set of polaroids she took at the grave were perfect in terms of light and composition. Yet, as frequently happens in Smith's adventures, somehow these perfect images got misplaced. Later she finds herself returning to the grave another two times in different seasons. While the new sets of photos she takes do not replace the original lost images, they add additional layers of meaning to her original visit, extending beyond her initial motivation for visiting the site.

While for those of us who regularly tend the gravestone of a loved one, seasonal shifts in the light and the foliage might seem obvious, the singular journeys we make to other memorial sites leave us with a freeze-frame image, a grave or statue fixed in time, unchanging. This is perhaps even more true of memorial museums. The gravity and intensity of the stories they present us with and the warnings they offer up do not necessarily encourage repeat visits. We recommend them to others with caveats. There are of course exceptions like the Shoah Memorial in Paris and the Imperial War Museum in London due to high-profile temporary exhibitions and public events alongside the permanent exhibitions. A site like Les Milles does not have the same draw but I wonder whether people do return and what brings them back.

On my third visit to the museum in April 2018, the first time I had seen the museum outside of the August vacation period, I looked up at the second-floor window from outside. Two adolescent boys were looking out. That day there were a lot of school trips – around half of the site's 100,000 annual visitors are school children (Mossé, 2020: 26) – and the archivist I met with told me that even those kids who pretended not to care could not help but be affected when they looked out of the window. I wonder what they make of the message presented at the end of the exhibition, the call to be vigilant against racism and to stand up for those who are excluded or subject to discrimination. I imagine this might feel empowering as if there were freedom and choice here. The freedom and choice not to make the kind of mistakes of past generations. The belief in that freedom and choice can only belong to the arrogance of youth. I wonder what will have changed in ten, twenty years' time when those same adolescents, now adults, return with their

own children. Will they feel the same? Will they return? Will they have forgotten they ever visited as a child on a school trip?[23]

Every time I return, I notice something different. Some of these things were already there and I had previously missed them. But there are things which have changed, too. In 2018 a new feature had been added to the landscaped area at Les Milles. Despite the imposing fixed structure of the tile factory's bricks or even the seemingly rigid organization of the different *volets* within the exhibition, the memorial is nevertheless an organic space which can adapt and develop. A series of panels now line the Chemin des déportés which focus on different individuals who took risks to help those interned in the camp. The panels are made from rusted iron, making them appear as if they have been there a long time. They include, notably, one dedicated to 'Alice Manen et son époux le Pasteur Henri Manen'. Henri Manen's role inside the camp is well-documented both inside the museum itself and in his own republished journal. However, the decision to emphasize Alice's role in offering to hide and lodge those escaping deportation reminds us of the complex activities occurring outside the barbed wire of the camp as well as the oft-overlooked gendered nature of certain acts of resistance.

The narrative of resistance and hospitality is thus extended beyond the confines of the exhibition to the space outside. This perhaps encourages more traffic along the Chemin des déportés but also offers something for those not paying for the visit inside the former factory space. Although I have been generally critical of the resistance narrative as over-privileged within the space of the museum, here it seems more pertinent located as it is outside, drawing our attention to the complex and frightening world outside the camp where acts of resistance and hospitality took place. This seems very different to the securitized space of the museum with its contentious claim that admission constitutes an 'act of resistance' facilitated by the presence of armed guards and X-ray machines. Yet located on the Chemin des déportés, these panels also attest to the

---

23 Numerous early studies have been conducted on the social impact of museum visits for school-age children. For an overview, see Jensen (1994). Sarah Gensburger's (2019) ethnographic account of visitor engagement, especially adolescents and children, at the temporary exhibition 'C'étaient des enfants. Déportation et sauvetage des enfants juifs à Paris', held at the Hôtel de Ville in Paris in 2012, offers insight into French Holocaust exhibitions and their impact. On the more general role and appropriateness of school visits to sites associated with the Holocaust from a British perspective, see the December 2010 special issue of *Teaching History*, notably the articles by Andrews (2010) and Salmons (2010).

insurmountable task whereby so many could not be saved or hidden. The panels show the helplessness of those who stood on the sidelines watching just as others came to offer water and food to those trapped inside wagons brought to a standstill at points along the journey to Auschwitz.

But this addition to the *chemin* also leads me to wonder whether this dismantles the possibility of thinking the wagon as a reconstruction. The path is now an exhibition, a text to be read and not a route to follow. The walk along it is now interrupted with pauses at each panel. Is the museum seeping out? The righteous heroes of Les Milles have been called upon to bridge the gap between the town's war memorials and the story of the deportations. A key aim of this chapter has been to draw attention to the awkward juxtapositions arising as a result of increased official recognition of camps and deportations emerging alongside long-standing memorials to colonial occupations and wartime resistance. A second aim has been to examine how the sitedness of the Camp des Milles memorial invites visitors to explore the wider 'galaxy' and its legacy, particularly in Marseille where, despite a small museum dedicated to the local history of deportations, there has been a deliberate erasure of the memory of internment at sites like the Bompard.[24] In the next chapter, the concept of the 'galaxy' and the related term 'satellite' will be taken up more directly as a means of expanding the trajectories leading from Les Milles towards other camps and other forms of deportation and forced migration. Despite the deliberate elisions and aporias in much of the museum's existing narrative, a major part of its interpretation is aimed at understanding the ongoing global effects of xenophobia and genocide and thus moves beyond the specific historical circumstances of the site's built heritage and location. Yet, in being asked to look elsewhere and in different directions, we should not lose site of our initial view or our position at the second-floor window.

\*

In his 2011 photo-essay based on a visit to Auschwitz-Birkenau, Didi-Huberman offers a more personal approach to encountering the natural landscape in and around the camp. The title *Écorces* [*Bark*] refers to the strips of bark he tears from the birch trees in the grounds.

---

24 The Mémorial des déportations is situated in a former WW2 infirmary shelter on the Old Port across from Mucem. https://musees.marseille.fr/memorial-des-deportations-0.

The trees have borne witness and their bark constitutes a material memory support just as the inner layer of birch bark was once used to write manuscripts before the mass production of paper. To tear off the bark is an act of vandalism or violence intended as a riposte to the presentation of the site as cultural centre with its turnstiles, signage and bookshop. Didi-Huberman questions what kind of culture can emerge from a site of barbarism such as Auschwitz. He also points to the importance of the mundanity of the surrounds in which there is little trace of what happened beyond the rusting barbed wire. This brings us back to the chapter's original point, taken from Mitchell, that landscapes are boring. Whether they are boring due to cliché or mundanity, such landscapes require our attention and accountability:

> We can therefore never say, 'There's nothing to see, there's no more to see.' To be able to doubt what we see, we must know how to keep looking, how to see in spite of everything. Despite the destruction, the erasure, of all things. We must know how to look as an archaeologist looks. And it's by way of such a gaze – such an interrogation – directed toward what we see that things begin to look at us from their concealed spaces and bygone time. (Didi-Huberman, 2017: 105)

That there is nothing much to see is precisely why we need to look.

CHAPTER FIVE

# Sky

Let's return to the space of the window as it frames the world outside. Taking up at least a third of the space inside the frame is the piercing blue sky often synonymous with the Provençal landscape. I wonder whether it is purely coincidental that Blaise Cendrars wrote his beautiful elegy to the sky and the gift of flight whilst he was in Aix-en-Provence. He finished *Le lotissement du ciel* in 1949 (translated into English simply as *Sky*, 1992) but had originally fled to Aix during the Second World War to hide after he was placed on a list of dangerous Jews. *Le lotissement du ciel* is a sustained reflection on humanity's strange relationship with the sky and, more specifically, flying. This is a relationship which is also about writing and death. Cendrars opens with the devastating account of his boat trip from Brazil back to France. To the horror of the ship's commissaire, Cendrars has filled a first-class cabin with cages full of monkeys and birds and more specifically 250 *sept-couleurs*.[1] Cendrars recounts how many of these poor creatures had already died before they even got to the Atlantic. His desire is to bring the birds to his granddaughter in Paris. A single bird completes the journey but dies the following day. '[W]here is the cemetery for birds?' (p.19), Cendrars asks. There is something otherworldly about them and their deaths. However, in his failed attempt to bring home to Paris the birds of the Amazon, Cendrars is forced to recognize these creatures' delicate fragility. Yet human fascination often involves attempts to capture and harness flight as a magical, quasi-divine power. This relationship with flight and death via the bird and its feathers becomes further apparent in a short postscript to the story of the *sept-couleurs* where Cendrars returns to his mother's death in 1907. He describes the

---

1   An avian species known in Portuguese as the *calliste septicolore* and in English as the Paradise Tanager although in the English translation, *Sky*, they are referred to as 'seven-colors'.

painful task of going through her belongings and coming across the luxury bird feathers adorning her hats:

> [T]hey found among her trunks and hatboxes some feathers, tufts, quills, plumes, bird-of-paradise tails, cockades from a black cock, like a *bersagliere*'s plumes, others from a white cockerel, like the ones the military cadets at St. Cyr wear on their *shakos*, a tuft of capercailzie feathers, some hummingbirds skewered on a brooch, toques and muffs from Himalayan pheasants, the crest of a hoopoe, swansdown, ostrich feathers, pheasants' tails, feathers from doves and seagulls, Bengalis, pigeons' throats and even a tender partridge. (1992: 22)

As he reflects, there is something ridiculous embedded in the tragedy of this second life as a Parisian fashion item belonging to 'an elderly, old-fashioned angel'. Here we might also acknowledge the word *plume* [feather] as often meaning pen in similar fashion to the word 'quill' in English but used for far longer to symbolize the writing tool. Take, for example, the idea of the *porte-plume* which was used to refer to nib pens but is sometimes used to refer to a pen or pencil pusher, the tedious administrative task of committing to paper. There is also the *nom de plume* or pen name adopted by Cendrars, born Frédéric-Louis Sauser. Cendrars, combining the French *cendres* [cinders] and the Latin *ars* [skill/craft], while Blaise is an approximate French homophone for the word 'blaze'. His nom de plume evokes both fire and what emerges from the fire:

> Writing sets ablaze a whole pandemonium of ideas, illuminating a chain of images before reducing them to crackling embers and crumbling ash. But though the flames set off the alarm, the spontaneity of the outbreak remains a mystery. For to write is to be burned alive, but it is also to be reborn from the ashes. (Cendrars, 2000: 14)

*Le lotissement du ciel* is also a work of mourning for his youngest son, Rémy Sauser. The memoir recounts in painstaking and amusing detail Cendrars's final meeting with his son in early 1940 and enacts a posthumous promise made to Rémy to write about the patron saint of flying, Saint Joseph de Cupertino. Rémy, who spends the war as a pilot in Arras, is killed in a plane accident in November 1945. Henceforth, the sky will continue to represent for Cendrars the human quest for immortality through flight, a quest that he perceives to be as ridiculous as it is tragic, as entertaining as it is sobering.

The sky I looked out on at Les Milles is not cloudless. A small, wispy cloud in the left-hand corner of the photograph reminds us that the

image has a specific timestamp. Countless snaps might be taken from that upper-storey window, but no others will include that cloud in that position. This is important as what I want from the photograph is not a timeless image of a timeless scene. I want to remember that *the time was now*. Does the cloud temper an otherwise relentless, unforgiving blue? It barely offers the promise of rain. Yet its presence, while fleeting, casts a shadow all the same.

This final chapter considers the window as an opening out onto the world beyond the camp network's limits in Vichy and occupied France. In certain respects, what follows constitutes an exploration of what Michael Rothberg (2009) has termed 'multidirectional memory'. Rothberg focuses much of his study of connections between the Holocaust and decolonization on the historical silences and forgetting together with the complex literary and philosophical threads binding together Vichy and the Algerian War of Independence, notably the internment of over a million Algerians in camps and prisons both in Algeria and France. This chapter will explore different sets of connections including the legacies of France's longer-term carceral landscapes in French Guiana. Such connections have emerged organically in researching and writing about the memorial landscape but are far from arbitrary. The archives relating to France's overseas penal colonies, of which French Guiana was the largest, are found in Aix and bear witness to a different set of exiles and forced migrations. Drawing a line between the archive and the museum highlights the overlapping historical geographies now contained within this small region of southwest France.

Maintaining focus on the story of the deportations told at Les Milles, different mobilities and trajectories will be followed via different meanings of 'satellite'. As suggested earlier, the window acts as a safety valve, offering respite from the intensity of the exhibition housed inside the tile factory's forbidding architecture. But pause at the window for more than a few moments, as indeed we have done, and this respite morphs into something else. We are confronted with the openness of the world. It is an openness, as the wagon reminds us, towards violence. The sky refuses to offer shelter, acting instead as an unmoved witness to humanity's propensity for self-destruction, one that did not cease with the liberation of the camps.

Cendrars does not actually talk much about the sky in Provence in *Le lotissement du ciel*.[2] He describes Aix instead as an atmosphere

---

[2] He alludes to its translucence in *L'Homme foudroyé* before describing a different summer night sky back in Royes in 1916 (1992: 11).

of claustrophobia and fear, but one also shaped by his dreams of Saint Joseph. It is an atmosphere through which radio waves connect him with Moscow and London, while he strives to remain undetected by the Gestapo member living on his corridor. He refers to this neighbour as 'immonde', invoking an altogether different otherworldliness. This unwanted, abject presence literally infuses and infects the air Cendrars breathes, via his neighbour's routine noises and pervasive cigar smoke. Hence, while this chapter is about the sky as opening, as vast air space and, from the mid-twentieth century onwards, a final territory to be colonized, it is also about atmosphere. Following Peter Sloterdijk and his epic *Spheres* project (1998–2004), atmosphere is understood in the broadest terms as air, particles, gas, diffusion, culture, politics, tension.

Throughout this chapter, we are followed by the small cloud. It hangs over us, lingers on, yet is never the same. Lorraine Dalston refers to this changeability as the 'vertiginous, variability of clouds' (2016: 47) that has posed such a problem for those seeking to create a taxonomy of clouds. As John Durham Peters points out, 'The black of night gives us our most exact science, astronomy; clouds that vanish yield some of our most beautiful paintings, and clouds that obscure give us some of our most precious meteorological knowledge' (2015: 11). The museum embodies this tension between the ephemeral and the material, the aesthetic and the scientific. It places hope in future knowledge and understanding whilst alerting us to past misuses of science and technology. Following Durham Peters's call for 'an elemental philosophy of media', might we consider the museum via the figure of the cloud? Doing so would surely also seek to rescue both from their contemporary definitions as repositories of deterritorialized information.

Even the whitest of clouds bear a hint of grey.

## A Shelterless Sky

> War is at once a summary and a museum […] its own.
> (Virilio, 2012: 27)

Peter Sloterdijk's *Terror from the Air* (2002) identifies the Ypres gas attack in April 1915 as one of the main legacies of the twentieth century, forever changing the assumption that the air around us is OK to breathe. Of course, there was plenty of unsafe air for humans to inhale before

the twentieth century. Toxic air was the reason canaries were sent into mines. The multiple pandemics and airborne diseases exacerbated by the poor sanitation of crowded urban settlements from the Middle Ages onwards provide a reminder today that we are desperately trying to learn from. But what Sloterdijk means was that the air was not suddenly and simply a potential hazard in poorly ventilated spaces indoors and underground. It is not a sudden lack of fresh air that constitutes our problem. Rather, what occurs at Ypres is the intentional weaponization of the air.

This human-wrought crisis which continues apace in the twenty-first century – embodied as Sloterdijk points out, in global reliance on 'air conditioning': 'The residual cultures of the future will assume increasingly explicitly that liveable internal climates must be created by technical means' (1999: 961) – is preceded by an earlier crisis. This is the loss of the heavens, the metaphysical space located above the earth. Space, immense yet finite, contains the earth and everything in it, offering shelter. Globalization, taken literally to mean the realization that the earth is a globe composed of multiple, contradictory beliefs about the sky and the stars, ushers in a new, modern age defined by this revised topographical knowledge. As Sloterdijk puts it in characteristically sardonic fashion: 'the topological message of the Modern Age [is] that humans are creatures which exist on the edge of an uneven round body – a body whose whole is neither a womb nor a vessel, and had no shelter to offer' (1999: 792). A concerted attempt to mitigate the impact of this knowledge of the earth as globular can be found in the figure of the twin globes, whereby the celestial globe was called upon to supplement the earthly sphere. Sloterdijk's account is worth quoting at some length here:

> Even the atmosphere, which was initially made to vanish by all earth globes, was understood by most more as part of the exterior than as an interior, and it is only in recent times, through the rise of meteorology to the exemplary science of chaos rationalism, that the earth's atmosphere has finally been recognized as the last remaining equivalent of the ethereal dome. Where is now the sky that could kiss the earth? Every globe adorning the libraries, studies and salons of educated Europe – until 1830 in the company of its obligatory twin, the celestial globe – embodied the new doctrine of the precedence of the outside, in which Europeans advanced into this outside as discoverers, merchants and tourists, but simultaneously withdrew into their artfully wallpapered inner spaces, which now displayed the specific flavor of the nineteenth

century in being called 'interiors' or 'private spheres.' The celestial globes set in parallel with the terrestrial globe still attempted, as long as it was all possible, to dispute the message revealed by the terrestrial globe; they continued to promote the illusion of cosmic shelter for mortals beneath the firmament, but their function became increasingly metaphorical and ornamental – like the art of the astrologers, who changed from experts on stars and fate to psychologists of edification and fairground prophets. (1999: 792–94)

Via its collections of objects and artefacts gathered (and frequently stolen), the museum becomes a meeting place of European activities of exploration and retreat. The museum shows its visitors the world, so they do not need to encounter it directly. To what extent does this remain the case? Is the museum a hopelessly nineteenth-century institution? What happens when it can no longer contain either the treasures or the suffering of the world?

The figure of the cloud might be called upon to think through some of the visual dilemmas of the museum in its attempt to commit atrocity to memory. The cloud is, after all, one of the enduring images of the wider destruction of the Second World War. The image of the atomic bombs dropped over Hiroshima and Nagasaki came to be defined in terms of the 'mushroom cloud', often used to represent the destruction and loss synonymous with this period of history.[3] Following its repeated alarmist warnings against the spread of 'extremism' in Europe, one of the final panels displayed in the main exhibition at Les Milles features a black-and-white photo of an atomic explosion. The image is flanked by two small text panels. The first, entitled 'Une question fondamentale: La puissance et le sens' [A fundamental question: Power and sense], asks whether society is capable of controlling its growing technological power. The second comprises a quotation attributed to French historian Maurice Olender (2005) but which appears to be an adapted version of a passage from Zygmunt Bauman's *Le Présent liquide* (2007: 47). The text is taken up with the idea of fear as a contemporary condition resulting from insecurity about the present and uncertainty over the future. It concludes that current society lacks the necessary political tools required to 'exorcise' the 'demon of fear'. Juxtaposed between these two panels, one focused on unrestrained technological development and the other, decontextualized from its wider argument, evoking biblical imagery

---

3 On the complex (often positive) symbolism of the mushroom cloud within a US context, see Rosenthal (1991).

of demons and exorcism, the image of the mushroom cloud seems the inevitable, nihilistic outcome. This is a far cry from the message of hope and empowerment at work elsewhere in the museum. Yet, as an urgent warning against human capacity for destruction, its moment seems to have passed.

In the original directions for the screenplay of *Hiroshima mon amour* (1959), Marguerite Duras (1972) proposes to open the film with an image of the Bikini atoll mushroom cloud. The directions suggest that it should be framed so that the audience is at once familiar with the image and what it represents, but also sees it as if for the first time. The difficulty of achieving the dual effect was undoubtedly one reason this opening was abandoned in favour of the image of the two bodies entwined whilst being covered in ash as if being buried alive.[4] Yet the mushroom cloud exists as a kind of palimpsest or ghost figure in the film, not least in the strange tension between the documentary footage and fictional plot, juxtaposed in the film. As James Monaco (1978) suggests, the opening 15 minutes are a reference to the documentary *that never was*.[5] Resnais had intended to make a documentary but struggled to do so due to the challenge of representing the Hiroshima atrocity and the risk of repeating, at least structurally and ideologically, the documentary he had made about the Holocaust, *Night and Fog*. The first 15 minutes of *Hiroshima mon amour*, following the initial scene of the lovers' bodies, involve a series of news and documentary footage and scenes filmed inside and around the memorial museum. The woman, known only as 'Elle', recounts how she first learned about the attack and the stories reported in the international media in the days immediately following the explosion. She states that she visited the museum in Hiroshima four times. She repeats this four times, in fact. Four times four. Each time her account is met with the same response from the man, 'Lui'. Her experience is not an experience. She did not see anything. This reference to the repeat visits to the museum reminds me of my own repeat visits to Les Milles and other museums taken up with mass suffering.

For the woman, visiting the museum multiple times seems to offer evidence of her willingness to see. More than simply passing through the museum as a tourist, her repeat visits demonstrate her commitment

---

4  For a close reading of this opening scene and a wider reading of 'skin' within the film, see Martin (2013).

5  See the chapter 'False Documentary' dedicated to *Hiroshima mon amour*: Monaco (1978: 34–52).

to seeing and knowing. Of course, with every subsequent visit, there is a chance of seeing more, of noticing new and different things. But there is also the potential to stop seeing altogether. This repetition echoes the repeated screening of the mushroom cloud, which in turn risks turning the tragic into banal cliché. The woman's careful descriptions, which attempt to show a more profound, sustained knowledge, are dismissed by the man as mere performance. This impossible tension, so well-articulated by the film, especially in its opening scenes and narration, also defines the impossible task of all memorial museums. Framed by a fictional love story, the museum, with its multiple display cases, objects and images, is always already embedded in a larger series of mediations. In trying to hold on to the content of one of these frames, we only end up with more frames, endlessly proliferating like a hall of mirrors.

Even as absence, the mushroom cloud image embodies Rob Nixon's claim that: 'Violence is customarily conceived as an event or action that is immediate in time, explosive and spectacular in space, and as erupting into instant sensational visibility' (2011: 2). For Nixon, it is this spectacle that works to conceal longer, slower forms of violence. These forms involve gradual erosion, decay, poisoning, displacement and dispossession, often occurring to populations and ecologies overlooked by the mainstream media. An opinion piece by Virginia Snitow entitled 'The Mushroom Cloud', which appeared in the *Western Political Quarterly* in 1958, makes this precise point: 'It is important to remember that radiation-caused cancer can take three, ten, or fifteen years to appear, and this lengthy latent period serves to shield the killer from a clear-cut charge of direct responsibility'. According to Nixon, new forms of representation are required to draw attention to these 'long dyings'; modes of storytelling and presentation counteract the visual lexicon of destruction embodied in images of fire, explosions and tidal waves, all of which are simply points along a far longer trajectory. Nixon turns to literature, and specifically the novel, as a source of such representation. However, we might also consider the role of the museum as a space in which complex, shifting scales of time and space can be explored and imagined.

How did the atomic explosion come to be universally described in terms of a 'mushroom' cloud? Other early names given to the cloud included 'rose' (Rosenthal, 1991: 86) and 'cauliflower' (Weart, 1988: 402). However, as Spencer R. Weart points out, mushrooms offered an image of transformation, of life amongst the dead and decaying. Mushrooms

are also known for their poisonous yet hallucinogenic properties, used in rituals of physical and spiritual transmutation (403). Anna Tsing's *The Mushroom at the End of the World* (2015) deliberately evokes the apocalyptic dimension attributed to the figure of the mushroom *qua* mushroom cloud. The aesthetics of the mushroom cloud has become semantically empty due to its overuse and the way it obscures long-term, micro effects – it is the big picture that obscures a billion little pictures. However, Tsing's 'grounded' mushrooms offer us the very stories Nixon proposes are required in shifting the frame of representation to slower, more nuanced accounts of human displacement and environmental loss. *The Mushroom at the End of the World* follows the seasonal collection and trading of the matsutake mushroom in Japan, the United States, China, Canada and Finland. It explores the unlikely forests in which the mushroom is found, the global marketplace for buying and selling it and the lives of the disenfranchised, displaced people (many as a result of the wars and conflicts of the last century) who are found working as collectors and traders. The figure of the mushroom becomes, via the stories, sketches and photographs that compose Tsing's book, one of hope. However, unlike the mushroom cloud, which suggests that hope is tied to destruction elsewhere, it posits such hope as both fragile and precarious, inextricably bound up in globalized networks, economies and histories.

### Star Wars

Speaking in short video interviews presented within the museum, survivors of Les Milles who had been children at the time of the deportations talk about their lives after the war. Many of them had succeeded in emigrating to the United States. One interviewee, Eric Herz, describes the feeling of dread he experienced every time he returned to Europe, as if there was a 'dark cloud' hanging over the continent. Yet this cloud or shadow extends far beyond European coastlines and the violence of war did not cease in 1945. The slower violence of subsequent colonial wars, followed by conflicts led or brokered by US imperialism, continues to unfold in the opening decades of a new century.

Much of this chapter has been written under another shelterless sky. In spring 2020, I found myself in Ho Chi Minh City, where I remained for several months during the first year of the COVID-19 pandemic. The sky there generally lacks the deep blue of Provence, but the climate is

less forgiving. It is frequently 35°C during the day and cools down only slightly at night. Being there provided a reminder of this world beyond Europe. A world that is not free of shadows either. To cite an example that we will return to later, Vietnam remains haunted by the ghosts of the Indochina wars that ended French colonial occupation and the subsequent American war, the ecological impact of whose effects, most notably of Agent Orange and landmines, extend well beyond the 12-year conflict (Nixon, 2011: 13–14).

In *Bunker Archaeology* (2012), Virilio explores the legacy of the monolithic structures left to ruin along the Atlantic coastline via photo-essay. The bunkers installed by the German occupation belong to a vision limited to the topographical limits of Europe, a vision that was obsolete even as it was playing out. Despite the extensive use of air and sea space both as battlefields and sites from which to launch attacks onto land, the German ideology of 'blood and soil' embodied an outdated understanding of borders (29–30):

> A long history was curled up here. These concrete blocks were in fact the final throw-offs of the history of frontiers, from the Roman *limes* to the Great Wall of China; the bunkers, as ultimate military surface architecture, had shipwrecked at the land's limits, at the precise moment of the sky's arrival in war; they marked off the horizontal littoral, the continental limit. History had changed course one final time before jumping into the immensity of aerial space. (12)

Thus, for Virilio, the bunkers persist as funerary monuments to the failed Nazi project of Total War.

The shadow hanging over Europe identifies this Europe as already dead. But what about the colonies? Instead of focusing on the aerial trajectory decoupled from the landmass, as Virilio does, I want to remain on the ground, at least for a while, to consider the sites that exceed Europe's topographical boundaries yet fall within the jurisdiction of its political borders. Sites that function at once as concentration camp and launchpad. The image of a galaxy, often used to describe the network of camps extending out from Les Milles and across the south of France, is useful in bringing together two key stakes of France's colonial ambitions. First, we might extend our conception of this 'galaxy' beyond its original usage to encompass a network of camps that both precedes and succeeds the refugee and internment camps set up during the Third Republic and is instrumentalized as deportation camps under Vichy and Occupied France and subsequently during the Algerian War. To these, we might

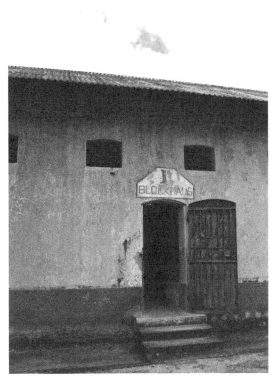

Figure 10. Blockhaus No. 1, Camp de la Transportation, Saint-Laurent-du-Maroni. Photograph by the author, June 2017.

add the vast network of camps composing France's largest penal colony, located in South America between Brazil and Dutch Guiana, as one further but significant example of this wider 'universe'. Over 70,000 convicts from France and its colonies were transported to French Guiana during the penal colony's 100-year operation, which did not close until 1946 (Donet-Vincent, 1992; Pierre, 2017).

If you visit the former Camp de la Transportation in Saint-Laurent-du-Maroni in French Guiana, you will be shown *blockhaus*es used to hold convicts awaiting sentencing for offences committed within the penal colony [Figure 10]. People shudder when their attention is drawn to the signage because of the term's specific association with the Nazi camps.[6] Yet, as the tour guides try to reassure them, this term was used

---

6  This is also implied in the exhibition at Les Milles, where panels describe the camps already being set up by Hitler in 1933 as 'the first concentration camps'.

generically during the early twentieth century. It was most likely first used during the Boer War, whence the term 'concentration camp' also derives (Stone, 2016). I am not so reassured by the idea of the *blockhaus* as commonplace, however. Inside these empty structures, 70 or so convicts would be grouped together, attached by leg irons to a single bar known as the *barre de justice*. The stone banks upon which they lay were slightly sloped to allow the runoff of urine. Frequently, the blockhouses were so overcrowded that it was impossible for men to sleep flat on their backs.

The same architectural structures can be found on the main island of Con Dao, formerly known as Poulo-Condore. Located 230 km from Vietnam's mainland, the archipelago functioned as a French colonial prison where Indochinese subjects were transported for both civilian and political crimes (Zinoman, 2001; Morlat, 1990; Angleviel, 2020). In his extensive study of the colonial prison system in French Indochina, Peter Zinoman describes the fundamental role of incarceration in colonial expansion and control in Indochina. In 1936, 117 people were locked up in prison for every 100,000 members of the population (in mainland France the ratio was 50:100,000) (Zinoman, 2001: 63). Within a vast and disorganized carceral network made up of provincial prisons, central prisons, civil prisons, houses of correction and penitentiaries, the reputation of the penal colony on Poulo-Condore endures as the most notorious. Over 20,000 prisoners are thought to have died on the island during its 100-year operation as penal colony. Where the penal colony in French Guiana was heavily criticized in the mainstream French media, such criticisms generally fell short of comparisons with the Nazi camp network. However, in addition to critiques by the anti-colonial press in Saigon and also Paris (see Zinoman, 2001: chapter 8), in October 1948, Poulo-Condore was compared to a concentration camp in an article published by the Czechoslovakian newspaper *Obrana Lidu*, causing alarm amongst the colonial authorities.[7] Entitled 'France Has Already Forgotten the Concentration Camps' (my translation), the article, written by a Shanghai correspondent, suggests that at that time over

---

There is no historical contextualization of these camps and their wider use globally prior to the Nazi regime.

7  ANOM 2HCI 54. Folder entitled 'Refoulement Indochinois'. The original article is not included in the dossier but paraphrased in a telegram dated 4 October 1948 sent from the Office for France's Overseas Territories in Paris to the Haussaire, Saigon.

2,000 Vietnamese were held on the island, around 500 of them subject to corporal violence. The article also claims that 'Summary executions are frequent'. The response of the colonial authorities was to circulate a press release insisting that the island only housed common criminals in conditions akin to the 'Maison Centrales' back in France and to dismiss the claim of physical brutality and summary executions as 'du domaine de l'imagination' [from the realm of the imagination].[8] However, a letter sent by General Latour, Commissioner PI of the French Republic in Cochinchina, to General Blaizot, Chief Commander of the Armed Forced in the Far East, on 22 October 1948 suggests that with regard to 'administrative internees' (i.e. political prisoners), the South Vietnamese government has adopted 'notre règlementation' [our regulations].[9] The letter, which reflects on the different uses of Poulo-Condore as both political and civilian prison, concludes by suggesting it is henceforth the responsibility of the South Vietnamese government to create 'un camp de concentration' for dealing with those deemed dangerous to public security. The letter thus appears to be at once an endorsement of the establishment of a concentration camp (located in Tay Ninh Province) as a means of suppressing political dissent and an abdication of the future responsibility of the French colonial authorities for this form of internment.

More recently, previously overlooked connections between French colonial carceral practices and wartime policies back home have begun to be explored.[10] In an opinion piece published in *Le Monde* in November 2017, former French Minister of Justice Robert Badinter called for a recognition of the *bagne* in French Guiana as a crime against humanity. The mistreatment of those sent to the penal colony became particularly pronounced under Vichy, Badinter argues, turning the colony into a 'veritable hecatomb'.[11] From these brief examples alone it is possible to see the extent to which the notion of a 'galaxy' of camps exceeds the network emanating out from Les Milles and across the south of France.

8   Press release (Circulaire No 302-IP) from the Ministry of Foreign Affairs dated Paris, 10 November 1948.
9   ANOM 2HCI 54.
10  On the Vichy regime in France's colonies, see also Jennings (2002).
11  The complex political stakes of evoking the 'concentration camp' within a postwar context and, more specifically, referring comparatively to the use of forms of detention in the early twenty-first century, is the focus of multiple scholarly debates. See, for example, Nethery (2009) on the case of Australian immigration detention centres.

Second, the concept of a galaxy and, moreover, the idea of 'satellite' camps prefaces the shift to the sky and, more precisely, the space beyond the earth's atmosphere as the new territory awaiting conquest. But with this shift, the ground does not simply fall away. The question of where to launch from offers France the opportunity to reaffirm its earthly empire within the context of postwar departmentalization. Included in this affirmation was the use of overseas territories as sites for testing rockets: satellite launches on the equator and nuclear testing in the Pacific.[12] Algeria was the original site for both nuclear detonations and satellite launches. The first satellite launch, the Asterix-I, took place at Hammaguir in the Saharan desert in 1965 using France's Diamant booster rocket. Permission to launch formed part of the Évian Accords premised on the understanding France would ultimately identify a new location for its space station.[13]

In the postwar era, the earlier failures to develop French Guiana in terms of economy, agriculture and infrastructure via either slave plantations or convict transportation suddenly becomes its greatest selling point alongside its proximity to the equator. On 21 March 1964, President de Gaulle appeared in Cayenne to promise a new era of technological innovation via the creation of a space station in the territory.[14] Inevitably, the intended beneficiaries are not amongst the crowds of Guyanais gathered around the town square and crammed onto the balconies of surrounding houses to hear the speech. Even during the mid-1960s, critics described the project in terms of a 'cancer', recognizing it would result in social cleansing of the Guyanais population living in and around Kourou (Redfield, 2000: 133). The architecture of the camp as embodied by the blockhouses and tiger cages of French colonial prisons is gradually replaced by rocket launches, a different form of colonization. There is both an irony and a logic in this transformation,

---

12 Between 1966 and 1996, France conducted 193 nuclear tests in French Polynesia, having conducted 17 previously in Algeria. The first, known as 'Gerboise Bleue', took place on 13 February 1960 close to the Mauritanian border. Only recently have calls for acknowledgement and reparations emerged from both Algeria and Tahiti. See Feldman (2018) and Alilat (2020).

13 In the original negotiations, the French had been holding out for a long-term (25-year) lease of both the Mers-el-Kébir naval base and the rocket and atomic bases located in the Sahara. As it transpired, they withdrew within five years of the Évian Accords (Horne, 2002 [1977]: 514).

14 Part of the speech can be viewed here: https://www.ina.fr/video/I08007293.

as described by Peter Redfield in his comparative analysis of the two colonizing projects:

> In both of these projects we glimpse edges of the world, as it were, different ends of the earth. On the one hand lies the colonial fall of thousands of men into the heat of tropical purgatory, and on the other the triumphant rise of a rocket into a cold and calculating heaven. The moral decay of social death fills one horizon, and the technical might of pure machinery fills the other. Yet the hands layer and the vision blurs, for these disparate events occur in the same geographic setting, separated only by the passing of years. At the margins of significance, far from the central circuitry of human affairs, things come together and the ground falls away. At different ends of a critical century paths lead up into orbit and down to the grave. (Redfield, 2000: xiv)

Of course, the camp never fully disappears from the territory following the closure of the penal colony. In Saint-Jean-du-Maroni, the former Camp de la Relégation was repurposed as a refugee camp for Eastern Europeans during the immediate postwar period. The camp operated between 1949 and 1961 but there is little enduring legacy. The site was repurposed as an army base after the camp's closure.[15] With the arrival of the space station in 1968, settlements were cleared out and people displaced from the town of Kourou. The Centre National d'Études Spatiales (CNES) took over jurisdiction of the Îles du Salut (Salvation Islands), including the once-notorious Devil's Island, which lie within the immediate trajectory of the rocket launches. The largest of the islands, Île Royale, now houses advanced telemetry equipment used to track the initial journey of the rockets. A small museum located at the main entrance to the space station in Kourou features a series of panels telling the story of space technology.[16] A single panel provides a brief reminder that Europe's technology is itself based on the Nazi's original V2 missiles (see Redfield, 2000: 117–19).

During the Surinamese Interior War which raged between 1986 and 1989, around 10,000 Maroons fled across the Maroni river to French Guiana (Bourgarel, 1989; Léobal, 2016). Over 5,000 were temporarily housed in camps located around Saint-Laurent-du-Maroni including at Charvein, the site once known for being one of the most brutal work camps of the penal colony. Despite claiming to be a 'terre d'asile' [land of

---

15  For a short introduction to the Camp de la Relégation at Saint-Jean-du-Maroni, see Gimenez, Renneville and Sanchez (2013).
16  https://centrespatialguyanais.cnes.fr/fr/musee-de-l-espace.

asylum], France refused to grant the Surinamese refugee status, instead describing them as temporarily displaced persons. As Clémence Léobal notes, during this period a marked shift occurred whereby the Maroon population who had long lived and worked along both banks of the Maroni river, ceased to be referred to as 'primitive' or 'indigenous' peoples and instead became redefined as illegal migrants (2016: 214–15). Thus, the pejorative designation of 'primitive', which displays a racist and exoticist condescension towards Maroons, gives way to another image that defines them as dangerous and a direct threat to French national security. Indeed, the small number of armed Surinamese amongst the wider population of those fleeing the war were presented as a threat to the security of the space station. Insisting on this temporary status, France refused the United Nations High Commission for Refugees access to the camps until 1988. When the High Commission was finally allowed into the territory it was under the purview of facilitating the return of the refugees to Suriname.

On 8 August 1992, the peace treaty was signed between the National Army, the Jungle Commandos and Tucayana Amazonas. The Surinamese refugees in French Guiana were offered a financial incentive to return home. However, many had lost their homes and livelihoods and had little reason to return. At the end of 1992, those who refused to leave – around 1,700 – were violently deported. According to Léobal: 'Pesticides were thrown on their fields, government agents sawed boats in half on the Acarouany River, artisans' shops were burned' (2016: 228). This dismantling of the camps in 1992 and 1993 formed part of a wider programme of social cleansing in which Maroon settlements along the Maroni river were destroyed with the intention of opening up possibilities for tourism development. Today the border between French Guiana and Suriname continues to be a contested zone as those living along the river are subjected to police regulations imported from Fortress Europe (Benoît, 2020). Such forms of border control on the Maroni and the Oyapock rivers in French Guiana reduce those who live and work along and across the banks of the rivers to stateless individuals, subject to repeat checks, arrests and deportations.

## Tracks in the Sky

We seem to have travelled a long way from Aix-en-Provence yet there is a strange repetition at work in the stories of border crossings, shifting identities, false declarations of hospitality and, finally, violent

deportations. Where, in recent years, many of France's war museums have changed their names to incorporate deportation alongside resistance, to what extent does this relegate the question of deportation to a specific historical moment? Can a critical space be created within the museum to examine contemporary border politics and, indeed, the 'necropolitics' (Mbembe, 2003) these frequently enact?

Again, the Provençal sky provides us with a starting point. What did people see when they looked up from what they were doing and observed the trains and the cattle trucks making their way across the French countryside? What do we see when we look up to the sky on a clear day and spot a tiny silver plane travelling across the blue expanse?

As suggested in Chapter 2, the memorial museum at Les Milles struggles to reconcile the multiple tensions between Fortress Europe and the French republicanism that underpin its operation *and* the radical hospitality towards the other, all others, necessary to circumvent racism, exclusion and, ultimately, genocide. Missing from the museum's narrative are the processes of decolonization and immigration taking place in the decades following the Second World War which have seen the Arab replace the Jew as figure of suspicion and hatred within French society. If the museum's interior is focused on individual responsibility and agency positioned against individual acts of extremism from recent history, what potential is there to think beyond this opposition? What about the policies, infrastructures, technologies which set the limits of our own individual agencies? What about the media ecologies that produce, organize and filter how we see ourselves and others?

To look from the wagon up to the sky is also to track the shifting forms of deportation and, perhaps more significantly, the extraordinary renditions carried out by the United States and other Western states as part of the so-called 'War on Terror'. The logistics of these flights in comparison with the complex planning across Europe's railways explored by Hilberg demonstrates one of the many legacies of the Holocaust in the disappearing of subjects using extra-legal procedures alongside established transport logistics. In the case of deportation of 'illegal' immigrants from Europe, this has become embedded in the day-to-day operations of both scheduled and charter carriers. Today most deportations are no longer conducted across land as they did in the mid-twentieth century. Instead, they occur by plane. The sky is called into the service of Fortress Europe. Those who try to protest are defined in the same terms as those committing acts of extremism. In December 2018, the so-called 'Stansted Fifteen' were found guilty of a

'terror-related offence' by the UK's Crown Prosecution Service (CPS) for preventing a Boeing 767 from taking off. The plane had been chartered by the Home Office to deport 60 people to Sierra Leone, Nigeria and Ghana.[17]

William Walters (2015) has defined the emergence of a new regime of deportation in Europe in terms of what he calls a 'viapolitics'. Part of Walters's claim is that despite the recent turn to 'mobilities' as an area of study within the wider political category of 'governmentalities' emerging from Michel Foucault's (2007) earlier concept of 'governmentality', less attention has been paid to the journeys and the technologies these involve. Furthermore, where deportation was largely invisible as a form of governmentality, it has in the past decade or so become increasingly visible within the 'policyscape' but has also given rise to various forms of resistances. 'For many years deportation was a rather marginal issue in the migration policy scene. However, in recent years it has become a very prominent practice of migration control and a highly symbolic assertion by states of their power over population and territory' (Walters, 2015: 103). The word 'via' has three distinct but interrelated definitions all of which, Walters claims, should be brought to bear on contemporary cultural politics of deportation: 'When imaginings of the journey acquire a prominent place in public mediations of migration, or when the policing of routes and vehicles becomes a central strategic undertaking in the governance of migration, then migration has become viapolitical' (100).

Firstly, *via* is commonly used to mean passing through somewhere *en route* to a destination. This meaning can be mapped back onto the camps and 'almost camps' of France not simply in a calling to account but also to better imagine the convoluted routes deportees had to travel. Walters echoes Gigliotti's contention in *The Train Journey* that in discussions of historical transportation, forced migration, deportation, not enough focus has been given to the journeys or the modes of transport themselves. Second, *via* references the specific mode of transport employed and demands that attention be paid to this as part of the violence of deportation. As Walters points out, the contemporary form of deportation takes place by air and often deportees are

---

17  While a terror-related offence could potentially result in a life sentence, in February 2019, the judge presiding over the trial determined that since the group's actions had been motivated by the safety of those on board the flight, no prison time should be served (Gayle, 2019).

transported amongst civilian travellers. This is one of the ways in which we are co-opted as unwitting witnesses and accomplices to the act of deportation. Passengers are frequently unaware that not everyone in the cabin is travelling for business or pleasure. Where extraordinary rendition frequently involves keeping names off flight plans, often using cargo flights, much deportation takes place in plain view. There is, however, an increasing awareness of which airlines, notably charter flights, are used for deportation.[18]

Finally, *via* is the Latin for 'road' or 'way'. The minute shift in our line of sight from wagon to sky should act as a warning here, a metaphor (or metonym) for the ease with which new technologies have been co-opted to the violence of deportation. Even when the tracks have been removed, the ruins of the railways connecting Europe's network of camps remain as archaeological phenomena. The white tracks in the sky produced by the tiny silver planes fade within minutes, disappearing without a trace.

### Into Thin Air

Arguably the efficacy of the camp lies in its ability to hold, process and ultimately disappear bodies. One of the most difficult tasks of the memorial museum is how to meaningfully commemorate those who disappeared never to be found again. And yet people continue to go missing. In October 2020, the *New York Times* reported that there were 545 children separated from their families at the US–Mexico border whose parents cannot be located (Dickerson, 2020).[19]

Increasingly the disappearance of people is accompanied by the disappearance of the architecture of the camp itself. As various studies have pointed out, the invention of barbed wire at the end of the nineteenth century allowed the rapid repurposing of buildings (including

---

18  At the time of writing part of this chapter in late 2020, global airline travel has been massively disrupted due to the COVID-19 pandemic. Borders have closed and many countries are restricting access to those seeking repatriation or in possession of diplomatic or specialist visas. Available flights are not always publicly listed and there has been a general obscuring of flight data. Repatriation flights are often listed as cargo or charter flights. Within this context and despite a certain increase in flexibility around immigration status, deportations are continuing and often under less scrutiny.

19  The separation of children from their parents at the US–Mexico border was introduced by the Trump administration in 2017.

Les Milles) as camps.[20] There is nevertheless a transformation which occurs following the Second World War in which structures that attest to the temporary, visible presence of war and occupation give way to a permanent, invisible non-presence. The built heritage of the Second World War tends to exist precisely as spaces of transition from peacetime to wartime activity. However, while architecture can be requisitioned, repurposed and subsequently transformed back, it nevertheless bears witness to those who passed through, who were detained and contained within its walls. The housing estate located at Drancy bears witness to this passing through in the graffiti left by detainees (Pouvreau, 2014). Thus, the disappearance of peoples requires a second act of disappearing – of the structures and infrastructures of the camp. Leave no trace. Considered thus, the exceptionalism of Camp des Milles is identified less with its temporary function as camp than in its continued presence as part of the Provençal landscape.

In April 2018, the immigration 'welcome' centre located at the Porte de la Chapelle in the north of Paris was dismantled. The centre, which opened in October 2016, was intended as a temporary measure for dealing with the influx of refugees arriving in Paris. Its nickname, La Bulle, refers to its resemblance to a giant cluster of bubbles. Photos of the dismantled structure lying limp on the ground such as that featured on the France 3 news site (Meyze, 2018), emphasize this temporary, malleable membrane which is so different to the bricks of Les Milles or the stone structures of the Camp de la Transportation in Saint-Laurent-du-Maroni. Coloured off-white and covered with grey and orange circles, it looks like a holiday camp or sports dome, not a place where people come as a last refuge and which, regrettably, is often just the next stage on their way to detention and deportation to other countries and possibly back home. The dismantling resembles a process in which the giant bubble, already a cluster rather than a single bubble, is reduced to foam. Sloterdijk (2004) describes foam as both metaphor and materiality for thinking the disasters of the twentieth century, disasters that we might argue have seeped, or spilled over into the twenty-first. The bombs and dust storms, the lorries and shipping containers, the spray of the sea before one goes under, the exhaust fumes, the tear gas and water

---

20  Razac (2002) identifies barbed wire as implicated in three major historical catastrophes – the genocide of Native Americans, the First World War and the Nazi concentration camps.

cannons, the police officer's knee on a neck, the lungs ravaged by a virus. The right to breathe continues to be a privilege.

In place of La Bulle, which could house up to 450 refugees at a time and saw over 25,000 people pass through its gates during its operation, five smaller centres have been set up in the Île de France region. Where La Bulle was visible for miles around – I spotted it on the train on the way from the Gare du Nord to Compiègne in summer 2017 – these new centres are intended to disperse refugees across the region, rendering their plight less visible. From bubble to foam. Meanwhile, unofficial camps continue to appear under the bridges and overpasses around Paris only to be aggressively dismantled by the police (France 24, 2020). In June 2018, in the area where La Bulle once stood, several artworks attributed to the street artist Banksy appeared (Rea, 2018). One featured a young girl spraying pink patterned wallpaper onto a concrete wall thinly veiling a large black swastika. At the foot of the painting, a battered teddy bear sits on a pile of rough bedding. The girl looks around nervously as if doing something wrong. Yet, in catching our gaze, she challenges us to rethink what is really wrong here. What or who is wrong? What or who is illegal? It is this challenge, this call to hospitality that is missing from the memorial museum despite its repeated statements to the contrary.

Street art such as Banksy's provocations has long been problematized as a form of sustained political resistance (Larkin, 2014). Most notable here are the artworks adorning the wall in Palestine which, if anything, have merely fostered dark tourism in the area. There is nevertheless something compelling in thinking about the compressed air of the spray can and the tiny particles of toxic paint as having the potential to create new images of the world. A political aesthetics of foam, perhaps. In reflecting on the image Banksy offers of the refugee in present-day Paris, we should recall once more the artwork produced in Les Milles. In similar fashion, I have already challenged the idea that such 'work' can truly represent political resistance since it also suggests productivity within the camp. As a 'product' of the camp, this artwork endorses the camp as site of creativity and labour rather than a space where these are suspended. I have also argued that the political resistance lies not in the creation of art as object or work but perhaps in the daring of the artists to imagine the camp taken to its (il)logical extremes. In other words, as a site of radical potential, where, according to Agamben, anything becomes possible. Yet, rehoused within the securitized space of the museum, such work becomes an exhibit, an artefact, co-opted to a space which short-circuits any sustained political resistance or commentary.

What is quite possibly missing from both Banksy's mural and other satirical artworks is the ability to imagine another world is possible.

### Dimming the Sun

> The conquest of the earth thus appears above all the conquest of energy's violence.
>
> (Virilio, 2012: 20)

What might it mean to imagine another world is possible? What are the limits placed on our ability to imagine? Is there a way out of the endless processes of containment and dispersal that define the treatment of both bodies and matter as required by colonial and capitalist projects? I made my second visit to Les Milles in August 2017. The temperature was 40 degrees. I took another photo from the second-floor window, but it was earlier in the day and the sun was stronger, washing out the sky. During this period forest fires raged in the south of France and Italy. The magnitude of these fires has since paled in comparison to those that have engulfed large areas of California and Australia since 2019. This is no doubt a sign of things to come. Beyond the shifting technologies of deportation and colonization, the sky takes us far from the narratives presented to us inside the museum. It obliges us to think about what a museum can do to help us think through the greatest challenges we face as a society and a species. In questioning the specific role of museums in the context of accelerated climate change and the increased pressure this is placing and will continue to place on peace and democracy, it is worth restating the Camp des Milles's status as headquarters of a UNESCO Chair of Education for Citizenship, Human Sciences and Shared Memories which was specially created in 2013. However, in reflecting on the future of the museum and the museum of the future within a context of accelerated climate change, it is also useful to situate the museum alongside other competing forms of cultural production. The following cinematic example has been chosen precisely because it adopts some of the same myths around international cooperation and technical innovation that are found in the reflective zone at Les Milles. It also allows us to remain with the figure of the satellite.

At the end of the film *Geostorm* (2017) the hero, Jake Lawson, played by Gerard Butler, looks up to an early evening sky which is lightly brushed with wispy clouds. The clouds and sky prevent us from seeing what he is

staring up at, the net of satellites that lies beyond the earth's atmosphere and which spans the entire surface area of the globe. This invisible net, described by Lawson's 13-year-old daughter in terms of human effort and collaboration, offers us an alternative image to the shelterless sky proposed by Sloterdijk. Here the sky once again offers us shelter, not as the result of a divine protector but rather as a defining moment of human achievement. Lawson is the engineer mastermind behind the net, an international programme designed to allow human intervention against the threat of extreme weather. Problems arise when some of the satellites are weaponized to cause rather than prevent extreme weather. Lawson, who has previously been fired for his hostility towards politicians, is called upon to fix the satellites while his younger brother, Max, based in Washington, DC, must find the saboteurs before a series of individual storms trigger a global 'geostorm' and mass extinction.

Most Hollywood disaster movies are really about commonplace human relationships. It is the threat of global apocalypse that is required to restore damaged families. Frequently, this involves the restoration of the nuclear family via the heroic actions of a previously ineffectual father.[21] *Geostorm* differs in that it is the broken relationship between siblings that is at stake. We might identify a shift here from the established American myth of the family to a more globalized myth of cooperation between technological innovation and political diplomacy embodied by the respective roles and personalities of an older and younger brother.

The fictional 'net' offers an image of connectivity that is as fragile and vulnerable as the humanity it is built to protect. It embodies the paradox identified by Jean-Pierre Dupuy in his writing on catastrophism (2004; 2005). This is the generally held belief that the same capacity for technological development that has led to climate disaster will also save us from it – *just in time*. Dupuy identifies this as part of 'l'orgueil métaphysique de l'humanité' (2005: 29) [the metaphysical arrogance of humanity]. Philippe Bihouix (2017) has described this collective belief as the 'myth of technological salvation'. This myth is underpinned by the assumption that the effects of climate change will force different nation states to work together more closely rather than engendering deeper divisions due to limited resources, polluted atmospheres and the creation of millions of unwanted climate refugees. Towards the film's climax, the geostorm

---

21 Notable examples that fall into this category include *The War of the Worlds* (2005) and *2012* (2009).

threat is discovered to be the work of a US politician bent on assuming total power by ensuring control of the net. This is posited as something unilateral and easily circumvented rather than creating and exacerbating a complex series of ongoing geopolitical tensions. Indeed, it is interesting to note that the film concludes with NASA assuming control of the satellite following the destruction of the International Space Station. There is an ambiguity here, a reluctance embedded in the film's script to cede US sovereignty even after the desire for such sovereignty is proven to be the cause of the weaponization of the net.

The imagined net as a feat of engineering that reacts to advanced forms of weather forecasting constitutes a fictional example of what Robert P. Marzec (2015) has referred to as 'environmentality'. Like Walters, Marzec also draws on Foucault's concept of 'governmentality' outlined in the 'Security, Territory, Population' Collège de France lectures. 'Environmentality' describes a specific understanding of environment and climate based on worst-case scenarios that necessitate a defensive or military response. Such responses already include the use of security, surveillance, borders, stockpiling of resources, displacement and forced migration of populations and the use of detention and incarceration. As Marzec argues: 'It is a policing action that deterritorializes the complexity and diversity of the environment and reterritorializes the earth so as to enframe it as a single naturalized identity: the ultimate threat to national security' (2015: 44). What he means here is that climate disaster is posited as an external, abstract threat, a natural disaster, by Western governments (and most notably the United States). This decouples the threat from the specific actions of an individual nation state whilst enabling a response that is unapologetic in its focus on the protection of its citizens. That governments insist on the validity of such claims in the face of extreme social inequalities and crumbling social infrastructure emphasizes the collective act of bad faith located at the centre of environmentality. Here we might cite the communities in Flint, Michigan in the United States who have been deprived of clean water since 2014 when the water supply was switched to the Flint River to reduce costs. Failure to adequately treat the water, combined with an ageing pipe system, meant tap water became contaminated with lead, causing a long-term public health crisis (Renwick, 2019) lasting five years. In the UK, it took years of campaigning before a coroner ruled that nine-year-old Ella Kissi-Debrah had died because of toxic levels of air pollution in the South London borough of Lewisham in 2013 (Laville, 2020). As Nadine El-Enany (2019) has pointed out, the final words of Kissi-Debrah, 'I can't breathe', echo and preface those uttered by

victims of police brutality as they are suffocated or strangled while under arrest. El-Enany draws our attention to the racial minorities who suffer disproportionately from a toxic ecology that denies access to breathable air in complex and multifarious ways.

Where governmentality is predicated upon the biopolitical, the production, maintenance and management of life as underlying aim, we might identify environmentality more closely with the thanatopolitical drives of the Nazi regime. Environmentality is based on what Virilio has termed 'the Accident', an event of total destruction. It involves an understanding of environment based on absolute loss of environment. In the face of such imagined threats, the reaffirmation of borders, together with the stockpiling of resources and widespread forms of extra-legal detention, engenders the same nihilistic implosion as Nazism. The task of identifying and seeking alternatives to multiple and often diffuse forms of environmentality lies both within and beyond the 'concentrationary memory' project set out by Pollock and Silverman which has driven much of the thinking in this book. As Pollock and Silverman ask in the series preface:

> Has the concentrationary passed from the political real into culture? Unhinged from its specific historical origins in Nazi camps and Stalinist gulags, does the concentrationary shape the contemporary cultural imaginary like a political unconscious, normalizing narratives of military superpowers enslaving and annihilating its subjected and dispensable others, and accustoming us to unspeakable violence and suffering where arbitrary extinction is no longer murder but wasting, or, worse, just business? (2015: xvii)

The atmospheric disasters of the twentieth century introduced by Sloterdijk in *Terror from the Air* and explored at greater length in *Foams* (2004), the final volume of his *Spheres* trilogy, seem to preface the climate crises that will shape the coming decades and beyond. Sloterdijk suggests that the idea of shared space and collectively breathed air will become increasingly under threat. Instead, we will retreat to artificial spaces of what he calls co-isolation. This offers a cynical if not realistic image of a future that is already here, one that contrasts with *Geostorm*'s closing image of shelter and protection underneath a shared sky. Since 2020 we have already begun to live in co-isolation. It is telling, in the context of the COVID-19 pandemic, that this co-isolation has been referred to in terms of bubbles. Social bubbles between households, travel bubbles between nation states.

Having considered the museum in relation to the cloud, might we also consider it as a form of bubble? The experience of visiting the Memorial Museum at Les Milles involves a form of sealing off from the outside world. But the bubble is defined by its fragility. The stories the museum tells and the warnings it issues risk dissipating the moment the visitor exits. However, the skylight and the suicide window act as valves that ensure the interior space of the museum does not become a vacuum. Instead, they alert us to the potential of the museum to be reconceived as a 'porous membrane'. Jonas Tinius uses this concept of a porous membrane to describe the complex relationships existing between a museum, its local surroundings and community, staff and visitors. As he points out: 'Membranes are ambiguous. They divide and connect' (2020: 255). His focus is on Galerie Wedding, a contemporary art gallery in Berlin, and involves a sustained reflection on what it means to 'do' anthropology within a gallery or museum notwithstanding the difficult history of anthropology as colonial form of knowledge production and appropriation. Nevertheless, his questions about inclusion and hospitality might equally be applied to museums more widely, including those such as Les Milles dedicated to commemorating victims of genocide and atrocity.

The pandemic of 2020 precipitated a crisis in museums that many had seen coming for years if not decades. The closure of museums and galleries followed by the imposition of social distancing measures calls into question earlier economic models based on footfall at museums' physical sites. In the first instance, closures forced an accelerated engagement with social media and virtual technologies. But in the second, the cautious reopening of museums in a world where global tourism had been put on hold, led to a reconsideration of local audiences over and above international visitors. In some instances, museums have altered perceptions of what they are for by providing services such as food banks and other forms of community support.[22] Considering

22   Examples of museums which temporarily operated as food banks during the COVID-19 pandemic include the Brooklyn Museum (Orlow, 2020). In June 2021, the National Gallery (UK) collaborated with the Bridge Food Bank in Lincoln, which displayed Jan van Huysum's *Flowers in a Terracotta Vase* as part of the 'Jan van Huysum's Visits' (National Gallery, 2021). In 2015, the Discovery Museum in Newcastle (UK) commissioned an artist to create an installation at the city's West End Food Bank as part of the Museums Association 'Transformer's Programme' (Sullivan, 2015).

these recent challenges helps identify the museum's most urgent tasks. Amongst these, I want to propose two tasks – both of which can be applied directly to Les Milles and to museums more generally.

The first task and perhaps the most difficult for many museums is to actively challenge Enlightenment discourses of science and man. If the consensus embodied by the International Council of Museum's definitions is that museums exist for future generations then they also have the task of ensuring that *there will be* future generations.[23] There is a need to engage critically with current discourses around climate change and how to respond to the challenges it presents. Bound up in these discourses are ideas about knowledge and scientific enquiry. As DeLoughrey (2019) and Yusoff (2018) have argued, the positivist approach of scientists towards the identification and mapping of the Anthropocene obscures and erases the violence of dispossession, forced migration, and plantation and extraction labour that defines the ongoing histories of colonialism and capitalism. Instead, a universalist image of 'Man' is presented as the singular figure of the Anthropocene. Such European Enlightenment discourse is present at Les Milles notably in its self-definition as a 'Musée de l'Histoire et des Sciences de l'Homme'. However, in telling the story of those whom history sought to eradicate and forget, the memorial museum must not only challenge existing histories but create space for different, localized forms of knowledge production and dissemination. Binding this to the challenge of responding to future threats to democracy that lies at the heart of the mission of the Les Milles memorial requires situating the camp within a wider carceral and (post)colonial landscape as this chapter has attempted to do.

The second task involves pushing the idea of the museum as a space of inclusion and hospitality. It is becoming increasingly evident that climate change is going to produce the largest displacement of populations since the transatlantic slave trade, perhaps even greater. Those forced to flee their homes due to climate disaster will be housed in camps and other

23 Following an extended consultation period, the International Council of Museums (n.d.) adopted a new definition on 24 August 2022: 'A museum is a not-for-profit, permanent institution in the service of society that researches, collects, conserves, interprets and exhibits tangible and intangible heritage. Open to the public, accessible and inclusive, museums foster diversity and sustainability. They operate and communicate ethically, professionally and with the participation of communities, offering varied experiences for education, enjoyment, reflection and knowledge sharing'. See https://icom.museum/en/resources/standards-guidelines/museum-definition/.

temporary forms of accommodation at the edges and margins of cities and towns. They will be subject to hostility as unwanted, undesirable problems; their lifestyles will be markedly different from their more settled neighbours. This makes discourses of genuine hospitality so essential. The museum, many kinds of museum, must provide a space not only to reflect upon these. Museums might also offer genuine spaces of shelter and refuge as both Mbembe (2013) and Vergès (2010) have proposed in different ways. But to achieve this, museums must also recognize the ever-changing nature of what hospitality requires, from whom and to whom.

## Rereading the Sky

When I first started thinking about the view from the window at Les Milles over eight years ago now, my immediate thought about the sky was its indifferent, implacable nature offering no shelter or solace in the face of the human tragedies unfolding below. The first example that came to mind was Albert Camus's anti-hero Meursault on the beach beneath a sky that he initially describes in terms of 'le bleu déjà dur' [hard, blue] (1942/1989: 80/49).

When I reread this passage in *L'Étranger*, I realize that it is not the sky's consistent hard blue that creates the backdrop for the violence committed by Meursault but rather the sky's changeability, its lack of constancy. So the same sky everywhere is, as our cloud reminds us, never the same. The hard blue gives way to a searing white light at midday. Then, in the moments before Meursault shoots the Arab, it appears to him 'que le ciel s'ouvrait sur toute son étendue pour laisser pleuvoir du feu' (95) [as if the sky split open from one end to the other to rain down fire (59)]. This is just one of the many ways, I have discovered, that I have misremembered the text. Such misremembering is hardly surprising given that I first read the novel at the age of 17 and had not read it again in its entirety until now.

In light of this, I want to end this chapter by calling for a rereading and a return, for a revisiting of museums as well as texts – especially those that we think we have fully grasped, that we think we have all the answers to – with a view to reading and looking differently. Faced with the increasing vicissitudes of global climate change and a dominant politics of fear towards the intensifying refugee crisis, I want to believe that museums can continue to create a space in which to think differently

and actively. This is not to say that museums do not continually fall short of their purported claims. Les Milles demonstrates the impossible and often paradoxical task of the museum as privately run, state-endorsed, public-facing institution. But there is no denying that my visits to the memorial museum have changed the way I think, have frustrated, angered, upset me for sure but also challenged me, inspired me and instilled in me a hopeless faith in the potential of museums and their role in our shared futures.

I want to conclude with a scene towards the end of Camus's novel after Meursault has been sentenced to death. He has also just discovered the crude reality of the procedure. He describes how one imagines climbing up to the scaffold based on images from the French Revolution. Instead, it turns out, the guillotine is situated on the ground, one does not climb towards the sky, which he suggests would offer the imagination something to hold on to. Despite this realization, the sky continues to provide Meursault with a focal point, structuring his time and thoughts. He spends his days lying on the bunk in his cell, looking up at the small 'pane' of sky that appears through the window and trying to discern 'something interesting in it' (Camus, 1989 [1942]: 113). Yet, as the sky turns green, which signals the start of night, Meursault's anxiety grows, and he stays awake waiting for the dawn. Dawn is when executions take place and, he points out, 'je n'ai jamais aimé être surpris' (172) [I never liked to be surprised (113)]. It is only when the red light of the early morning comes into view and no footsteps or knock have arrived that he knows he will live another 24 hours. But more important than the relief offered by the changing colour of the sky is the proximity it brings him to his mother:

> Maman disait souvent qu'on n'est jamais tout à fait malheureux. Je l'approuvais dans ma prison, quand le ciel se colorait et qu'un nouveau jour glissait dans ma cellule. Parce qu'aussi bien, j'aurais pu entendre des pas et mon cœur aurait pu éclater. (172)

> Maman used to say that you can always find something to be happy about. In my prison, when the sky turned red and a new day slipped into my cell, I found out that she was right. Because I might just as easily have heard footsteps and my heart could have burst. (113)

It might seem puzzling and almost counterintuitive that I should end this chapter which started with an account of the sky as seen from the Camp des Milles memorial in the south of France with this extended reference to Meursault awaiting the guillotine in his cell in Algiers. But it is perhaps not so illogical that we should finish with waiting.

## France's Memorial Landscape

The view from Les Milles is one that is also defined by waiting and to look towards the sky reminds us of all those elsewhere who continue to wait. Awaiting eviction, discovery, arrest, sentencing, deportation, death ... but also awaiting appeal hearings, deferrals, clemency, asylum, citizenship, acceptance and maybe, one day, even freedom.

# Conclusion
## Recollections of a View

A significant part of this book has been taken up with offering a critical assessment on the immense task of creating a site of memory such as Les Milles. The memorial site and its multiple exhibitions constitute the end point of over 30 years of campaigning and memory work by the Chouraqui family and others. But the museum is not simply an end point. Self-defined as a 'Musée de l'Histoire et des Sciences de l'Homme', it takes up the difficult challenge of 'concentrationary memory' in seeking not only to produce knowledge and understanding about the events that took place at the tile factory and surrounding area between 1940 and 1942 but to use these events to foster awareness and, arguably, militancy in the face of new forms of xenophobia and racism. The museum has been able to draw on a wealth of interpretive material including photos, documentary footage, autobiography, oral histories, maps, advertising, models, painting and poetry alongside the traces left of the camp within the site itself. One of the approaches taken in analysing the exhibition interpretation has been to explore the different ways in which established symbols and iconography associated more widely with the Second World War and Holocaust have been adopted and adapted within the memorial space. A key stake for the museum has involved establishing its exceptionality as the only internment camp in France remaining intact today whilst acknowledging the decades of memory work across Europe that has shaped the memorial's own interpretive strategies, layout and design.

While the sheer amount of material contained within the museum can seem overwhelming, the exhibition spaces have been carefully conceived to allow for moments of respite and reflection, balancing the artificial light of the historical exhibition with the natural light offered by skylights and the second-floor 'suicide' window. Moreover, the different forms of interpretation invite visitors to make their own

choices in terms of which panels they read and which oral histories they listen to. Conversely, the reflective space which constitutes the third and final section of the permanent exhibition raises a number of issues both in terms of its overarching narrative and the sources drawn upon to substantiate its claims. Such sources include the use of psychological and sociological studies such as the Stanford Prison Experiment and the bystander effect which have been widely critiqued and discredited. What emerges in both the material presented in this part of the exhibition and the supporting statements published about Les Milles by the museum's president-founder, Alain Chouraqui, and its head of scientific and pedagogical content, Bernard Mossé, is a deep anxiety around the memorial's narrative which risks shutting down a space for difficult discussions and debates around citizenship, identity and inclusion. Such an anxiety is linked to the museum's role as a public-facing institution which must espouse French republican discourse on these issues. This discourse bears witness to an increased focus on securitization and a dangerous conflation of religious extremism, right-wing fascism and earlier forms of totalitarianism. This is perhaps most powerfully felt at the entrance to the museum, where a sign outside the controlled entrance doors and X-ray machine informs visitors that their presence at the site represents an act of resistance.

Making multiple visits to the museum between 2015 and 2021, it has been possible to observe inevitable changes to the museum's exhibitions. As discussed in Chapter 4, one of the most significant is the introduction of panels positioned along the Chemin des déportés celebrating the 'righteous', those who offered support and sanctuary to those awaiting deportation. Elsewhere, additions or changes to interpretive material have not brought about significant changes to the overall narrative or organization of the permanent exhibition space. Instead, these have intensified the museum's original message. Of note here is the sign for the 'Volet réflexif', which originally read 'Comprendre pour demain' [understand for tomorrow]. Since at least 2017, 'demain' has been crossed out and replaced with 'aujourd'hui'. The mock defacing of the official sign is intended to create a sense of urgency in the face of growing social unrest across France and Europe. Yet, despite this alteration, the interpretive material within the reflective section has not been significantly adapted. While there are detailed explanations of the multiple steps leading to totalitarian regimes and the persecution of marginalized racial and religious groups, little attempt is made to understand how

current socioeconomic conditions in France and across Europe, coupled with overt hostility to asylum seekers, are fostering extremist behaviour.

In seeking to tease out the paradoxes, tensions and aporias that define the project of the memorial museum at Les Milles, the intention has been to avoid an exhaustive account of the exhibition space and its displays. Likewise, contextualizing the relatively recent inauguration of the site in 2012 in relation to France's wider memorial landscape has not resulted in a complete map or guidebook. If anything, it has demonstrated the impossibility of this type of mapping activity. Instead, the aim has been to show how, as visitors, we might creatively move beyond a museum's reductive and problematic discourse and that frustration can itself become inspiration and, ultimately, meaningful engagement. As suggested in chapters 4 and 5, perhaps one of the predominant tasks of today's museums is to invite visitors to undertake their own enquiries or map out their own paths beyond the limits of the exhibition space. Mapping out my own path across France's Second World War memorial landscape has necessarily involved recognizing the 'entangled' histories of its colonial occupations and the wider use of networks of camps and related technologies of violence across France's overseas empire, which were discussed in Chapter 5. Here my work takes on Michael Rothberg's claim that 'we cannot stem the structural multidirectionality of memory' (2009: 313). As he goes on to conclude: 'Even if it were desirable – as it sometimes seems to be – to maintain a wall, or *cordon sanitaire*, between different histories, it is not possible to do so. Memories are mobile; histories are implicated in each other' (313).

Despite the seemingly infinite routes leading us out of Les Milles, I have also sought to retain focus throughout the book on the view from the second-storey so-called 'suicide' window. Each chapter has coalesced around a specific visual marker which has allowed sustained reflection on the different ways in which Les Milles is framed by and, at the same time, reframes a complex set of iconographies and narratives associated with the Shoah and its memory. However, the story of the women who jumped can also be situated within a much longer global set of histories of women who jumped to escape, of women whose plight has been reduced to a brief reference in a police report or an entry in a ledger. In centring this study of Les Milles around this window, I have also sought to centre these women whose identities and lives have been erased from history and memory. The view from the window offers a pause, an ellipsis, a suspension and a silencing of all the other silences.

# Archival References

Archives départementales Bouches-du-Rhône (ADBR)
7 W 108-112
76 W 177

Archives Mémorial de la Shoah (MdS)
MDXVIII-36
MXII_11726
CIII_272

Archives Nationales de France (ANF)
AJ/41/505
F7/15088

Archives Nationales d'Outre-Mer (ANOM)
2HCI 54

# Bibliography

Achille, Etienne, Charles Forsdick and Lydie Moudileno, eds. 2020. *Postcolonial Realms of Memory: Sites and Symbols in Modern France*. Liverpool: Liverpool University Press.

Adamson, Thomas. 2018. 'Hitler in War, Merkel in Peace: A Train Car for History'. *Associated Press*. 8 November. https://www.apnews.com/45ed2aad6c7a4261a92339db16fd3a79.

AFP. 2015. 'Le camp de Natzwiller-Struthof, seul camp de concentration sur le territoire français'. France 3. 25 April. http://france3-regions.francetvinfo.fr/grand-est/2015/04/25/le-camp-de-natzwiller-struthof-seul-camp-de-concentration-sur-le-territoire-francais-712395.html.

Agamben, Giorgio. 1998a. *Homo Sacer: Sovereign Power and Bare Life*. Translated by Daniel Heller-Roazen. Stanford, CA: Stanford University Press.

———. 1998b. *Remnants of Auschwitz: The Witness and the Archive*. Translated by Daniel Heller-Roazen. New York, NY: Zone Books.

Agence France-Presse. 2017. 'Marine Le Pen Denies French Role in Wartime Roundup of Paris Jews'. *Guardian*. 9 April. https://www.theguardian.com/world/2017/apr/09/marine-le-pen-denies-french-role-wartime-roundup-paris-jews.

Alilat, Farid. 2020. 'Algeria: France Urged to Reveal Truth about Past Nuclear Tests'. *The Africa Report*. 10 September. https://www.theafricareport.com/41067/algeria-france-urged-to-reveal-truth-about-past-nuclear-tests/.

Allmer, Patricia. 2006. 'Framing the Real: Frames and Processes in René Magritte's Œuvre'. In *Framing Borders in Literature and Other Media*. Edited by Werner Wolf and Walter Bernhart, 113–38. Amsterdam and New York, NY: Rodopi.

Alvarez, Natalie. 2018. *Immersions in Cultural Difference: Tourism, War, Performance*. Ann Arbor, MI: University of Michigan Press.

Andrews, Kay. 2010. 'Finding a Place for the Victim: Building a Rationale for Educational Visits to Holocaust-Related Sites'. *Teaching History* 141: 42–49.

# Bibliography 199

Angleviel, Frédéric. 2020. *Poulo-Condore: un bagne français en Indochine*. Paris: Vendémiaire.

Apel, Dora. 2002. *Memory Effects: The Holocaust and the Art of Secondary Witnessing*. New Brunswick, NJ and London: Rutgers University Press.

Arendt, Hannah. 1964. *Eichmann in Jerusalem: A Report on the Banality of Evil*. New York, NY: The Viking Press.

Association du Wagon-souvenir des Milles. 1992. *Mémoire pour demain: Camp des Milles. Cinquantenaire des déportations d'août–septembre 1942. Revue de presse*. Aix-en-Provence: Association du Wagon-souvenir des Milles.

Atelier L'épicerie. 2013. 'Graphic Design and Signs'. In *Memory of the Camp des Milles, 1939–1942*. Edited by Alain Chouraqui, 226. Marseille: Métamorphoses/Le Bec en l'air.

Atelier Novembre. 2013. 'The Camp des Milles: A Memorial Site …'. In *Memory of the Camp des Milles, 1939–1942*. Edited by Alain Chouraqui, 209–31. Marseille: Métamorphoses/Le Bec en l'air.

Azoulay, Ariella. 2001. *Death's Showcase: The Power of the Image in Contemporary Democracy*. Cambridge, MA: The MIT Press.

———. 2008. *The Civil Contract of Photography*. Cambridge, MA: The MIT Press.

Bachelier, Christian. 1996. *La SNCF sous l'occupation allemande 1940–1944. Rapport documentaire*. 5 vols. Paris: IHTP-CNRS.

Badinter, Robert. 2017. 'Le bagne de Guyane, un crime contre l'humanité'. *Le Monde*. 24 November. https://www.lemonde.fr/idees/article/2017/11/24/robert-badinter-le-bagne-de-guyane-un-crime-contre-l-humanite_5219546_3232.html.

Barthes, Roland. 1972 [1957]. *Mythologies*. Translated by Annette Lavers. New York, NY: Noonday Press.

———. 1980. *Camera Lucida: Reflections on Photography*. Translated by Richard Howard. New York, NY: Hill & Wang.

Baruch Stier, Oren. 2015. *Holocaust Icons: Symbolizing the Shoah in History and Memory*. New Brunswick, NJ: Rutgers University Press.

Bauman, Zygmunt. 2007. *Le Présent liquide: Peurs sociales et obsessions sécuritaires*. Paris: Seuil.

BBC. 2017. 'Netanyahu in Paris to Commemorate Vel d'Hiv Deportation of Jews'. 16 July. https://www.bbc.co.uk/news/world-europe-40622845.

Benjamin, Walter. 2003. *Selected Writings: Volume 4, 1938–1940*. Translated by Edmund Jephcott, Howard Eiland and Michael W. Jennings. Cambridge, MA: The Belknap Press of Harvard University Press.

———. 2005. [1940]. *On the Concept of History*. Translated by Dennis Redmond. https://www.marxists.org/reference/archive/benjamin/1940/history.htm.

Benoît, Catherine. 2020. 'Fortress Europe's Far-Flung Borderlands: "Illegality" and the "Deportation Regime" in France's Caribbean and Indian Ocean Territories'. *Mobilities* 15.2: 220–40.

Benoit, Jean-Marc, and Jessica Scale. 2008. *Bleu, blanc, pub: trente ans de communication gouvernementale en France*. Paris: Le Cherche Midi.

Bertaigne, Jean-Paul. 1992. 'Wagon: une porte ouverte sur la mémoire'. *Le Provençal*. 4 November.

Bihouix, Philippe. 2017. 'Le mythe de la technologie salvatrice'. *Esprit*. March–April. https://esprit.presse.fr/article/philippe-bihouix/le-mythe-de-la-technologie-salvatrice-39262.

Bitgood, Stephen. 2009. 'Museum Fatigue: A Critical Review'. *Visitor Studies* 12.2: 93–111.

Blum, Benjamin. 2018. 'The Life Span of a Lie'. *Medium*. 7 June. https://gen.medium.com/the-lifespan-of-a-lie-d869212b1f62.

Boime, Albert. 1998. 'Cézanne's Real and Imaginary Estate'. *Zeitschrift Für Kunstgeschichte* 61.4: 552–67.

Boum Make, Jennifer. 2022. 'Le potentiel de la fiction face à l'absence archivistique des expériences d'esclavisé.e.s: entre prise de conscience de la violence de l'esclavage et nécessité du prendre soin'. *Society of Francophone Postcolonial Studies*. Annual Conference, 18–19 November.

Bourgarel, Sophie. 1989. 'Migration sur le Maroni: les réfugiés surinamais en Guyane'. *Revue européenne des migrations internationales* 5.2: 145–53.

Bretton, Laure. 2015. 'Hollande au Camp des Milles: "Le devoir de refuser certains mots"'. *Libération*. 8 October. https://www.liberation.fr/france/2015/10/08/camp-des-milles-francois-hollande-attaque-ceux-qui-utilisent-ces-angoisses-pour-separer-diviser-et-p_1399777/.

Brinkley, Robert, and Stephen Youra. 1996. 'Tracing Shoah'. *PMLA* 111.1: 108–27.

Broch, Ludivine. 2016. *Ordinary Workers, Vichy and the Holocaust: French Railwaymen and the Second World War*. Cambridge: Cambridge University Press.

———. 2017. 'The SNCF Affair: *Cheminots* in the Divided Memories of Vichy France'. In *Lessons and Legacies XVII: New Directions in Holocaust Research and Education*. Edited by Wendy Lower and Laura Faulkner Rossi, 164–89. Evanston, IL: Northwestern University Press.

Brozgal, Lia. 2020. *Absent the Archive: Cultural Traces of a Massacre in Paris, 17 October 1961*. Liverpool: Liverpool University Press.

Butler, Judith. 2010. *Frames of War: When Is Life Grievable?* London and New York, NY: Verso.

Camus, Albert. 1942. *L'Étranger*. Paris: Gallimard.

———. 1989. *The Stranger*. Translated by Matthew Ward. New York, NY: Vintage.

Cendrars, Blaise. 1973. *L'Homme foudroyé* (Paris: Gallimard).

———. 1992. *Sky: Memoirs*. Translated by Nina Rootes. London: Paragon House.

Centre de Documentation Juive Contemporaine (CDJC). 1996. *L'Internement des Juifs sous Vichy. Catalogue de l'exposition*. Paris: Centre de Documentation Juive Contemporaine.
de Certeau, Michel. 1984 [1980]. *The Practice of Everyday Life*. Translated by Steven Rendall. Berkeley, CA: University of California Press.
Chappey, Jean-Luc. 2006. 'De la science de l'homme aux sciences humaines: enjeux politiques d'une configuration de savoir (1770–1808)'. *Revue d'Histoire des Sciences Humaines* 15.2: 43–68.
Chirac, Jacques. 1992. 'Préface'. In *Les temps des rafles: le sort des Juifs en France pendant la guerre*, 3–4. Paris: Centre de documentation juive contemporaine.
Chouraqui, Alain 1996. 'Le camp des Milles ou la mémoire au forceps'. *L'Arche* 460: 68.
———. 2013. 'A Memorial So We Can Learn from Our Past'. In *Memory of the Camp des Milles, 1939–1942*. Edited by Alain Chouraqui, 9–11. Marseille: Métamorphoses/Le Bec en l'air.
———, ed. 2015. *Pour résister: à l'engrenage des extrémismes, des racismes et de l'antisémitisme*. Paris: Cherche Midi.
Cohen, Erik H. 2011. 'Educational Dark Tourism at an *In Populo* Site: The Holocaust Museum in Jerusalem'. *Annals of Tourism Research* 38.1: 193–209.
Collectif Piment. 2020. *Le dérangeur. Petit lexique en voie de décolonisation*. Marseille: Hors d'Atteinte.
Cooke, Steven. 2000. 'Negotiating Memory and Identity: The Hyde Park Holocaust Memorial, London'. *Journal of Historical Geography* 26.3: 449–65.
Dalston, Lorraine. 2016. 'Cloud Physiognomy'. *Representations* 135: 45–71.
Darley, John M., and Latané Bibb. 1968. 'Bystander Intervention in Emergencies: Diffusion of Responsibility'. *Journal of Personality and Social Psychology* 8.4: 377–83.
Davey, Gareth. 2005. 'What Is Museum Fatigue?' *Visitor Studies Today* 8.3: 17–21.
Day, Joe. 2013. *Corrections and Collections: Architectures of Art and Crime*. Abingdon: Routledge.
Delbo, Charlotte, 1968. *None of Us Will Return*. Translated by John Githens. New York, NY: Grove Press.
Deleuze, Gilles. 1972. *Proust and Signs*. Translated by Richard Howard. New York, NY: George Braziller.
DeLoughrey, Elizabeth. 2019. *Allegories of the Anthropocene*. Durham, NC: Duke University Press.
Dély, Renaud. 2015. 'Hollande attendu au Camp des Milles: "Les crispations identitaires peuvent toujours mener au pire"'. *L'Obs*. 7 October. https://www.nouvelobs.com/politique/20151007.

OBS7263/hollande-attendu-au-camp-des-milles-les-crispations-identi-taires-peuvent-toujours-mener-au-pire.html.
Denis, Cécile. 2015. 'Le camp d'internement des Milles: enjeux mémoriels (1939–2013)'. *Essais* 6: 70–92.
Derobert-Ratel, Christiane. 2015. 'Le vieux cimetière juif d'Aix-en-Provence, un précieux instrument de connaissance de l'histoire d'une communauté'. *L'Écho des Carrières* 79: 5–25.
Derrida, Jacques. 2000 [1967]. *De la grammatologie*. Paris: Minuit.
———. *Of Hospitality: Anne Dufourmantelle Invites Jacques Derrida to Respond*. Translated by Rachel Bowlby. Stanford, CA: Stanford University Press.
Dickerson, Caitlin. 2020. 'Parents of 545 Children Separated at the Border Cannot Be Found'. *New York Times*. 21 October. https://www.nytimes.com/2020/10/21/us/migrant-children-separated.html.
Didi-Huberman, Georges. 2008. *Images in Spite of All: Four Photographs from Auschwitz*. Translated by Shane B. Lillis. Chicago, IL: Chicago University Press.
———. 2017. *Bark*. Translated by Samuel E. Martin. Cambridge, MA: MIT Press.
Diken, Bülent, and Carsten Bagge Laustsen. 2005. *The Culture of Exception: Sociology Facing the Camp*. Abingdon: Routledge.
Donet-Vincent, Danielle. 1992. *La fin du bagne, 1923–1953*. Rennes: Éditions Ouest France.
Dres, Jérémie. 2011. *Nous n'irons pas voir Auschwitz*. Paris: Éditions Cambourakis.
Dreyfus, Jean-Marc, and Sarah Gensburger. 2003. *Des camps dans Paris: Austerlitz, Lévitan, Bassano, juillet 1943–août 1944*. Paris: Favard.
Dubromel, Stéphane. 2016. 'Dans l'enfer du seul camp de concentration français'. *Ouest France*. 30 September. https://www.ouest-france.fr/culture/histoire/dans-l-enfer-du-seul-camp-de-concentration-francais-4527197.
Dumas, Alexandre. 2007 [1846]. *Le Comte de Monte Cristo*. 2 vols. Paris: Gallimard.
Dunlap, David W. 2016. 'How Many Witnessed the Murder of Kitty Genovese?' *New York Times*. 6 April.
Dupuy, Jean-Pierre. 2004. *Pour un catastrophisme éclairé: Quand l'impossible est certain*. Paris: Seuil.
———. 2005. *Petite métaphysique des tsunamis*. Paris: Seuil.
Duras, Marguerite. 1972. *Hiroshima mon amour: scénario et dialogue*. Paris: Gallimard.
Durham Peters, John. 2015. *The Marvelous Clouds: Towards an Elemental Philosophy of Media*. Chicago, IL: University of Chicago Press.
Eaude, Michael. 2007. *Catalonia: A Cultural History*. Oxford: Signal Books.

Eddo-Lodge, Reni. 2018. *Why I'm No Longer Talking to White People about Race*. London and New York, NY: Bloomsbury.

Edwards, Elizabeth. 1999. 'Photographs as Objects of Memory'. In *Material Memories: Design and Evocation*. Edited by Maruis Kwint, Christopher Breward and Jeremy Aynsley, 221–36. Oxford and New York, NY: Berg.

El-Enany, Nadine. 2019. 'Carceral Continuum'. In conversation with Nicholas Shapiro. Nottingham Contemporary. 20 June. https://www.nottinghamcontemporary.org/record/contemporary-conversation-carceral-continuum/.

Élysée.fr. 2017. 'Speech by the President of the Republic Emmanuel Macron at the Vel d'Hiv Commemoration'. 16 July. https://www.elysee.fr/en/emmanuel-macron/2017/07/18/speech-by-the-president-of-the-republic-emmanuel-macron-at-the-vel-dhiv-commemoration.

Faiola, Anthony. 2017. 'Berlin's Holocaust Memorial Is "not a place for fun selfies"'. *The Washington Post*. 29 January. https://www.washingtonpost.com/world/europe/berlins-holocaust-memorial-is-not-a-place-for-fun-selfies/2017/01/27/2e5b6324-e1ac-11e6-a419-eefe8eff0835_story.html.

Feldman, Jackie. 2007. 'Between Yad Vashem and Mt. Herzl: Changing Inscriptions of Sacrifice on Jerusalem's "Mountain of Memory"'. *Anthropological Quarterly* 80.4: 1147–74.

———. 2008. *Above the Death Pits, Beneath the Flag: Youth Voyages to Poland and the Performance of Israeli National Identity*. London and New York, NY: Berghahn Books.

Feldman, Kim. 2018. 'Beyond Radioactivity: How French Nuclear Tests Changed Polynesia Forever'. *Equal Times*. 15 October. https://www.equaltimes.org/beyond-radioactivity-how-french?lang=en#.YaKx8NbP2kp.

Felman, Shoshana. 1991. 'In an Era of Testimony: Claude Lanzmann's *Shoah*'. *Yale French Studies* 79: 39–81.

Feuchtwanger, Lion. 1941. *The Devil in France: My Encounter with Him in the Summer of 1940*. Translated by Elisabeth Abbott. New York, NY: The Viking Press.

Fivaz-Silbermann, Ruth. 2020. *La fuite en Suisse: les juifs à la frontière franco-suisse durant les années de la 'solution finale'*. Paris: Calmann-Levy.

Fleetwood, Jennifer, and Jennifer Turner. 2017. 'The Backpacker's Guide to the Prison: (In)Formalizing Prison Boundaries in Latin America'. In *The Palgrave Handbook of Prison Tourism*. Edited by Jacqueline Z. Wilson, Sarah Hodgkinson, Justin Piché and Kevin Walby, 887–908. London and New York, NY: Palgrave Macmillan.

Fontaine, André. 1989. *Un camp de concentration à Aix-en-Provence? Le camp d'étrangers des Milles, 1939–1943*. Cahors: Édisud.

Forsdick, Charles. 2015. '*Cette île n'est pas une île*: Locating Gorée'. In *At the Limits of Memory: Legacies of Slavery in the Francophone World*. Edited by Kate Hodgson and Nicole Frith, 131–53. Liverpool: Liverpool University Press.

——. 2020. 'Le Bagne'. In *Postcolonial Realms of Memory: Sites and Symbols in Modern France*. Edited by Etienne Achille, Charles Forsdick and Lydie Moudileno, 217–26. Liverpool: Liverpool University Press.

Foucault, Michel. 1970 [1966]. *The Order of Things*. New York, NY: Pantheon Books.

——. 1977 [1975]. *Discipline and Punish: Birth of the Prison*. Translated by Alan Sheridan. London: Penguin.

——. 2007. *Security, Territory, Population: Lectures at the Collège de France, 1977–1978*. Translated by Graham Burchell. London: Palgrave.

France 24. 2020. 'French Police to Investigate "Brutal" Dispersal of Paris Migrant Camp'. 24 November. https://www.france24.com/en/france/20201124-anger-mounts-over-police-use-of-excessive-force-to-clear-paris-migrant-camp.

Friedman, James. n.d. '12 Nazi Concentration Camps'. https://www.jamesfriedmanphotographer.com/index.php?/projects/thumbnails/61.

Furman, Nelly. 1995. 'The Languages of Pain in *Shoah*'. In *Auschwitz and After: Race, Culture and the 'Jewish Question' in France*. Edited by Lawrence D. Kritzman, 299–312. New York, NY: Routledge.

Gayle, Damian. 2019. 'Stansted 15: No Jail for Activists Convicted of Terror-Related Offences'. *Guardian*. 6 February. https://www.theguardian.com/global/2019/feb/06/stansted-15-rights-campaigners-urge-judge-to-show-leniency.

Gensburger, Sarah. 2012. 'From Jerusalem to Paris: The Institutionalization of the Category of "Righteous of France"'. *French Politics, Culture & Society* 30.2: 150–71.

——. 2019. 'Visiting History, Witnessing Memory: A Study of a Holocaust Exhibition in Paris in 2012'. *Memory Studies* 12.6: 630–45.

Gigliotti, Simone. 2009. *The Train Journey*. London and New York, NY: Berghahn Books.

Gilbert, Martin. 1997. *Holocaust Journey: Travelling in Search of the Past*. London: Weidenfeld and Nicolson.

Gimenez, Daniel, Marc Renneville and Jean-Lucien Sanchez. 2013. 'Le camp de la relégation de Saint-Jean-du-Maroni'. *Musée Criminocorpus*. https://criminocorpus.org/fr/ref/25/17295/.

Gordon, Bertrand M. 2018. *War Tourism: Second World War France from Defeat and Occupation to the Creation of Heritage*. Ithaca, NY: Cornell University Press.

Gorrara, Claire. 2018. 'Not Seeing Auschwitz: Memory, Generation and Representations of the Holocaust in Twenty-First Century French Comics'. *Journal of Modern Jewish Studies* 17.1: 111–26.

Goven, François, ed. 2018. 'Le patrimoine de l'enfermement'. Special issue of *Monumental: Revue scientifique et technique des monuments historiques*. Semestriel 1.

Grandjonc, Jacques, and Theresia Grundtner, eds. 1990. *Zone d'ombres 1933–1944: éxil et internement d'Allemands et Autrichiens dans le sud-est de la France*. Aix-en-Provence: Alinéa.

Grésillon, Boris, Olivier Lambert and Philippe Mioche. 2007. *De la terre et des hommes: la tuilerie des Milles d'Aix-en-Provence (1882–2006)*. Aix-en-Provence: REF.2C Éditions.

Grynberg, Anne. 1999. *Les camps de la honte: les internés juifs des camps français, 1938–1944*. Paris: La Découverte.

Guerrier, Sophie. 2014. 'Le discours de Jacques Chirac au Vél d'hiv en 1995'. *Le Figaro*. 27 March. https://www.lefigaro.fr/politique/le-scan/2014/03/27/25001-20140327ARTFIG00092-le-discours-de-jacques-chirac-au-vel-d-hiv-en-1995.php.

Habib, André. 2015. 'Delay, Estrangement, Loss: The Meanings of Translation in Claude Lanzmann's "Shoah" (1985)'. *SubStance* 44.2: 108–28.

Hansen-Glucklich, Jennifer. 2014. *Holocaust Memory Reframed: Museums and the Challenges of Representation*. New Brunswick, NJ: Rutgers University Press.

Heath, Christian, and Vom Lehn, Dirk. 2010. 'Interactivity and Collaboration: New Forms of Participation in Museums, Galleries and Science Centres'. In *Museums in a Digital Age*. Edited by Ross Parry, 266–80. London and New York, NY: Routledge.

Hilberg, Raul. 1994. *The Destruction of the European Jews*. 3 vols. 3rd ed. New Haven, CT: Yale University Press.

Hirsch, Marianne. 1997. *Family Frames: Photography, Narrative, and Postmemory*. Cambridge, MA: Harvard University Press.

———. 2012. *The Generation of Postmemory: Writing and Visual Culture after the Holocaust*. New York, NY: Columbia University Press.

Horne, Alistair. 2002 [1977]. *A Savage War of Peace: Algeria, 1954–1962*. London: Pan Books.

Hucal, Sarah. 2019. 'When a Selfie Goes Too Far: How Holocaust Memorial Sites around Europe Combat Social Media Disrespect'. *ABC News*. 30 March. https://abcnews.go.com/International/selfie-holocaust-memorial-sites-europe-combat-social-media/story?id=62025268.

*L'Humanité*. 2013. 'Camp des Milles. L'antichambre de la mort devenue outil de réflexion'. 8 August. https://www.humanite.fr/politique/camp-des-milles-lantichambre-de-la-mort-devenue-ou-547069.

International Council of Museums. 2020. 'Defining the Museum in Times of Change'. https://icom.museum/wp-content/uploads/2020/12/ICOM-Define-Methodology.pdf.

———. n.d. 'Museum Definition'. https://icom.museum/en/resources/standards-guidelines/museum-definition/.

Ireland, Susan. 2020. 'Rivesaltes'. In *Postcolonial Realms of Memory: Sites and Symbols in Modern France*. Edited by Etienne Achille, Charles Forsdick and Lydie Moudileno, 227–35. Liverpool: Liverpool University Press.

Ives Gilman, Benjamin. 1916. 'Museum Fatigue'. *The Scientific Monthly* 2.1: 62–74.

Jaeglé, Yves. 2013. 'L'été 42 dans le Vél d'Hiv du Sud'. *Le Parisien*, 20 October. https://www.leparisien.fr/archives/l-ete-42-dans-le-vel-d-hiv-du-sud-20-10-2013-3242157.php.

James, Klem. 2015. 'Entropy and Osmosis in Conceptualisations of the Surrealist Frame'. In *Framing French Culture*. Edited by Natalie Edwards, Ben McCann and Peter Poiana, 257–74. Adelaide: University of Adelaide Press.

Jarry, Alfred. 2015 [1896]. *Ubu roi*. Paris: Gallimard.

Jeanmougin, Yves. 2013. 'In These Brick Walls …'. In *Memory of the Camp des Milles, 1939–1942*. Edited by Alain Chouraqui, 73–192. Marseille: Métamorphoses/Le Bec en l'air.

Jennings, Eric. 2002. *Vichy in the Tropics: Petain's National Revolution in Madagascar, Guadeloupe, and Indochina, 1940–44*. Stanford, CA: Stanford University Press.

———. 2018. *Escape from Vichy: The Refugee Exodus to the French Caribbean*. Cambridge, MA: Harvard University Press.

Jensen, Nina. 1994. 'Children's Perceptions of Their Museum Experiences: A Contextual Perspective'. *Children's Environments* 11.4: 300–24.

Jordi, Jean-Jacques. 2003. 'The Creation of the *Pieds-Noirs*: Arrival and Settlement in Marseille, 1962'. In *Europe's Invisible Migrants*. Edited by Andrea L. Smith, 61–74. Amsterdam: Amsterdam University Press.

Journal Officiel de la République française. 1938. 'Décret-loi du 12 novembre 1938 relatif à la situation et à la police des étrangers'. *Lois et Décrets* 266: 12920.

Jung, Yuha. 2010. 'The Ignorant Museum: Transforming the Elitist Museum into an Inclusive Learning Place'. In *The New Museum Community: Audiences, Challenges, Benefits*. Edited by Nicole Abery, 272–91. Edinburgh, MuseumsEtc.

Kanor, Fabienne. *Humus*. Paris: Gallimard, 2006.

Kitchen, Martin. 2015. *Speer: Hitler's Architect*. Hartford, CT: Yale University Press.

Klarsfeld, Serge. 2008. 'Se souvenir de ces 11 400 enfants'. *Le Monde*. 18 February. https://www.lemonde.fr/idees/article/2008/02/18/se-souvenir-de-ces-11-400-enfants-par-serge-klarsfeld_1012754_3232.html.

Kleeblatt, Norman L., ed. 1987. *The Dreyfus Affair: Art, Truth and Justice*. Berkeley, CA: University of California Press.

Kulka, Otto Dov. 2014. *Landscapes of the Metropolis of Death*. London: Penguin.
LaCapra, Dominick. 1997. 'Lanzmann's "Shoah": "Here there is no why"'. *Critical Inquiry* 23.2: 231–69.
Lalieu, Olivier. 2013. 'History, Memory, Museography'. In *Memory of the Camp des Milles, 1939–1942*. Edited by Alain Chouraqui, 193–201. Marseille: Métamorphoses/Le Bec en l'air.
Lambert, Elise. 2015. 'Nadine Morano et "la race blanche": la polémique en cinq actes'. *France Info*. 30 September. https://www.francetvinfo.fr/politique/ump/nadine-morano/nadine-morano-et-la-race-blanche-la-polemique-en-cinq-actes_1106339.html.
Lanzmann, Claude, Ruth Larson and David Rodowick. 1990. 'Seminar with Claude Lanzmann 11 April 1990'. *Yale French Studies* 79: 82–99.
Larkin, Craig. 2014. 'Jerusalem's Separation Wall and Global Message Board: Graffiti, Murals, and the Art of Sumud'. *The Arab Studies Journal* 22.1: 134–69.
Laville, Sandra. 2020. 'Ella Kissi-Debrah: How a Mother's Fight for Justice May Help Prevent Other Air Pollution Deaths'. *Guardian*. 16 December. https://www.theguardian.com/environment/2020/dec/16/ella-kissi-debrah-mother-fight-justice-air-pollution-death.
*Le Monde*. 2015. 'Hollande: "La République ne connaît pas de race"'. 8 October. https://www.lemonde.fr/politique/video/2015/10/08/hollande-la-republique-ne-connait-pas-de-race_4785668_823448.html.
Legendre, Jean-Pierre. 2018. 'Les vestiges des camps d'internement français, de la Retirada espagnole à l'après-guerre (1939–1948)'. *Monumental: Revue scientifique et technique des monuments historiques* 2018.1: 78–81.
Lekan, Thomas. 1999. 'Regionalism and the Politics of Landscape Preservation in the Third Reich'. *Environmental History* 4.3: 384–404.
Léobal, Clémence. 2016. 'From "Primitives" to "Refugees": French Guianese Categorizations of Maroons in the Aftermath of Surinamese Civil War'. In *Legacy of Slavery and Indentured Labour: Historical and Contemporary Issues in Suriname and the Caribbean*. Edited by Maurits S Hassankhan, Lomarsh Roopnarine, Cheryl White Radica Mahase, 213–30. London and New York, NY: Routledge.
Leslie, Esther. 2007. *Walter Benjamin*. London: Reaktion Books.
———. 2010. 'Siegfried Kracauer and Walter Benjamin: Memory from Weimar to Hitler'. In *Memory: Histories, Theories, Debates*. Edited by Susannah Radstone and Bill Schwartz, 123–35. New York, NY: Fordham University Press.
Levi, Primo. 1989. *The Drowned and the Saved*. London: Abacus Books.
Lipman-Wulf, Peter. 1993. *Period of Internment: Letters and Drawings from Les Milles, 1939–1940*. New York, NY: Canio's Editions.

Love Spots. 2019. 'Hôtel Marseille Bompard La Corniche'. https://marseille.love-spots.com/adresses/ou-dormir/hotels-marseille/30583-hotel-marseille-bompard-la-corniche.html.

Lovin, Clifford R. 1967. '*Blut und Boden*: The Ideological Basis of the Nazi Agricultural Program'. *Journal of the History of Ideas* 28.2: 279–88.

MacCannell, Dean. 1992. *Empty Meeting Grounds: The Tourist Papers*. London and New York, NY: Routledge.

MacDonald, Joseph A. 1994. 'Normandy: Armed Forces – Memorial – Garden'. *The Military Engineer* 86.565: 67–68.

Madranges, Étienne. 2013. *Prisons: Patrimoine de France*. Paris: LexisNexis.

Manen, Henri. 2013. *Au fond de l'abîme: journal du camp des Milles*. Paris: Éditions Ampelos.

Marshall, Tim. 2016. *Worth Dying For: The Power and Politics of Flags*. London: Elliott and Thompson.

Martin, Christian. 2013. 'Skin Deep: Bodies without Limits in *Hiroshima mon amour*'. *French Forum* 38.1–2: 267–82.

Martin, Stéphane. 1990. 'Le chemin du souvenir'. *Le Provençal*. 17 December.

Marzec, Robert P. 2015. *Militarizing the Environment: Climate Change and the Security State*. Minneapolis, MN: Minnesota University Press.

Mayo, James. M. 2009. 'Temporary Landscapes'. *Journal of Architectural and Planning Research* 26.2: 124–35.

Mayorga, Juan. 2014. 'The Cartographer. Warsaw, 1:400,000'. Translated by Sarah Maitland. In *Space and the Memories of Violence: Landscapes of Erasure, Disappearance and Exception*. Edited by Estela Schindel and Pamela Colombo, 91–104. London and New York, NY: Palgrave Macmillan.

Mbembe, Achille. 2003. 'Necropolitics'. Translated by Libby Meintjes. *Public Culture* 15.1: 11–40.

——. 2013. 'L'esclave, figure de l'anti-musée?' *Africultures* 91: 37–40.

McGlothlin, Erin. 2010. 'Listening to the Perpetrators in Claude Lanzmann's "Shoah"'. *Colloquia Germanica* 43.3: 235–71.

Megargee, Geoffrey P., Joseph R. White and Mel Hecker, eds. 2017. *The United States Holocaust Museum Encyclopedia of Camps and Ghettos, 1933–1945. Volume 3: Camps and Ghettos under European Regimes Aligned with Nazi Germany*. Bloomington, IN: Indiana University Press.

Mémorial du Camp des Milles. n.d. *Camp des Milles. Le seul grand camp français d'internement et de déportation encore intact et accessible au public*. Brochure.

——. 2009. *Histoire et témoignages*. http://www.campdesmilles.org/videos.html.

——. 2013. *Bellmer, Ernst, Springer, Wols au camp des Milles*. Paris: Flammarion.

———. 2016. *Petit manuel de survie démocratique: pour résister à l'engrenage des extrémismes, des racismes et de l'anti-sémitisme*. https://issuu.com/sunmed/docs/cdm_survie_democratique.

Mencherini, Robert, ed. 2008. *Provence-Auschwitz: de l'internement des étrangers à la déportation des Juifs (1939–1944)*. Aix-en-Provence: Publications de l'Université de Provence.

———. 2013. 'Internment, Transit, Deportation'. In *Memory of the Camp des Milles, 1939–1942*. Edited by Alain Chouraqui, 15–34. Marseille: Métamorphoses/Le Bec en l'air.

Merleau-Ponty, Maurice. 1964. *Sense and Non-Sense*. Evanston, IL: Northwestern University Press.

Meyze, Christian. 2018. 'La "bulle" de la Chapelle, dispositif d'accueil des migrants cède la place à 5 centres'. France 3. 11 April. https://france3-regions.francetvinfo.fr/paris-ile-de-france/paris/bulle-chapelle-dispositif-accueil-migrants-cede-place-5-centres-1456909.html.

Mioche, Philippe. 2011. 'Une histoire du management à la tuilerie des Milles 1882–2006'. https://docplayer.fr/55328717-Une-histoire-du-management-a-la-tuilerie-des-milles.html.

Mitchell, W.J.T. 2002. 'Imperial Landscape'. In *Landscape and Power*. Edited by W.J.T. Mitchell. 2nd ed., 5–34. Chicago, IL and London.

Monaco, James. 1978. *Alain Resnais: The Role of Imagination*. New York, NY: Oxford University Press.

Monnier, Alain. 2008. *Rivesaltes: un camp en France*. Cahors: La Louve.

Morlat, Patrice. 1990. *La repression coloniale au Vietnam (1908–1940)*. Paris: Harmattan.

Mossé, Bernard. 2020. 'Against the Expansion of Racism: The Experience of the Camp des Milles'. In *Europe and the Refugee Response: A Crisis of Values?* Edited by Elżbieta M. Goździak, Izabella Main and Brigitte Suter, 25–38. London and New York, NY: Routledge.

Mutabilis. n.d. 'Jardin des Enfants du Vel d'Hiv'. https://mutabilis-paysage.com/projet/jardin-des-enfants-du-vel-dhiv/.

National Gallery. 2021. 'National Gallery Painting Goes on Display at Lincoln Food Bank as Part of "Jan van Huysum Visits" (21–26 june 2021)'. https://www.nationalgallery.org.uk/about-us/press-and-media/press-releases/national-gallery-painting-goes-on-display-at-lincoln-food-bank-as-part-of-jan-van-huysum-visits-21-26-june-2021.

Natzweiler Memorials Network. n.d. 'Concentration Camps in the Service of the War Industry'. https://www.natzweiler.eu/en/a-european-history/concentration-camps-serving-the-wartime-industry.

Nethery, Amy. 2009. '"A Modern-Day Concentration Camp": Using History to Make Sense of Australian Immigration Detention Centres'. In *Does History Matter? Making and Debating Citizenship, Immigration and Refugee Policy in Australia and New Zealand*. Edited by Klaus Neumann and Gwenda Tavan, 65–80. Canberra, ANU Press.

Nixon, Rob. 2011. *Slow Violence and the Environmentalism of the Poor*. Cambridge, MA: Harvard University Press.

Nondrof, John. 2015. '*Nous vous remercions*: The French Gratitude Train'. *The Wisconsin Magazine of History* 99.1 (Autumn): 2–13.

Nora, Pierre, ed. 1984–1992. *Les lieux de mémoire*. 3 vols. Paris: Gallimard.

———. 2007. 'Le nationalisme nous a caché la nation'. Interview with Sophie Gherardi. *Le Monde*. 17 March. https://www.lemonde.fr/societe/article/2007/03/17/pierre-nora-le-nationalisme-nous-a-cache-la-nation_884396_3224.html.

Nord, Philip. 1998. 'The New Painting and the Dreyfus Affair'. *Historical Reflections / Réflexions Historiques* 24.1: 115–36.

———. 2020. *After the Deportations: Memory Battles in Postwar France*. Cambridge: Cambridge University Press.

Nusan Porter, Jack. 1999. 'Holocaust Suicides'. In *Problems Unique to the Holocaust*. Edited by Harry James Kargas, 51–66. Lexington, KY: University Press of Kentucky.

O'Brien, William E. 2016. *Landscapes of Exclusion: State Parks and Jim Crow in the American South*. Amherst and Boston, MA: University of Massachusetts Press.

Office national de radiodiffusion télévision française. 1964. 'Visite du Général de Gaulle à Cayenne'. *Édition spéciale*. 28 March. https://www.ina.fr/ina-eclaire-actu/video/i08007293/visite-du-general-de-gaulle-a-cayenne.

Olender, Maurice. 2005. *La chasse aux évidences: sur quelques formes de racism entre mythe et histoire*. Paris: Galaade.

Olin, Margaret. 1997. 'Lanzmann's *Shoah* and the Topography of Holocaust Film'. *Representations* 57: 1–23.

Oren, Gila, and Amir Shani. 2012. 'The Yad Vashem Holocaust Museum: Educational Dark Tourism in Futuristic Form'. *Journal of Heritage Tourism* 7.3: 255–70.

Orlow, Emma. 2020. 'Brooklyn Museum Will Become a Temporary Food Pantry Starting in June'. *Time Out*. 28 May. https://www.timeout.com/newyork/news/brooklyn-museum-will-become-a-temporary-food-pantry-starting-in-june-052820.

Paeda, Yael. 2017. *Modelscapes of Nationalism: Collective Memories and Future Visions*. Amsterdam: Amsterdam University Press.

Pastoreau, Michel. 2000. *Bleu: histoire d'une couleur*. Paris: Seuil.

Patterson, Duncan P.R. 2011. '"There's Glass between Us": A Critical Examination of "the Window" in Art and Architecture from Ancient Greece to the Present Day'. *FORUM Ejournal* 10: 1–21.

Paxton, Robert O. 1972. *Vichy France: Old Guard and New Order, 1940–1944*. New York, NY: Knopf.

Perego, Simon, and Renée Poznanski. 2013. *Le Centre de documentation juive contemporaine, 1943–2013: documenter la Shoah*. Paris: Mémorial de la Shoah.
Peschanski, Denis. 2002. *La France des camps: l'internement, 1938–1946*. Paris: Gallimard.
———. 2008. 'Préface. Des lieux sans mémoire à des mémoires sans lieu'. In Guillaume Ribot, *Camps en France: histoire d'une déportation*, 9–10. Paris: De l'effacement des traces.
Pierre, Michel. 2017. *Le temps des bagnes, 1748–1953*. Paris: Tallandier.
Pollock, Griselda. 2015. 'Nameless Before the Concentrationary Void: Charlotte Salomon's *Leben? Oder Theater?* 1941–2 "After Gurs"'. In *Concentrationary Imaginaries: Tracing Totalitarian Violence in Popular Culture*. Edited by Griselda Pollock and Max Silverman, 159–89. London and New York, NY: I.B. Tauris.
Pollock, Griselda, and Max Silverman, eds. 2011. *Concentrationary Cinema: Aesthetics as Political Resistance in Alain Resnais'* Night and Fog. New York, NY: Berghahn Books.
———, eds. 2013. *Concentrationary Memories: Totalitarian Terror and Cultural Resistance*. London and New York, NY: I.B. Tauris.
———, eds. 2015a. *Concentrationary Imaginaries: Tracing Totalitarian Terror in Popular Culture*. London and New York, NY: I.B. Tauris.
———. 2015b. 'Series Preface – Concentrationary Memories: The Politics of Representation'. In *Concentrationary Imaginaries: Tracing Totalitarian Violence in Popular Culture*. Edited by Griselda Pollock and Max Silverman, xiii–xix. London and New York, NY: I.B. Tauris.
———, 2019. *Concentrationary Art: Jean Cayrol, the Lazarean and the Everyday in Post-War Film, Literature, Music and the Visual Arts*. New York, NY: Berghahn Books.
Pouvreau, Benoît, ed. 2014. *Les graffiti du camp de Drancy: des noms sur des murs*. Ghent: Snoeck.
Rancière, Jacques. 1991. *The Ignorant Schoolmaster: Five Lessons in Intellectual Emancipation*. Translated by Kristin Ross. Stanford, CA: Stanford University Press.
———. 2009. *The Emancipated Spectator*. Translated by Gregory Elliott. London and New York, NY: Verso.
Rasenberger, Jim. 2004. 'Kitty, 40 Years Later'. *New York Times*. 8 February.
Rawas, Kamal. 2021. *Les Milles – empreintes*. Paris: Harmattan.
Razac, Olivier. 2002. *Barbed Wire: A Political History*. Translated by Jonathan Kneight. New York, NY: The New Press.
Rea, Naomi. 2018. 'Banksy Takes Aim at France's Callous Response to the Refugee Crisis with Poignant Murals in Paris'. *artnet*. 25 June. https://news.artnet.com/art-world/banksy-paris-1308641.

Redfield, Peter. 2000. *Space in the Tropics: From Convicts to Rockets in French Guiana*. Berkeley, CA: University of California Press.
Renwick, Dustin. 2019. 'Five Years on, the Flint Water Crisis Is Nowhere Near Over'. *National Geographic*. 25 April. https://www.nationalgeographic.com/environment/article/flint-water-crisis-fifth-anniversary-flint-river-pollution.
Reynolds, Daniel. 2016. 'Consumers of Witnesses? Holocaust Tourists and the Problem of Authenticity'. *Journal of Consumer Culture* 16.2: 334–53.
RFI. 2017. 'Row over Netanyahu Invite to Paris Vel d'Hiv Ceremony'. 16 July. https://www.rfi.fr/en/france/20170716-row-over-netanyahu-invite-paris-vel-dhiv-ceremony.
Ribot, Guillaume. 2008. *Camps en France: histoire d'une déportation*. Paris: De l'effacement des traces.
Richard, Bernard. 2016. *Petite histoire du drapeau français*. Paris: CNRS.
Richardson, John. 1956. 'Cézanne at Aix-en-Provence'. *The Burlington Magazine* 98.644: 411–13.
Rigouste, Mathieu. 2011. *L'Ennemi intérieur: la généalogie coloniale et militaire de l'ordre sécuritaire dans la France contemporaine*. Paris: La Découverte.
Ringelheim, Joan. 1995. 'Women and the Holocaust: A Reconsideration of Research'. In *Feminism and Community*. Edited by Penny A. Weiss and Marilyn Friedman, 317–40. Philadelphia, PA: Temple University Press.
Robson, Kathryn. 2019. *I Suffer, Therefore I Am: Engaging with Empathy in Contemporary French Women's Writing*. Cambridge: Legenda.
Rosenthal, Peggy. 1991. 'The Nuclear Mushroom Cloud as Cultural Image'. *American Literary History* 3.1: 63–92.
Rothberg, Michael. 2009. *Multidirectional Memory: Remembering the Holocaust in the Age of Decolonization*. Stanford, CA: Stanford University Press.
Rousset, David. 1965. *L'Univers concentrationnaire*. Paris: Éditions de Minuit.
Rousso, Henry. 1991 [1987]. *The Vichy Syndrome: History and Memory in France since 1944*. Translated by Arthur Goldhammer. Cambridge, MA: Harvard University Press.
Ryan, Donna F. 1996. *The Holocaust and the Jews of Marseille: The Enforcement of Anti-Semitic Policies in Vichy France*. Champaign, IL: University of Illinois Press.
Rykner, Arnaud. 2010. *Le wagon*. Rodez: Éditions du Rouergue.
Salmons, Paul. 2010. 'Universal Meaning or Historical Understanding? The Holocaust in History and History in the Curriculum'. *Teaching History* 141: 57–63.
Salor, Audrey. 2012. 'Vel d'Hiv: et Hollande se fit l'héritier de Chirac'. *L'Obs*, 23 July. https://www.nouvelobs.com/politique/20120722.OBS7931/vel-d-hiv-et-hollande-se-fit-l-heritier-de-chirac.html.

Salor, Audrey, and Morgane Bertrand. 2012. 'Comment Hollande s'est emparé du devoir de mémoire'. *L'Obs*, 17 October. https://www.nouvelobs.com/politique/20121017.OBS6031/comment-hollande-s-est-empare-du-devoir-de-memoire.html.
Sanyal, Debarati. 2011. 'Auschwitz as Allegory in *Night and Fog*'. In *Concentrationary Cinema: Aesthetics as Political Resistance in Alain Resnais' Night and Fog*. Edited by Griselda Pollock and Max Silverman, 152–82. New York, NY: Berghahn Books.
Schama, Simon. 1996. *Landscape and Memory*. New York, NY: Vintage.
Schept, Judah. 2014. '(Un)seeing like a Prison: Counter-Visual Ethnography of the Carceral State'. *Theoretical Criminology* 18.2: 198–223.
Schwartz, Stephen. 2001. 'The Mysterious Death of Walter Benjamin'. *Washington Examiner*. 11 June. https://www.washingtonexaminer.com/weekly-standard/the-mysterious-death-of-walter-benjamin.
Seghers, Anna. 2013 [1951]. *Transit*. Translated by Margot Bettauer Dembo. New York, NY: New York Review of Books.
Sexton Joe. 1995. 'Reviving the Kitty Genovese Case and Its Passions'. *New York Times*. 25 July.
Shapira, Shahak, 2017. *Yolocaust*. https://yolocaust.de/.
Sherman, Daniel J. 2011. 'Commemoration'. In *The French Republic: History, Values, Debates*. Edited by Edward Berenson, Vincent Duclert and Christophe Prochasson, 324–33. Ithaca, NY: Cornell University Press.
Sitzia, Emily. 2018. 'The Ignorant Art Museum: Beyond Meaning-Making'. *International Journal of Lifelong Education* 37.1: 73–87.
Sloterdijk, Peter. 1998. *Spheres I. Bubbles*. Cambridge, MA: The MIT Press.
——. 1999. *Spheres II. Globes*. Cambridge, MA: The MIT Press.
——. 2002. *Terror from the Air*. Cambridge, MA: The MIT Press.
——. 2004. *Spheres III. Foams*. Cambridge, MA: The MIT Press.
Smith, Andrea. 2013. 'Settler Sites of Memory and the Work of Mourning'. *French Politics, Culture and Society* 31.3: 65–92.
Smith, Patti. 2015. *M Train*. London and New York, NY: Random House.
Smith, Paul. 2013. Cézanne's "Primitive" Perspective, or the "View from Everywhere". *The Art Bulletin* 95.1: 102–19.
Snitow, Virginia L. 1958. 'The Mushroom Cloud'. *The Western Political Quarterly* 11.4: 875–85.
Sodaro, Amy. 2018. *Exhibiting Atrocity: Memorial Museums and the Politics of Past Violence*. New Brunswick, NJ and London: Rutgers University Press.
Spiegelman, Art. 2003. *The Complete Maus*. London: Penguin.
Stańczyk, Ewa, ed. 2020. *Comic Books, Graphic Novels and the Holocaust beyond Maus*. London and New York, NY: Routledge.
Still, Judith. 2010. *Derrida and Hospitality: Theory and Practice*. Edinburgh, Edinburgh University Press.

Stoekl, Allan. 1998. 'Lanzmann and Deleuze: On the Question of Memory'. *Symploke* 6.1: 72–82.
Stoicea, Gabriela. 2006. The Difficulties of Verbalizing Trauma: Translation and the Economy of Loss in Claude Lanzmann's "Shoah". *The Journal of the Midwest Modern Language Association* 39.2: 43–53.
Stone, Dan. 2016. *Concentration Camps: A Short History*. Oxford: Oxford University Press.
Sullivan, Nicola. 2015. 'Museum to Commission Artist to Create Work Based on a Food Bank'. *Museums Association*. 28 October. https://www.museumsassociation.org/museums-journal/news/2015/10/28102015-museum-to-commission-artist-to-create-work-based-on-a-food-bank/.
Sumartojo, Shanti, and Matthew Graves. 2018. 'Rust and Dust: Materiality and the Feel of Memory at Camp des Milles'. *Journal of Material Culture* 23.3: 328–43.
Taussig, Michael. 2006. *Walter Benjamin's Grave*. Chicago, IL: University of Chicago Press.
Tézenas, Ambroise. 2014. *Tourisme de la désolation*. Arles: Actes Sud.
Tinius, Jonas. 2020. 'Porous Membranes: Hospitality, Alterity, and Anthropology in a Berlin District Gallery'. In *Across Anthropology: Troubling Colonial Legacies, Museums, and the Curatorial*. Edited by Jonas Tinius and Margareta von Oswald, 254–77. Leuven: Leuven University Press.
Tsing, Anna Lowenhaupt. 2015. *The Mushroom at the End of the World: On the Possibility of Life in Capitalist Ruins*. Princeton, NJ: Princeton University Press.
United States Holocaust Memorial Museum. n.d. 'The Album'. https://www.ushmm.org/collections/the-museums-collections/collections-highlights/auschwitz-ssalbum/album.
———. 2021. 'Drancy'. *Holocaust Encyclopedia*. https://encyclopedia.ushmm.org/content/en/article/drancy.
van der Laarse, Rob. 2015. 'Fatal Attraction: Nazi Landscapes, Modernism, and Holocaust Memory'. In *Landscape Biographies: Geographical, Historical and Archaeological Perspectives on the Production and Transmission of Landscapes*. Edited by Jan Kolen, Johannes Renes and Rita Hermans, 345–75. Amsterdam: Amsterdam University Press.
Vergès, Françoise. 2010. 'Le musée postcolonial: un musée sans objets'. In *Ruptures postcoloniales*. Edited by Achille Mbembe et al., 455–79. Paris: La Découverte.
Virilio, Paul. 1989. *War and Cinema: The Logistics of Perception*. Translated by Patrick Camiller. London and New York, NY: Verso.
———. 2006. 'The Museum of Accidents'. *International Journal of Baudrillard Studies* 3.2. https://baudrillardstudies.ubishops.ca/the-museum-of-accidents/.

———. 2007. *The Original Accident*. Cambridge: Polity.
———. 2012. *Bunker Archaeology*. Translated by George Collins. New York, NY: Princeton Architectural Press.
Wahnich, Sophie. 1997. *L'Impossible citoyen: l'étranger dans le discours de la Révolution française*. Paris: Albin Michel.
———. 2008. 'Constructing the History of Wars in Museums: Art as the Means of a Postmodern Installation'. In *Politics of Collective Memory: Cultural Patterns of Commemorative Practices in Post-War Europe*. Edited by Sophie Wahnich, Barbara Lášticová and Andrej Findor, 201–35. Vienna: Lit Verlag.
Walsh, Kevin, and Florence Mocci. 2003. 'Fame and Marginality: The Archaeology of the Montagne Sainte-Victoire (Provence, France)'. *American Journal of Archaeology* 107.1: 46–69.
Walters, William. 2015. 'On the Road with Michel Foucault: Migration, Deportation and Viapolitics'. In *Foucault and the History of Our Present*. Edited by Sophie Fuggle, Yari Lanci and Martina Tazzioli, 94–110. London and New York, NY: Palgrave.
Weart, Spencer R. 1988. *Nuclear Fear: A History of Images*. Cambridge, MA: Harvard University Press.
Weinberg, David. 1974. *Les Juifs à Paris de 1933 à 1939*. Paris: Calmann-Lévy.
Weygand, Lucien. 1997. 'Préface'. In *Des peintres au camp des Milles, Septembre 1939–été 1941*. Aix-en-Provence: Actes Sud.
Wieviorka, Annette. 1993. '1992. Refléxions sur une commémoration'. *Annales. Histoire, Sciences Sociales* 48.3: 703–14.
Williams, Paul. 2007. *Memorial Museums: The Global Rush to Commemorate Atrocity*. London and New York, NY: Bloomsbury.
Yusoff, Kathryn. 2018. *A Billion Black Anthropocenes or None*. Minneapolis, MN: University of Minnesota Press.
Zinoman, Peter. 2001. *The Colonial Bastille: A History of Imprisonment in Vietnam, 1862–1940*. Berkeley, CA: University of California Press.

**Filmography**

*2012*. 2009. Directed by Roland Emmerich. United States.
*La bataille du rail*. 1945. Directed by René Clément. France.
*Le chagrin et la pitié*. 1969. Directed by Marcel Ophüls. France.
*La cité muette*. 2015. Directed by Sabrina van Tassel. France.
*Les convois de la honte*. 2010. Directed by Raphaël Delpard. France.
*Festliches*. Nürnberg. 1937. Directed by Hans Weidemann. Germany.
*Geostorm*. 2017. Directed by Dean Devlin. United States.
*Hiroshima mon amour*. 1959. Directed by Alain Resnais. France.
*Les Milles: le train de la liberté*. 1995. Directed by Sébastien Grall. France.
*Nuit et brouillard*. 1955. Directed by Alain Resnais. France.

*La Rafle*. 2010. Directed by Roselyne Bosch. France.
*Récits du Camp des Milles: l'engrenage fatal*. 2015. Directed by Antony Fayada and Renaud Lavergne. France.
*Sarah's Key*. 2010. Directed by Gilles Paquet-Brenner. France.
*Shoah*. 1985. Directed by Claude Lanzmann. France.
*Les voyages du maréchal*. 1990. Directed by Christian Delage. France.
*War of the Worlds*. 2005. Directed by Steven Spielberg. United States.
*The Witness*. 2016. Directed by James Solomon. United States.

**Museum and Memorial Websites**
https://www.auschwitz.org/
http://campdesmilles.org/
http://www.campdesmilles.org/fondation-genese.html
http://www.campdesmilles.org/site-memorial-detail-visite.html
https://centrespatialguyanais.cnes.fr/fr/musee-de-l-espace
https://www.dhhrm.org/exhibitions/holocaust-shoah-wing/
https://kazernedossin.eu/
https://www.memorialcamprivesaltes.eu/
https://www.memorial-compiegne.fr/
https://www.memorialdelashoah.org/
https://musees.marseille.fr/memorial-des-deportations-0
http://www.musee-armistice-14-18.fr/
http://www.natzweiler.eu
https://normandy.memorial-caen.com/
https://normandy.memorial-caen.com/museum/souvenir-gardens
https://www.struthof.fr/
https://www.yadvashem.org/

# Index

Agamben, Giorgio 6, 41, 48–50, 183
Aix-en-Provence 2, 5, 9, 11, 21, 64,
    101n, 116, 137–38, 141–42, 147,
    150–51, 163, 165, 178
Algeria 22, 60, 150, 152, 165, 176
Algerian War (of Independence) 9, 165,
    172
    17 October 1961 massacre 71, 113n
Algiers 191
Allied Forces, Allies 7, 45, 63, 99, 101n,
    132, 133, 140
almost-camp 156–57, 180
anarchive 113
Anthropocene 189
anthropology 188
antisemitism 70, 77, 79, 82, 86, 140,
    144–47
Apel, Dora 37–38, 105, 148–49
Arab 190
    figure of 179
    status of 86
architecture 12–13, 27, 28, 31, 33, 38,
    95, 106, 122, 134, 139, 165, 172,
    176, 181–82
archives 44, 96, 106, 113, 114, 115n,
    117–18, 123, 165
    see also anarchive
archival material 3, 5n, 18, 21, 29, 59,
    64, 65, 93, 100, 104–05, 106
archival research 102n, 117–18, 149
Arendt, Hannah 112
Armenian Genocide 29

Armistice 100
artistic imagination 34
    see also creativity
artists 11, 21, 25, 42, 55n, 57, 62, 73–75,
    102, 106, 117, 130, 136–37, 139,
    147, 148, 155, 183, 188n
artwork 7, 38, 44, 47, 73–74, 113, 118,
    126, 136, 141–42, 183
atmospheres 22, 33n, 78, 165–67, 176, 185
atrocities 2, 5, 7, 17, 21, 26, 32, 37, 44,
    47, 49, 51, 57, 62, 66, 69, 84, 92,
    106, 149, 153, 158, 168, 169
    atrocity museums 13, 27, 31, 54, 60,
        126, 143, 188
Auschwitz, Auschwitz-Birkenau 2,
    5, 6–8, 9, 14, 26, 31, 33–34,
    38, 47, 48–49, 50n, 51, 57, 59,
    68–69, 94, 95, 97, 102, 109–10,
    113, 117–18, 121, 126, 147–48,
    149–50, 151–52, 158, 161–62
    antechamber of 5–7, 84, 112
    see also camps, concentration;
        camps, extermination
Australia 184
    government 10
    immigration detention 175
Azoulay, Ariella 20, 21, 54, 55n, 57–59,
    92, 124

Badinter, Robert 175
*bagne* 146n, 175
    see also penal colony

Banksy 183–84
barbed wire 9, 67, 123, 158, 160, 162, 181
Bardach, Moritz 114n, 115n
*barre de justice* 174
Barthes, Roland 39, 75
Baruch Stier, Oren 6, 31, 94, 97–98, 110, 126, 143
Bauman, Zygmunt 168
Bayonne 103–04
Bellmer, Hans 11, 36, 44, 47, 104, 137
Benjamin, Walter 42–45, 52, 84, 114, 122
Bergen-Belsen 138–40
Berlin 100, 102, 188
    Berlin Holocaust Memorial 38
Bihouix, Philippe 185
biopolitics 9, 187
blankets 61, 76–77, 82
blockhouse, *blockhaus* 173–74, 176
Blood and Soil, *Blut und Boden* 139–40, 172
Bobigny, Gare de 95
Boer War 174
borders 27, 33, 35–36, 157n, 172, 176, 178–79, 186, 187
    French Guiana–Suriname 178
    German 3
    Spanish 104, 122
    US–Mexico 181
Bousquet, René 111
Boyer, Auguste 103
boxcars 99, 126n
Brazil 163, 173
bricks 2, 12, 13, 22, 25, 26, 36, 70, 152, 160, 182
Brooklyn Museum 188n
Brutalism, New 12, 70, 95
bubbles 22, 182–83, 187–88
    La Bulle 182–83
built heritage 12, 21, 25, 147, 161, 182
Butler, Judith 53
bystander effect 40–41, 48, 194

Cado, Henri 111
Caen
    Musée de la Paix 45, 61–63, 87, 130, 132, 134, 138
Calais Jungle 10
California 102n, 184
Camp de la Relégation 177
Camp de la Transportation 173, 182
Camp des Milles
    administration of 15, 103
    *see also* Chemin des déportés; Les Milles (town); *Les Milles – empreintes* (theatre); *Les Mille: Le train de la liberté* (film); tile factory; Wagon of Remembrance
Camp Royalieu *see* Compiègne
camps
    annexes 8, 14–15, 156n
    concentration 3, 5–8, 10, 22, 37, 38, 47, 49, 80, 97, 172–75, 182n
    extermination 5, 6, 9, 57, 59, 92, 95, 108–09, 148
    holiday 140, 156, 182
    as (in)difference machine 15–17, 42
    internment 2, 16, 52, 65, 73, 102, 121, 147, 156, 157n, 172, 193
    labour, work 9–10, 177
    network 3n, 15–16, 44, 60, 78, 84, 95–96, 104, 122, 131, 134, 146n, 149, 152, 165, 172–73, 174–75, 181, 195
    refugee 6, 146, 177
    satellite 3n, 15, 22, 161
    transit 5, 14, 95, 153
Camus, Albert 190–1
cattle truck 1, 4n, 13, 14, 20–21, 65, 92, 94, 96–100, 104–05, 109, 110–11, 125–26, 142, 143, 179
    *see also* boxcars; wagon, wagons
Cayrol, Jean 59
Cendrars, Blaise 163–66
Centre de documentation juive contemporaine (CDJC) 3, 66–67

ceremonies 65, 66, 71, 81, 91–92, 144
    see also flags, flag-waving
Certeau, Michel de 136
Cézanne, Paul 21, 136–42, 150
Château d'If 157
Chemin des déportés 4, 69, 72, 87, 89, 91–92, 129, 132, 136, 145, 150, 160, 194
*cheminots* 101
children 5, 14, 15, 21, 64, 68, 74, 83, 99, 102, 111, 114, 116, 118, 120, 124, 134, 143, 151, 152, 156, 159–60, 171, 181
Chirac, Jacques 4, 61–62, 64, 66–67, 71–72, 92, 103
Chouraqui, Alain 17–18, 61, 71–72, 75, 84, 92, 194
Chouraqui, Sidney 17, 72, 150
cinema, cinematic 27, 29–32, 64n, 101, 104–06, 184
    see also video
Cité de la Muette 95
citizens, citizenship 9, 14, 17, 41, 52, 63, 79, 82–83, 86–87, 126, 157n, 186, 192, 194
    repaired 20, 21, 54, 57–59, 113, 124
Clair, René 154–55
climate change 184–85, 189–90
climate disaster 23, 185–86, 189
clouds 22, 35, 164–66, 168, 171, 184, 188, 190
    see also mushroom, cloud
collaboration (with Nazis) 3, 73, 111
colonial occupation 131, 146n, 161, 172, 174–76, 195
comics 148
commemoration 4, 6, 45, 65–66, 69, 71, 92, 130–31, 133, 146–47
Compiègne 18, 63, 94n, 96, 100, 111, 183
    Camp de Royalieu 64–65, 95
    Mémorial de l'internement et de la déportation 47, 61, 95, 100
Con Dao (Poulo-Condore) 174–75
concentrationary, the 49, 83, 98
    memory 7, 50–52, 117–18, 187, 193

universe 50
    see also camps, concentration
cone of vision 2, 56, 93, 116, 142
COVID-19 pandemic 171, 181n, 187–88
Crémieux, Gaston 157
Croix de Lorraine 65–66, 87

Dachau 2, 8
Dallas Holocaust and Human Rights Museum (DHHRM) 97, 126
Dalston, Lorraine 166
Dannecker, Theodor 111
dark heritage 38, 54
dark tourism 147, 183
darkness 26–27, 29–30, 33–34, 35
Day, Joe 27–28, 54
De Gaulle, Charles 3, 5, 64–65, 67–68, 87, 133, 138, 176
death 6, 15, 42–43, 51, 59, 66, 69, 71n, 98, 107–10, 111–14, 116, 118–20, 123–25, 139, 146, 158, 163, 191, 192
    death march walks 149
    deathscapes 130, 134, 140, 142
    see also suicide
decolonization 86, 165, 179
defenestration 93, 116, 118–19, 123–24
    see also suicide
Delbo, Charlotte 126
Deleuze, Gilles 19
DeLoughrey, Elizabeth 189
democracy, democratic 14, 32, 41, 45, 58, 63, 140, 184, 189
departmentalization 176
deportation 3–4, 6–7, 13, 14–17, 20–22, 32, 33, 42, 59–61, 63, 66, 68–69, 73, 84, 89, 92–96, 97–105, 108, 110–11, 115–16, 122, 125, 127, 129–30, 133–34, 144, 146n, 147, 151–53, 160–61, 165, 171–72, 178–82, 184, 192, 194
Derrida, Jacques 76, 85, 87
Didi-Huberman, Georges 38, 51, 57, 161–62

Discovery Museum 188n
documentary, documentary footage
    7, 18, 40n, 64n, 83, 95n, 101n,
    102n, 104–05, 116, 131, 169, 193
Dorey, Paul 62
Drancy 5, 6, 14, 26, 38, 63, 94–97,
    109–11, 113, 117, 150, 151, 156n
    housing estate 182
    see also Cité de la Muette
Dres, Jérémie 147–48
Dreyfus Affair 141
Dumas, Alexandre
    Count of Monte Cristo, The 157
Dupuy, Jean-Pierre 185
Duras, Marguerite 169
Durham Peters, John 166
dust, dustiness 9, 26–27, 43, 52, 129,
    138, 182

economic production 8–10
Edwards, Elizabeth 44
Eichmann, Adolf 112n
Éluard, Paul 69
enemies 6, 14, 81–82, 86, 102, 122
Enlightenment
    discourses of science and man 84,
        189
    ideals 83
environmentality 186–87
Ernst, Max 11, 26, 36, 42, 47, 104, 137
escape 16, 66–67, 69, 103–04, 115,
    118–19, 120–22, 132, 139, 157n,
    158, 195
Europe, European Union 7, 10, 16,
    20–21, 30, 37, 47, 59–60, 66n,
    68, 71–72, 79–80, 88, 92, 94–95,
    98–99, 101, 104, 106, 108–11,
    113, 122, 132, 139–40, 143–44,
    145–47, 157, 167–68, 171–72,
    177, 179–81, 193–95
    see also Fortress Europe
Évian Accords 176
extraordinary rendition 179, 181
extremism 18, 45, 54, 70, 87, 168, 179,
    194–95

fascism 66n, 87, 122, 140, 194
    anti-fascism 79, 81
fear 67, 70, 82, 86, 144–45, 166, 168,
    190
Feuchtwanger, Lion 11, 25–27, 42, 47,
    74, 81, 102
Final Solution 3, 5, 68, 106, 108–10,
    112n, 142
First World War 30, 100, 182n
flags 45, 53, 61–63, 69–70, 77, 86
    EU flag 87–89
    flagpoles 1, 62, 77, 87, 89
    flag-waving 64, 101n
    folds, folded 81–82
    Tricolore 1, 20, 60, 61, 63–65,
        77–78, 81, 86, 87–89
    see also Croix de Lorraine;
        Franciscan Axe
Flint, Michigan 186
foam 22, 182–83
Fontaine, André 2, 5, 9, 26, 36, 111,
    113–15, 119, 120, 122, 135–36,
    138–39
food banks 188
food shortages 114, 153
Foreign Legion 11
forest fires 138, 184
forgetting, forgotten 2, 3, 5, 33, 44,
    46–47, 50, 66–67, 70, 129, 131,
    134, 142, 145–46, 148, 149,
    151–52, 156, 158, 160, 165, 174,
    189
Fortress Europe 178–79
Foucault, Michel 8, 84, 180, 186
Franciscan Axe 65–66, 87
France, see Occupied France
freeze-frame 159
French Guiana 22, 146n, 165, 173–78
French Revolution 20, 77–78, 191
    revolutionary tradition 79
Friedman, James 37
Fry, Varian 103–04

galaxy, galaxie (des Milles) 15–16, 21–22,
    42, 44, 151, 161, 172, 175–76

Galerie Wedding 188
*Geostorm* 184–85, 187
gift shops 45–46
Gigliotti, Simone 96–97, 104–05, 111–13, 180
Girson, Matthew 148–49
globalization 167
Gorée Island 126, 127n
Goruchon, Charles 103
governmentality 180, 186
graffiti 113, 182
graves, gravestones 4, 42–44, 150–51, 159
Grynberg, Anne 2–5, 15, 78–81, 111, 123, 146
*groupe des travailleurs étrangers* (GTE) 10, 14
Guantánamo 2, 10
guests 76, 81, 85
guillotine 191
Gurs 6, 12, 14, 15, 117–18, 123–24, 150

Hamburg 74
Hammaguir 176
Herz, Eric 171
Hilberg, Raul 108, 111, 179
Hiroshima 2, 168
 *Hiroshima mon amour* 169
Hirsch, Marianne 7, 49, 148
historiography 3, 96, 108
Hitler, Adolf 3, 5, 30, 100–01, 108, 139, 173n
Ho Chi Minh City 171–72
 see also Saigon
Höcker, Karl 139
Hollande, François 62, 70n, 71–72, 82, 95, 144
Holocaust 5, 7, 18, 29, 49–51, 73, 96, 102, 108, 121, 131, 148, 165, 169, 179
 icon, iconography 37, 55, 93–94, 97, 105, 125
 memorial, museum 2, 13, 27, 31, 38, 46, 47, 49, 50n, 53–54, 60, 70, 94–95, 97, 105, 112, 126, 143, 145, 160, 193
 see also Shoah, the; *Shoah* (film)
hospitality 20, 22, 41, 60–61, 64, 72, 75, 76–77, 78, 80, 82, 84–85, 87–88, 157, 160, 179, 183, 188–90
 myth of 17, 77, 89, 144, 178
Hôtel Bompard 15, 21, 115, 117, 119–20, 122, 130, 152–58, 161
Hôtel Levant 21, 117, 152
Hôtel Terminus des Ports 15, 21, 115, 117, 152
human rights 2, 57, 67, 73
Hyde Park 140
hygiene 10

Ikea, ikeafication 27
Îles du Salut 177
immigrants 78
 illegal 72, 79, 179
immigration 41, 77, 79–80, 86, 179, 181n
 anti-immigration 144
 detention centres 10, 175n, 182
*in populo* sites 31
Indochina Wars 172
infotestine 28, 54
intellectuals 11, 42, 73–74, 102, 117, 121
interactivity 29, 106
International Council of Museums 189n
International Space Station 186
interpretation, interpretive strategies 7, 13, 17–19, 25, 31, 32, 34, 41, 55–56, 59, 60, 93, 98, 133, 161, 193–94
Islamophobia 144
Israel 33, 69, 107, 110, 143, 145, 158
 occupation of Palestine 33, 57–58, 144–45
 see also Mount Herzl; Yad Vashem
Italy 66n, 99, 157n, 184

Jeanmougin, Yves 26–27, 37
Jews, Jewishness 42, 43, 74, 86, 110, 140, 143–44, 147–48, 150
    persecution of 3, 4, 14, 17, 65–69, 79, 81, 92, 95, 97–98, 102, 105, 107–11, 121, 129, 146–47, 156n, 163, 179
    resistance fighters 67, 151

Kafka, Franz 36, 158
    Kafkaesque 102
Katz, Manfred 116
kilns 47
Kissi-Debrah, Ella 186
Klarsfeld, Serge 67–68, 102
Kourou 176–77
Kuhn, Gerard 149-50
Kulka, Otto Dov 158

Landmesser, August 74–75
landscaping 21, 132–33, 135, 138
Lanzmann, Claude 18–19, 106–09, 112, 122
    *see also Shoah* (film)
Laval, Pierre 111
laws, law-making 10, 41, 73, 76, 87, 123
leisure 51–52, 146n, 156
Léobal, Clémence 177–78
Les Milles (town) 2, 8, 9, 12, 92–93, 113, 135–36, 150–51, 161
*Les Milles – empreintes* (theatre) 32–33, 120, 124
*Les Milles: Le train de la liberté* (film) 101–04
Levi, Primo 47–49, 51
Lewisham 186
Liberation, the 3, 7, 49, 100n, 150, 165
Liebknecht, Robert 11
lieux de mémoire 3, 146
light 20, 25–31, 33–34, 38, 40, 53, 76, 94, 159, 190, 191, 193
    skylight 27, 33, 188, 193
Lipman-Wulf, Peter 9, 11, 76, 137

Macron, Emmanuel 100, 144–45
Magritte, René 34–37
Manen, Alice 160
Manen, Henri 103, 111, 114–15, 118–19, 122, 125, 160
Manus Island 10
maps 6, 108, 134, 195
mapping 3n, 131, 195
Marianne 64
Maroni River 177–78
Maroons 177–78
Marschütz, Leo 11
Marseille 6, 8–9, 14–15, 21, 44, 64n, 104, 114, 117, 119, 120, 122, 131, 136, 147, 152–57, 161
Marshall, Tim 63
Marzec, Robert P. 186
Maulavé, Robert 103
media 3, 6, 7, 21, 29, 32, 166, 169, 170, 174
    ecologies 179
    multimedia 20, 56, 100, 102n
    social 188
    *see also* propaganda
membranes 182, 188
Mémorial aux martyrs de la déportation (Paris) 130, 133
Mémorial de la Shoah
    *see* Shoah Memorial
Mémorial de l'internement et de la déportation
    *see* Compiègne
memorial gardens 63, 130, 132–34, 135n, 138, 143, 144
Merci Train 99–100
Merleau-Ponty, Maurice 141
Mersault 190–91
metaphors, metaphoric 16, 19, 34, 181–82
migration 180
    forced 99, 161, 165, 180, 186, 189
militancy 193
military barracks 95
Mille, Albert 9

Mitchell, W.J.T. 21, 129, 132, 135, 142, 162
*Monde, Le* 63, 82, 175
Montagne Sainte-Victoire 21, 130, 135–38, 141–43
Morano, Nadine 82
morgues 134
mothers 114, 116, 121, 124, 163, 191
Mount Herzl 144
multidirectional memory 7, 22, 165, 195
museography 32, 106
museum fatigue 56, 143
Museums Association (UK) 188n
mushroom
 cloud 22, 168–71
 matsutake 171
Muslims 33, 86–87, 145

Napoleon I 87
NASA 186
nation states 57, 59, 143, 185–87
National Gallery (UK) 188
national identity 20, 45, 63, 72, 75, 82, 86, 88–89, 132–33, 138
naturalization 14, 78–79
Nauru 10
Nazism 4, 140, 187
 Nazi Germany 11
 Nazi regime 3, 7, 15, 17, 29, 59, 61, 66, 69, 72, 79, 100, 102, 110–11, 113, 133, 146, 172, 174n, 187
 occupation of Europe 92, 103, 111
 propaganda 104–05
 *see also* camps, concentration; camps, extermination; Final Solution
necropolitics 179
Netanyahu, Benjamin 144–45
*New York Times, The* 40, 181
Nexon 3–4
Nice terrorist attacks 70, 86
Nixon, Rob 170–72
Nora, Pierre 3, 63, 146
*Nouvel Observateur, Le (L'Obs)* 71

nuclear testing 176
Nuremberg rallies 29

Occupied France 3, 6, 66, 95, 103, 111, 134, 142, 152, 165, 172

painting 34–36, 130, 141, 148, 153, 166, 183, 193
 *see also* artwork
Paris 42n, 95–96, 100, 111, 118, 134, 156n, 160n, 163, 174, 182–83
 October 1961 massacre 113n
 terrorist attacks 70–71, 86
 *see also* Drancy; Mémorial aux martyrs de la déportation; Shoah Memorial; Vélodrome d'Hiver
*Paris Match* 75
Pastoreau, Michel 88
Paxton, Robert 3, 133
penal colony, penal colonies 146n, 165, 173–75, 177
Pétain, Philippe 3, 64–65, 82, 86–87, 101, 103, 133
photography, photographs 1, 7, 20, 21, 22, 26–27, 36, 37–40, 44, 46, 48–49, 50n, 51–54, 57–60, 65, 74n, 92, 98, 104–06, 113, 119–20, 130, 139–40, 147–50, 164–65, 171, 184
 black and white 105, 168
 colour 37
 negative 34
 photo-essay 161, 172
 selfie 38
 sepia 105
Picasso, Pablo 137n
Pingunsson, Georges-Henri 134
Pirotte, Julia 119–20, 156
plaques 3, 66, 68–69, 99, 133–34, 147, 151, 153
Plath, Sylvia 159
Poland 98, 110, 144–45
police 41, 71, 79, 92, 111, 113n, 115, 119, 152–53, 178, 183, 187, 195

Pollock, Griselda 7, 49–51, 83, 98, 117–18, 187
postcards 45–46, 59, 74, 130
posters 64, 81–82
postmemory 7, 49, 148
power 8, 21, 29, 32, 41, 57, 60, 63, 64, 73, 87, 97, 130, 132, 163, 168, 180, 186
prisons 4n, 8, 10, 15, 28, 65, 79, 139, 147, 152n, 153, 156–58, 165, 174–76, 180n, 191
  see also Stanford Prison Experiment
Provence 2, 42, 130, 138, 155, 165, 171
  see also Aix-en-Provence 2, 4n, 6, 42, 130, 138, 155, 165, 171
punctum 39

racism 28, 41, 70, 73, 82–84, 87, 145, 159, 179, 193
  see also xenophobia
Rafle, La 6, 66–67
  see also round-ups; Vélodrome d'Hiver
*Rafle, La* (film) 101
railways 21, 92–93, 96, 98–102, 104, 108–09, 110–11, 113, 122, 142, 179, 181
  tracks 34, 38, 68, 91–92, 106, 129, 151
  see also SNCF
Rancière, Jacques 20, 54–56
Rastoin, Édouard 8
Redfield, Peter 176–77
refugees 71–73, 76, 79, 182–83
  climate 185
  crisis 190
  Surinamese 73, 178
  see also camps
repatriation 9, 150n, 181n
researcher
  as tourist 38
resistance
  discourse, narrative of 4, 20, 29, 45, 60, 64, 66, 69–70, 72, 74–75, 83, 85, 88, 96, 99, 104, 121, 135, 160, 183, 194
Resistance (French) 17, 49, 66–67, 81–82, 95, 101, 111n, 119, 150–51
  myth of 3, 17, 73, 77, 87, 89, 125, 144
Resnais, Alain 59–60, 106, 169
Réunion, Ile de 85
Reuterswärd, Carl Fredrik 62
ribbons 61, 77–78, 82
Ribot, Guillaume 149–50
Richard, Bernard 63, 77, 81, 86
righteous acts 20, 69, 72
Righteous among Nations 68–69, 73, 127, 161, 194
Rivesaltes 4n, 6, 15, 47, 63, 68, 146n, 150
Robson, Kathryn
Rothberg, Michael 7–8, 22, 165, 195
round-ups 4, 6, 66–67, 71, 101, 119, 134, 144
ruins 9, 27, 37, 51, 146n, 158, 172, 181
Rwandan Genocide 29

Safdie, Moshe 110
Saigon 174
Saint Cyprien 12, 147
Saint Joseph de Cupertino 164, 166
Saint-Laurent-du-Maroni 173, 177, 182
Saint-Nicolas (camp) 104
Salomon, Charlotte 117–18
*sans papiers* 20, 72
  see also immigrants
*Sarah's Key* (film) 101
Sarkozy, Nicolas 71n
Sarraut, Albert 79
satellite 22, 161, 165, 176, 184–86
  see also camps
Schafir, Anna 114n
school visits 51, 55, 143, 159–60
Scott Thomas, Kristen 103
Second World War 2, 5, 7–8, 10, 17, 22, 54, 61, 62–3, 86, 94–95, 99, 104,

125, 131, 133, 145–47, 152, 154, 163, 168, 179, 182, 193, 195
security 2, 41, 57, 60, 63, 69–70, 78, 80, 85, 87, 146, 175, 178, 186
 securitization 61–62, 70, 132, 144, 160, 183, 194
Seghers, Anne 156
shame 3, 5, 63, 66–67, 69, 72
Shoah, the 18, 31, 49–51, 54, 57, 84, 106–07, 195
 see also Holocaust
*Shoah* (film) 18–19, 106–09
Shoah Memorial 13, 18, 42, 66, 70, 117, 120n, 133, 159
 Documentation Centre (Drancy) 95
Silas, Susan 149
Silverman, Max 7, 49–51, 83, 98, 187
sitedness 39–40, 129, 161
 *in situ* 31
sky 1, 22–23, 35, 59, 141, 163–67, 171–72, 176, 179, 181, 184–85, 187, 190–92
 see also light, skylight
slavery 123, 126–27, 176, 189
Sloterdijk, Peter 22, 166–67, 182, 185, 187
Smith, Patti 159
SNCF 101
 reparation claims 102
 see also railways
Sobibór 95
social media 188
sociology 83, 150, 194
souvenirs 26, 44–46, 52, 81
 see also Wagon of Remembrance
sovereignty 87, 186
spectators, spectatorship 20, 30, 54–57, 92, 101n, 106, 109, 125, 141–42
speech 4, 62, 66–67, 71–72, 91–92, 103, 144, 176
Springer, Ferdinand 11, 36n
Stanford Prison Experiment 40n, 194
Stansted Fifteen 179
state of exception 10, 123

stations (railway) 91–92, 94–96, 99, 102, 109, 112, 129, 151, 152
statues 64, 134n, 151, 159
Steinitz, Elizabeth 119
Still, Judith 76
Stoekl, Allan 18–19
storytelling 19, 56, 148, 170
striped pyjamas 6, 47, 97
Struthof (KL-Natzweiler) 3, 5
suicide 16, 42, 49, 63, 112–13, 115–16, 118–21, 123, 150
 see also windows
Suriname (Dutch Guiana) 178
 Surinamese Interior War 73, 177–78
surveillance 60, 79–81, 186
survivors 3, 6, 58, 60, 102, 107, 158
 testimony 29, 39, 48–49, 96, 111n, 116, 119, 125, 171
suspension 8–9, 121–24, 156, 195
swastika 183

Taussig, Michael 43
Temple Mount 158
Terror, the 78
Tézenas, Ambroise 37
thanatopolitics 6
 see also necropolitics
theatre 32–33, 54, 56, 120, 123–24
Third Republic 6, 10, 13–15, 65, 73, 81, 172
tiger cages 176
tile factory 1, 2, 8, 11–13, 26, 32, 36, 91, 95, 101, 105, 122, 131–32, 139–40, 151, 160, 165, 193
tiles 9
timescape 110
Tinius, Jonas 188
Toro-Mater, Denise 6
totalitarianism 14, 41, 68, 87, 145, 194
toxicity 167, 183, 186–87
traces 52, 96, 98, 113, 118, 122, 125, 134, 147, 149, 153, 157, 162, 181, 182, 193

trains 21, 91–93, 95–97, 99–106, 109–14, 116, 122, 124–27, 136, 179–80, 183
    Merci Train 99
    phantom 93, 104
Traube, Herbert 125
Treblinka 2, 109, 148
Tricolore 1, 20, 60, 61, 63–65, 69, 77–78, 81, 86–87, 89
Trump administration 181n
Tsing, Anna 171

UNESCO 18, 71, 184
United Nations High Commission for Refugees 178
United States 31, 42, 97, 99–100, 103–04, 112, 143, 150, 171, 179, 186
United States Holocaust Memorial Museum (USHMM) 31, 42, 97–98
universal rights of man 18, 59, 78, 125

Valley of the Communities 143
van der Laarse, Rob 139–40
Vélodrome d'Hiver, Vél d'Hiv 4–6, 66, 71–72, 92, 101, 103, 134, 144
Vergès, Françoise 84, 190
vexillology 63
viapolitics 180
Vichy 4–6, 14, 42, 61, 64–70, 72, 81–82, 86–87, 89, 92, 101n, 103, 111, 115, 131, 133, 142, 152, 165, 172, 175
    syndrome 3
video 28, 33, 39, 40n, 64, 101n, 105, 116, 171
    screens 25, 29–32, 58
views 1, 5, 13, 16, 19, 20–21, 35, 37–42, 44, 52–53, 56n, 58–60, 69, 89–90, 92, 95–96, 106, 110, 113, 126–27, 129–30, 132, 134–38, 141–42, 157, 161, 190, 192, 195

violence 12, 22, 41, 48, 63, 85, 110, 124, 162, 165, 175, 180–81, 187, 189–90, 195
    slow 170–71
Virilio, Paul 29–32, 98, 166, 172, 184, 187
visitors 7, 13, 17, 19–20, 27–30, 33, 37–39, 40, 44, 47, 50, 54, 56, 60, 69, 73, 96–98, 101, 105, 110, 112–13, 116, 126, 133, 135, 142–43, 145, 149, 159–61, 168, 188, 193–95

*Wagon, Le* (novel) 111n
wagon, wagons 21, 53, 61, 69, 91–92, 94–98, 111–12, 129, 161, 179, 181
Wagon de l'armistice 100
Wagon of Remembrance, Wagon du souvenir 1, 4, 13, 18, 21, 53, 59, 61, 64–65, 69, 72, 87–89, 91–98, 101, 103, 105–07, 109, 110, 112, 126, 129, 131, 136, 141, 161, 165, 179, 181
Wahnich, Sophie 62, 78
waiting 11, 92, 110, 122, 156, 191–92
walks, walking 89, 92, 96, 132–34, 136, 145–46, 150, 157, 158, 161
    *see also* death, death march walks
Walters, William 180, 186
war industry 3n
War on Terror 144, 179
Warsaw 147–48
whiteness 82, 88
windows 1, 9, 12, 16, 19, 20, 25, 27, 38–41, 53–54, 56, 59–60, 89, 94–96, 110, 112–14, 116, 119–20, 122–24, 127, 129–30, 132, 136, 159, 161, 163, 165, 184, 190–91, 195
    frame 20, 22, 25–26, 34–37, 53–54, 57–60
    glass 27, 31, 136

shutters 26, 28, 53
suicide window 21, 23, 25, 28, 33, 36, 41, 4–44, 46, 52–53, 58, 60, 69, 92, 95, 106, 116, 120, 136, 141, 188, 193, 195
  *see also* light, skylight
witnesses, witnessing 19, 20, 22, 40–41, 46–51, 52, 56, 70, 83, 96, 98, 106–08, 115–16, 118–19, 125–26, 158, 181, 182
  secondary 22, 26, 37, 50–51, 56, 60, 92, 97, 106, 108, 125–26, 131–32, 142, 149
Wols 11, 36n
women
  experience of the camps 14–15, 21, 44, 108, 115–18, 120–22, 125, 152–53, 156
  Muslim 86

suicides 20–21, 42–44, 58–60, 113, 116–17, 120–25, 150, 195
women's writing 124

xenophobia 20, 28, 41, 54, 68, 145, 161, 193

Yad Vashem 27n, 31, 53, 69, 97, 110, 138, 143–45
Yarlswood 10
yolocaust 38
Ypres gas attack 166–67
Yusoff, Kathryn 123–24, 189

Żelechów 148
Zionism 143–45
  anti-Zionism 145
zones 3, 5–6, 28, 49, 66, 68, 111, 134, 178
  historical zone 28, 33, 39, 81
  reflective zone 28–29, 39–41, 74, 83, 145, 184

Printed and bound by CPI Group (UK) Ltd, Croydon, CR0 4YY

12/05/2024

14500778-0002